SURREALISM AND AFTER

THE GABRIELLE KEILLER COLLECTION

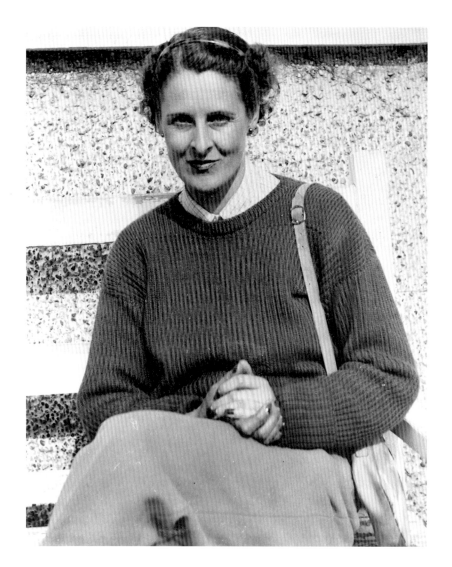

GABRIELLE KEILLER 1908–1995

ELIZABETH COWLING

WITH RICHARD CALVOCORESSI, PATRICK ELLIOTT
AND ANN SIMPSON

SURREALISM AND AFTER

The Gabrielle Keiller Collection

SCOTTISH NATIONAL GALLERY OF MODERN ART

EDINBURGH · 1997

Published by the Trustees of the National Galleries
of Scotland for the exhibition held at the Scottish National
Gallery of Modern Art, Edinburgh, 5 July – 9 November 1997
Text © The Trustees of the National Galleries of Scotland 1997
Illustrations © as listed below

ISBN 0 903598 68 X

Designed and typeset in Quadraat and Birch by Dalrymple
Printed and bound by BAS Printers Ltd, Over Wallop

Front cover: René Magritte *La Représentation* 1937 (cat.62)

Back cover: Andy Warhol *Portrait of Maurice* 1976 (cat.168)

Inside cover: Decalcomania endpapers by Georges Hugnet from
Immortelle maladie, Benjamin Péret, 1929 (cat.359)

Contents

Foreword

Gabrielle Keiller's bequest is by the far the most important gift made to the Scottish National Gallery of Modern Art since it opened in 1960 – the date, coincidentally, that Mrs Keiller's interest in modern and contemporary art was first aroused. It joins the group of works acquired since 1990 from the collection of Roland Penrose (including the latter's library and archive) with the result that Scotland can now boast a centre for the study and enjoyment of Dada and Surrealism which is of international significance.

From 1978 to 1985 Mrs Keiller was a valued member of the Gallery of Modern Art's advisory committee but her links with Scotland, through her husband Alexander Keiller, stretch back further. Her decision to leave her collection to us was taken in 1988 when we exhibited the core Dada and Surrealist works, including artists' books and periodicals, in the Royal Scottish Academy under the title *The Magic Mirror: Dada and Surrealism from a Private Collection*. At the time Mrs Keiller understandably did not wish to be identified as the owner of that private collection. Today we are delighted to be able to lift her anonymity, albeit posthumously.

The Magic Mirror catalogue was written by Elizabeth Cowling, Senior Lecturer at the University of Edinburgh and an authority on Surrealism. The present book, which is in part a considerably expanded version of the 1988 catalogue, is again substantially the work of Elizabeth Cowling, to whom we are enormously grateful. Patrick Elliott and Ann Simpson (respectively, Assistant Keeper and Librarian at the Gallery of Modern Art) have also made extensive contributions. The editing has been done by Dr Elliott in conjunction with Keith Hartley, Deputy Keeper of the Gallery of Modern Art.

The Keiller collection includes paintings, drawings, sculptures, prints, books, manuscripts, photographs, rare periodicals, pamphlets, exhibition catalogues and other ephemera. All the original artworks have been included in this catalogue, but since Mrs Keiller's art library consisted of more than 1,000 items, the recent publications, monographs and general books have been excluded. This leaves an impressive body of original Surrealist publications, rare or significant items relating to the main collection, and other publications which contain original prints or manuscript material.

The catalogue has been divided into two parts. The first part, which includes 173 items, comprises the framed or sculpted items which Mrs Keiller had on permanent display at her house. The second part, more than 250 items, consists of library material which was (and remains) shelved or boxed. There is, inevitably, an element of subjectivity in defining what is and what is not a library item – for example, George Grosz's collage postcard (cat.49) has been included in the first section, since Mrs Keiller purchased it as an independent, framed work. The catalogue entries in the library section concentrate on visual material rather than on literary content.

Finally, we are indebted to McGrigor Donald for their sponsorship of the exhibition.

TIMOTHY CLIFFORD
Director, National Galleries of Scotland

RICHARD CALVOCORESSI
Keeper, Scottish National Gallery of Modern Art

Sources and Acknowledgements

Much of the information published in this catalogue is drawn from Gabrielle Keiller's papers, now in the Archive of the Scottish National Gallery of Modern Art. In Richard Calvocoressi's essay, use has also been made of the obituaries of Mrs Keiller in *The Times* (10 January 1996), *The Guardian* and *The Independent* (both 12 January 1996). For information on Mrs Keiller's American family background, thanks are due to her niece, Mrs Cornelia Bivins; and on her English background, to Lucy Hoare. The principal source for the brief account of Alexander Keiller's archaeological work is Caroline Malone's exhibition catalogue, *Alexander Keiller's Avebury 50 Years Ago*, Southampton, 1986. Ros Cleal, curator at the Alexander Keiller Museum, Avebury, has also been particularly helpful. The article by Lanning Roper referrred to is 'A Feeling for Scale: Gardens of Telegraph Cottage, Kingston Hill' in *Country Life*, 11 November 1976. Roper also wrote about the gardens at Glenveagh in *Country Life*, 24 May 1973.

We are grateful to all the artists who responded to queries about their work, especially Sir Eduardo Paolozzi, and also to D. W. Hopkin and Richard Gibbon of the National Railway Museum, York, who provided information concerning the engine diagram used by Francis Picabia in cat.152. Within the National Galleries of Scotland, in addition to those mentioned in the Foreword, the following have contributed to the exhibition or catalogue: Janis Adams, Ian Craigie, Nicola Christie, Graeme Gollan, Philip Long, Fiona Pearson and Julia Lloyd Williams. We would like to thank John Armbruster, Dr David Brown, Mr and Mrs Giles Currie, Caroline Cuthbert, Claire Hudson (National Theatre Museum, London), Mme Myrtille Hugnet, James Mayor, Judith Mallin (Young Mallin Archive, New York) and Karole Vail for their help in various ways.

The catalogue entries have been written by Elizabeth Cowling, with the following exceptions. Catalogue numbers 2, 4, 5, 13, 14, 20–2, 36–40, 42–8, 55–8, 71–147, 159, 161, 164, 174, 316, 322–4, 349, 372, 376, 384, 407, 409, 415 and 416 were written by Patrick Elliott; numbers 169–73 by Dr Robin Barber of the Department of Classics, University of Edinburgh; numbers 41 and 155 by Mungo Campbell, formerly Assistant Keeper at the National Gallery of Scotland, now Deputy Director of the Hunterian Museum, Glasgow; and numbers 49 and 380 by Keith Hartley. The original listings of the works in the first section were compiled by Patrick Elliott, and those in the second section by Ann Simpson. Catalogue numbers 4, 34, 41, 155, 162 and 169–73 are currently the subject of negotiations with the Capital Taxes Office and have not been accessioned.

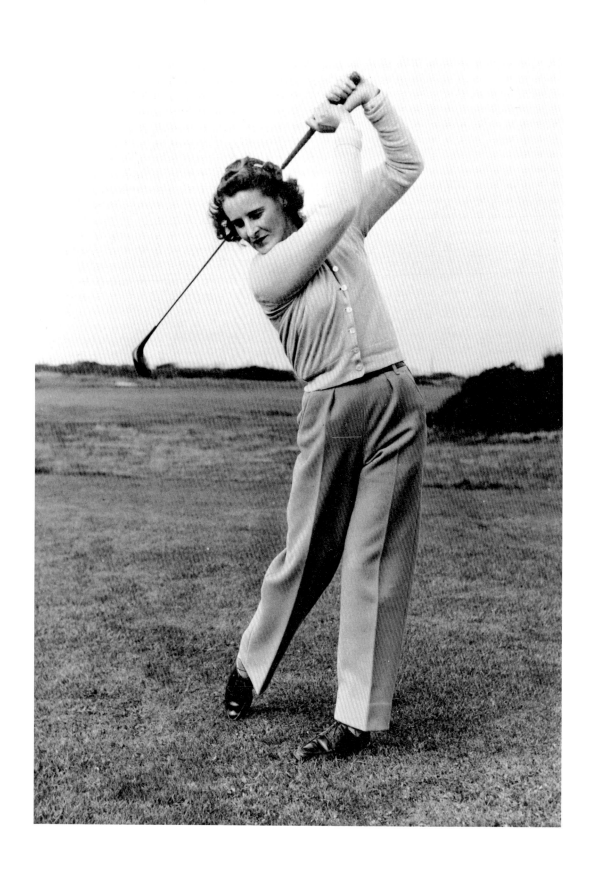

RICHARD CALVOCORESSI

Gabrielle Keiller: A Biographical Sketch

The first half of Gabrielle Keiller's life was dedicated to golf, the second to art. She was practically born on a golf course – at North Berwick, where her father, accompanied by his presumably heavily pregnant wife, had gone on a golfing holiday. By the time she was thirty, Gabrielle Style (as she then was) was being noticed as an amateur golfer of exceptional promise. In 1939 she played for the Ladies' Parliamentary team against Belgium, and in the French Ladies' Open Championship at Le Touquet. The war interrupted her golfing career but she resumed it afterwards with the help of some expert coaching by Archie Compston at Wentworth and Arthur Lees at Sunningdale. She played regularly for the strong Royal Mid-Surrey team, reached the semi-finals of the French Ladies' Open in 1947, won the Ladies' Open Championships in Luxembourg, Switzerland and Monaco in 1948 (fig.1), retained the Monaco title in 1949 – the year she also won the Ladies' London Foursomes – was selected for England more than once, and was narrowly beaten by Jeanne Bisgood in a thrilling final of the English Ladies' Close Championship in 1951. A woman of striking good looks and a tall, athletic figure, she was described in the golfing press as 'one of the longest hitters in the country'. At the age of forty-seven she was shortlisted for the 1956 Curtis Cup team. But in 1955 her husband of four years and golfing companion of not much longer, Alexander Keiller, died of cancer and she never lifted a golf club again.

Mrs Keiller was born Gabrielle Ritchie on 10 August 1908, the oldest of three children and the only girl (fig.2). Dick Ritchie, the younger of her two brothers, died in his twenties while her other brother Monty survived her. Her mother, Daisy Hoare, was from the well-known family of bankers and brewers. Gabrielle Keiller's father, James (Jack) Ritchie, was an American who was brought by his widowed mother to be educated in Europe after his father's death during the American Civil War. There his mother met and married an unscrupulous Irish landowner called John Adair. Together they built in the early 1870s Glenveagh Castle on the shores of Lough Veagh in County Donegal, on land acquired from the Earl of Leitrim. Shortly afterwards the Adairs bought a million acres of cattle grazing on either side of the Palo Duro Canyon in Texas, which became the J. A. Ranch (after John Adair, who died in 1885).

Jack Ritchie worked at the J. A. Ranch as a young man and his stories of cowboy life inspired his son Monty, Gabrielle's brother, to follow in his footsteps. In the early 1930s Monty Ritchie took over the management of the J. A. Ranch which the Ritchie children had inherited on their father's death in 1925

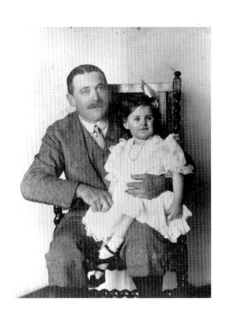

opposite fig.1 Gabrielle Style, 1948

above fig.2 Gabrielle aged one year eight months with her father, Jack Ritchie, April 1910

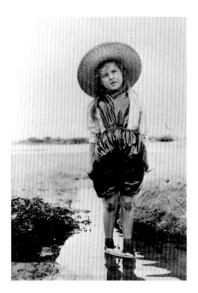

fig.3 Gabrielle at North Berwick, July 1914

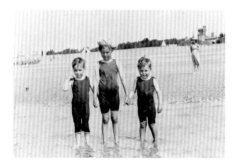

fig.4 Gabrielle with her brothers Monty (left) and Dick (right), Hayling Island, August 1915

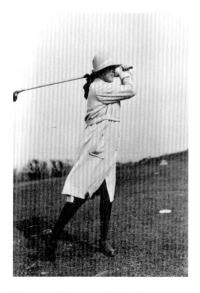

fig.5 The first recorded swing, Easter 1922

but which was suffering from the effects of taxation, drought and the Depression. It was the sale after the last war of her share in this by now lucrative asset which provided the funds for Gabrielle Keiller's art collecting.

In old age Gabrielle Keiller vividly recalled childhood summers spent at Glenveagh, where her American grandmother, who became a prominent Edwardian society hostess, had created a luxuriant garden amid spectacular mountain scenery; she remembered with special delight picnics in the boathouse and boat trips up the lough. Years later Mrs Keiller would create her own garden, planting rhododendrons as her grandmother had done and introducing water. Glenveagh was sold in 1929 to Arthur Kingsley Porter, a Professor of Fine Art at Harvard and a Bostonian like Jack Ritchie's father. In 1938 it was bought by Henry P. McIlhenny, the art collector, philanthropist and former museum curator from Philadelphia (whose grandfather was from Co. Donegal). McIlhenny, whom Gabrielle Keiller came to know and like, further developed the garden and on his death in the 1980s left it and the house to the Irish state; it is now a national park.

The Ritchies lived in a large comfortable house, Ashwell Rise, in hunting country near Oakham in Rutland. The young Gabrielle Ritchie appears to have been educated by a series of governesses before being sent to boarding school at an unusually young age. Her surviving childhood photograph albums illustrate carefree family holidays spent in fashionable seaside resorts and rambling country houses (figs.3–5), one of which, Bignell Park in Oxfordshire, was the home of her maternal aunt Violet Ruck Keene. In her early twenties Gabrielle Ritchie graduated to ski-ing in the Alps and summers on the Normandy coast, where she may have met her first husband. The couple were married in London in 1931 and lived at Le Havre; the marriage produced a son but it was short-lived. By 1939 she had remarried and was playing in golf tournaments as Mrs Style. During the war she drove ambulances in London for the L.C.C. Auxiliary Ambulance Service, chiefly in Hammersmith which was heavily bombed (fig.6). In February 1940 she passed with distinction the examination in the First Aid Treatment of Air Raid Casualties, and in 1940–41 was awarded the Civil Defence Safe Driving certificate with merit. (She later passed the Advanced Motoring test and continued driving a car into her eightieth year.)

Gabrielle Keiller's second marriage also ended in divorce and in June 1951 she married for the third and last time (fig.8). She had met Alexander Keiller in 1947 and in 1949 accompanied him on a ski-ing holiday. Almost twenty years her senior, Keiller was dashing, a fine sportsman (he excelled at ski-ing and loved motor-racing and golf) and – as sole heir to the Dundee marmalade firm – was a man of considerable wealth. But he used his money in a constructive and altruistic way. An archaeologist, he had been concerned by a proposal in 1923 to construct a wireless station on Windmill Hill near Avebury in Wiltshire (fig.7). So he bought the site and embarked upon a programme of excavation and restoration that lasted five years. In 1934 he also acquired the land containing the Stone Circle at Avebury, including the sixteenth-century Avebury Manor which became his base until the early fifties. Excavation and reconstruction of both the Stone Circle and West Kennett Avenue continued until the outbreak of war. Keiller was assisted initially in this painstaking project by Stuart Piggott, later Professor of

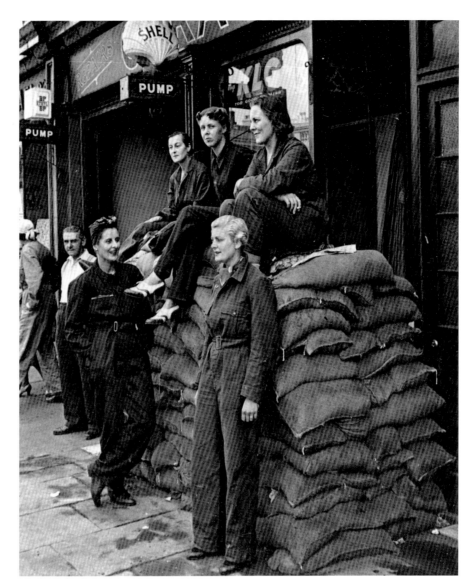

right fig.6 Gabrielle Style (left) with L.C.C. Auxiliary Ambulance crews, 1940

below fig.7 Alexander Keiller (centre) with his archaeological team, Windmill Hill, 1920s

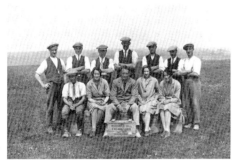

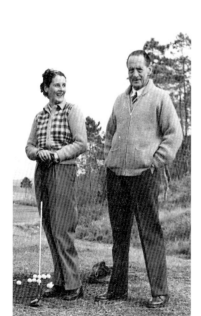

fig.8 The Keillers at Cannes, winter 1952

Prehistoric Archaeology at Edinburgh University. The work was carried out using the latest technical equipment and scientific methods, such as aerial photographic survey of which Keiller was a pioneer.

Keiller financed the work on the neolithic henge monument at Avebury himself. The stable block at Avebury Manor became the headquarters of his Morven Institute for Archaeological Research, named after a mountain on his family's estate in the Grampians, where as a young man he had carried out his first archaeological dig. (He later made a special study of the megalithic monuments of north-east Scotland.) In 1938 he also opened a museum of the Avebury excavations in the old stables. Four years later he offered the Avebury Stone Circle as well as Windmill Hill to the National Trust who purchased the whole site following a public appeal. The contents of the museum were presented by Mrs Keiller after her husband's death to the Ministry of Public Buildings and Works, now English Heritage, who describe them in their handbook as 'one of the most important prehistoric archeological collections in Britain'. They can be seen today in the museum that bears Alexander Keiller's name.

Gabrielle Keiller used to say that, had her late husband lived to witness the

direction which her art collecting took, she was certain he would have approved. Alexander Keiller's eclectic interests and eye for the bizarre may well have helped shape Mrs Keiller's own unconventional taste. His personal collections included Ushabti and Egyptian antiquities; manuscripts of William Stukeley, the eighteenth-century archaeologist and antiquary who was one of the first to record the stones at Avebury; and some 240 books on witchcraft and demonology from the fifteenth century onwards. He presented the Stukeley papers to the Bodleian Library shortly before his death in 1955; and in 1966 Mrs Keiller gave his books on witchcraft to the National Library of Scotland.

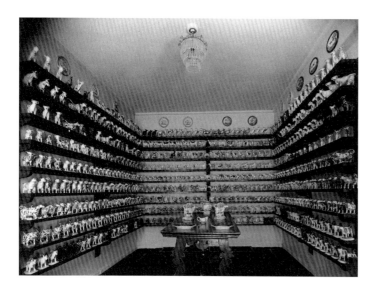

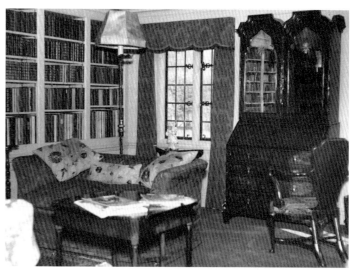

left fig.9 The Keiller collection of pottery cows

right fig.10 Interior at Telegraph Cottage, 1955

In the brief period they were together the Keillers amassed a collection of hundreds of pottery cow creamers which filled an entire room of their flat (fig.9) at Fairacres, the crescent-shaped thirties block on Roehampton golf course. Gabrielle Keiller later donated these to the city museum at Stoke-on-Trent where they were joined many years later by her smaller and arguably more valuable (though less colourful and idiosyncratic) collection of silver cows. But it was in the field of English furniture and decorative art that the Keillers' tastes coincided so exquisitely. They concentrated on seventeenth- and early eighteenth-century walnut pieces but there were also examples of Jacobean tapestry and stumpwork. Keiller, one assumes, had acquired a number of these objects to furnish Avebury Manor but Gabrielle Keiller continued buying after his death.

At first the couple divided their time between Avebury and Roehampton but in 1954 they bought Telegraph Cottage on Kingston Hill in Surrey, a short car journey from central London (fig.10). Situated between two golf courses, with direct access to one through a gate in the garden, its attractions were obvious to both of them – and had not been lost on General Eisenhower, one of whose residences it had been during the war. Telegraph Cottage (an architectually undistinguished house of medium size) was so-called on account of its function during the 19th century as a semaphore station on the route from the Admiralty to Portsmouth. When the Keillers bought the property the garden of some four-and-a-half acres was a wilderness. But Gabrielle Keiller soon initiated a radical campaign of clearing and planting (fig.11). Twenty years later her achievements were the subject of an article in *Country Life* by the celebrated garden designer

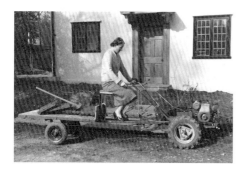

fig.11 Early work on the garden at Telegraph Cottage, 1955

Lanning Roper, who had become a friend and who offered occasional advice. 'The garden could be in the country', wrote Roper. 'The completely flat site was in itself a challenge, but thanks to clever planning, the garden is full of mystery and surprises [...] Inside the gate a lovely prospect awaits. To the right is a formal rose garden. To the left is a little paved pool garden, tucked in between the house and the fence, and a path bordered by colourful herbaceous borders and a long bed of roses, both hybrid tea and shrub, stretches to a wooded area beyond.'

Roper particularly noted 'Mrs Keiller's large collection of modern sculptures, many of which are by Eduardo Paolozzi' and praised their imaginative siting

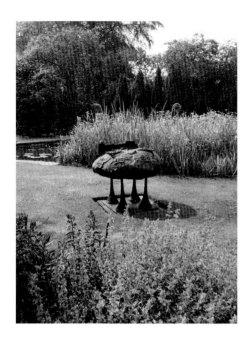

figs.12,13 & 14 The garden at Telegraph Cottage, mid-1970s, with sculptures by Eduardo Paolozzi. Top: *Large Frog* (cat.119) Right: *Kreuzberg* (cat.144)
© *Alex Starkey and Country Life Picture Library*

'with proper light, so that they are seen to best advantage against appropriate backgrounds, and a feeling for scale' (figs.12, 13, 14 & 16).

Alexander Keiller's death in October 1955, only a year or so after the move to Telegraph Cottage, cruelly terminated what by all accounts had been a supremely contented and fulfilling relationship. Gabrielle Keiller's life changed fundamentally. She became a Roman Catholic. She gave up golf – its associations with her

husband must have been painful – and channelled her energies into the garden and a series of more intellectual pursuits. In 1956 she wrote offering her services to Rupert Bruce-Mitford, then Keeper of British and Medieval Antiquities at the British Museum. For more than a decade she worked there as a part-time volunteer, making a valuable and acknowledged contribution to Bruce-Mitford's magisterial study of the Sutton Hoo Ship-Burial, including taking photographs 'in the field and in the Museum' which were eventually published in the massive first volume (1975). She had become a skilled photographer of monuments and buildings, developing and printing her own work. She later worked on Celtic hanging bowls, the subject of Bruce-Mitford's last publication, which she may have helped finance. The seriousness with which she pursued her new interests can be judged by the fact that between 1958 and 1960 she attended four Medieval Archaeology conferences or summer schools, in Sheffield, Durham, the Isle of Man and Hereford. At the same time she commissioned a memorial volume on her late husband's work, *Windmill Hill and Avebury: Excavations by Alexander Keiller 1925–1939*, which appeared in 1965 with a memoir and an appreciation by Stuart Piggott. As late as 1982 she was honouring Keiller's memory in a letter she wrote to *The Times*, joining in a protest at the threat of traffic pollution to the Ridgeway, one of the oldest roads in Europe, which begins close to the Avenue at Avebury.

In the autumn of 1959 Mrs Keiller travelled through Italy on the first of a succession of art and architecture tours that took her over the next few years to the principal European sights. She also visited the American West in 1962, spending time with her brother Monty Ritchie on the family ranch in Texas, and the following year went to Mexico and Brazil, where she saw the São Paolo Biennale. By now her interest in modern art had been awakened and she was beginning to acquire it. There were two reasons for this. In Venice in 1960 she had been introduced to Peggy Guggenheim by a mutual friend, Wyn Henderson, and had been intrigued by her collection. Before the war Henderson had run Peggy Guggenheim's gallery, Guggenheim Jeune, in Cork Street; her son, the artist Nigel Henderson, was a fellow student and friend of Eduardo Paolozzi at the Slade. On the same trip, therefore, Gabrielle Keiller was taken to see Paolozzi's work in the British Pavilion at the Venice Biennale. Both experiences decisively influenced her taste.

The development of Mrs Keiller's collection over the next twenty-five years is recounted by Elizabeth Cowling (pp.21–30). Here one can only attempt to suggest how modern art affected her life. Her initial foray into the world of contemporary art took place in 1962. From the avant-garde gallery off Grosvenor Square run by the young Robert Fraser, whose mother Gabrielle Keiller knew well, she bought a painting by Richard Lindner (cat.56); she also acquired her first Paolozzi sculptures the same year, direct from the artist, with whom she developed a close friendship. Further purchases from Fraser followed over the next few years, including a Tanguy (cat.163, colour plate 46) and a Picabia (cat.153, colour plate 42), both in 1966, which shows that she was by now turning her attention to Dada and Surrealism. Her fondness for Freddy Mayor (the first to show Paolozzi) resulted in a long connection with the Mayor Gallery – her first purchase from them was in 1963 – that continued with Mayor's son James until she ceased buying art in the late 1980s. At Marlborough Fine Art (from whom she

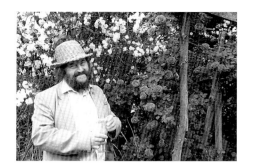

fig.15 David Brown in the rose garden at Telegraph Cottage, 1980s

bought, also in 1963, the first of two Francis Bacons that she consecutively owned) she formed a fruitful relationship with Tony Reichardt, through whom many of the most important Surrealist books were acquired. Other books, periodicals and library items came from H. A. Landry in London and John Armbruster in Paris.

Although the main focus of her interests was Dada and Surrealism, wherein lies the heart of the collection as well as its outstanding significance, Gabrielle Keiller did not ignore the work of younger British artists. Encouraged by David Brown (fig.15), an assistant keeper at the Tate Gallery from 1974 until his retirement in 1985, she made a number of important purchases in the early 1980s of work by Richard Long, Barry Flanagan, Hamish Fulton, Gilbert and George, Bruce McLean, John Davies and Ian Hamilton Finlay (whose garden at Stonypath she visited). She also bought large paintings by the German artist A. R. Penck and the Jugoslav-born Braco Dimitrijevic, both of which hung on the staircase at Telegraph Cottage, and a drawing by the Italian Enzo Cucchi. Of these, the Longs, Fultons, Gilbert and Georges, one of the Flanagans, the Dimitrijevic and the Penck were all sold after Mrs Keiller abandoned Telegraph Cottage following a serious fire there in 1986 and moved to a smaller house in central London.

One of the pleasures Gabrielle Keiller derived from buying art was getting to know the artists, who were frequent guests at Telegraph Cottage. Richard Long, by whom she owned a total of seven works, created a sculpture specially for her garden in 1981. Consisting of approximately 150 pieces of grey slate laid out in six concentric circles, Long installed it himself in a woodland clearing fringed with conifers (fig.17). Coming across it unexpectedly was an unforgettable experience. A couple of years later she bought another sculpture by Long, this time a compact circle of flints, which also found a perfect home in a glade at the end of the garden. The garden was the scene of regular summer parties in which Mrs Keiller entertained the London art world and a stream of people from abroad.

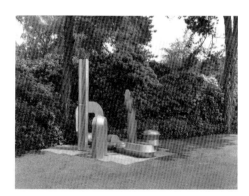

above fig.16 Paolozzi's *Domino* (cat.136) in the garden at Telegraph Cottage, mid-1970s
© *Alex Starkey and Country Life Picture Library*

right fig.17 Richard Long's *Six Stone Circles* 1981, specially created for the garden at Telegraph Cottage

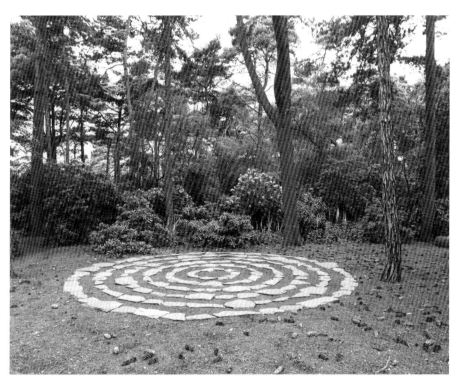

Preserved in her papers is a letter from Dominique de Menil (whose own art collection in Houston, Texas includes magnificent examples of Surrealism) after one such visit. 'As time passes', she wrote to Mrs Keiller in the summer of 1979, 'the vision of your beautiful garden remains radiant. With it persists the memory of some great paintings, and more than anything else, of your lovely hospitality.'

The paintings, works on paper and smaller sculptures were displayed in every corner of the house, including Gabrielle Keiller's bedroom and bathroom which she never minded throwing open to the various art-loving groups who requested a visit. On the first floor a snug library contained her astonishing collection of rare books, periodicals and manuscripts, each volume meticulously catalogued, with the more fragile or valuable neatly boxed. An inventory, probably compiled in the early 1970s, indicates that for a while her Surrealist and contemporary works coexisted with more conservative acquisitions of Old Masters and classic modern art made a decade or so earlier; these were gradually sold off as the collection became more concentrated and refined. Mrs Keiller's evident talent for making modern art look at ease in the company of antique furniture and porcelain did not imply an indifference to contemporary design. In the mid-sixties she commissioned the architect Colin St John Wilson to build a new house for her on the site of Telegraph Cottage but this was never realised. She later took a lease on a small flat in Chelsea which she refurbished in a contemporary style (fig.18). At more or less the same time an area opposite her bedroom on the first floor of Telegraph Cottage was converted into a small cinema where she and her friends could watch art films after dinner. She also added a garden room or conservatory to the house where sculptures by Turnbull and Flanagan were displayed.

Gabrielle Keiller's commitment to modern art, as well as her desire to share her passion for it with others, led her in the 1970s to accept a handful of unpaid public or semi-public duties. The most important of these was her membership from 1978 to 1985 of the Scottish National Gallery of Modern Art's advisory committee. Based near London, she was ideally placed to visit exhibitions and view works available for purchase both in the capital and abroad. Her experience and knowledge proved invaluable and she played a crucial role in the acquisition of many of the Gallery's most notable works during the period leading up to its move to new and larger premises in 1984. She would argue for the acquisition of what she felt were outstanding examples and was not afraid to disagree over works she considered to be of secondary importance. 'I am certain that one masterpiece is worth all the lesser works by lesser artists', she wrote to the then Keeper, Douglas Hall, when the Gallery was trying (unsuccessfully, as it turned out) to buy at auction a major Dalí. 'A painting like this raises for all time the prestige of the Gallery, enhances enormously the other Surrealist holdings in the collection, and we will at least fill one gap'. Typical of her blend of enthusiasm and incisiveness are the comments she drafted in preparation for a long acquisitions meeting in 1983, when works by, among others, Freud ('surely a major Freud and a "Gallery Painting" if ever there was one'), Gaudier-Brzeska ('I am sure we can do better. NO'), Poliakoff ('A big NO'), Spencer ('everything we look for in Spencer. YES!'), Craig-Martin ('I thought this a boring work – prefer his taped pictures'), Kirchner ('We have a master Kirchner – Let's stop there') and Bacon ('atypical, almost Whistlerian: a good Bacon or nothing') were on the

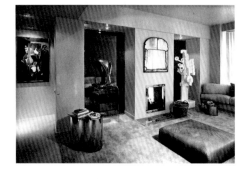

fig.18 Interior of Gabrielle Keiller's flat in Chelsea, showing (from left) works by Lindner (cat.56), Arp and Paolozzi (cat.131)

agenda. Her notes on the latter run uncharacteristically to three pages. As someone who knew Bacon's work, she was clearly troubled by the possibility that the rest of the committee had been seduced by this particular painting's 'ravishing' qualities. 'If we acquire works only because they appeal to us personally, we could, I think, be criticised by posterity for having a collection of interesting but atypical paintings. I think if we decide to buy a Bacon, it should really be a strong, poignant, typical work. I don't think it matters if we personally don't all like the subject matter, so long as the painting is what Bacon stands for. [...] This picture, to me, is just a shadow of a great Bacon.'

No wonder that Douglas Hall once thanked Gabrielle Keiller for her 'acerbity of eye which does not go to sleep [...] and for consistently applying a different and perhaps more rigorous standard of judgement as compared with some of us'.

During the time she served as a committee member Gabrielle Keiller gave the Gallery a sculpture and a portfolio of prints by Paolozzi and a sculpture by Gavin Scobie. She also at various times donated works by Paolozzi to the Hunterian Art Gallery at the University of Glasgow, the Art Gallery of New South Wales, the Museum of Modern Art, New York, and the Tate. Her association with Glasgow was a serious one. In 1971 she had decided to bequeath her collection to the Hunterian but changed her Will in 1980 when the university threatened to sell off eleven paintings by Whistler in order to meet a deficit on the building of the new Hunterian. To the Tate she also gave a photographic work by Hans Bellmer, which had once belonged to Georges Hugnet (see cat.300), and Roland Penrose's sculpture *The Last Voyage of Captain Cook* (fig.19). In the late seventies and early eighties Penrose sold Mrs Keiller some important pieces from his collection, including Magritte's *La Représentation* (cat.62, colour plate 30) and Giacometti's *Objet désagréable, à jeter* (cat.45, colour plate 23). Far from being rivals, the two collectors found much in common and were touchingly fond of one another.

Gabrielle Keiller's other main activity during this time was her work as a volunteer guide at the Tate Gallery, part of the first intake in 1976. On her retirement a decade later she received numerous letters of appreciation from friends, former colleagues and members of the public. She gave talks on, and in front of, a wide range of artworks – not just those of her beloved Surrealists but paintings by Monet, Braque, Matisse, Sickert, Pollock and Warhol, as well as by artists in the Historic British Collection such as Lely, Stubbs, Turner, Constable and Burne-Jones. She conscientiously compiled, and regularly updated, a card index on virtually every artist in the Tate. Her research was a model of thoroughness: for example, she asked her old friend Rupert Bruce-Mitford for help in identifying the ornamental motifs in Burne-Jones's *King Cophetua and the Beggar Maid*, and was thus able to point to some esoteric sources in the British Museum. Her lecture on Max Ernst's *Pietà* contained a number of her own original insights; that on Ernst's *Celebes* so impressed one member of her audience that he wrote asking for a copy. She punctuated her talks with large blown-up photographs, backed onto stiff card (made presumably at her own expense), which she would hold up at intervals to illustrate points of comparison. Mrs Keiller typed out each lecture in full, marking precisely what to emphasise and where to pause. But her delivery was more than just polished: 'thrilling', 'I thank her for communicating her excitement about the art very well' were typical comments.

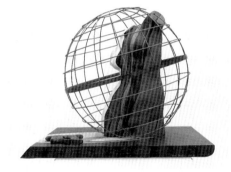

fig.19 Roland Penrose *The Last Voyage of Captain Cook* 1936, given by Gabrielle Keiller to the Tate Gallery in 1982

In whatever she did, Gabrielle Keiller was a perfectionist. 'Mrs Style is one of the most deliberate players', noted the magazine *Golf Illustrated* in 1947, 'and always has a practice swing before every shot'. This methodical approach went hand in hand with – was perhaps a symptom of – an unexpected diffidence and reserve. After her death, one obituarist alluded to her 'uncertainty' and 'self-denigration'. Paradoxically, these qualities were combined with humour, a zest for life and a sophisticated sense of style. For example, she took great pains over her appearance, attending the Paris collections twice a year and dressing in discreet but elegant couture clothes. But it was entirely characteristic of her inner self-doubt that she should have felt the need, half-way through her long stint as a Tate guide, to attend the Fine Arts course at Christie's for a year. (Some years earlier, at the age of sixty-three, she had gained an A level in Italian.) Her self-confidence must have been boosted, however, when she was invited the same year (1979) to act as a buyer for the Contemporary Art Society. Spending £11,000 on the work of nineteen different artists destined for public collections was a form of support and encouragement that appealed to her.

In 1986 the threat of an extensive development next to Telegraph Cottage persuaded a reluctant Gabrielle Keiller that it was time to move. 'To leave the garden will be a blow', she wrote to her solicitor, 'but I sense that it will no longer be the same, with houses overlooking it, all down one side.' She asked Caroline Cuthbert, whom she had got to know in the seventies when Cuthbert worked for the Anthony d'Offay Gallery, to put in train the sale of her outdoor sculptures to public collections. Cuthbert had the garden photographed and arranged an exhibition of the Paolozzis at the Serpentine Gallery the following year (fig.20), which travelled to the Glasgow Garden Festival in 1988. The majority were acquired by the Gallery of Modern Art, with others going to Leeds and Birmingham. Meanwhile, during the early hours of 12 June 1986, a bad fire broke out in

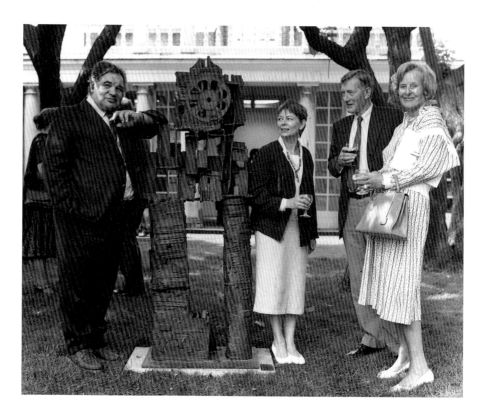

fig.20 Gabrielle Keiller (far right) and Eduardo Paolozzi (far left) with Paolozzi's *His Majesty the Wheel* (cat.120) at the private view of *Sculptures from a Garden*, Serpentine Gallery, August 1987

an upstairs bedroom at Telegraph Cottage. Fortunately the night was dry and Mrs Keiller and her faithful Italian butler Remo, assisted by a passing gang of workmen on an early shift, succeeded in removing most of the collection to the lawn. Miraculously few works were destroyed, although some suffered smoke or water damage, most severely Miró's *Le Cri* which was unglazed. However, the seventeenth-century furniture and hangings in the bedroom where the fire started were burnt without trace and most of the rest of the top floor was gutted.

For the next few months Gabrielle Keiller was homeless. In October 1986 she sold Telegraph Cottage and bought a smaller house in Chelsea. With the exception of the core Surrealist collection, any work of art that didn't fit was consigned to one of a small number of trusted dealers to sell. She responded enthusiastically to the Gallery of Modern Art's proposal to hold an exhibition of her Dada and Surrealist collection in the 1988 Edinburgh Festival and eagerly participated in cataloguing it. Afterwards, she presented the Gallery (anonymously) with Duchamp's *Bôite-en-Valise* (cat.28, colour plate 10). But she never felt settled in Chelsea and missed her garden acutely. 'The repercussions of that wretched fire seem endless', she had written despairingly to her solicitor at Christmas 1986, contemplating not only the devastation, but the complicated insurance claims that had to be filed, the cost of rescue work, restoration and storage, and the daunting prospect of having to move house at the age of seventy-eight. Now the trauma of the fire and subsequent upheaval were beginning to have a delayed effect on her health. From 1990, when she moved again to a mansion flat near Sloane Square, her decline was more noticeable. In early 1993 she entered a nursing home outside Bath, taking Warhol's portrait of her adored Maurice (cat.168, colour plate 47) – the last in a long line of dachshunds (fig.21) – and a few other pictures with her.

Her remaining few years were relatively happy. From her south-west facing bedroom window she looked out over rolling countryside. She went for short walks in the grounds. Her brother Monty flew over from America, old friends came to see her, her son and daughter-in-law lived nearby. In spite of her failing powers, she never lost her intense interest in others or her sense of fun. She died peacefully on 23 December 1995, aged eighty-seven. The simple funeral service was conducted by a Catholic priest. Her ashes were buried alongside those of her husband on the family land in Deeside – in that part of Scotland where, three-quarters of a century earlier, Alexander Keiller had begun his archaeological career.

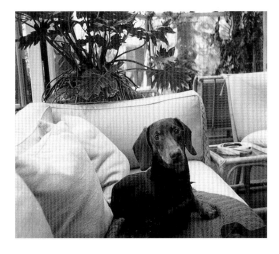

fig.21 Maurice in the garden room at Telegraph Cottage

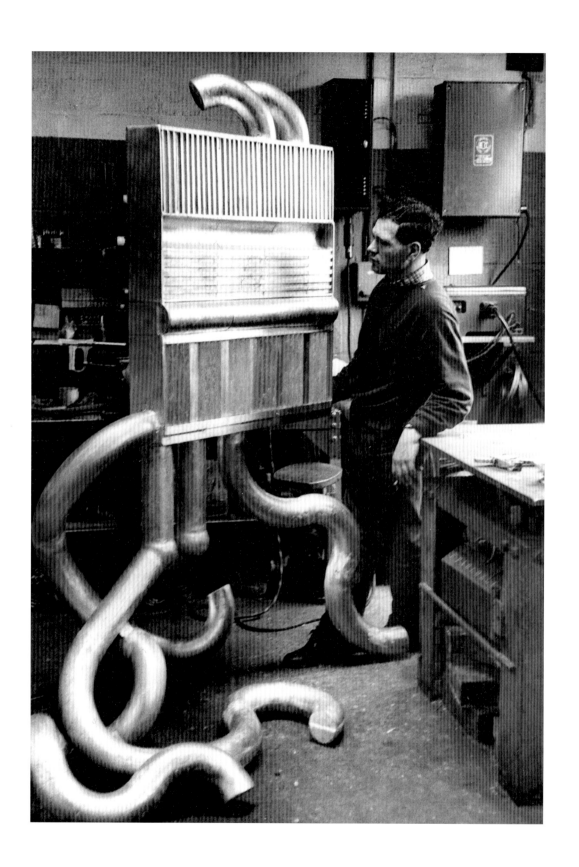

ELIZABETH COWLING

Gabrielle Keiller Collects

If there is one item in the Gabrielle Keiller collection which could be said to sum it up that item would have to be Marcel Duchamp's *Boîte-en-valise* (cat.28, colour plate 10). I say this for two reasons. The first has to do with the history of twentieth-century art: Duchamp is the vital link between the three dominant strands in the collection – Dada, Surrealism and the work of Paolozzi (fig.22) – animating the first, intervening in the second, influencing the third. The second has to do with the character of the collection: the *Boîte-en-valise* was conceived on an intimate scale to suit the private connoisseur and was tailor-made to offer a private view of the things packed away so neatly and ingeniously inside its leather-bound carrying case. For, like the samples of the travelling journeyman, the replicas of his works that Duchamp made for the *Boîte* are all miniatures. Ideally the contents have to be unpacked slowly and meticulously in the privacy of one's home; and once one has folded out the mock museum display, the retrospective Duchamp has staged can only be examined properly by one or two people at the same time. The experience is both like putting on a toy theatre production and going through a portfolio of prints.

The connection between the *Boîte-en-valise* and the Keiller collection as a whole resides in this element of intimacy, for despite the presence of a number of larger works it is mainly a collection of portable, private-scale things – modestly proportioned paintings and collages, drawings and prints, hand-sized *objets*, manuscripts and rare books. Like Duchamp's *Boîte-en-valise* – which was his selection from within his entire oeuvre – it displays an idiosyncratic taste and vision, and expects the spectator to come close – ideally to touch and hold and browse. Gabrielle Keiller herself loved to browse among her treasures. Perceiving my covetous looks when I visited her once she proposed that we 'play with Duchamp's box'. For the next half hour we were totally engrossed, and she admitted that she quite often unpacked and repacked it on her own, as excited as a child at last permitted to play with a precious doll's house.

Like most private collections formed over a long period of time, this collection underwent various mutations. Many things, once acquired, remained, but others were sold and replaced as Mrs Keiller's priorities or circumstances altered. Of those which she bequeathed to the Gallery of Modern Art, the first was bought in 1959 – a tiny oil by the Douanier Rousseau (cat.156, colour plate 43) – and the last nearly thirty years later – several quirkish Dada and Surrealist relics, including Duchamp's *The Non-Dada* bought in 1987 (cat.27), and a small cut-out by Matta bought the following year (cat.68). The dynamic of her taste is revealed when we

fig.22 Eduardo Paolozzi at Juby's workshops, Ipswich, 1964

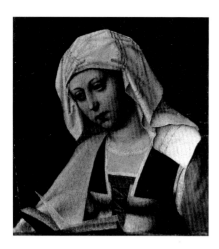

fig.23 *Gerard David A Female Saint*

look more closely at the bills of sale, many of which, fortunately, survive. A critical turning-point came in 1960 when Mrs Keiller went to Venice. Hitherto she had shown little interest in modern art but had collected Old Master paintings, antique furniture and period silver, pottery and porcelain; six months before she bought the Rousseau mentioned above she bought a small panel depicting a female saint by the early Netherlandish painter Gerard David (fig.23). But on this particular trip to Venice she visited Peggy Guggenheim's magnificent collection of Surrealist and Abstract Expressionist art and was introduced to the work of Eduardo Paolozzi then on show in the Biennale. These experiences reinforced each other and within a few years her collection had begun to take a radically different course. The Gerard David was sold off. So were a misty late landscape by Corot and a tiny portrait of a woman by Renoir. So too were three drawings by the nineteenth-century illustrator Constantin Guys which had been bought in 1959 at the same moment as the Rousseau. But the Rousseau itself was allowed to stay: the painter of *The Dream* was one of the all-time heroes of the Surrealist movement and owning a Rousseau, if one was committed to Surrealism, was tantamount to living with one's household god.

Among the earliest purchases to reflect Mrs Keiller's conversion to strictly contemporary art was Lindner's *Solitary III* (cat.56), finished in 1962 and bought from the Robert Fraser Gallery in London that same year. This was followed by Paolozzi and Kitaj's *Work in Progress* (cat.147, colour plate 39), made in 1962 and bought from Marlborough Fine Art in 1963. As a close friendship between artist and patron developed, many more Paolozzis in all media entered the collection over the next twenty years. Paolozzi has made no secret of his debt to or sense of affinity with Dada and Surrealism. Through him and a growing understanding of his work, as much as through her friendship with Peggy Guggenheim, Mrs Keiller's decision to collect Dada and Surrealist art took definite form, and in 1963 she bought *Türme* (cat.31, colour plate 13), a curious, pre-Dada work by Max Ernst. This may have particularly appealed to her because, with its abstracted imagery of an urban roof-scape of chimneys and gutters and its collage-like structure, it looks like an ancestor of many a Paolozzi of the late 1950s. In any case this was her first purchase of a picture by one of the canonical Dada-Surrealists and she never parted with it. Her marked and constant susceptibility to true collage as a medium may be a further sign of Paolozzi's influence. An early acquisition, made in 1964, was Burra's racecourse scene surrealistically transformed by means of a bizarre medley of cut-outs (cat.11, colour plate 3); one of her final purchases well over twenty years later was a Surrealist collage made collaboratively by André Breton, his wife Jacqueline Lamba and Yves Tanguy (cat.9). Meanwhile Mrs Keiller's friendship with Roland Penrose, the leader of the Surrealist group in England, confirmed the new orientation of her taste and several important Dada and Surrealist works were added to her collection in the late 1960s: Picabia's *Sotileza* (cat.153, colour plate 42) and Tanguy's *Plus jamais* (cat.163, colour plate 46) in 1966, and in 1969 one of its chief highlights, Ernst's *Max Ernst montrant à une jeune fille la tête de son père* (cat.34, colour plate 16).

In the 1970s the pace of Mrs Keiller's collecting in her chosen area quickened. To name just some of the cardinal works, Delvaux's *La Rue du tramway* (cat.23, colour plate 8) was acquired in 1971, Dalí's *Le Signal de l'angoisse* (cat.17, colour

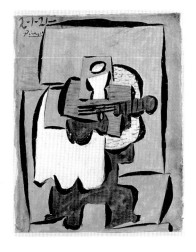

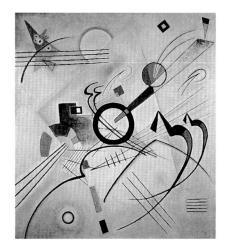

left fig.24 Pablo Picasso *Nature morte (Still Life)*, 1921

centre fig.25 Georges Braque *Guitare et compotier sur fond mauve (Guitar and Compotier on Mauve Ground)*, 1937–40

right fig.26 Wassily Kandinsky *Rosa Viereck (Pink Quadrangle)*, 1923

fig.27 Francis Bacon *Pope No.2*, 1960

plate 6) in 1974, Picabia's *Fille née sans mère* (cat.152, colour plate 41) in 1977, Cornell's *Bird Box* (cat.12) in 1978 and Magritte's *La Représentation* (cat.62, colour plate 30) in 1979. This was also the decade in which the library took shape in an extravagant, energetic campaign which resulted in a rare hoard. By this time she had decided definitively where to focus: four still lifes by Picasso (fig.24), Braque (fig.25), Gris and Léger bought between 1960 and 1965, which might have augured the formation of a Cubist collection, were all sold off because there was nothing to connect them with Dada or Surrealism. So was an equally out of place Kandinsky of the Bauhaus period bought in 1967 (fig.26). In the early 1980s, with prices booming and the competition getting hotter all the time, she was still able to make some substantial acquisitions – among them Magritte's *Le Miroir magique* (cat.60, colour plate 29) in 1982, Giacometti's *Objet désagréable, à jeter* (cat.45, colour plate 23) in 1983 and Tanguy's *Ruban des excès* (cat.162, colour plate 45) in 1984. This was also the moment when she realized a long cherished ambition and bought Duchamp's *Boîte-en-valise*.

Simultaneously, Gabrielle Keiller continued in her staunch support of living British artists, tending to concentrate on those whose roots lay in the Dada-Surrealist tradition. Although she sold her first Francis Bacon, *Pope No.2*, 1960, acquired in 1963 (fig.27), in 1979 she bought an important early painting, *Figure Study I*, 1945–46 (cat.4, colour plate 1). Here the irrational juxtaposition of tweed coat, felt hat and flowering plant reveals Bacon's knowledge of Ernst's *frottages* and the menacing shrouded figures of Magritte. Gilbert and George, as heirs to the iconoclasm of Dada, briefly found a niche in her collection in the early 1980s when she also bought a series of major works by Richard Long. But her collection of contemporary British art was hit hard by the fire which devastated part of her house in Kingston-upon-Thames in 1986: when she decided to move to a much smaller house in Chelsea she disposed of works that were too large for her to display there. William Turnbull's *Metamorphosis I* (cat.164), sculpted in 1980 and bought two years later, did, however, survive the move. As a small piece it was easily accommodated. And, possessing the hieratic dignity of an ancient idol, it was the ideal partner to the three prehistoric Cycladic marbles she had bought in 1981 (cats.169–171): to separate them would have been unthinkable. Furthermore, *Metamorphosis I* has certain underlying, if entirely fortuitous, affinities with other works in the collection, notably Magritte's torso-shaped canvas *La*

Représentation. In this company the innate mystery of the Turnbull is preserved intact but its muffled eroticism becomes definitely more audible. She also kept the three early pieces by John Davies (cats.20–22) bought around the same time as the Turnbull: perhaps she felt their visionary qualities only emerged fully when they were in direct contact with their Surrealist 'ancestors'.

Although committed in principle to Dada and Surrealism in her purchases of pre-war art, Mrs Keiller was not afraid to follow a hunch now and then. One of the most unexpected of all the large-scale pictures in the collection is Herbin's *Composition* of 1919 (cat.50, colour plate 24). Bought in 1970 when the parameters of the collection – Dada / Surrealist / contemporary British – were already well established, this painting survived the test of time. Yet Herbin never became a Surrealist and was never involved in Dada exploits. On the contrary, he was associated with the rationalist tendencies in avant-garde French art of the post-1918 period – with geometric abstraction on the one hand and the 'classical revival' on the other. This said, an undeniable current of irrationality informs the Keiller Herbin: the secret presence of a female figure is suggested and in structure the picture resembles an elaborate, decorative collage; it is dominated by irregular organic forms and a bold cursive line, as is so much Dada and Surrealist art, and has especially strong affinities with Picabia's paintings of the proto-Dada 'Udnie' phase (1913–14). So, rather against the odds, it justified its position within the collection – a timely reminder that artists do not fit neatly into predetermined categories and that supposedly antithetical tendencies have much more common ground than is commonly assumed.

The story of what arrived but didn't stay gives further insight into Gabrielle Keiller's convictions and discriminations. The fate of the Magrittes she bought is particularly telling. *Perspective: Madame Récamier de Gérard*, 1950 (fig.28) – an amusing transcription of the famous neoclassical portrait by Gérard in which the renowned beauty is replaced by a seated coffin – was bought in 1970. But within three years she had sold it and purchased, in its place, a small but intense Miró (cat.70, colour plate 34): Magritte's joke had worn thin and the Miró plugged a serious gap. Another Magritte, *La Révolution* of 1935 (fig.29), also bought in 1970, failed to find a lasting place in the collection perhaps because it too came to seem a rather routine instance of Magrittian wit. (It is a variant on an earlier composition, and the knowledge that this was so may have put her off the painting.) Eventually replacements were found. *La Représentation* (cat.62, colour plate 30), acquired in 1979 from Roland Penrose's superb Surrealist collection, is one of Magritte's most pungent essays on the relationship between art and sexual desire and one of his most radical attempts to break down the barriers between conventional painting and 'the object'. Although it does not look much like anything by Duchamp, it belongs conceptually to the Duchampian universe, exploring the same territory as the latter's erotic object-sculptures *Feuille de vigne femelle* (cat.29, colour plate 11) and *Coin de chasteté* (cat.30, colour plate 12). As such it was the perfect choice for the collection. Magritte's *Le Miroir magique* of 1929 (cat.60, colour plate 29), bought in 1982, is a brain-teaser of a picture and is much more austere and abstracted in style than his more illusionistic and therefore more popular paintings of the 1930s. But as one of the artist's word-paintings it belonged as if by birthright in the Keiller collection – Duchampian in its irony

above fig.28 René Magritte *Perspective: Madame Récamier de Gérard* 1950

below fig.29 René Magritte *La Révolution* 1935

fig.30 Joan Miró *Le Cri (The Cry)*, 1925 (cat.69) prior to fire damage

and iconoclasm, yet simultaneously inhabiting the ideal Surrealist realm of *peinture-poésie* where the traditional barriers between word and image break down.

Mention should be made of a few of the other major works in the collection. Fortunately, only one of them, Miró's *Le Cri* (fig.30), was damaged in the fire at Mrs Keiller's house in 1986 (see pp.18–19). Picabia's *Fille née sans mère* (cat.152, colour plate 41) – a bold example of his machine style of the 1915–18 period and of the nihilistic satire of the Dada movement as a whole – is one of the best known. Implicitly equating a steam locomotive with a divine daughter born (rather than conceived) immaculately, Picabia reinforces the blasphemous humour of his message by appropriating a readymade illustration from a mechanics' manual but painting the ground bright gold to parody the golden backgrounds of Christian icons and altarpieces. Ernst's *Max Ernst montrant à une jeune fille la tête de son père* (cat.34, colour plate 16) summarises in one canvas several themes which obsessed the artist throughout his life – the menacing German forest of Romantic tradition, the Oedipal rivalry with his father, the beautiful but elusive woman who is lover, sister and muse all at once. And it was important enough in Breton's eyes to warrant illustration in his pivotal essay *Le Surréalisme et la peinture* in 1928. Giacometti's *Objet désagréable, à jeter* (cat.45, colour plate 23) was produced shortly after he joined the Surrealist movement and is exactly the kind of indefinable 'thing' which set off the whole object-making craze that absorbed the Surrealists in the 1930s. Part-fetish, part-toy, part-weapon, part-sculpture, a Sphinx's enigma if ever there was one, it is none the less so nicely crafted in wood that it is almost homely to the touch. Of the two Tanguys (cats.162 and 163, colour plates 45 and 46), the smaller and more exquisite, *Le Ruban des excès*, is possibly the more significant because it marked a change of direction towards a more manifestly sculptural style. Delvaux's painting, it must be admitted, varies considerably in quality, but *La Rue du tramway*

(cat.23, colour plate 8) is unquestionably one of his most powerful early works with its disturbing mixture of erotic peepshow and banal industrialised townscape. Finally, with Paolozzi and Kitaj's *Work in Progress* (cat.147, colour plate 39) we have an intriguing neo-Dadaist, proto-Pop construction, which commemorates a stimulating and fruitful exchange between two of the foremost members of the British avant-garde when at its most sparky in the early 1960s.

'Museum pieces' like these are, however, greatly outnumbered by small and more personal works. The Schwitters collage (cat.158, colour plate 44) is a fine example of his Merz style, but it is intimate in scale and was in fact a gift to a friend. In a similar category is the photomontage by Hannah Höch (cat.51, colour plate 26), which in the most succinct manner satirises contemporary colonialist values and attitudes to women through the juxtaposition of a few fragments of photographs of an African mask, a plump baby and a woman's boldly made-up eye. The rapid pen and ink drawing by de Chirico, later used as the frontispiece to Henri Pastoureau's *Le Corps trop grand pour un cercueil* (cat.352), is an informal sketch: it has all the elements one expects to find in a 'classic' de Chirico of 1913 – arcade, tower, piazza, steam train – but the sleeping dog, in alliance with the portentous title *Le Rêve mystérieux*, suggests that he was having fun. George Grosz's transformed Titian (cat.49, colour plate 25) was an in-joke sent to his friend and mentor Georg Scholtz, and yet it perfectly encapsulates the irreverence intrinsic to the Dada spirit. In this respect it is like the 'assisted readymade' Duchamp sent to Man Ray in 1922 (cat.27) – a pamphlet put out by an American religious sect with a photograph of an inanely grinning boy-convert on the front, the *Non-Dada* of Duchamp's ironic title. Since everything Duchamp signed acquired the status of a sacred relic, Man Ray carefully preserved it for posterity. Several of the 'presentation' pieces in the collection are of an even more intimate nature, among them the refined and suggestive white ink drawing ornamented with a paper rose which Hans Bellmer sent 'with his compliments' to the adolescent poetess Gisèle Prassinos (cat.6, colour plate 4), and the two-part *Coin de chasteté* (cat.30, colour plate 12) Duchamp gave as a most ambiguous wedding-day present to his second wife. The list of works like these, which may be small and even ephemeral, but which carry a strong explosive charge, could run on and on.

With the Grosz postcard we find ourselves in the realm of the manuscript letter and thus at the private core of the Keiller collection. Nothing can bring one closer to the mainspring of an artist's work than the sketchbook or to the poet's work than the handwritten draft. And nothing can bring one closer to the mainspring of the Dada and Surrealist movements than the periodicals, manifestos, signed and dedicated books, letters and manuscripts which bear witness to the constant interchange of ideas and the constant effort to win converts to the cause. Had this collection been formed by an erstwhile member of either movement – or by an historian – it would not be surprising to find a substantial amount of this 'documentary' material. But it was not. That we should find so many mementos of the day-to-day life and the evolving thought of these men and women is testimony to Mrs Keiller's insight into and desire fully to comprehend the deepest motives of the painters and poets whose work had come to fascinate her.

Dalí is well represented in the collection with his small but high-quality painting *Le Signal de l'angoisse* (cat.17, colour plate 6) and the magnificent copy of Lautréamont's *Les Chants de Maldoror* (cat.320) which he illustrated. Among the most important manuscripts Mrs Keiller bought is Dalí's draft scenario for a documentary film on Surrealism (cat.237), illustrated with idiosyncratic diagrams and summarising and interpreting the theories of Freud. Very likely this project was suggested by Breton in recognition of Dalí's proven experience as a film-maker and as part of his sustained effort in the 1930s to publicise Surrealism through the most up-to-date methods as well as through established media like the exhibition. Whatever the motive, the project was abortive. The Keiller collection also contains an absorbing and historically crucial correspondence between Breton and Dalí (cat.196), running from 1930 to 1939, which plainly documents Breton's (well-founded) suspicions about Dalí's Fascist leanings and vacillating commitment to Surrealism, and his misgivings about some of Dalí's recent paintings, notably the enormous and grotesque *L'Enigme de Guillaume Tell* which incorporated a portrait of Lenin and, Breton feared, might be construed as an act of mockery not homage. Dalí's responses to his leader's mixture of bullying and blandishment are models of self-justification and evasion. This correspondence also sheds light on the painful political tensions within the Surrealist group at the time and on Breton's ambitions for an international rôle for the movement.

To complement the private manuscript material, the library Mrs Keiller assembled contains a comprehensive collection of the major Dada and Surrealist reviews – including *291* (cat.440), *391* (cat.438), *La Révolution Surréaliste* (cat.432), *Le Surréalisme au Service de la Révolution* (cat.434), *Minotaure* (cat.426) and *VVV* (cat.445). These represented the proselytising public voice, and a knowledge of them is literally indispensable to an understanding of Dada and Surrealism as self-proclaimed revolutionary movements for whom art was – theoretically at least – never more than a means to an end. With the exception of the much glossier and less strictly partisan *Minotaure* (1933–39), which was distributed in Britain through Zwemmer's bookshop in London's Charing Cross Road, these magazines are exceedingly rare, absent from practically all public libraries in Britain and accessible only in recent reprints. To be able to study at first hand the flamboyantly eccentric typography and layout of *291* or *391* or the mock scientific, studiedly deadpan design of *La Révolution Surréaliste* is a great privilege. The potent visual impact of the magazines closes the gap between our era and theirs, bringing vividly to life the urgent debates that animated both movements, and dispelling the flattening, anodyne effect of academic history.

Mrs Keiller also managed to assemble a lot of the even rarer, more ephemeral publications, such as catalogues of the earliest Surrealist exhibitions and the single-issue pamphlets produced clandestinely in Paris during the Occupation by the Main à Plume group (e.g. cats.183, 398 and 399). A special treasure is the scrapbook filled with a mass of this kind of material and all sorts of other memorabilia which David Gascoyne created in spare moments during the war (cat.281). Gascoyne was still only a teenager when he wrote some of the best Surrealist poetry ever to come out of Britain and helped Penrose organise *The International Surrealist Exhibition* held in London in 1936, and this scrapbook is therefore a true insider's compilation.

Books, naturally, form the main bulk of the library. But since Dada and Surrealist books were frequently collaborative ventures between poets and painters, the relationship between the library and the art collection is very close indeed. In any case the distinction between writer and artist can hardly be maintained since a significant number of the leading protagonists were active on both fronts – Arp, Schwitters, Duchamp, Picabia, Giacometti and Dalí, among them. In Surrealism the theoretical ideal was *peinture-poésie* and several genres were developed with the specific aim of fusing the visual and the verbal. Thus in the 1920s Ernst and Miró included words, phrases and even complete poems in some of their paintings and a decade later Breton invented the aptly named *poème-objet* to breathe new life into the composite art-form. Another development was the 'collage novel', which is read like a book, but read in images: Ernst was the supreme master of this genre (cats.269–271). Finances permitting, in most Dada and Surrealist periodicals the juxtaposition of text and image was carefully staged to create a catalytic interaction. But it was through the production of illustrated books, in which the images exist on terms of equality with the text, each enhancing and complementing the impact of the other, that the ideal of *peinture-poésie* was most successfully and consistently realized.

Tristan Tzara's *vingt-cinq poèmes*, published with ten woodcuts by Arp under the Zurich Dada imprint in 1918, established the pattern for these creative collaborations, and a copy of this purposely rough-looking but admirably designed little book is in the Keiller collection (cat.386). Tzara's poems and Arp's abstract images are printed on double-page spreads in such a way that a fully integrated visual effect results, the meandering graphic contour produced by the printed lines of the poems seeming to echo the unpredictable shrinking and swelling of Arp's solid black organic forms. Distinctions between text and image seem to dissolve when, as here, this ideal twinning is achieved: reading and looking become a single act, the poem expanding one's 'reading' of the image, and vice versa.

Of all the painters Ernst was probably the one to take book illustration most seriously, designing bindings and experimenting with unusual printmaking processes in the search for the ideal presentation and reproductive medium for his drawings and collages. A bibliophile with a fine library of his own and an artist whose work has an unashamedly literary character, Ernst derived as much inspiration from poetry as painting and was himself a writer of some originality. His relationship with Paul Eluard was particularly fertile. They met in 1921 before Ernst moved to Paris, and the following year collaborated on *Les Malheurs des immortels* (cat.268), a book of poetic texts and collages which is in a real sense the forerunner of Ernst's later collage novels. On several subsequent occasions Ernst supplied pen and ink drawings, lithographs or etchings to accompany collections of Eluard's poems. In *Au défaut du silence*, for instance (cat.256), they both celebrated their obsessive passion for the same woman, Eluard's first wife Gala (she who subsequently cast an irresistible spell over Dalí). For Eluard himself book collecting and book production were consuming interests: it was typical of him that when times were hard he could bring himself to sell off his art collection, but never his rare books. Perhaps more than anyone else in the Surrealist movement, he was determined not only to keep alive but to develop the nine-

teenth-century tradition of the *beau livre*, and was responsible for initiating several de luxe publications and encouraging new partnerships between the poets and painters. A devoted friend of Eluard's and another true bibliophile was Georges Hugnet. Hugnet's work is little known in Britain, yet he was an influential figure in the Surrealist movement in the 1930s and did much to make that decade the golden period of the Surrealist *beau livre*. Hugnet is a cornerstone of the Gabrielle Keiller collection because so many of its rarest items came from his library through the book dealer John Armbruster. Among these is *La Belle en dormant*, the unpublished manuscript of the music the American pianist and composer Virgil Thomson wrote in 1931 to accompany four of Hugnet's poems (cat.289). The binding is embellished with two of Hugnet's characteristic decalcomania endpapers, and etchings by another friend, the Cubist painter Louis Marcoussis, serve as the frontispiece. Even more important is the suite of forty-two unpublished collages probably composed in the early 1960s (cat.53, colour plate 48), which Hugnet arranged in a narrative sequence leaving space for an accompanying text. No doubt this was a new collage novel in the making, and as such a sequel to the 'poem cut-outs' he gathered in *La Septième Face du dé* (cat.295) in 1936. Paolozzi's *Metafisikal Translations* of 1962 (cat.349), in which the artist's collage-style texts are reproduced by screenprinting, is in the neo-Dada tradition of *La Septième Face du dé* and makes a fascinating partner to it.

Hugnet opened a small bookbinding studio in Paris in 1934 and at the same time acted as a book-buyer for his friends, tracking down rare volumes of esoterica and erotica. In the late 1930s he specialised in creating elaborate, one-off, three-dimensional bindings and slip-cases for books in his collection and for books belonging to his friends. In recognition of their unique status these were baptised *livres-objets* and shown in Surrealist exhibitions. The mutual sympathy that existed between Hugnet and Duchamp, who shared this preoccupation with craftsmanship, is commemorated in several items in Mrs Keiller's collection, including her *Boîte-en-valise* and *Green Box* (cat.249) both of which are dedicated to Hugnet. Hugnet was also close to Bellmer in the late 1930s and collaborated with him on the creation of the exquisite, if extremely louche, *Œillades ciselées en branche* (cat.300). Hugnet's own copy is in the collection and is remarkable for its special pink leather protective box, lined inside with dried flowers and stamped provocatively on the spine with the abbreviated title *Œillades* (making eyes). The collection also contains Hugnet's handwritten draft translation of Bellmer's text for *Les Jeux de la poupée* (cat.188).

Hugnet also collaborated occasionally with Oscar Domínguez, who invented the Surrealist version of the 'decalcomania' technique and thus bestowed on the movement a quasi-automatist means of creating fantastical landscapes of haunting beauty. One of the 'Adults-Only' highlights of the Keiller library is Hugnet's personal copy of *Le Feu au cul* (cat.304). This was a very exclusive, anonymous publication, with a print-run of a mere fifty-three copies, which came out clandestinely during the Occupation. Dominguez provided an etching for the frontispiece (which appears in different states in Hugnet's copy), as well as a series of schematised drawings of copulating couples which are printed in scarlet on top of Hugnet's pornographic text so that word and image are literally fused. An example of Surrealist erotica at its most fetishistic, the book is small enough to

be hidden in one's breast pocket. The binding for this copy was made to Hugnet's precise specifications. The book itself has a cream-coloured leather cover with a reproduction of one of Domínguez's frankest drawings on the front and fine original decalcomania endpapers. Such a delicate and costly object was obviously vulnerable and so Hugnet ordered a supple bamboo-coloured folder, lined in mushroom-coloured suede, to contain it, and to protect the folder a hard, bamboo-coloured, leather-trimmed slip-case which is itself lined in a soft white material. Getting at the forbidden book secreted within this padded bower thus involves a stage-managed undressing and a range of subtly varied tactile sensations designed to place the reader-voyeur in the appropriate frame of mind. The alliance of 'convulsive' and brutal sexuality with meticulous, time-consuming craftsmanship is highly paradoxical, and as such fits well with Breton's definition of the supreme Surrealist goal as the 'reconciliation of opposites'.

Gabrielle Keiller was no prude and understood perfectly that the idea and experience of l'amour fou belonged at the very core of Surrealism. In addition to Le Feu au cul, her library included other notorious clandestine publications such as Aragon's Le Con d'Irène illustrated by Masson (cat.179), and his and Péret's 1929 illustrated by Man Ray's close-up photographs (cat.360). She also owned the more lyrical and rapturous Surrealist celebrations of love and desire, such as Facile (cat.260) in which Eluard's poems inspired by his love for Nusch are framed by Man Ray's beautiful photographs of her posed in the nude.

In accordance with the tradition of the beau livre most Surrealist books were produced in limited editions, and within any given edition there was usually a small de luxe print-run on expensive handmade papers. These copies were intended for the connoisseur market and there might in addition be a handful of hors commerce copies printed for friends of the author and illustrator. Many of the Surrealist books in the Keiller collection are from these de luxe print-runs and several are the 'first' copies containing original manuscripts and drawings. Thus her copy of Henri Pastoureau's Le Corps trop grand pour un cercueil (cat.352) published by Editions Surréalistes in 1936, is number one out of a total edition of 200, and contains the manuscripts of Pastoureau's poems and Breton's preface as well as the original drawing by de Chirico mentioned above. Indeed the majority of the books bear inscriptions or dedications of some kind and several are embellished with original drawings or collages. Thus Mrs Keiller's copy of a little known book of poems by Alice Paalen, Sablier couché, not only has the deleted proof of Miró's frontispiece etching but a fine pencil and crayon drawing by him on the title-page (cat.347). Miró was fond of Hugnet and this is yet another relic from the latter's personal library.

These private inscriptions and decorations allow us a vivid and privileged glimpse into the intimate life of the painters and poets themselves and a clearer perspective on the dynamic of the movements to which they belonged. For an intricate network of personal relationships – enmities as well as friendships, of course – underpinned Dada and Surrealism and helped to determine the way they evolved. For anyone interested in the inner as well as the outer life of both movements, the Keiller collection is therefore the perfect 'open sesame'.

Works of Art Colour Plates

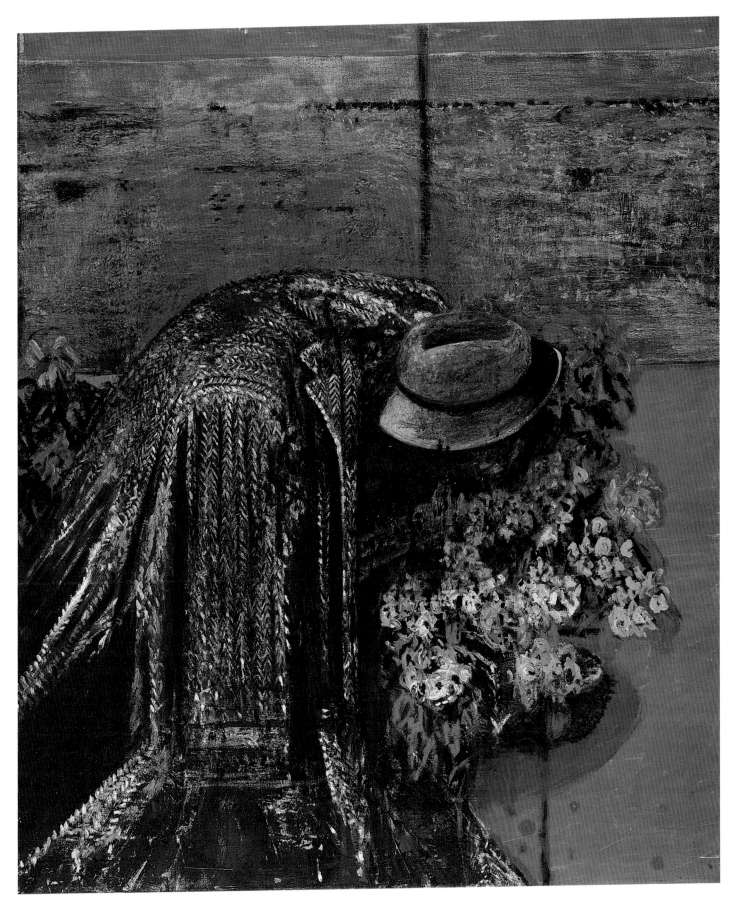

1 Francis Bacon, Figure Study I, 1945–46 (cat.4)

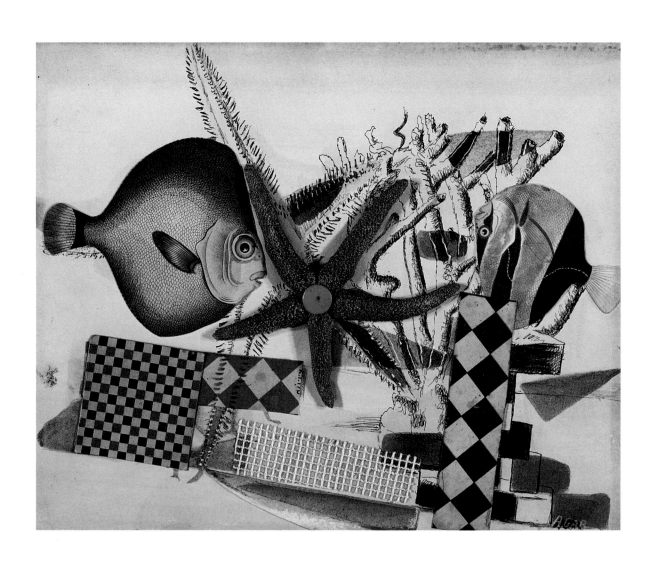

2 *Eileen Agar, Fish Circus, 1939 (cat.1)*

3 Edward Burra, Collage, 1930 (cat.11)

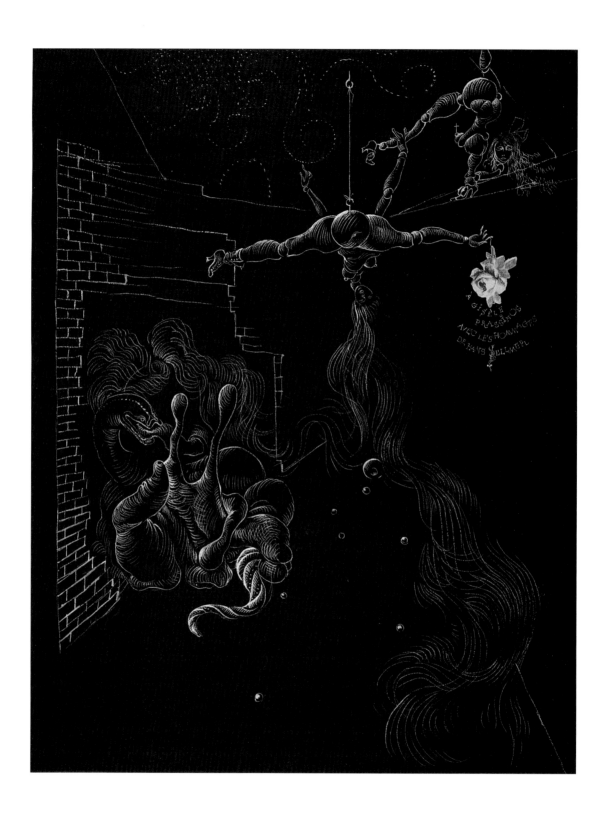

4 *Hans Bellmer, Untitled, c.1935–36 (cat.6)*

5 *André Breton*, Le Déclin de la société bourgeoise (The Decline of Bourgeois Society),
c.1935–40 (cat.8)

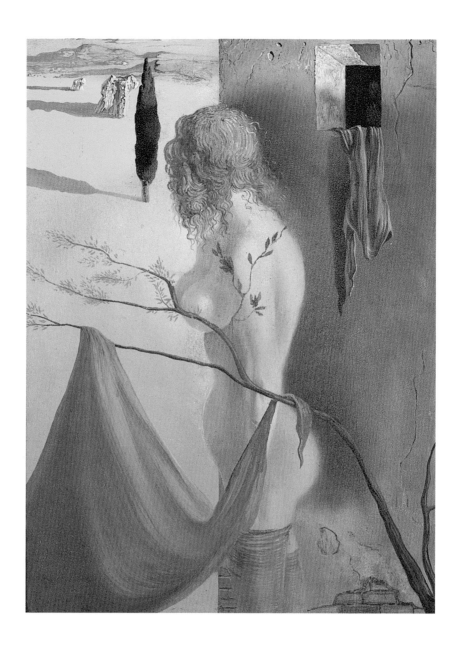

6 *Salvador Dalí*, Le Signal de l'angoisse (The Signal of Anguish), *c.1932–36 (cat.17)*

7 *Salvador Dalí*, Untitled (Composition with Soda Siphon), *1937 (cat.18)*

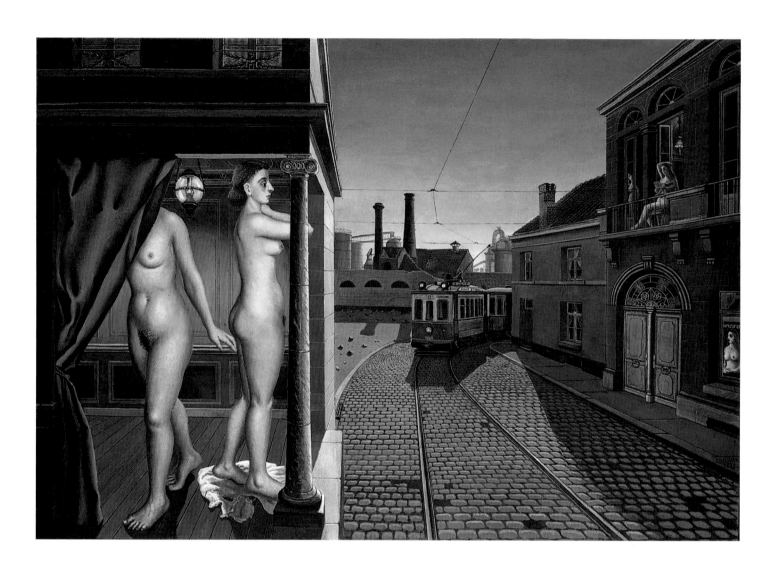

8 *Paul Delvaux, La Rue du tramway (Street of the Trams), 1938–39 (cat.23)*

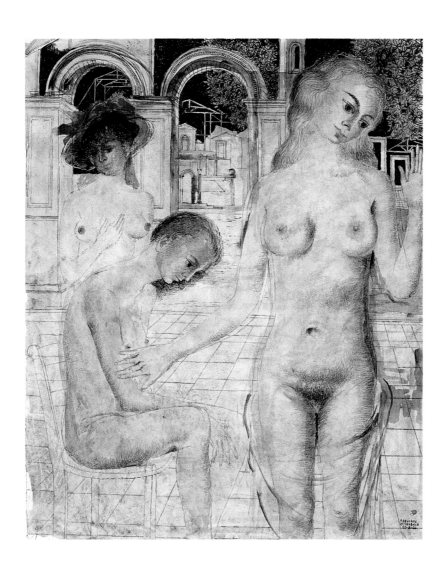

9 *Paul Delvaux, Nu au jardin (Nude in the Garden), 1966 (cat.26)*

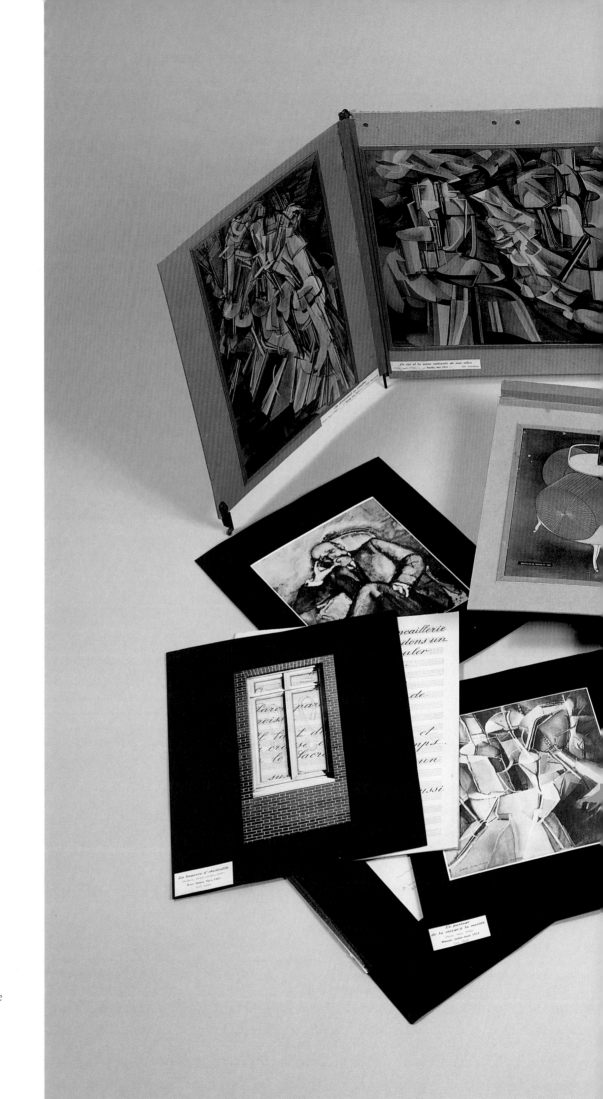

10 *Marcel Duchamp, La Boîte-en-valise (Box in a Suitcase), 1935–41 (cat.28)*

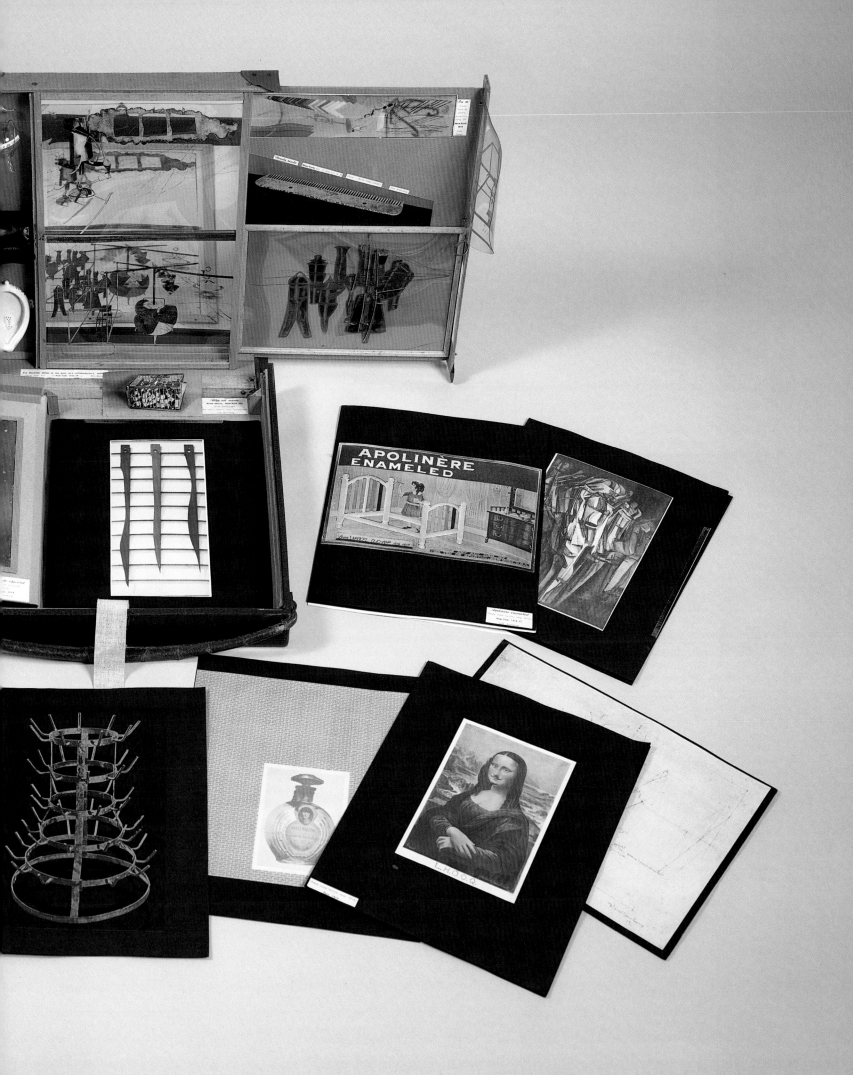

11 *Marcel Duchamp, Feuille de vigne femelle (Female Fig-leaf), 1950/61 (cat.29)*

12 *Marcel Duchamp, Coin de chasteté (Wedge of Chastity), 1954/63 (cat.30)*

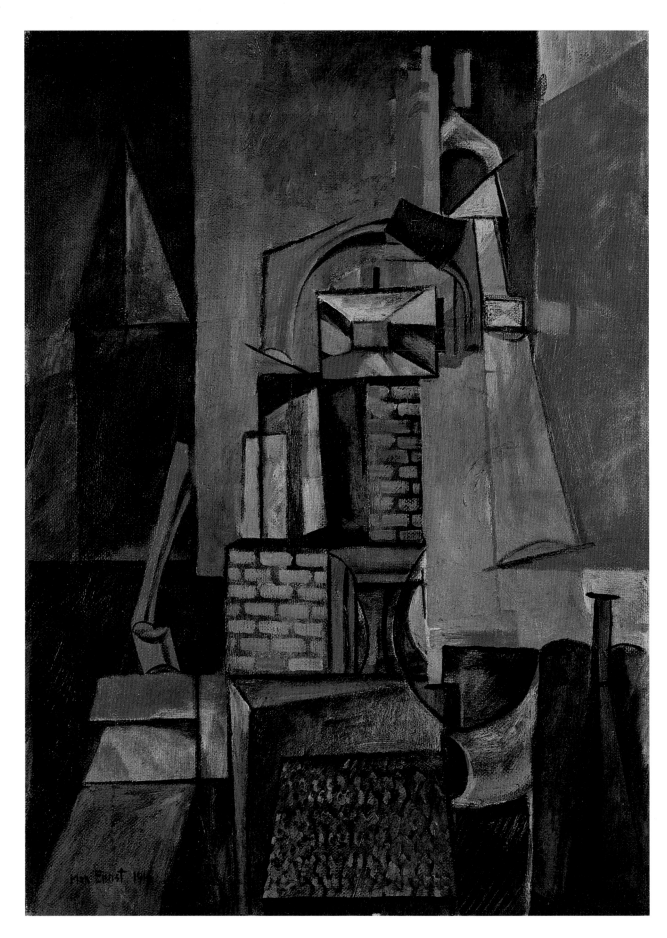

13 Max Ernst, Türme (Towers), 1916 (cat.31)

14 Max Ernst, Untitled, 1921 (cat. 32)

15 *Max Ernst, La Femme au parapluie (Woman with an Umbrella), c.1921 (cat.33)*

16 *Max Ernst*, Max Ernst montrant à une jeune fille la tête de son père (Max Ernst Showing a Young Girl the Head of his Father), *1926 or 1927 (cat.34)*

17 Ian Hamilton Finlay, Beware of the Lark, 1974 (cat.37) 18 Barry Flanagan, Hello Cello, 1976 (cat.38)

19 John Davies, Head, 1979–80 (cat. 21)

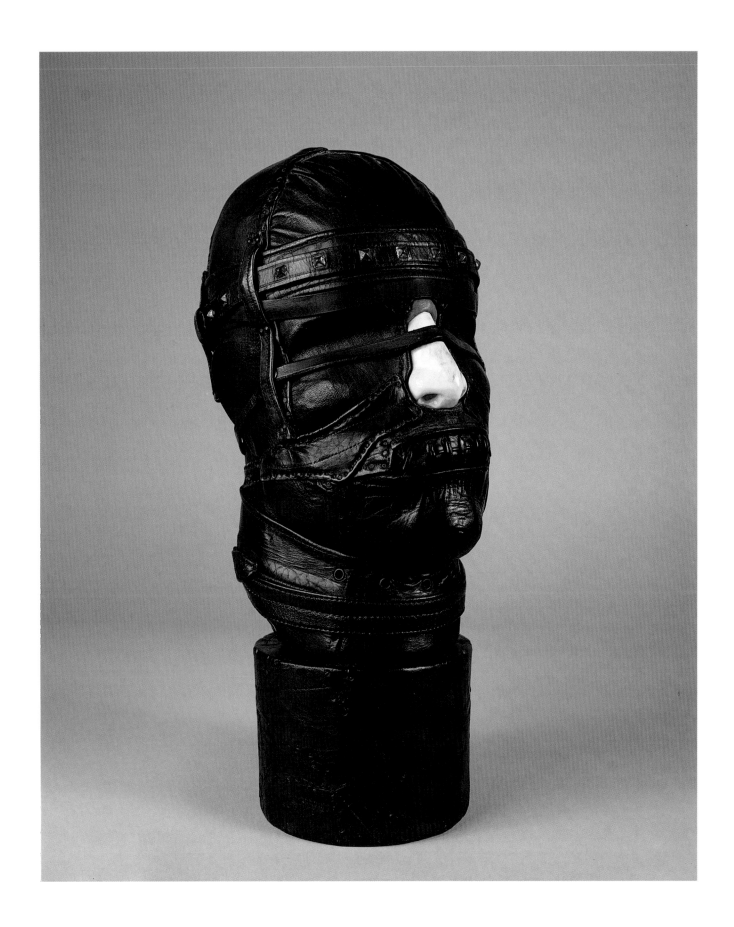

20 Nancy Grossman, Head, 1968 (cat.48)

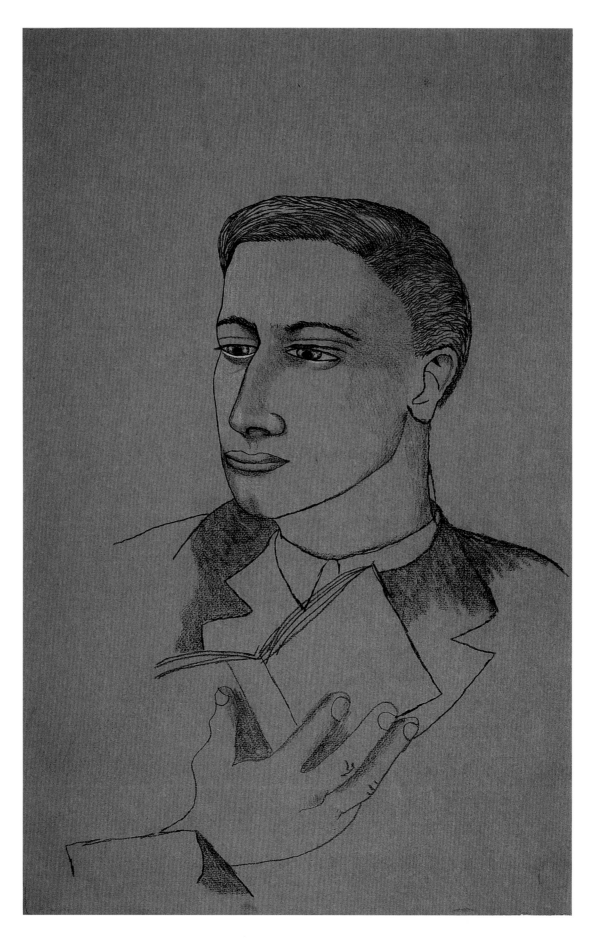

21 Lucian Freud, Head of a Boy with Book, 1944 (cat.42)

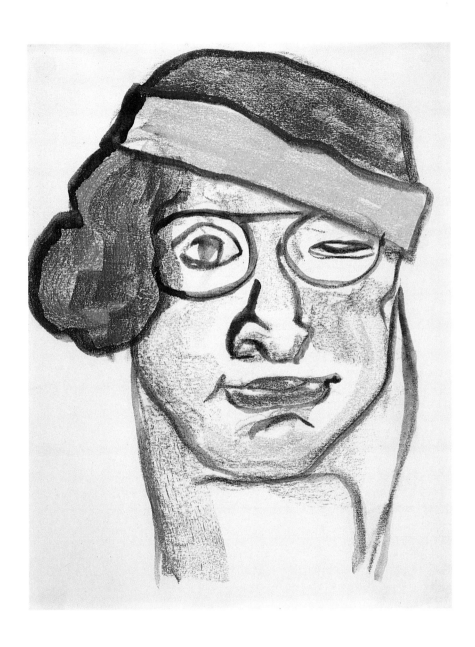

22 Henri Gaudier-Brzeska, Enid Bagnold, 1912 (cat.44)

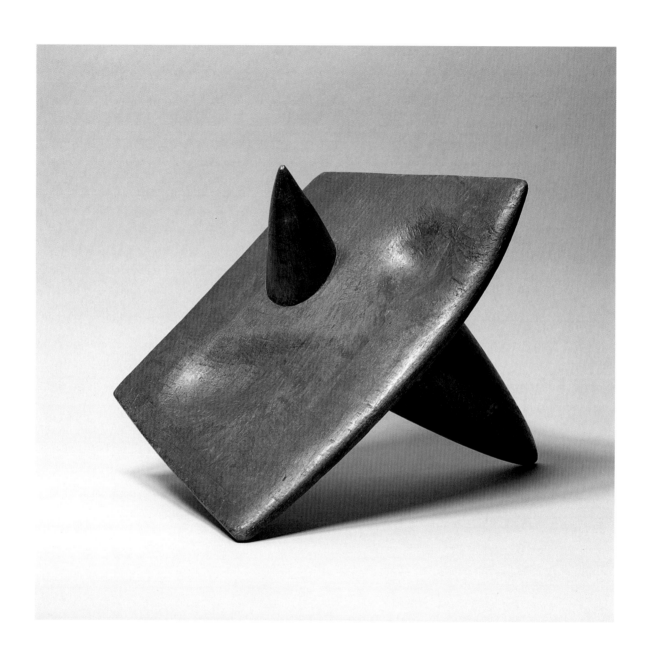

23 *Alberto Giacometti, Objet désagréable, à jeter (Disagreeable Object, to be Thrown Away), 1931 (cat.45)*

24 *Auguste Herbin, Composition, 1919 (cat. 50)*

25 *George Grosz, Eberts Bestattung (The Funeral of Ebert), 1923 (cat.49)*

26 *Hannah Höch, Aus der Sammlung: Aus einem ethnographischen Museum*
(From the Collection: from an Ethnographic Museum), *1929 (cat. 51)*

27 Richard Lindner, Untitled, 1965 (cat.57)

28 Bruce McLean, The Gucci Girls, 1984 (cat.58)

29 *René Magritte, Le Miroir magique (The Magic Mirror), 1929 (cat.60)*

30 René Magritte, *La Représentation* (Representation), 1937 (cat.62)

31 *René Magritte, La Gâcheuse (The Bungler), 1935 (cat.61)*

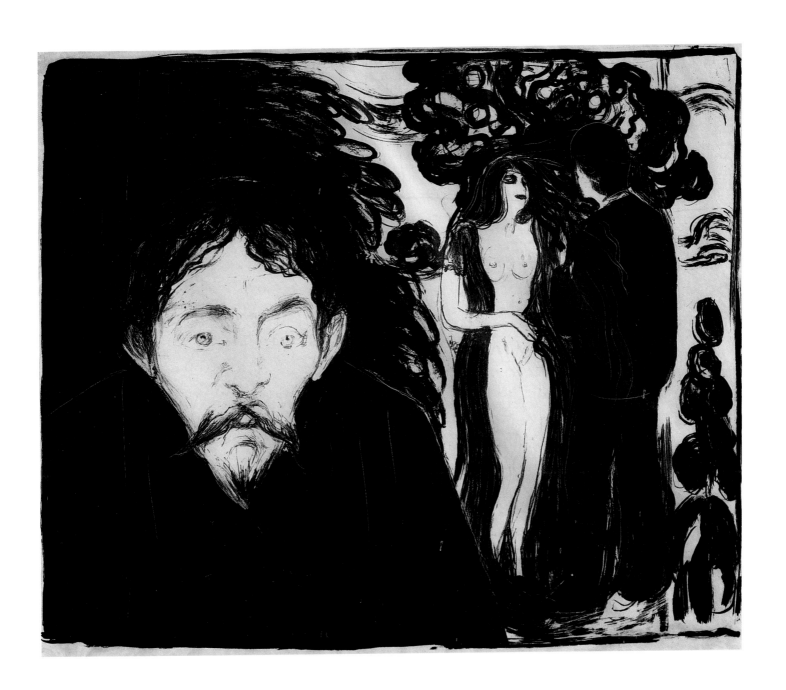

32 Edvard Munch, Eifersucht (Jealousy), 1896 (cat.73)

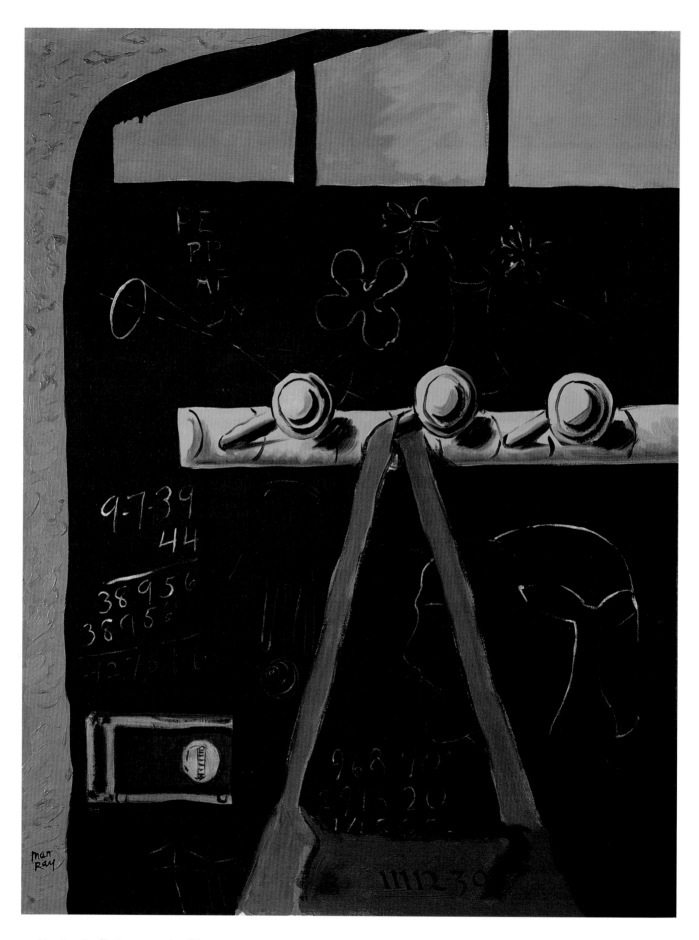

33 Man Ray, *Studio Door*, 1939 *(cat.65)*

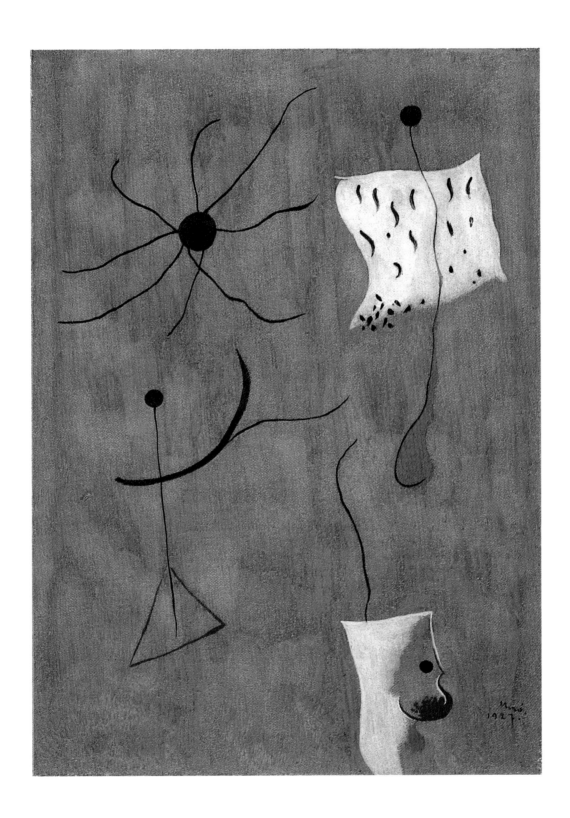

34 Joan Miró, Peinture (Painting), 1927 (cat.70)

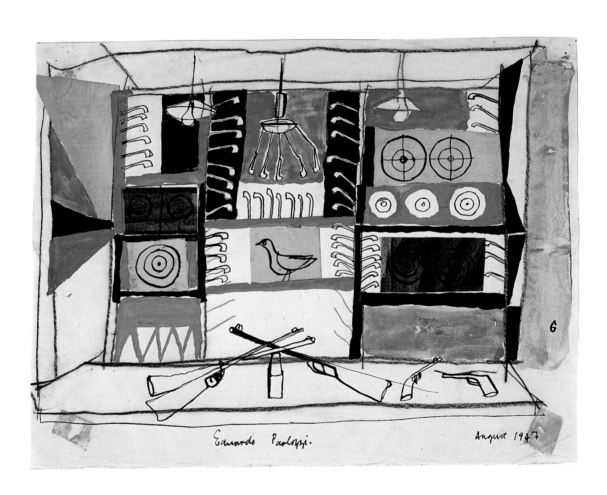

35 Eduardo Paolozzi, *Shooting Gallery*, 1947 (*cat.86*)

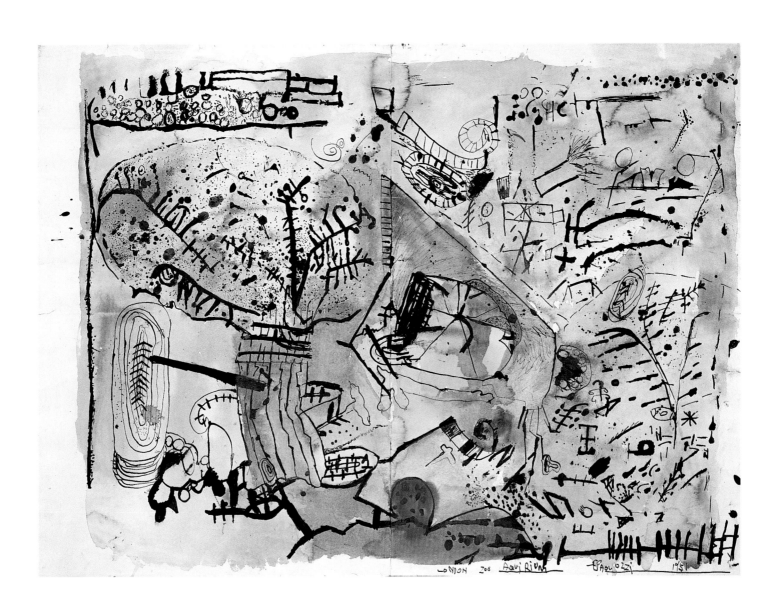

36 Eduardo Paolozzi, London Zoo Aquirium, 1951 (cat.95)

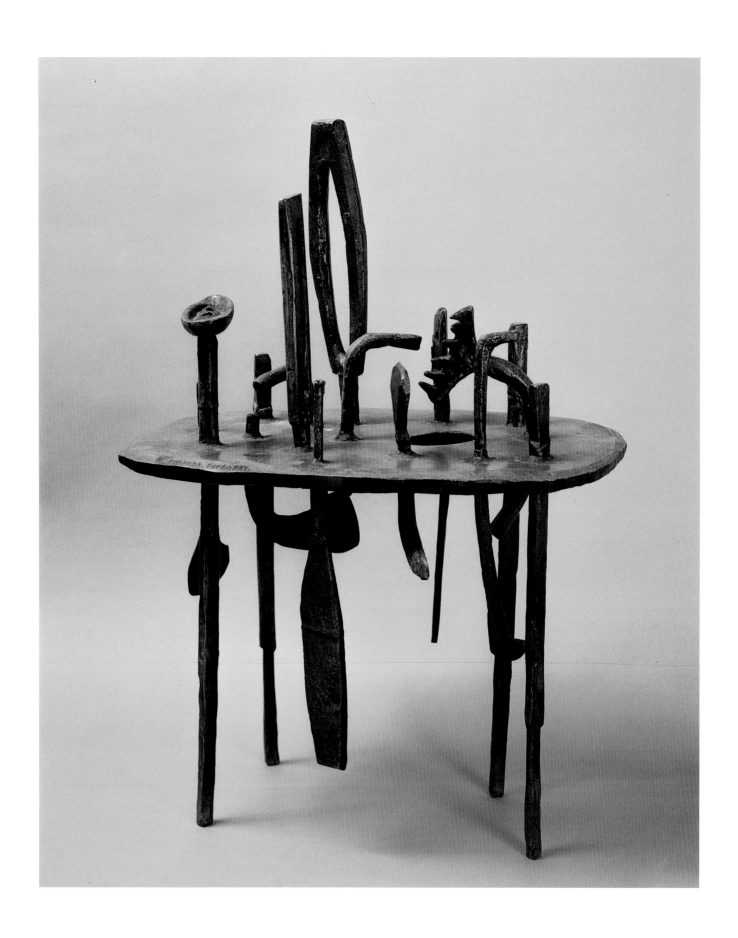

37 *Eduardo Paolozzi, Table Sculpture (Growth), 1949 (cat.92)* 38 *Eduardo Paolozzi, St Sebastian I, 1957 (cat.116)*

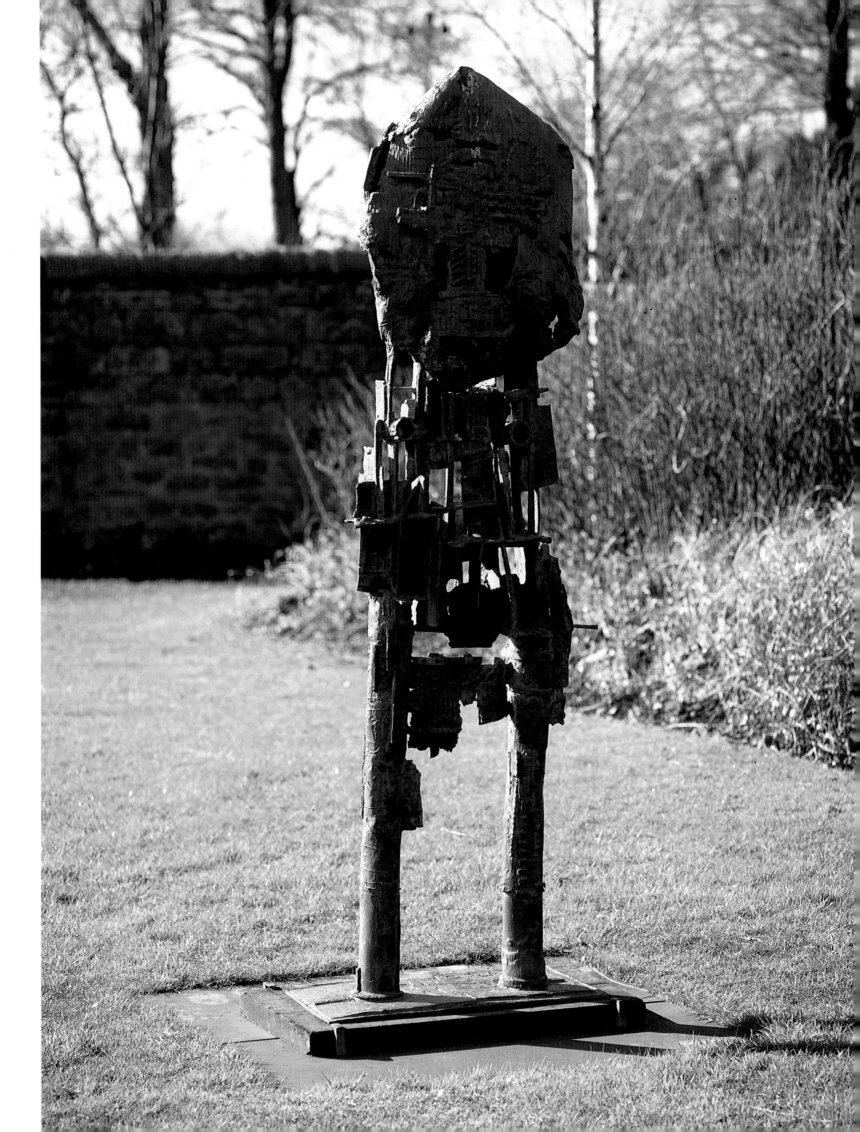

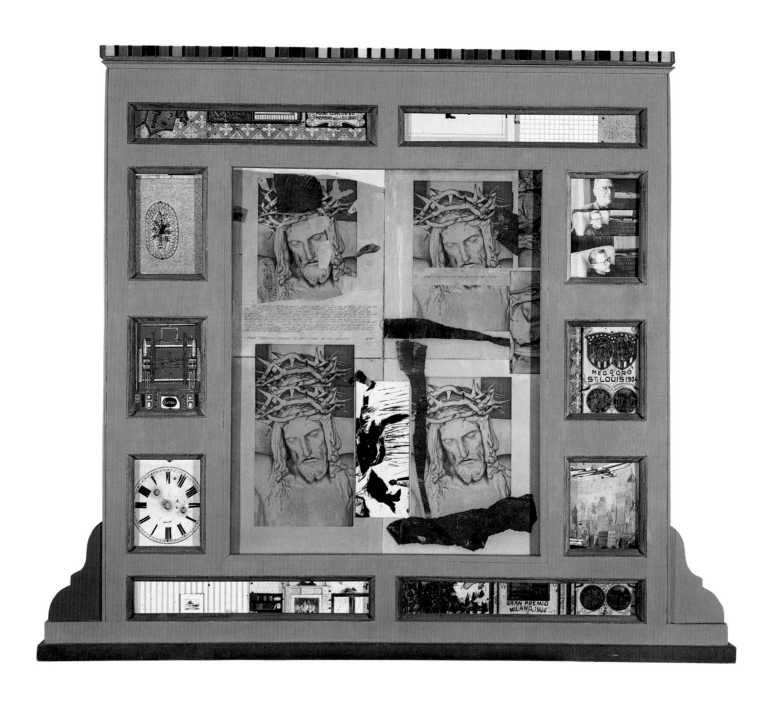

39 Eduardo Paolozzi and R.B. Kitaj, *Work in Progress*, 1962 (cat.147)

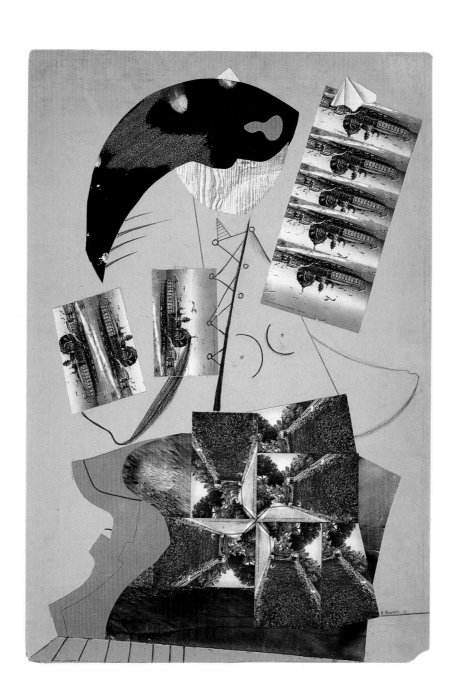

40 Roland Penrose, Untitled, 1937 (cat.148)

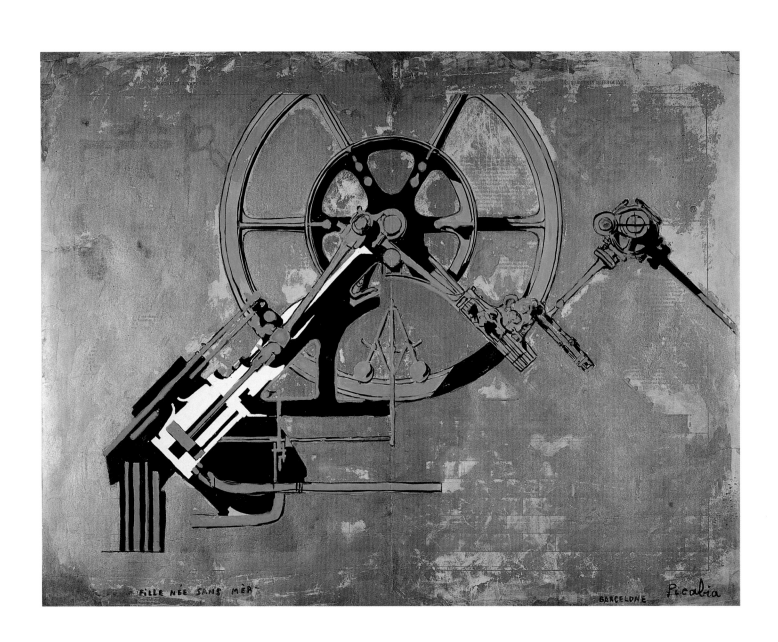

41 Francis Picabia, *Fille née sans mère* (Girl Born without a Mother), *c.*1916–17 (cat.152)

42 Francis Picabia, *Sotileza* (Subtlety), c.1928 (cat.153)

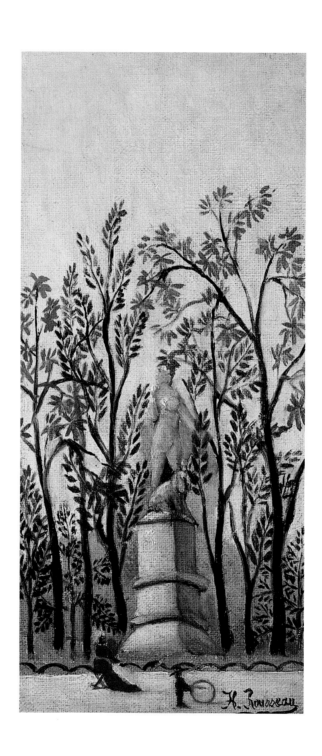

43 *Henri Rousseau, La Statue de Diane au parc*
(Statue of Diana in the Park), c.1909 (cat.156)

44 Kurt Schwitters, Mz.299, 1921 (cat.158)

45 *Yves Tanguy, Le Ruban des excès (The Ribbon of Excess), 1932 (cat.162)*

46 *Yves Tanguy, Plus Jamais (Never Again), 1939 (cat.163)*

47 *Andy Warhol, Portrait of Maurice, 1976 (cat.168)*

Works of Art Catalogue

1

EILEEN AGAR 1899–1991

Fish Circus, 1939

Collage, pen and ink and watercolour on paper,
21 × 26 (laid on paper. 25.5 × 30.5)
Inscribed bottom right: AGAR; and on label on
reverse, in the artist's hand: EILEEN AGAR / FISH
CIRCUS / 1939 COLLAGE
GMA 3938

Colour plate 2

Gabrielle Keiller purchased this from the Mayor Gallery, London, in April 1979. A label on the back in the artist's own hand confirms the title and date. In her autobiography Agar describes an episode which it is tempting to connect with the seaside imagery and festive mood of this collage. In the spring of 1939, sensing the imminence of war and 'determined to have a last fling on the Mediterranean coast', she and her future husband Joseph Bard rented a house near Toulon, and there she was the unwitting victim of an April Fool (*poisson d'avril*): a sailor stuck paper fish onto the back of her coat (*A Look at my Life*, London, 1988, p.143).

Agar studied at the Slade and in Paris in the late 1920s, and first became interested in making collages with found objects (*objets trouvés*) when she worked closely with Paul Nash in Swanage in 1935. The following year, through him, she met Roland Penrose and Herbert Read who instantly elected her a fellow Surrealist and invited her to participate in the forthcoming *International Surrealist Exhibition* in London. She showed in other major Surrealist exhibitions thereafter and made friends with many of the Surrealist poets and painters. Yet she never felt obliged to submit to the movement's political or artistic orthodoxy, and wondered openly whether she could indeed be described as Surrealist.

Like Nash and Picasso – whom she met on another Mediterranean holiday in 1937 – Agar loved beachcombing and often incorporated flotsam and jetsam into her collages. *Fish Circus*, with its pinned-on starfish, is typical in this respect. As she explained in *A Look at my Life*: 'Surrealism for me draws its inspiration from nature.' As a technique she found collage especially congenial because: 'it is a form of inspired correction, a displacement of the banal by the fertile intervention of chance or coincidence.' And for Agar, to whom the formal structure of her work was always of major concern, there was no incompatibility between Surrealism and abstraction: 'at the same time,

abstraction would also be exerting its influence upon me, giving me the benefit of geometry and design to match and balance and strengthen the imaginative elements of the composition' (op. cit., pp.121 and 147). In *Fish Circus* the starfish is the pivot of the composition and, by virtue of its identity and shape, acts as the ideal link between the contrasting geometric and organic elements.

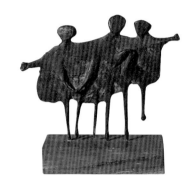

2

KENNETH ARMITAGE b.1916

Children Playing, 1953

Bronze, 23.2 × 31.1 × 3.1
(on stone base 5 × 22.8 × 7.6)
Inscribed on back: C (in square box)
GMA 3939

Following Moore and Hepworth, Armitage was one of the second generaton of leading British sculptors to be born in Yorkshire (he was born in Leeds). War service meant that his studies were interrupted and he remained relatively unknown until the exhibition in the British Pavilion of the 1952 Venice Biennale, *New Aspects of British Sculpture*, (which also featured work by Adams, Butler, Chadwick, Clarke, Meadows, Paolozzi and Turnbull), provoked intense interest and ushered in a new wave in British sculpture.

Children Playing was made in 1953 when Armitage was teaching sculpture at the Bath Academy of Art in Corsham (1946–56). The sculpture was modelled in plaster for casting in bronze and was made in an edition of six. It is one of a series of works, beginning in 1948, in which the artist combined two or more figures engaged in everyday activities, into a simple mass sprouting arms and legs. He commented that: 'Joining figures together I found in time I wanted to merge them so completely that they formed a new organic unit – a simple mass of whatever shape I liked containing only that number of heads, limbs or other detail I felt necessary.' The artist has also noted how the flat form of this work (and of others of the period) relates to the forms of aircraft: during World War II he had been in charge of a War Office School of Aircraft Indentification.

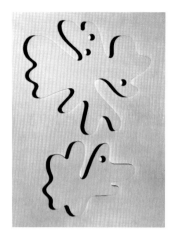

3

JEAN ARP 1886–1966

Bird Waking Under a Tree, 1965

Painted wood relief, 73.3 × 52.6 × 3.8
Not inscribed
GMA 3940

This is reproduced in Herbert Read's monograph on Arp (Thames and Hudson, London, 1968, no.200) as *Bird Waking under a Tree* and dated 1965. As such it is one of Arp's final essays in the technique of the painted wood relief which he had pioneered some fifty years earlier during the Dada period. The first owner was the Swiss sculptor Remo Rossi, whom Arp had met when he and his wife settled in Locarno, Lake Maggiore, in 1959. Rossi, a native of Locarno, owned studios known affectionately by locals as 'the kibbutz', and Arp found himself working there alongside such old friends and associates as Hans Richter and Ben Nicholson. This final phase of his life proved to be highly productive and his international reputation was confirmed in a series of major retrospectives.

4

FRANCIS BACON 1909–92

Figure Study I, 1945–46

Oil on canvas, 123 × 105.5
Not inscribed

Colour plate 1

Gabrielle Keiller's interest in Bacon's work was partly inspired by Paolozzi, on whose advice she bought one of Bacon's 'Pope' paintings in 1963 (*Pope No. 2*, 1960). She sold it in 1979 and the same year purchased this, one of Bacon's earliest surviving paintings. Her choice of such an early work may be due to its loose association with Surrealism: in the late 1930s Bacon had been on the fringes of the British Surrealist movement, and tried, unsuccessfully, to have his work included in *The International Surrealist*

Exhibition organised in London in 1936.

Bacon was born in Dublin and in the late 1920s spent time in Berlin and Paris before settling in London. It was only on seeing an exhibition of Picasso's work in Paris that he decided to become a painter. Self-taught, he gained some success as a designer of furniture and rugs in the Modernist style, but painted comparatively little in the 1930s. He also destroyed much of his work of this period and almost no work from the ten year period 1935–44 survives. Bacon later said that painting only became really important to him in about 1945, the date that his triptych of 1944, *Three Studies for Figures at the Base of a Crucifixion* (Tate Gallery, London) was exhibited at the Lefevre Gallery. The work was a *succès de scandale* and served to launch the artist's career. Compared to the implicit violence of that work, *Figure Study I* is almost pastoral in feel. It is one of the few works in Bacon's oeuvre not to feature a figure, though a human presence is suggested under the coat and hat and is made explicit in the title. The painting was followed by a similar but slightly larger work, *Figure Study II* (Huddersfield Art Gallery), which shows the same coat motif, from which a deformed, screaming figure – perhaps lurking under the coat in the Keiller painting – emerges. While *Figure Study I* may show the influence of Bacon's close friend Graham Sutherland (Bacon was acquainted with a number of the British Neo-Romantic artists and writers in the early 1940s), it also marks the shift towards a more enigmatic style of painting, based on the tormented human figure set in the centre of a stage-like space. The painting has also been published as *Study for the Human Figure at the Cross I*, though Bacon later refuted this title.

5

QUENTIN BELL 1910–96

Untitled

Pencil, wash, and pen and ink on paper, 29.4 × 21.6 (unfolded)
Top image inscribed bottom right: *Quentin Bell*
GMA 3942

Quentin Bell was the son of the writer Clive Bell and the artist Vanessa Bell, and was the nephew of Virginia Woolf. He lectured at King's College Newcastle and was then Professor of Fine Art at Leeds University, before going on to teach at Oxford and later Sussex universities. He is known primarily as the author of books about the Bloomsbury Group, but was also a noted potter, draughtsman and painter. This drawing of a female figure levitating from her floating bed, next to which a full-length dress stands up on its own, probably dates from the mid-1970s. There is a slight watercolour sketch on the lower portion of the paper, but this has been folded over to show only the signed drawing.

6

HANS BELLMER 1902–75

Untitled, c.1935–36

Ink and collage on black paper, 24 × 19
Inscribed upper right: À GISÈLE / PRASSINOS / AVEC LES HOMMAGES / DE HANS BELLMER
GMA 3943

Colour plate 4

One of Mrs Keiller's last acquisitions, purchased from the Mayor Gallery, London, in July 1987.

Bellmer first made a decisive impact in Surrealist circles when photographs of his notorious *Poupée* (Doll) were published in the sixth issue of *Minotaure* in the winter of 1934–35 under the title 'Variations on the Assemblage of an Articulated Minor' (see cat.187). He visited Paris in 1935 and moved there in 1938, forming close friendships with, in particular, Paul Eluard and Georges Hugnet. During his trip to Paris in 1935 Bellmer was invited to make the frontispiece for a short story by Gisèle Prassinos, the fourteen-year-old poetess who, as the archetypal *femme enfant*, was the Surrealists' adored child prodigy and muse. Given his obsession with the sexuality of adolescent girls, Bellmer was the obvious – if provocative – choice of partner, and *Une Demande en mariage* was duly published later that year (Paris, G.L.M., 1935). It is quite possible that this exquisite drawing, with its turn-of-the-century paper scrap and respectful dedication, was given to Prassinos at this moment. On the other hand it may have been given to her in 1936 when she dedicated several of her writings to Bellmer; the admiration was entirely mutual.

The imagery of the drawing appears to be a characteristically perverse adaptation of traditional legends and fairy stories about beautiful maidens devoured or menaced by insatiable dragons; a predatory dragon resembling a giant hand lies in wait in its brick cave / fireplace while a hapless princess / *poupée* hangs splayed like a chandelier from the ceiling, with a second victim suspended nearby. The unusual medium – white ink on black paper – was favoured by Bellmer in 1935–36 and reflects his admiration for the drawings of the early sixteenth-century master Urs Graf, who is famed for his white-line engravings and fantastic imagery. Despite his utterly personal and idiosyncratic vision, Bellmer frequently made such allusions to historic literary and artistic sources.

7

HANS BELLMER 1902–75

Untitled, c.1938–39

Pencil on paper, 12 × 8.6 (unfolded 15.2 × 8.6)
Inscribed bottom right: *Bellmer*
GMA 3944

This is a preparatory study for one of Bellmer's illustrations to Hugnet's *Œillades ciselées en branche* (cat.300), and was probably executed in 1938 or early 1939. It is, however, markedly different from the published illustration, for the figures are drawn in a more geometric and abstract style. As such they are somewhat reminiscent of Bellmer's photographs of his first *Poupée*, published in 1934, which show the doll's internal wooden and metal armature (see cat.186). At the same time there are similarities with the grotesque constructed figures which the Italian Mannerist artist Giovanni Battista Bracelli published in his *Bizarie di varie figure* (1624). Bellmer certainly knew Bracelli's prints for they were prized by the Surrealists and included in *Fantastic Art, Dada, Surrealism*, the influential exhibition held at the Museum of Modern Art in New York (1936–37) which made a serious attempt to identify some of the artistic ancestors of the movement.

8

ANDRÉ BRETON 1896–1966

Le Déclin de la société bourgeoise (The Decline of Bourgeois Society), c.1935–40

Collage on paper, 13.5 × 8.7
Inscribed bottom centre: A. B.
GMA 3945

Colour plate 5

Breton's fascination with the visual arts dated back to his youth and he always lived surrounded by paintings, sculptures and artefacts of all kinds. With him at the helm, it was always inevitable that art would play as central a role as poetry within the Surrealist movement, but unlike some of the other Surrealist poets (such as Max Morise and Georges Hugnet) Breton was, by his own admission, totally devoid of any aptitude as an artist. He compensated by eagerly experimenting with any technique which required only minimal expertise. Thus he was an active participant in the *cadavre exquis* game from the mid 1920s onwards (see cat.9), and made a number of collages, decalcomanias and Surrealist objects in the 1930s and 1940s. Indeed, it was Breton who, as early as 1924, had called for the creation and circulation of objects seen in dreams – a suggestion which bore fruit in 1930–31 when the craze for making objects overtook the whole movement. His personal contribution to the realization of the Surrealist ideal of *peinture-poésie* was the *poème-objet* – a construction incorporating a poem.

The Surrealists were committed to the overthrow of bourgeois values and systems, so the phrase pasted onto the image of a fairground carrousel turns this collage into a Bretonian prophecy. No evidence about its date has come to light, but its resemblance to the imagery of Ernst's collage novels (e. g. cat.272) suggests a date in the mid- to late 1930s.

9

9

ANDRÉ BRETON 1896–1966,
JACQUELINE LAMBA 1910–93
& YVES TANGUY 1900–55

Cadavre exquis (Exquisite Corpse), 1938

Collage on paper, folded in half, 31 × 21.1 (unfolded 31 × 42.2)
Inscribed on folded part of sheet: *Jacqueline* LAMBA 9 *février 1938 André-Jacqueline-Yves*
GMA 3946

Purchased from Richard Salmon Ltd, London, in January 1987. It is one of a series of *cadavres exquis* made during the weekend of 7–9 February 1938 when Breton, his second wife Jacqueline Lamba, and Yves and Jeannette Tanguy were staying with Charles Ratton and his wife in Cinqueux. (Ratton was a dealer in tribal art and a close associate of the Surrealists. His gallery was the venue of the famous *Exposition Surréaliste d'objets* in May 1936.) Like all the others made during the same weekend, the Keiller collage involved only three participants and was lovingly preserved by Ratton for the rest of his life.

The *cadavre exquis*, whether visual or verbal, was the Surrealists' favourite collective game. Modelled on the children's game of consequences, it usually involved three or four participants who added to a sentence or a drawing of a figure without seeing what had been done already. According to Breton (in the catalogue preface to the exhibition *Le Cadavre Exquis*, Paris, Galerie Nina Dausset, 1948), the Surrealists first began playing the game towards the end of 1925 at 54 rue du Château, the house Marcel Duhamel shared with Tanguy, Prévert and Péret. In his estimation: 'With the *cadavre exquis* we – at last – had at our disposal an infallible method of overruling the mind's critical faculties and completely liberating its capacity for metaphor.' Their special title for the game was derived from the first sentence produced collaboratively in this way: 'Le *cadavre exquis* boira le vin nouveau' (The equisite corpse will drink the new wine).

The Keiller example is made entirely with cut-outs from the kinds of magazine illustrations Ernst used in his collage novels. It would seem that the paper was never folded but was divided into three equal sections – the ruled demarcation lines are still visible – and that the composite male figure was created by the three participants working knowingly together rather than blind. The other collages made on the same day were made in this way, whereas those made on 7 and 8 February show fold marks and were, presumably, produced

according to the 'classic' formula. (For these, see *Juegos Surrealistas: 100 Cadaveres Exquisitos*, Madrid, Fundación Thyssen-Bornemisza, 1996–97.)

10

EDWARD BURRA 1905–76

Honky-Tonk Girl, 1929

Pen and ink on paper, 55.5 × 38.1
Inscribed bottom right: E J Burra 1929
GMA 3947

Purchased from the Anthony d'Offay Gallery in March 1982; it is included in Andrew Causey's *Edward Burra. Complete Catalogue*, Oxford, 1985 (Drawings, no.30). The inscription was written with a ballpoint pen and was probably added many years after the drawing was made. However, on stylistic grounds the date of 1929 seems right.

Burra's training, first at the Chelsea Polytechnic (1921–23), then at the Royal College of Art (1923–25), was mainly in draftsmanship and his early work reflects his strong sense of affinity with the tradition of illustration and caricature. His many visits to France (from 1925 onwards) brought him into contact with contemporary French illustrators and, through avant-garde periodicals such as *Variétés* (cat.442) and *Der Querschnitt*, with Dada, Surrealist and German Neue Sachlichkeit art and photography. This drawing, which is closely related to Burra's contemporary watercolours of the cabarets, bars and nightspots he frequented in Paris and Toulon, reflects both his delight in popular culture and his deep admiration for the brilliant satirical drawings of George Grosz published in *Ecce Homo* in Berlin in 1923. There is a drawing of a seated woman on the verso.

11

EDWARD BURRA 1905–76

Collage, 1930

Collage, gouache, pen and ink and pencil on paper,
62.2 × 50.6
Not inscribed
GMA 3948

Colour plate 3

Purchased from the Mayor Gallery in May
1964; no.59 in Andrew Causey's *Edward Burra.
Complete Catalogue*, Oxford, 1985.

Compared with the earlier *Honky-Tonk Girl*
(cat.10), this collage has a more fantastic
character and reflects Burra's awareness of the
proto-Surrealist collages which Ernst, Höch
and Hausmann had created in Cologne and
Berlin in the years following the end of the
First World War. The element of satire typical
of German Dada was wholly congenial to Burra
and he was able to exploit the collage tech-
nique in this work to provide a witty and
imaginative send-up of a day at the races,
where the horses are corsetted centauresses, a
zeppelin smokes a pipe and a toothy mouth is a
peapod. In converting to collage – his first
probably dates from January 1930 – Burra was
in line with contemporary developments in
Surrealism, for the technique was consecrated
in March 1930 in an exhibition held at the
Galerie Goemans in Paris and in Aragon's
famous prefatory essay, 'La peinture au défi'
(A Challenge to Painting) (cat.181). However,
Burra quickly tired of the technique and by
1931 had reverted to his favourite medium,
watercolour.

Although he was too independent – and too
close to Jean Cocteau, Breton's *bête noire* – to
become a committed, orthodox member of the
movement, Burra showed in *The International
Surrealist Exhibition* in London in 1936 and then
in *Fantastic Art, Dada, Surrealism* in New York in
1936–37.

12

12

JOSEPH CORNELL 1903–72

Untitled (Bird Box), c.1948

Mixed-media assemblage in glass-fronted wooden
box with electric light, 32 × 23.3 × 11.2
Inscribed on reverse: *Pour Betsy – Hommage | Pierre
Ronsard Joseph C 1.24.70.; Joseph Cornell*
GMA 3950

This was purchased from the Mayor Gallery in
March 1978. A label in Cornell's hand on the
back indicates that it was given to Betsy von
Furstenberg, the well-known American stage
actress, on 24 January 1970. He had been
thrilled by her performance in a play and, after
they were introduced by a mutual friend in the
late 1960s, met and corresponded with her and
her young daughter from time to time. The
reference in the dedication to the French
sixteenth-century poet, Ronsard, is typical of
Cornell's allusive style in his private letters and
diaries. The precise date of the box is un-
known. It was ascribed to c.1952 by the Mayor
Gallery but is very similar indeed to another
box with a driftwood perch, blue glass panel,
internal electric light fitting and identical
artificial song-bird, which has been dated
c.1946–48. (The latter box was exhibited in the
Cornell retrospective at the Galerie 1900–2000,
Paris, in 1989.)

Cornell's association with Surrealism was
first publicly stated when he was included in a
group exhibition held at the Julien Levy Gallery
in New York in January 1932, and designed the
cover of the catalogue. At the end of that year
he showed a collection of small collage objects
at Levy's gallery under the title 'Minutiae, Glass
Bells, Coups d'Oeil, Jouets Surréalistes', and
thereafter was represented in major Surrealist
exhibitions, and became friends with the exiled
Surrealists when they made New York the
centre of their activities during the Second
World War. However, his attitude to Surreal-
ism remained somewhat ambivalent, even
though he greatly respected Breton and
Duchamp and, among the painters, admired
Magritte unreservedly. Thus in November 1936
when preparations were underway for the
exhibition *Fantastic Art, Dada, Surrealism* (at the
Museum of Modern Art, New York), Cornell
wrote to Alfred Barr asking him to point out in
the catalogue that: 'I do not share in the
subconscious and dream theories of the
Surrealists. While fervently admiring much of
their work I have never been an official
Surrealist and I believe that Surrealism has
healthier possibilities than have been devel-
oped' (Museum of Modern Art Archives). From
this it would seem that Cornell, whose own

work was lyrical and tender, was disturbed by
the perverse and violent sexuality of artists like
Dalí. (Dalí had been promoted in America as
the archetypal Surrealist.)

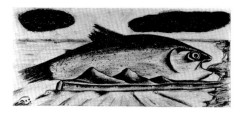

13

ENZO CUCCHI b.1949

Pesce Predicatore (Preacher Fish), 1984

Black crayon on paper, 17.6 × 40.1
Inscribed on reverse: 1984 PESCE PREDICATORE |
Enzo Cucchi | 1984
GMA 3951

Cucchi is one of the small group of Italian
figurative artists who achieved international
reknown in the 1980s: the other artist with
whom he is most often compared is Sandro
Chia. Cucchi's drawings and paintings are
often fantastic visions of apocalypse and
catastrophe, referring for example to great
fires or to the world after the flood. It is a
mythic world littered with skulls, disembodied
heads, debris, and abandoned buildings, and
in which black clouds hang over the earth like
great, menacing boulders. Of the buildings
which often feature in his works Cucchi
remarks: 'These long, drawn-out houses which
in Sironi's paintings are big factories, are for
me like so many Noah's arks. With me it's a
much more archaic, much more elementary
thing' (Prato, Museo d'Arte Contemporanea,
Enzo Cucchi, 1989, p.90). The works are
informed in a general, suggestive way, by
ancient mythology and legend, though Cucchi
manages to weave his own myths. An impor-
tant influence on his work – and one which
may perhaps be detected in this drawing – has
been Melville's *Moby Dick*, in which Man's
desire for reason and control is pitted against
the dark, mysterious forces of nature in the
form of a great white whale.

Gabrielle Keiller purchased the drawing
from an exhibition at the Anthony d'Offay
Gallery, London, in 1984. Another version is in
a US private collection (exhibited Solomon R.
Guggenheim Museum, New York, *Enzo Cucchi*,
1986, no.93).

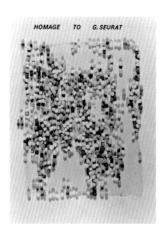

14

SIMON CUTTS b.1944

Homage to G. Seurat, 1972

'Hundreds and thousands' on glue on paper,
8.6 × 6.5
Captioned: HOMAGE TO G. SEURAT
GMA 3952

Cutts was born in Derbyshire. Following a
period as a cattle-minder and dustman, and
other assorted activities, in 1965 he and Stuart
Mills (owner of the Trent Bookshop in
Nottingham) founded the journal *Tarasque*.
Twelve issues were produced, and the Press
also published several prints, including Ian
Hamilton Finlay's earliest word-poem
screenprints of 1966 (see cat.36). He studied at
Nottingham College of Art from 1969–72. His
work at this time was much influenced by
Finlay, with whom Cutts has since collaborated
on various projects. Cutts's work fits into the
same critical arena, employing text in a plastic,
sculptural way, and visual images in a poetic
way (his works have been described as 'poetic
objects'), as here in *Homage to G. Seurat*. It dates
from the same year as Finlay's own *Homage to
Seurat*, a wittily subversive join-the-dots image.

The work was made during Cutts's final
year at art college. It was made by dabbing a
sponge in PVA glue and applying this to the
paper, and then immediately dipping the paper
into a tin of 'hundreds and thousands' cake
decorations. It was produced in an edition of
50, and owing to the nature of the process
involved, each 'print' is different. Cutts moved
to London in the mid-1970s, co-founding (with
Kay Roberts) the Coracle Press in 1975. The
Press opened a gallery in Camberwell in 1975,
and has since published work by Richard
Long, Hamish Fulton, Antony Gormley,
Thomas A. Clark and many others. Gabrielle
Keiller was a keen supporter of the Press,
purchasing their books, booklets and prints,
and buying a number of works by Cutts. She
acquired this work from the Press in about

1977. Another copy was purchased by the Arts
Council of Great Britain, and the protracted
correspondence relating to its acquisition and
conservation treatment led to a new book-
work, *Homage to Homage to Seurat*.

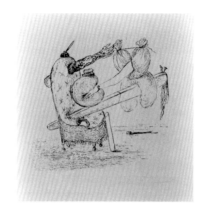

15

SALVADOR DALÍ 1904–89

Untitled (Composition with Skeleton Figure) from 'Les Chants de Maldoror', 1934

Heliogravure with drypoint on paper, 29.8 × 18.6
(paper 33.2 × 25.2)
Inscribed bottom right: *Dalí*
GMA 3955

Purchased from P. and D. Colnaghi in July
1973, together with cat.16. It is no.20 in R.
Michler and L. W. Löpsinger, *Salvador Dalí.
Catalogue Raisonné of Etchings and Mixed Media
Prints, 1924–1980*, Munich, 1994. In trimmed
form, without the small still life of bones in the
bottom right foreground and with less empty
space at the top and right side, it appeared
among the loose plates Dalí made in 1933–34
for a new illustrated edition of the Comte de
Lautréamont's *Les Chants de Maldoror* (cat.320).
A kneeling figure in the same pose appears in
several other of the plates, but apart from one
other this is the most completely skeletal. Two
principal visual sources appear to lie behind it:
on one hand, illustrations in anatomical
treatises from the sixteenth to nineteenth
centuries, which were much prized by the
Surrealists for their equivocal beauty; and on
the other, the sculptural 'bone' drawings and
paintings made by Picasso between 1928 and
1932 when he was in close contact with the
movement.

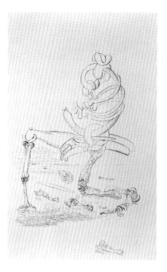

16

SALVADOR DALÍ 1904–89

Untitled (Composition with Chair and Inkstand) from 'Les Chants de Maldoror', 1934

Heliogravure with drypoint on paper, 33.1 × 25.3
(paper size)
Inscribed below image, right: *Dalí*
GMA 3954

See the entry on cat.15. The present print is
no.45 in R. Michler and L. W. Löpsinger, op.
cit., and appears as the heading to the
'Deuxième chant', on page 37 of the edition of
the Comte de Lautréamont's *Les Chants de
Maldoror*, which Dalí illustrated in 1933–34 (see
cat.320). A very similar, but not identical, ink
drawing is dated 1934 (collection Dieter
Scharf, Hamburg). The grotesque combination
of human limbs with furniture, cushions, etc.
in this etching may be compared with that in
contemporary Surrealist drawings by Picasso,
in particular *Two Figures on a Beach* (Museum of
Modern Art, New York), which is dated 28 July
1933 and appears to be a self-conscious
pastiche of Dalí's *Maldoror* imagery. The two
artists, who had known each other for several
years, met by chance at the atelier of Roger
Lacourière, the master-printer of *Les Chants de
Maldoror*, and collaborated on an etching
together, passing the plate back and forth.
This combined motifs from Dalí's *Maldoror*
illustrations with motifs from Picasso's recent
suite of drawings, *Une Anatomie* (Musée
Picasso, Paris), some of which also represent
figures in terms of furniture. Although this
joint effort is undated, it can probably be
ascribed to the spring of 1933 since Picasso
was working on the 'Sculptor's Studio'
etchings for the Vollard Suite in Lacourière's
atelier at that time and had completed the
Anatomie drawings in March.

17

SALVADOR DALÍ 1904–89

Le Signal de l'angoisse (The Signal of Anguish), c.1932–36

Oil on wood, 21.8 × 16.2
Inscribed on reverse: *Le signal de l'angoisse / Dalí 1936*
GMA 3956

Colour plate 6

Purchased through the Mayor Gallery in April 1974. The picture is dated 1936 on the back, but this must have been when Dalí made several minor changes to the composition, not when he painted it. In its original state it was reproduced in *Minotaure*, no.5, 12 May 1934, but without a title or date. It might have been a new painting at the time or have been painted a year or two earlier; it shares many details with the drawing Dalí made for Breton's *Le Revolver à cheveux blancs*, 1932 (cat.198), and may well date from that year. At all events the *Minotaure* photograph enables us to see what alterations Dalí made in 1936; originally the cypress tree in the background had both a limb of some kind projecting from it and also a circular gap lower down in the foliage; on the other hand the foreground branch did not sprout the forked leafy shoot which spreads over the nude woman's shoulder in the painting as we know it.

Dawn Ades in her monograph on the artist (London, 1982, p.93) has convincingly suggested that the imagery of *Le Signal de l'angoisse* relates to a long and involved masturbatory fantasy Dalí published under the title 'Rêverie' in *Le Surréalisme au Service de la Révolution*, no.4, December 1931. The specific points of contact include the Böcklinesque cypress tree, the dilapidated building, the window which allows the (hidden) voyeur to watch his object of desire (who may be a young girl, a middle-aged woman, a whore, or all three), the enigmatic, ominous drapery, and the insistence on prolonged looking into deep space. But the painting is in no sense a direct illustration of the fantasy as a whole or of any episode within it, and works as a generalised evocation of the typical erotic dream or daydream which turns on intense but fragmentary visions and memories. In its sharp colour, exquisite, miniaturist technique and glossy illusionism, it is characteristic of Dalí's best work of the early 1930s.

By 1932 Dalí was well on the way to becoming the most celebrated of all the Surrealist painters, not just in France or in Spain and Britain but also in America where he enjoyed star status and where *Le Signal de l'angoisse* found its first purchaser. His rapid rise to fame was to a considerable extent the result of his exhibitionist behaviour and the flagrantly scatological nature of both his paintings and texts like 'Rêverie'. *Un Chien andalou*, the Surrealist film he made with his compatriot Luis Buñuel, caused a public scandal when it was premièred in Paris in October 1929 and guaranteed him a place of honour within the Surrealist movement; when his one-man show opened in Paris at the Galerie Goemans about six weeks later the catalogue carried a preface by Breton, a sure sign of the high esteem he already enjoyed.

18

SALVADOR DALÍ 1904–89

Untitled (Composition with Soda Siphon), 1937

Pen and ink and gouache on paper, 43.6 × 54
Inscribed bottom right: *Salvador Dalí '37*
GMA 3957

Colour plate 7

Purchased from the Mayor Gallery in December 1983, having formerly been in the collection of the eccentric millionaire Edward James. James became the most important British patron of the Surrealists in the late 1930s and was a particular admirer of Dalí, from whom he commissioned several major works for his house in London. The drawing is a good example of Dalí's transformation of the traditional genre of still life and is a rather light-hearted variant of a contemporary oil painting, also formerly owned by Edward James. (It may, indeed, be the preparatory study for this picture.) It combines several of Dalí's signature themes – a hard utilitarian object which has gone as soft as melted gruyère cheese, a flaccid projection from a body which requires the support of crutches, and an irrationally deep perspectival space.

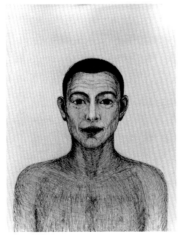

20

19

SALVADOR DALÍ 1904–89

Untitled (Composition with Figures and Boat), c.1938

Pen and ink on paper, 28.9 × 45.9
Not inscribed
GMA 3958

Like cat.18 this drawing was formerly in the Edward James collection and was bought by Mrs Keiller from the Mayor Gallery at the same time. It is undated but relates closely in iconography and graphic style to other drawings dated 1937 or 1938. With its theatrical composition, declamatory gestures and boat moored by the shore, it suggests a dramatic or operatic source, and may be connected with an Homeric or other legend, such as the Return of Odysseus or the Flying Dutchman.

20

JOHN DAVIES b.1946

Drawing of P. D., 1979

Pastel, pencil and pen on paper, 57.6 × 45.8
(mounted to show 50 × 39.5)
Inscribed on reverse: *John Davies Drawing of P. D.1979*
GMA 3959

Born in Cheshire, Davies studied painting at Hull and Manchester Colleges of Art. At college he also executed a number of sculptures, though he was largely self-taught as a sculptor. He applied for a postgraduate place in the painting department at the Slade School of Art, London, but was accepted instead into the sculpture department. In the late 1960s he began making body and head casts in plaster, incorporating glass eyes and clothing the figures in real clothes. These enigmatic, disturbing works, were first shown at Davies's solo exhibition at the Whitechapel Art Gallery in London in 1972. He has shown regularly with Marlborough Fine Art in London since 1980 and has had exhibitions in New York, Germany and Spain.

Though best known for his sculpture, Davies has continued to draw. As he remarks: 'I draw when I find it hard to make sculpture

and make sculpture when I find it hard to draw.' Painting and sculpture are united in his work as a sculptor since many of the works are painted (see cats.21 and 22). This is a drawing of the artist's brother, Peter. Gabrielle Keiller purchased the work from Marlborough Fine Art in 1980.

21

JOHN DAVIES b.1946

Head, 1979–80

Painted polyester resin and mixed media,
21 × 12.6 × 14.6 (base 12.8 × 13.9 × 13.6)
Inscribed under neck: 30
GMA 3960

Colour plate 19

This is one of the thirty-nine mainly smaller than life-size heads shown in Davies's exhibition at Marlborough Fine Art, London, in November-December 1980. For cataloguing purposes each was given a number, and the present work was titled *Head No.30*. However, the artist's preferred title is simply *Head*.

Davies's resin sculptures are initially modelled in polyester resin mixed with stone dust and powder paint; once set he carves them with a knife and rubs ink or paint into the surface. The eyes in the present work are made from glass-headed pins. Most of Davies's heads are modelled on metal rods, a practice he initially developed in order to avoid sculpting a plinth and also to have the head at eye level; the rods in some of the works are up to five feet tall. The present head is an invented one and is not a portrait bust.

22

JOHN DAVIES b.1946

Figure on a Swing (painted version), 1981–84

Painted fibreglass and rope. Figure 74 × 35.5 × 42
Not inscribed
GMA 3961

This work was initially made as part of a group of three figures suspended from the ceiling: one stands on a swing or trapeze, one climbs a rope and the third is seated on a swing. The work was titled *Group of Three (Shadow Figures)*, and each of the three figures was modelled in resin on a metal armature. Davies also made two or three fibreglass casts of each of the figures, painting them differently with oil paint, acrylic and other materials. In the late 1970s and early 1980s Davies made a number of drawings and sculptures of figures climbing ropes and ladders; these were partly inspired by his memories of the circus which, as a child, he was taken to see in Manchester every year on Boxing Day. Like the two other works by Davies listed here (cats.20 and 21), the sculpture was made at the artist's studio in Faversham, Kent.

23

PAUL DELVAUX 1897–1994

La Rue du tramway (Street of the Trams), 1938–39

Oil on canvas, 90.3 × 130.5
Inscribed bottom right: P. Delvaux 1–39; and on reverse: A MA CHERE SUZANNE
GMA 3692

Colour plate 8

Purchased through the Mayor Gallery in January 1971. A classic example of Delvaux's speciality – the dream-like, arrested, narrative scenario which emanates an atmosphere of profound but muffled sexual tension – it was shown for the first time in Delvaux's one-man exhibition at the Palais des Beaux-Arts, Brussels, in February 1940 (no.4). It has frequently been exhibited since then. Although Delvaux's first wife, Suzanne Purnal, does not appear in the published provenance of the painting, the dedication on the stretcher, 'A ma chère Suzanne', reveals that Delvaux gave it to her. (They married in 1937 but separated some years later.) The next owners were P. G. van Hecke, the leading Brussels dealer-collector who edited the avant-garde periodical, *Variétés* (cat.442), and his couturière-wife Norine. The picture then passed to the collection of Gilbert Perier, the chief administrator of Sabena, the Belgian national airline, for whose mansion in Brussels Delvaux painted a vast mural decoration in 1954–56.

The painting has gone under various titles, including 'La Rue du tram', 'Le Tramway', 'La Rue du tramway', 'Banlieue', 'La Rue' and, when reproduced in *London Bulletin*, nos.18–20, in June 1940, 'L'Arrière-saison'. It is not clear which, if any, of these titles is Delvaux's own. It

has been suggested that the factory in the background is the Coke Oven Plant of the Union Chimique Belge.

Delvaux is perhaps best described as a semi-detached member of the Surrealist movement. Influenced especially by the work of de Chirico, Ernst and Magritte, his paintings first revealed distinct Surrealist tendencies in about 1933, and the following year he exhibited alongside de Chirico, Dalí and Magritte in the *Exposition Minotaure* in Brussels (cat.276). Thereafter he participated in major Surrealist exhibitions and became a close friend of Eluard, whom he met for the first time in 1938. However, he never committed himself to the political goals of the movement and, unlike Magritte, remained aloof from the activities of the Brussels branch. In 1966, during a conference on Surrealism at the Cercle Culturel de la Panne, he summed up his position: 'In my view [Surrealism] is above all an outbreak of the poetic spirit in art, the reintroduction of the subject, but in the very specific sense of the strange and the illogical.'

24

PAUL DELVAUX 1897–1994

Untitled (Woman by the Sea), 1947

Pen and ink and ink wash on paper, 20.6 × 26.7
Inscribed bottom right: P. DELVAUX / le 30.3.47; and on separate sheet now attached to backboard: *pour Madame Davenport le 30.3.47*; and: *From E Paolozzi / for G Keiller 21.4.72*
GMA 3963

From the inscription and the dedication on the back, it seems that Delvaux gave this drawing away the day he made it. It later entered the collection of Eduardo Paolozzi, who gave it to Gabrielle Keiller in April 1972, just over a year after she had made her major Delvaux acquisition, *La Rue du tramway* (cat.23). The drawing does not appear to be a study for a painting, although the heavy-limbed, pensive woman in the foreground is a familiar physical type in Delvaux's work at this period, and may reflect the influence on him of the monumental neoclassical figures that Picasso and de Chirico painted in the 1920s.

25

PAUL DELVAUX 1897–1994

La Visite (The Visit), 1955

Pen and ink and ink wash on paper, 23.5 × 31.6
Inscribed bottom right: P. DELVAUX / 1955
GMA 3964

Mrs Keiller purchased this drawing from the Mayor Gallery in March 1972 at a moment when her interest in Delvaux's work appears to have been intense. (All four works by Delvaux in her collection were acquired between January 1971 and November 1972, and each dates from a different moment in the artist's career.) The title, *La Visite*, appears on an old label and may therefore be Delvaux's own. The subject and composition of the drawing suggests that Delvaux, whose work often alludes more or less openly to well-known paintings, had Manet's *Olympia* (1863; Musée d'Orsay, Paris) in mind. Even the elaborate hat worn by the visitor on the right is reminiscent of the bouquet presented by the black maid in Manet's picture. In graphic style, however, it is more reminiscent of the figure drawings Picasso made during the Occupation, some of which turn on the theme of a male or female figure contemplating a beautiful reclining nude.

26

PAUL DELVAUX 1897–1994

Nu au jardin (Nude in the Garden), 1966

Pen and ink and watercolour on paper, 62.2 × 50.3
Inscribed bottom right: P. DELVAUX / St IDESBALD / 10.8.66
GMA 3965

Colour plate 9

Purchased from the Mayor Gallery in November 1972. It was first shown in an exhibition of Delvaux's recent drawings in the Galerie du Bateau Lavoir, Paris, in November-December 1966 (no.9), and almost immediately reproduced in colour in *Les Dessins de Paul Delvaux*, a collection mainly of Delvaux's more overtly erotic drawings on lesbian themes published with an introduction by Maurice Nadeau in

1967. Inappropriate as it may seem, the drawing was reproduced on both occasions with the title 'Nu au jardin'. As the inscription makes clear, Delvaux executed it at St. Idesbald on the Belgian coast. He had first gone there in 1945 and returned frequently over the years. In 1980 the Fondation Paul Delvaux was established at St. Idesbald and the Musée Paul Delvaux opened there in 1982.

27

MARCEL DUCHAMP 1887–1968

The Non-Dada, 1922

Printed brochure with ink inscription, 14 × 11
Inscribed: (Man Ray Collection) / The Non-Dada /
affectueusement Rrose
GMA 3966

This readymade was purchased from the Mayor Gallery in July 1987. It was a gift from the artist to Man Ray and later belonged to Mary Sisler, who formed an important collection of Duchamp's works. The object Duchamp has appropriated and turned into a Dada readymade is a 48-page, perfectly serious, religious pamphlet published by the Vocational Pupils at the School of the Four Cs, (Caney Creek Community Centre, Pippopass, Knott County, Kentucky) in April-May 1922. He came across it in New York, where he was working on *The Large Glass* (see cat.28), added the ironic title and his greetings – Rrose Sélavy was Duchamp's female alter-ego – and sent it to Man Ray who had settled permanently in Paris in the summer of 1921. Man Ray preserved it carefully, and it has been exhibited occasionally (for instance, in the Duchamp retrospective at the Tate Gallery in 1966, no.196), but it does not appear in the standard comprehensive catalogues of Duchamp's work.

Man Ray and Duchamp had been close friends since 1915 when they met in New York through Duchamp's patrons, Louise and Walter Arensberg. They collaborated often over the years and there are many similarities in the

spirit as well as the form of their works. Man Ray quite often acted as Duchamp's assistant; in 1920, for instance, he helped him create his *Rotary Glass Plates* (*Precision Optics*), a motor-driven apparatus, and photographed dust 'breeding' on the still unfinished *Large Glass* as it lay on the studio floor. At about the same time he also collaborated in the creation of Duchamp's alternative female persona by taking a soft-focus studio photograph of him dressed as Rrose Sélavy – hence the signature on *The Non-Dada*. Duchamp and Man Ray had been in Paris together, taking part in Dada events, during the second half of 1921. In January 1922 Duchamp returned to New York; *The Non-Dada* is one of many signs of their continuing contact.

28

MARCEL DUCHAMP 1887–1968

La Boîte-en-valise (Box in a Suitcase), 1935–41

Leather-covered case containing miniature replicas and photographs of Duchamp's works, 10 × 38 × 35.7 (closed)
Inscribed within: pour Georges Hugnet ce no. II / de vingt boîtes-en-valise contenant / chacune 69 items et un original / et par Marcel Duchamp / Paris mai 1941
GMA 3472

Colour plate 10

This was purchased from the dealer John Armbruster, Paris in about 1983. Mrs Keiller gave it to the Gallery, anonymously, in 1989. It is number II of the limited de-luxe edition of twenty-four *Boîtes-en-valise* and was made in Paris for Georges Hugnet in 1941. Duchamp completed four others in France between the beginning of that year and May 1942, the remaining nineteen being assembled in New York between the summer of 1942 and 1949. Eventually Duchamp tired of the repetitive and time-consuming labour involved in editioning the *Boîte*, and relied on assistants to help him, among them Joseph Cornell (see cat.12). Each of the de-luxe *Boîtes* had its own leather-covered *valise* with carrying-handle, and contained an 'original' work – usually mounted on the inside of the lid – in addition to the 69 standard reproductions of Duchamp's works. In the Hugnet / Keiller *Boîte* the 'original' is a hand-coloured collotype on celluloid of the *Large Glass*, which is signed and dated 1939. Duchamp decreed that the ordinary, unnumbered edition of the *Boîte* should not exceed 300: depending upon the moment when these were assembled, they contained either 68 or 80 reproductions. (For full details, see the definitive study by E. Bonk, *Marcel Duchamp: The Portable Museum*, London, 1989.)

Duchamp worked from 1935 to 1940 in Paris on collecting together the material for his portable museum, assembling photographs, supervising the meticulous colour reproduction of his works, procuring the miniature replicas of three of his readymades, designing and printing the labels, and so on. The lay-out of the works within the *Boîte* was most ingenious and required much trial and error to get everything to push and pull and fold out as it was supposed to, and then to pack away again neatly and safely. Pride of place was quite properly given to Duchamp's masterpiece *The Bride Stripped Bare by her Bachelors, Even* (or *Large Glass*), which was flanked on the left by the three miniature readymades arranged at appropriate intervals. Thus the urinal (*Fountain*) lined up with the realm of the Bachelors at the bottom, the typewriter cover (... *pliant ... de voyage*) with the 'horizon' at the centre where the Bride's clothes have supposedly fallen, and the glass ampoule (*Air de Paris*) with the Bride's 'Blossoming' or 'Milky Way' at the top. During the German Occupation, armed with a cheese merchant's identity card which enabled him to move in and out of the occupied zone, Duchamp transported the facsimiles to Marseilles from where he shipped them safely to New York. (See cat.251 for his letters to Hugnet referring to the difficulties.) He himself returned to New York in June 1942 where most of the *Boîtes* were made.

There were precedents in Duchamp's work for this kind of time-consuming bulk replication, in particular *The Green Box* of 1934 (cat.249), and he regarded the process as a valid alternative to creating new, original works. The relationship in terms of status and value between an original and its reproduction was something that had always fascinated him – as witness the readymades – and it was rendered paradoxical in the de-luxe *Boîtes-en-valise* by the insertion of an original into what was supposed to be a collection of reproductions. In conversation with J. J. Sweeney in 1955, Duchamp claimed that the *Boîte-en-valise* 'was a new form of expression for me.' He continued: 'Instead of painting something, the idea was to reproduce the paintings that I loved so much in miniature. I didn't know how to do it. I thought of a book, but I didn't like that idea. Then I thought of the idea of the box in which all my works would be mounted like in a small museum, a portable museum, so to speak, and here it is in this valise' (M. Sanouillet and E. Peterson (eds.), *The Essential Writings of Marcel Duchamp*, London, 1975, p.136). It has been suggested that he may have been prompted to catalogue, and thus perpetuate, his existing work by the sense of impending disaster that afflicted Europe in the years before the outbreak of the Second World War.

29

MARCEL DUCHAMP 1887–1968

Feuille de vigne femelle (Female Fig-leaf), 1950 / 1961

Bronze, 9 × 14 × 12.5
Inscribed on back: *Feuille de vigne femelle / Marcel Duchamp 1951*
GMA 3967

Colour plate 11

In 1950–54 Duchamp made a series of four small-scale erotic objects of which this and cat.30 are two, the others being *Not a Shoe*, 1950 (A. Schwarz, *The Complete Works of Marcel Duchamp*, London, 1969, no.331), and the phallic-shaped *Objet-dard*, 1951 (Schwarz 335). They are connected – although this only became apparent after his death – with his final major work, *Etants donnés: 1. La chute d'eau, 2. Le gaz d'éclairage* (Schwarz 392), an elaborate erotic tableau dominated by a female nude with her legs spread apart which is viewed through a peep-hole in an old wooden door. Putting it about that he had given up art for chess, Duchamp worked on this installation in total secrecy from 1946 to 1966. It was unveiled in the Philadelphia Museum of Art only after his death.

The original of *Feuille de vigne femelle* was made in galvanised plaster in 1950. Duchamp kept one cast for himself and gave the other to Man Ray as a farewell gift when the latter left New York for Paris in 1951. With Duchamp's authorisation, Man Ray made an edition of ten casts in plaster painted brown in 1951. The present bronze is from the edition of ten unnumbered bronze casts made in 1961 by the Galerie Rive Droite, Paris (see Schwarz 332). Lit in such a way as to reverse the values and give the impression of a convex form, the sculpture was photographed and reproduced on the cover of the first issue of *Le Surréalisme, même*, winter 1956 (cat.436).

As the title suggests, *Feuille de vigne femelle* claims to conceal the female genitalia – just as the fig-leaf traditionally conceals the male's – but in fact draws attention to them; the female genitals become a hand-size *objet d'art* suitable for display on the mantelpiece or the occasional table. How exactly the sculpture was made remains a matter of debate; it has been described both as a *simulated* and an *actual* (albeit modified) cast of a real woman's genitals. Typically, Duchamp kept his own counsel and created an object sufficiently ambiguous in form that it would be bound to raise questions about its status and therefore about the making of erotic art. Questioned in late life by Pierre Cabanne on the place of eroticism in his oeuvre, Duchamp replied that it was: 'Enormous. Visible or conspicuous, or, at any rate, underlying. [...] I believe in eroticism a lot, because it's truly a rather widespread thing throughout the world, a thing that everyone understands. It replaces, if you wish, what other literary schools called Symbolism, Romanticism. It could be another 'ism', so to speak. [...] To be able to reveal them [things that are usually hidden], and to place them at everyone's disposal – I think this is important because it's the basis of everything, and no one talks about it. Eroticism was a theme, even an 'ism', which was the basis of everything I was doing at the time of the 'Large Glass'. It kept me from being obligated to return to already existing theories, aesthetic or otherwise' (*Dialogues with Marcel Duchamp*, London, 1971, p.88).

30

MARCEL DUCHAMP 1887–1968

Coin de chasteté (Wedge of Chastity), 1954 / 1963

Bronze and dental plastic, 5.7 × 8.5 × 4.2
Inscribed on top of base element: *coin de chasteté / M. Duchamp 54*; and on side of bronze element: *0 / 8*; and on base of plastic element: EDITION DE LA GALERIE / SCHWARZ MILAN / EXEMPLAIRE POUR / MARCEL DUCHAMP
GMA 3968

Colour plate 12

This sculpture was purchased from the Mayor Gallery in December 1974. Like cat.29, it formerly belonged to Mary Sisler. The original was made in January 1954 in galvanised plaster and dental plastic, with technical assistance from a chess-playing dental mechanic called Sacha Maruchess (according to Schwarz in his catalogue raisonné, no.338). In using dental plastic, Duchamp was ironically equating sculpture and dentistry; the plaster wedge sunk in its pink plastic casing is like a tooth set in the gum. In 1963 Duchamp authorised the Galleria Schwarz in Milan to make a numbered edition of eight casts in bronze and dental plastic, with two additional unnumbered casts, one of which Duchamp kept for himself. The Keiller cast is Duchamp's own.

The wedge section of *Coin de chasteté* (plaster in the original, bronze here) was adapted from *Not a Shoe*, 1950 (Schwarz 331), which some critics have interpreted as a fragment of *Feuille de vigne femelle* (cat.30) and therefore as a simulated

90

or real cast of a woman's genitals. Paradoxically, this assumes the male role in the coupling which is enacted in the present two-piece sculpture. It has been suggested that the title involves the kind of word-play to which Duchamp was addicted: a pun on the English word 'cast' and the Latin root of the word 'chasteté / chastity' which is *castus* (pure).

Coin de chasteté was originally made as a present for his new wife, Teeny, whom he married in New York on 16 January 1954. He explained to Pierre Cabanne: 'It was my wedding present to her. We still have it on our table. We usually take it with us, like a wedding ring, no? It was *coin* in the sense of a wedge that fits in, not a corner.' (*Dialogues with Marcel Duchamp*, London, 1971, p.88). As a wedding gift *Coin de chasteté* was, of course, highly equivocal and objectified Duchamp's determination to remain sterile as a man. Teeny Duchamp had three children by her first marriage to Pierre Matisse, but was beyond child-bearing age when she married Duchamp – a fact which Duchamp himself pointed out in justifying his abandonment of bachelorhood. (He had been married before in 1927, but the marriage was dissolved after only about six months.)

31
MAX ERNST 1891–1976
Türme (Towers), 1916

Oil on canvas, 60 × 43
Inscribed bottom left: *Max Ernst 1916*
GMA 3969

Colour plate 13

Purchased from Marlborough Fine Art in September 1963. It is no.261 in W. Spies and S. and G. Metken, *Max Ernst. Oeuvre-Katalog*, vol. I, Menil Foundation, Cologne, 1975. The painting has evidently been reworked and X-rays reveal that it may have started out as a flower painting.

At the outbreak of war Ernst was called up and served first on the Western, then on the Eastern Front. His military duties did not, however, put an end to all his artistic activities and in January 1916 he showed fifty works in a two-man exhibition at Der Sturm gallery in Berlin, meeting Grosz and Wieland Herzfelde for the first time there. He had already met Arp in Cologne shortly before war was declared, so at an early date had made contact with several future Dadaists. *Türme* seems with hindsight to be a transitional work. It reflects quite detailed knowledge of analytical Cubism, particularly Delaunay's 1910–11 views through a window of Parisian rooftops and the Eiffel Tower which were much admired in Blaue Reiter circles in Germany. (Ernst had actually met Delaunay and Apollinaire in January 1913, and it is possible that the painting records in abstracted form a view actually seen when Ernst was stationed near Laon and Soissons in 1915–16.) On the other hand it anticipates the Dadaist works he executed in Cologne in 1919–20, such as *Demi-monde oriental* (Spies 358), which are dominated by tall and precariously assembled tower-like structures but which depend upon a collage technique.

32
MAX ERNST 1891–1976
Untitled, 1921

Collage mounted on paper, 7.2 × 4.4 (mount 11.8 × 8.8)
Inscribed bottom right of paper mount: *m. e.*
GMA 3971

Colour plate 14

Purchased from the Mayor Gallery in April 1984. It is no.460 in Spies's catalogue raisonné (op. cit. under cat.31). Its first owner was Tristan Tzara, a leading figure in Zurich Dada with whom Ernst was in correspondence by the end of 1919 and whom he first met when he was on holiday in the Tirol in August 1921. They became close friends and this small collage and another very like it, which was also in Tzara's collection (Spies 459), may well have been gifts.

In many of the collages he made in Cologne at the height of the Dada period Ernst cannibalised popular – often outdated – manuals and magazines which were profusely illustrated with engravings of machines, instruments, appliances, etc. Sometimes his intervention was limited, as here, to one or two additions to the main borrowed image, but the absence of any explanatory text released the inherent strangeness and absurdity of the original source. (See cat.254 for Ernst's own account of the collage process.) The central importance of bizarre juxtapositions to his collages, the way inanimate objects tend to be endowed with a more or less obvious human presence, and the exploitation of illusionism to strengthen the atmosphere of irrationality are all devices which reflect the direct influence upon Ernst of the wartime Metaphysical paintings of de Chirico and Carrà which he had seen reproduced in *Valori Plastici* in 1919. His profound admiration for de Chirico, coupled with his informed interest in Freud and the art of the insane, made him a natural ally of the poets in the Dada group in Paris who would shortly break away to found the Surrealist movement. His exhibition at the Au Sans Pareil gallery in Paris in May 1921 carried an important preface by Breton. In August 1922 Ernst, who had desired this move for some time, was finally able to get a passport and settle in Paris where, during the *époque des sommeils* (1922–24), he was the most important painter in the fledgling Surrealist group.

33
MAX ERNST 1891–1976
La Femme au parapluie (Woman with an Umbrella), c.1921

Gouache, crayon and pencil on printed paper, laid on card, 16.5 × 10.5
Not inscribed
GMA 3970

Colour plate 15

This painting has passed through several important Surrealist collections. Its first owner was Ernst's great friend Paul Eluard, who sold it to Roland Penrose, who sold it to Edouard and Sybil Mesens. Mrs Keiller bought it from the Mayor Gallery. It is ascribed to c.1921 by Spies in his catalogue raisonné (op. cit., no.416; see cat.31), which seems right given the close relationship to contemporary collages in which Ernst deployed elements cut from advertisements for women's clothing, knitting and crochet patterns, etc. Moreover Ernst's use of a pointed instrument to incise the details into the goauche may have been done in imitation of the technique of the engravings he was appropriating for his collages.

In the almost fetishistic emphasis on the rolled umbrella, high-heeled boots and tailored gloves one can detect the influence of Max Klinger, the German Symbolist artist whose story-in-pictures *Paraphrase über den Fund eines Handschuhes* (Paraphrase on the Finding of a Glove), first published in 1881, Ernst particularly admired. (It was a taste he shared with another of his heroes, de Chirico.) The sexual tension created by cramming the girl into a very confined space, focusing on her exposed legs and open skirt, and using the device of the open door to suggest a stolen view became an increasingly important feature of Ernst's work in 1922–23 after his move to Paris.

The work seems to have been painted specifically for the carved frame, indeed seems to have been painted when the card was actually in the frame, since traces of the same blue paint are visible around the inside edge of the wood.

34

MAX ERNST 1891–1976

Max Ernst montrant à une jeune fille la tête de son père (Max Ernst Showing a Young Girl the Head of his Father), 1926 or 1927

Oil on canvas, 114.3 × 146.8
Inscribed lower left: *max ernst*

Colour plate 16

Purchased in May 1969 via the Mayor Gallery. Its first owner was the Belgian abstract painter Victor Servranckx. The painting is dated 1927 in Spies's catalogue raisonné (op. cit. under cat.31, Vol. II, Cologne 1976, no.1169). If Spies is correct it must have been painted early in the year because it was exhibited for the first time in Ernst's one-man show which opened at the Galerie Van Leer in Paris on 15 March 1927 (no.18). A couple of months later it was shown at the Galerie Le Centaure in Brussels (*Exposition Max Ernst*, no.51), where Servranckx may possibly have bought it. However M. Mouradian, Van Leer's partner, has stated in a letter dated 31 January 1969 that the painting was bought from Ernst in 1926 when he was under contract to them. Moreover it was dated 1926 in *Le Surréalisme et la peinture*, André Breton's seminal study of Surrealist painting, when the latter was published in book form in 1928.

Whatever its exact date, *Max Ernst montrant…* represents an unusual combination of two distinct modes employed by Ernst after he settled in Paris: the pseudo-illusionistic figurative style, which was predominant in 1923–24 but which resurfaced occasionally in 1926–27, and the suggestive, metaphoric, 'automatic' technique he employed in most works from 1925 onwards. The forest looming menacingly behind the figures was executed 'automatically' using the *grattage* (scraping) technique just as Ernst used it in his celebrated series of *Forest* paintings of 1927. (Indeed the landscape of the Keiller picture is virtually identical to that found in a number of these *Forests*.) The 'jeune fille' by contrast seems to be a reprise of the woman with streaming hair in *La Femme chancelante*, 1923 (Spies 627), and the male figure a blend of traits which recur in grotesque animalistic males in such works as *Le Couple*, 1924 (Spies 664), and *La Carmagnole de l'amour*, 1926–27 (Spies 1078).

The meaning of this grim and savage picture remains obscure, for although the title invites us to read it as autobiographical the syntax is so ambiguous that we cannot even be certain about the relationship between the three named protagonists: grammatically, the father could be Ernst's or the young girl's. Ernst's Oedipal conflicts with his father had been the subject of various earlier 'dream' paintings, so the suggestion of patricide may be read as a potent, continuing fantasy. In 1927 he married for the second time and one is perhaps entitled to see the 'jeune fille' as a reference to Marie-Berthe Aurenche. On the other hand she might be Ernst's beloved dead sister who is alluded to in other texts, in which case an incestuous triangle of father, son, daughter, sister may be implied. However one interprets the painting, it was clearly important in Ernst's own eyes because he alluded to it in 'Au-delà de la peinture', an autobiographical essay written in 1936 and published in Paris the following year. Having just described his discovery of the *frottage* (rubbing) technique, its relationship to automatic writing, his own 'passivity' when creating his work, and his desire to become a 'seer', Ernst goes on: 'C'est alors que je me suis vu moi-même, *montrant à une jeune fille la tête de mon père*. La terre ne trembla que mollement' (It was then that I saw myself, *showing a young girl the head of my father*. The earth quivered only gently).

35

LYONEL FEININGER 1871–1956

Spaziergänger, Arceuil (Promenaders, Arceuil), 1918

Woodcut on paper, 36.5 × 29 (paper 47.7 × 33.9)
Inscribed below image, left: *Lyonel Feininger*
GMA 3973

This is catalogued in L. E. Prasse, *Lyonel Feininger. A Definitive Catalogue of his Graphic Work: Etchings, Lithographs, Woodcuts*, Cleveland Museum of Art, 1972 (W1113). Feininger himself numbered the surviving woodblock '18102' according to his own system, thus indicating that it was the 102nd woodcut he made in 1918. He titled it variously *Spaziergänger* (Promenaders), *Promenade*, and *Arceuil* (a Parisian suburb), the subject matter being derived from a painting entitled *Arceuil I* which he executed when living in Paris in 1907. In style it reflects Feininger's response both to Cubism and to the work of the artists in the Brücke group.

Feininger's first etchings and lithographs date from 1906 but it was only in 1918 that he began to make woodcuts, ultimately his preferred printmaking medium. In 1919 Walter Gropius invited him to teach graphic art at the Weimar Bauhaus, and this woodcut was first published in 1921 in the Bauhaus portfolio entitled *Neue europaeische Graphik. Erste Mappe. Meister des Staatlichen Bauhauses in Weimar*. The 130 impressions were printed by hand in Feininger's Bauhaus workshop, this impression being printed on tissue-thin Japanese *Kozo* paper which the artist used whenever he could obtain it. Mrs Keiller purchased it in June 1974 from Colnaghi's, exactly a year after her Bauhaus-period print by Kandinsky (cat.54) from which it differs markedly in both style and technique.

36

IAN HAMILTON FINLAY b.1925
(WITH MICHAEL HARVEY)

Interior / Intérieur: Homage to Vuillard, 1971

Screenprint on paper, 27.9 × 27.9
Printed text on reverse: INTERIOR / INTÉRIEUR / *Homage to Vuillard / Ian Hamilton Finlay / Michael Harvey / Of 300 copies printed for the Wild Hawthorn Press this copy is number 190.* And inscribed: *Ian Hamilton Finlay.*
GMA 3974

Finlay is a difficult artist to classify, occupying a position somewhere between poet, sculptor, graphic artist, landscape gardener and *agent provocateur*. In the 1950s he wrote short stories, plays and verse, and in the early 1960s began

publishing his own poems, designing unusual layouts and using special typography. One of the originators of concrete poetry, some of his poems consisted of just a single word, crisply positioned on the page. Finlay employed this principle in a series of screenprints dating from c.1966, relying on metaphor, the suggestive qualities of sound, and the way in which words and language (not least the titles he uses) interact with images. Here 'Singer' refers to the manufacturer of sewing machines, which is related, in the title, to the French artist Edouard Vuillard. Vuillard was very close to his mother (he married and moved out of the family home only late in life), and his mother's corset-making business had a strong influence on his work; the decorative, patterned surfaces of his paintings may be related to the fabrics used by his mother; and sewing machines feature in a number of his works. Nearly all his works depict intimate interiors, spaces also perhaps suggested by the sound (the 'song' of the 'singer') of the dressmaker's sewing machine. The clarity of the image and the allusiveness of the meaning is a recurrent feature of Finlay's work. It is one of a series of tongue-in-cheek but mildly subversive prints made by Finlay 'in homage' to famous artists (others include Malevich, Gris, Tatlin, Seurat, Watteau and Kandinsky).

37

IAN HAMILTON FINLAY b.1925
(WITH MICHAEL HARVEY)

Beware of the Lark, 1974

Stone, 23 × 43 × 39
Inscribed with the title and: *pour René Char*
GMA 3706

Colour plate 17

This is one of several boulders (Finlay calls them 'wild stones') carved by Michael Harvey with gnomic notices conceived by Finlay. Finlay and his wife created from 1966 onwards an impressive garden at their home at Stonypath, some twenty-five miles south-west of Edinburgh. The garden, which is situated in a sparsely populated hillside location, is replete with sculptures and carved inscriptions, nestling among the trees, shrubbery and grassy areas. The artworks are generally inspired by classical and neoclassical themes and artists (Arcadia, Poussin, Claude ...) and often allude to the power of nature. As so often in Finlay's work, this sculpture (or poem, or stone) stands on the borderline between nature and art, between the written word and the object. It is designed to lie on the ground, ideally in a garden, and therefore comes as a

surprise when one encounters it and notices the inscription.

The work carries a dedication to the French poet René Char (1907–88). Finlay admired Char's poetry for, as he put it in a letter to Gabrielle Keiller, the sense of 'a kind of frenzy in Nature, and a sense of danger'. The inscription has no counterpart in Char's poetry, but Finlay wrote that 'I mean to suggest the way that larks rise from a hillside, with the suddenness of disturbed dogs ... and this relates to a sense of joy and danger which recurs in Char's poetry'. The inscription is intentionally allusive and suggestive, placing the mild-mannered lark in the position normally occupied by a dog or bull in such notices. *L'Alouette* (The Lark) is actually the title of a booklet by Char published in 1954 (G. L. M., Paris) with an illustration by Miró, but it seems that this is coincidental. Mrs Keiller purchased the work directly from the artist in 1977, following a visit to Stonypath. She sold it to the Scottish National Gallery of Modern Art in 1993.

38

BARRY FLANAGAN b.1941

Hello Cello, 1976

Clipsham stone, 40.6 × 25.5 × 22.9; on constructed wood base, 96 × 41 × 41
Not inscribed
GMA 3977

Colour plate 18

In the late 1960s Flanagan was one of a number of British sculptors who rejected the traditional materials of sculpture (stone, bronze, wood, or even the steel girders favoured by the previous generation of British sculptors), for materials such as rope, sackcloth, branches or sand for use in installation projects. However, he took up carving in 1973, learning the techniques in a carving studio at Pietrasanta in Italy, which specialised in monumental carving and ornamental stonework. In the studio the head carver would rapidly engrave the block with a chisel, marking out the form which an assistant would then translate into three dimensions. Flanagan appropriated the method in his sculptures, engraving different forms on each of the sides of a stone block. It was the point at which the 'sculpture' subsumes the block that interested Flanagan, and whether he could set the two in balance. As he remarked: 'to what degree can the original character of the piece of stone be retained; to what degree must it be sacrificed in the pursuit and realization of the carved image?' In *Hello Cello* three of the sides depict parts of a figure

from the shoulders down, while the fourth side depicts a cello. The sculpture, originally conceived as a free-standing object, was sold to Mrs Keiller in 1980, and was exhibited in that state in Flanagan's one-man show in the British Pavilion at the 1982 Venice Biennale. The wooden plinth element, which is riveted together, originated in Flanagan's designs for seating at the Hayward Gallery in London (commissioned in 1979 and manufactured by a technique known as the Rowford Process). It was made at a later date specifically for the sculpture. Many of Flanagan's sculptures now have similar bases.

39

BARRY FLANAGAN b.1941

Jolly Dog, 1972 / c.1983

Etching on paper, 24.9 × 19.8 (paper 37.9 × 28.4)
Inscribed below plate mark: *Jolly Dog 19 / 27 Flanagan*
GMA 3975

This print develops from an etching of 1972, *Dancing Dog*. Flanagan re-used the same etching plate in about 1983, creating a new image by adding tennis-balls. It was re-titled *Jolly Dog* and was published by Waddington Graphics in an edition of 27. (See Tate Gallery, *Illustrated Catalogue of Acquisitions 1984–86*, London 1988, for details of this and many other prints by Flanagan.)

40

40

BARRY FLANAGAN b.1941

Mule, 1983

Etching on paper, 18.3 × 21.8 (paper 28.5 × 38.7)
Inscribed below plate mark: *Flanagan 15 / 41*
GMA 3976

This is one of a series of prints (four etchings and three linocuts) by Flanagan depicting a Welsh cob. They are: *Stepney Green*, *Mule*, *Cob Study*, *Field Day*, *Welsh Cob*, *Welsh Lights* and *Ganymead*, all dating from 1983. Flanagan's interest in depicting horses was sparked off by the exhibition *The Horses of San Marco* at the Royal Academy of Arts in London in 1979. In 1983 Flanagan had a horse brought from Stepney Green to his studio for the day in order to make the prints, and these in turn relate to several large sculptures of horses begun that same year. In this particular print, the drawing of the horse looked rather awkward so Flanagan titled it *Mule*. The black rectangle at the bottom of the plate mark comes from the tongs which are used to hold the copper etching plate when the wax layer is heated to give an even covering. Normally this uncovered area would be re-waxed afterwards, but Flanagan has often preferred to leave the mark as a kind of signature (see Tate Gallery, *Catalogue of Acquisitions 1982–84*, op. cit.).

41

JOHN FLAXMAN 1755–1826

Evil Spirits Cast Out

Pencil and wash on paper, 22.3 × 18.3
Not inscribed; later pencil inscriptions on reverse

Very rarely indeed did Flaxman use colour washes in the manner seen here, and on this scale. The subject is identified with a passage from Emmanuel Swedenborg's *Arcana Coelestia* and is one of a number of drawings by Flaxman based on the mystical imagery in these texts; deceitful spirits who believed that they could

do as they pleased are 'thrust down again to their infernal abodes by a little child at whose presence they begin so to totter and tremble that they could not help expressing their anguish by cries.'

Flaxman's formal involvement with the Swedenborgians appears largely to have been limited to his membership of a society, established in 1810, and dedicated to the publication of the movement's founder. Closely associated with him in this was his friend Charles Tulk, an associate of both Blake and Coleridge.

A pencil inscription on the reverse records that the drawing was the property of Flaxman's sister and that it was sold by the auctioneers Christie and Manson's on 10 April 1862, lot 200, under the title *The Damned Fleeing from the Infant Christ*. However, as we have seen, the figure should not necessarily be identified with the Christ child. The present title, under which the work was shown in the British Council's exhibition *John Flaxman: Mythology and Industry* (no.160), may be preferred.

Gabrielle Keiller acquired a number of Old Master and nineteenth-century paintings and drawings in the 1950s, but sold most of them during the 1960s as her collection of Dada and Surrealist art developed. This drawing, and the Romney (cat.155), were the only pre-twentieth century drawings in her collection at the time of her death. Both drawings formerly belonged to Christopher Powney and were probably purchased from him in the 1970s.

42

LUCIAN FREUD b.1922

Head of a Boy with Book, 1944

Conté crayon and coloured chalk on grey paper, 48 × 30.5
Not inscribed
GMA 3979

Colour plate 21

Born in Berlin, Freud moved with his family to London in 1933. He studied intermittently at the East Anglian School of Painting and Drawing, under Cedric Morris, but was largely self-taught.

Life drawing predominates in Freud's early work, which is characterised by a terse unbroken line and an almost obsessive attention to detail. This drawing dates from 1944, the year Freud moved into his own flat in Delamere Terace, Paddington and the year in which his interest in Surrealism reached its peak. The sitter is unknown. At one point Mrs Keiller owned two small sketches by Freud besides this finished drawing: *Night Train to*

Inverness 1943, and one of the studies for *The Painter's Room 1944*, a work which shows a large stuffed zebra's head, its stripes painted red and yellow, intruding through a window into an interior space dominated by a battered sofa. The present work was bought from the Anthony d'Offay Gallery in March 1974.

43

ELISABETH FRINK 1930–93

Dog, 1987

Acrylic and chalk on paper, 105 × 71.5
Inscribed bottom left: *Frink 87*
GMA 3980

Dogs, birds, horses and other animals were a staple element of Frink's sculpture. In the 1950s they were often presented as fierce, predatory creatures, and while her sculptures of the human figure often continued to have an ominous presence, her *animalier* work of the later years was more benign in feeling. Frink made a very similar painting in which the dog lifts its front right paw (National Museum of Women in the Arts, Washington DC, *Elisabeth Frink*, 1990, repr. p.14; there is also a screenprint version). The two works are probably based on one of Frink's own painted plaster sculptures, *Dog* of 1986.

Gabrielle Keiller bought the work from the New Grafton Gallery in July 1988, making it possibly her last major purchase. A passionate dog-lover (her pet was a dachshund: see cat.168), the subject-matter no doubt held great appeal for her.

44

HENRI GAUDIER-BRZESKA
1891–1915

Enid Bagnold, 1912

Coloured ink and pastel on paper, 26.1 × 22
Not inscribed
GMA 3981

Colour plate 22

Enid Bagnold (1889–1980) was a writer who achieved widespread fame with novels such as *National Velvet*, and latterly wrote for the stage. Her autobiography was published in 1969. Gaudier-Brzeska made a powerful, larger than life-size bust of her in 1912, and this drawing is probably preparatory to that bust. Gaudier-Brzeska described Bagnold, who was twenty-three at the time as: 'a beautiful young girl with a magnificent figure ... [and] clear, lively eyes.' Coloured drawings are rare in Gaudier-Brzeska's oeuvre; most of his drawings are rapid sketches in pencil or pen.

45

ALBERTO GIACOMETTI 1901–66

Objet désagréable, à jeter (Disagreeable Object, to be Thrown Away), 1931

Wood, 19.6 × 31 × 29
Not inscribed
GMA 3547

Colour plate 23

Giacometti's presence in the Surrealist group was one of the principal factors in establishing sculpture, or, more properly, the object, as a central concern within the movement as a whole. Miró, Breton and Dalí are among those who followed his lead in making sculptural objects. Giacometti was closely involved with the group from 1929 to 1933, during which time he produced about thirty sculptures, less than a third of which are carved in wood. These wood sculptures were carved by specialist craftsmen, following Giacometti's plaster models. Posthumous bronze casts of the plaster model for this work exist, but the present wood version is unique.

The thrusting, horn-shaped forms, which appear in several other works of the period, have obvious phallic overtones. They are reminiscent of rhinoceros horns, which are tools of violence and are also prized for their aphrodisiacal properties; Dalí included rhino horns in several paintings and drawings. Comparisons may also be drawn with sculptures from the South Seas and Africa, and particularly with Senufo stools. The sculpture is an enigmatic and sexually-charged object, at once threatening and compelling, which is designed to be picked up, examined, turned about and played with. The precise, craftsmanlike nature of its construction and form is deliberately at odds with its non-utilitarian status.

In a list of his own works, written in 1947, Giacometti titled this work *Objet désagréable, à jeter* (Disagreeable Object, to be Thrown Away), though it has also been known as 'Object without a Base' and 'Sculpture without a Base'. The sculpture is designed to be handled and placed in different positions. However, according to the artist's younger brother, Bruno (to whom Alberto gave a plaster copy of the sculpture as a wedding present in 1935), Giacometti preferred it to stand with the single horn facing the viewer and pointing upwards. The work originally belonged to Roland Penrose, who bought it from the artist early in 1936: he included it in the seminal *International Surrealist Exhibition* held at the New Burlington Galleries in London in June that year. Gabrielle Keiller purchased the sculpture from Penrose in 1983 and sold it to the Scottish National Gallery of Modern Art in 1990.

46

ALBERTO GIACOMETTI 1901–66

Femme égorgée (Woman with her Throat Cut), c.1932

Pen and ink on paper, 31.6 × 24.5
Not inscribed
GMA 3982

This drawing relates to the sculpture *Femme égorgée* (*Woman with her Throat Cut*), 1932, a bronze cast of which is in the collection of the Scottish National Gallery of Modern Art (four further casts exist). The subject may relate to a dream or nightmare, and may also have been inspired by a short story by Robert Desnos about Jack the Ripper. The drawing was reproduced in the periodical *Minotaure*, no.3–4, December 1933, set incongruously in an article on music. An almost identical pen-drawing is in the collection of the Staatsgalerie, Stuttgart, and a very similar, though slightly less resolved pencil drawing is in the Musée National d'Art Moderne, Centre Georges Pompidou, Paris. The three drawings are so close that it is likely that the two pen drawings were copied, or even traced, from the pencil sketch. The present version formerly belonged to the English collector Edward James, an important patron of both Dalí and Magritte. It was sold at auction at Christie's, London, on 26 June 1984, incorrectly attributed to André Masson. Mrs Keiller bought it the following year from Sam and David Sylvester.

47

ANTHONY GREEN b.1939

The Wedding Night, Paris, '61, 1983

Watercolour and pencil on paper, 27.8 × 57.8
Inscribed: *The Wedding Night. Paris '61. Anthony Green 1983*
GMA 3983

Anthony Green's work is intensely autobiographical, chronicling as it does his youth, married life and the growth of his family. His marriage to Mary Cozens-Walker has been a particularly important theme. They met at the Slade in London, where Green was a student from 1956–60, and were married in July 1961. Since then Green has commemorated each wedding anniversary with a painting. This preparatory drawing shows them on their honeymoon at the Hotel Florida, behind the Place de la Madeleine in Paris, where the couple stayed from 31 July to 4 August 1961. Green made three large paintings of the subject in 1984–85: one is in a private collection in Chicago, another belongs to the artist and the third is in the Hiroshima City Museum of Contemporary Art, Japan. Like the drawing, all three paintings are shaped, a practice Green first employed in 1964.

48

NANCY GROSSMAN b.1940

Head, 1968

Leather, studs, nails and epoxy resin over wood,
31.8 × 19 × 23.1 on base 10.6 × 14.5 × 14.5
Inscribed on underside of head element, spelt out in
nail-heads: Grossman / 68
GMA 3984

Colour plate 20

Grossman was born in New York City. She grew
up in up-state New York, where her parents
worked in the garment manufacture industry;
as a teenager she worked in the factory as a 'dart
and gusset girl', an experience which doubtless
informed her later work. She was a student of
Richard Lindner (see cats.56–57) at the Pratt
Institute in New York from 1957–62, and
Lindner's subject matter of plump women
dressed up in weird bondage gear seems also to
have had a profound effect on her. Her work was
mainly in the form of collage (often incorporat-
ing fabric) until 1968, the year she began a series
of sinister heads trussed up in black leather.
These oppressive heads with their intimations
of power-play and sexual violence, marked
Grossman out as one of the leading feminist
artists of the period.

49

GEORGE GROSZ 1893–1959

Eberts Bestattung
(The Funeral of Ebert), 1923

Collage on postcard, 8.5 × 13.5
Inscribed bottom centre: Sammelt Ansichtskarten!!!!;
and date-stamped on right side: 1-März 1923
Tel. Uhland 8102
GMA 3985

Colour plate 25

Purchased from the Mayor Gallery, London in
the mid-1980s. The Funeral of Ebert is one of a
number of 'corrected masterpieces' that Grosz
made, using postcards of Old Master or even
modern works of art, throughout his life in order
to send to his friends. This particular card was
sent to the artist and former Dadaist Georg
Scholz (1890–1945) who had recently been
engaged to teach at the Karlsruhe Art Academy.
Grosz wrote on the back of the card (in transla-
tion): 'Dear Georg, Here is the photo of the
enormous painting The Funeral of Ebert. The man
on the left with the fiery red beard seems to be
Mr Stinnes. Ebert has become old, his mous-
tache grey, care-worn, in masterly chiaroscuro.
Tomorrow Dr Westheim – the Kunstblatt-Laus –
is coming to see me. I will broach his article etc.
(do you know about it?) I heard you have become
a teacher and prof. Write some time. Yours
George.'

The card is also signed by 'Rudolf'. This is
probably Rudolf Schlichter (1890–1955) who
knew Scholz from when he lived in Karlsruhe
and was an artist, Dadaist and close friend of
Grosz.

Grosz has taken a postcard of Titian's
famous painting The Entombment of Christ (in
the Louvre) and turned it into a piece of
political satire. Instead of Christ being
entombed Grosz makes out that it is
Friedrich Ebert (1871–1925), the President of
newly republican Germany. Ebert was one of
the Communist Left's, and Grosz's in
partiular, great hate figures. As leader of the
Socialists (SPD) he had voted in 1914 for war
credits and after the war, in 1919, as Chancel-
lor of Germany, had ultimately been respon-
sible for the savage and bloody suppression
of the Sparticists' (Communists') uprising in
Berlin.

The bearded man with the bowler hat who
is laying Ebert to rest is Hugo Stinnes (1870–
1924), one of Germany's top monopoly
capitalists, who had put together an enor-
mous industrial empire during and after the
war. He was a noted anti-communist and had
supported Ebert and the SPD with money in
order to prevent it moving further to the Left.
He was a frequent target of Grosz in the
drawings the latter did for the communist
satirical newspaper Die Pleite (Bankruptcy). In
one issue in 1921 he even produced a pictorial
story called 'Der Stinnes geht um' (Stinnes is
out and about). When Stinnes died in 1924
Grosz wrote jokingly to a friend that it was a
pity about Stinnes; what would they put into
Die Pleite now?

The other two heads pasted onto the card
may simply be two anonymous figures,
chosen for their pleased expressions.
However, they do bear a certain resemblance
to Karl Liebknecht (1871–1919) and Rosa
Luxembourg (1871–1919), the two leaders of
the Berlin Sparticists who had been brutally
murdered in 1919 as part of the suppression
of the Communists.

The reference to Dr Westheim in the note
on the back of the postcard is to Paul
Westheim, the editor of the avant-garde art
periodical Das Kunstblatt, which was pub-
lished in Berlin from 1917 to 1931 and which
gave fairly generous and sympathetic
treatment to the Dada artists. The article
referred to may be a piece that Grosz was to
write himself and was eventually published in
the periodical in 1924 (Heft 2; 'Abwicklung'
(Disentanglement)). The pun in 'Kunstblatt-
Laus' is impossible to translate. 'Kunstblatt'
means Art Paper. A 'Blattlaus' is an aphid.

50

AUGUSTE HERBIN 1882–1960

Composition, 1919

Oil on canvas, 73 × 91.5
Inscribed bottom right: herbin nov.1919
GMA 3986

Colour plate 24

Purchased from the Mayor Gallery in December
1970. On the back is an old stock label from
Léonce Rosenberg's Galerie de L'Effort
Moderne, which specialised in cubist and
abstract art. Herbin's early work was fauve in
style but in 1909 he took a studio in the famous
Bateau-Lavoir in Montmartre, where he was a
neighbour of Picasso and Gris, and his work
soon began to show the influence of Cubism.
He exhibited with the 'Salon' Cubists before the
First World War, and in 1916 signed a contract
with Léonce Rosenberg, who gave him two
one-man shows in 1919 and 1921.

Composition was painted in Céret, a pictur-
esque village in French Catalonia popular with
the Cubists before the war. Herbin had been
there with Picasso and Gris in 1913 and in 1918
decided to stay for a prolonged period. In the
event he remained for two years. The Keiller
picture is very characteristic of his work at this
time in its colourful palette, boldly contrasted
decorative patterns and general air of festivity.
Indeed it somewhat resembles a patchwork
hanging and even imitates blanket stitching in
many of the defining contours. (In this respect
it anticipates the designs for carpets and
tapestries Herbin made a few years later.) Like
his other Céret canvases of 1918–20 it has
definite figurative connotations despite its high
degree of abstraction; thus the more purely
abstract configuration on the left is juxtaposed
with forms on the right which conjure up a
half-length female figure facing forward and
holding a fan. Echoes of works by Gris and
Léger can be detected here and there, but in its
sensual organic rhythms it is perhaps most
reminiscent of Picabia's painting in 1913–14.

51

HANNAH HÖCH 1889–1960

Aus der Sammlung: Aus einem
ethnographischen Museum
(From the Collection: From an
Ethnographic Museum), 1929

Collage and gouache on paper, 25.7 × 17.1
Inscribed bottom right: H. H.29; and on separate
label: Aus der Sammlung: Aus einem ethnographischen
Museum / H. Höch 1929
GMA 3987

Colour plate 26

Purchased in October 1984 from Annely Juda Fine Art, London, where it was included in a mixed exhibition of Dada and Constructivist art. It was formerly in the collection of the German abstract painter Friedrich Vordemberge-Gildewart who, like Höch herself, was associated with the Dada and De Stijl movements. Presumably he bought it directly from the artist or received it as a gift.

Höch met Raoul Hausmann in 1915 and through him became involved in the activities of the Dadaists in Berlin at the end of the First World War, exhibiting her often bitingly satirical 'photomontages' in all their principal group shows. After her separation from Hausmann in 1922 she drew close to the Dutch De Stijl group, while remaining on good terms with Schwitters (see cat.158). Photomontage remained a central plank in her work for the rest of her life although, increasingly, she worked as a painter too.

The Keiller collage reflects her Dadaist leanings in its imagery and technique and her admiration for De Stijl in the carefully ordered geometric background and border. It belongs to a series of around twenty photomontages, all given the generic title *Aus einem ethnographischen Museum* but executed sporadically over a period of about ten years from 1924 or 1925 onwards. Maud Lavin has established that Höch referred to the Keiller collage as *Kinderkörper Negerplastikkopf* (Child's body / Negro sculpture head), or simply as *Negerplastik* (Negro sculpture), which is the title of the pioneering study of African art by her friend and fellow Dadaist, Carl Einstein, first published in 1915. Lavin has also shown that Höch exhibited it several times in the early 1930s, beginning with the Werkbund *Film und Foto* show which travelled widely in 1929–31 (M. Lavin, *Cut with the Kitchen Knife. The Weimar Photomontages of Hannah Höch*, New Haven and London, 1993, pp.163 and 238, notes 7–8).

Common to all the photomontages in the *Aus einem ethnographischen Museum* series is the combination of references to Western women and tribal sculpture. In this case the photograph of a baby's truncated torso is combined with one of part of an ivory pendant mask from the Court of Benin, Nigeria, onto which Höch has glued a woman's made-up eye cut out of a contemporary fashion magazine. The brutally mutilated but quizzical hybrid which results has been mounted on small feet as if it were an *objet d'art*. The precise meaning of these abrupt and troubling juxtapositions remains debatable, but there seems at least to be an ironic reference to the way women in Weimar Germany were equated with so-called primitive

peoples, and like them treated as infantile, while simultaneously being 'raised on a pedestal' and prized as valuable possessions. Whatever her attitude to issues of race or colonialism may have been, Höch's interest in tribal art went back to the Dada period; Berlin has a magnificent ethnographic collection with which she would have been familiar, but she herself specifically associated the series with a visit to the ethnographic museum in Leiden made in the company of Schwitters in 1926.

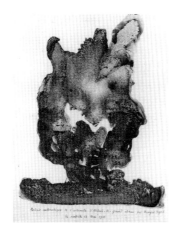

52
GEORGES HUGNET 1906–74
Portrait automatique de l'automate d'Albert-le-Grand (Automatic Portrait of the Automaton of Albertus Magnus), 1938

Gouache on paper, 37.9 × 29
Inscribed bottom: *Portrait automatique de l'automate d'Albert-le-Grand obtenu par Georges Hugnet le vendredi 13 Mai 1938*
GMA 3988

The 'automatic' technique Hugnet has used to obtain this portrait is decalcomania. According to the *Dictionnaire abrégé du Surréalisme*, compiled by Breton, Eluard and others and published in 1938 (Paris, Galerie des Beaux-Arts), 'decalcomania (without a preconceived object or decalcomania of desire)' was 'discovered' by Oscar Domínguez in 1936. To obtain a decalcomania one should, the dictionary continues: 'first, by means of a big brush, spread black gouache, more or less diluted here and there, onto satin-smooth paper, next cover it immediately with a similar piece of paper, on which one exerts medium pressure, and finally remove carefully the second sheet.' The characteristic result is spongy-textured and infinitely suggestive, and was often interpreted by the Surrealists in terms of landscape and underwater scenes.

The technique itself was not a new invention but an adaptation of a traditional transfer

process; according to the definition in the 1910 edition of *Petit Larousse illustré*, the popular French illustrated dictionary of which the *Dictionnaire abrégé* is a clever pastiche, decalcomania was a process particularly associated with transferring painted decoration onto glass and porcelain. In this respect it was like other 'automatic' techniques practised by the Surrealists, many of which had their origins in familiar children's games or popular crafts. And many of the Surrealists besides Domínguez practised it, including Breton. Ernst was particularly adept and used decalcomania to brilliant effect in his paintings of the late 1930s and during the war. Hugnet often used it to provide the endpapers of books he was binding (see cat.289) but also made decalcomanias as images in their own right. Here his 'subject' – not preconceived but identified after the head-like shape had appeared spontaneously on the paper – is, we are informed in the meticulous inscription, the automaton of Albertus Magnus, the thirteenth-century German theologian, philosopher, natural scientist, mystic and alchemist who was a hero to the Surrealists.

53 / Page 13

53
GEORGES HUGNET 1906–74
Untitled (Suite of Collages)

Portfolio containing 42 mounted collages.
Page 1, 32.5 × 49; pages 2 to 42, 32.5 × 24.5
Not inscribed
GMA 3989

Colour plate 48

Hugnet began making collages in the mid-1930s and continued to do so until ill health forced him to stop in the early 1960s. The present suite of forty-two, important as it obviously is, has never been the subject of detailed research; in the absence of any documentation, one can therefore only make tentative suggestions.

The collages have been ordered into what appears to be a quasi-narrative sequence on numbered pages. The evenly-spaced lines, hand-ruled in pencil on the pages onto which the collage-pictures are glued, suggest that Hugnet planned to add an accompanying text – not perhaps in the form of continuous prose but as cut-out fragments of text, such as he deployed to stunning effect in *La Septième Face du dé* in 1936 (cat.295). (The left-hand pages are completely blank, except in the few cases where the image on the right has spread beyond the centrefold.) It seems likely, then, that Hugnet was creating some kind of collage novel in the tradition of those made by Max Ernst (see cats.270–272). This would be consistent with the pattern of his career, for *La Septième Face du dé* was succeeded by *Huit jours à Trébaumec*, a series of 82 collages made in 1947 and eventually published in book form in 1969.

The Keiller suite opens with a double-page spread – unique in that it uses mainly colour photographs, not black and white, and covers the entire spread from side to side and top to bottom. This picture immediately establishes the erotic storyline and the Bluebeard-style castle setting against which the subsequent sado-masochistic adventures of the heroines unfold. On page 7 interior scenes of crypts, cloisters, courtyards etc. replace the exterior castle views of the first episodes, and on page 13 these in turn give way to specifically ecclesiastical settings. After a brief interlude indoors again (pages 19–21), the courtyard, gallery and bedroom scenarios return, punctuated by the odd ecclesiastical backdrop, the overall ambience becoming ever more like a most elaborately equipped bordello. The final four images (pages 39–42) mark a return to the kinds of exterior views of remote medieval castles with which the 'novel' had opened. Throughout Hugnet has culled his imagery from a variety of popular sources each of which has its own distinctive style and period flavour.

These include late nineteenth-century engravings of the kind Ernst loved to use in his collages, turn-of-the century picture postcards (of which Hugnet had a very large collection), twentieth-century advertisements, illustrations from travel brochures and natural history books, guidebook-type photographs of historic buildings (including the Palace of Fontainebleau), illustrations from fashion magazines, photographs of movie stars and 'artistic' nudes, and, in pride of place, photographs from pornographic magazines. This twentieth-century material varies considerably in date. Few men are depicted, for the images are couched in terms of male voyeuristic sexual fantasies, and the favoured themes are those familiar in pornographic literature and films – lesbianism, sacrilege, bondage, exhibitionism and so forth. Hugnet had a notable collection of erotica and it is conceivable that the collages were intended as a homage to de Sade or even as illustrations to selections from his writings; he owned a copy of de Sade's *Les Crimes de l'amour* annotated in the author's hand. (See *Pérégrinations de Georges Hugnet*, Paris, Centre Georges Pompidou, Cabinet d'Art Graphique, 1978, no.211). The date of the Keiller collages remains an unanswered question, but since some of the pornographic photographs appear to date from c.1960 the collages were probably made at that time.

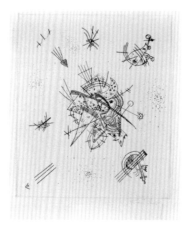

54

WASSILY KANDINSKY 1866–1944

Kleine Welten (Small Worlds), plate X, 1922

Drypoint on paper, 23.3 × 19.7 (paper 37.8 × 28)
Inscribed below plate mark, right: *Kandinsky*; and in the plate bottom left: *K*
GMA 3990

Purchased from Colnaghi's gallery in London in June 1973. *Kleine Welten* was Kandinsky's most important graphic publication during his years as Professor at the Weimar Bauhaus, and

consists of twelve hand-printed plates of diverse style and technique. The first four in the series are colour lithographs, the next four are woodcuts – colour alternating with black and white – and the final four, including this one, are drypoints. In the accompanying brief introduction, Kandinsky emphasised the different character of his chosen media – stone, wood, copper – and the importance of the alternation between colour and black and white, concluding: 'In all 12 cases, each of the 'Small Worlds' adopts, in line or patch, its own necessary language.' In *Point and Line to Plane*, the famous 'textbook' for artists he published in 1926, he analysed the differences between the main printmaking techniques, describing etching as 'aristocratic by nature' because 'it only gives a few good prints, which in any case turn out differently each time, so that every print is unique'. Lithography, he argues, by contrast, is, 'truly democratic'.

The Keiller impression is from the thirty deluxe copies of the portfolio. It is no.173 in H. R. Roethel's catalogue raisonné, *Kandinsky. Das graphische Werk* (Cologne, 1970).

55 A & B

ROY LICHTENSTEIN b.1923

Wallpaper, 1968

Screenprint on fabric-backed metallic foil.
Two rolls, each 495 × 76
Not inscribed
GMA 3992 A / B

This wallpaper (Lichtenstein's only venture into interior decoration) was made in an unlimited edition for Bert Stern's gallery-cum-shop, On 1st Store, which was on First Avenue in New York in the late 1960s. Lichtenstein also made wrapping paper with the same design but different colours for sale at the store. It is not known when Gabrielle Keiller bought the rolls (she may have bought five rolls originally; one of the rolls is inscribed '5 rolls' on the reverse), but it seems that she did not paper any of her house with it.

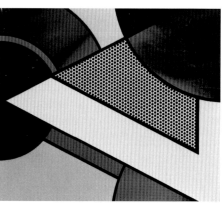

55 / Detail

53 / Page 16

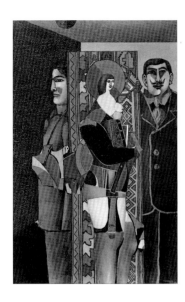

56

RICHARD LINDNER 1901–78

Solitary III, 1959–62

Oil on canvas, 107.2 × 68.8
Inscribed bottom right: R. LINDNER 1962 / 59; and
on reverse: R. LINDNER / 1959
GMA 3993

Lindner was born in Hamburg and studied art at Nuremberg and Munich before fleeing Nazi Germany in 1933. He settled in Paris, then emigrated to the USA in 1941. Living in New York he became a successful commercial illustrator. His first exhibition took place at the Betty Parsons Gallery in New York in 1954. His paintings of the 1950s, with their defiantly figurative subject matter, ran counter to the growing trend for Abstract Expressionism, and to some extent they prefigure the Pop Art of the 1960s. Peopled by buxom, corsetted women and enigmatic male figures, his paintings lie within the German tradition of satire, carica-ture and sexual frankness that can be seen in the work of George Grosz and Otto Dix. This aspect of his art combines with the vibrant, colourful, and sometimes vulgar world of post-war New York. *Solitary III* was painted in 1959 but reworked in 1962.

Gabrielle Keiller purchased the painting from Lindner's first exhibition in Britain at the Robert Fraser Gallery in London in June 1962. Fraser himself was a personal friend of Mrs Keiller and an important figure in the emer-gence of Pop Art in Britain. He achieved notoriety when he was arrested with Mick Jagger on drugs charges; the handcuffed pair are the subject of Richard Hamilton's cel-ebrated print *Release*.

57

RICHARD LINDNER 1901–78

Untitled, 1965

Mixed-media collage on board, 40 × 30
Inscribed bottom right: R. LINDNER / 1965
GMA 3994

Colour plate 27

This is one of just a handful of collages made by Lindner and is unique in his oeuvre for having no painted elements and being composed entirely of found objects. Having lived in Germany until the early 1930s, Lindner was strongly affected not only by the satirical art of Grosz and Dix (see cat.56), but also by the German Dada movement which flourished for a few years immediately after the war. He also acknowledged a debt to the work of Duchamp and Picabia, and it was no doubt this link with Dada and Surrealism which appealed to Gabrielle Keiller. She purchased the work, which has not previously been reproduced, from the Robert Fraser Gallery in 1966.

58

BRUCE MCLEAN b.1944

The Gucci Girls, 1984

Acrylic on canvas, 211.5 × 168.5
Not inscribed
GMA 3996

Colour plate 28

From 1963–66 McLean was a student in the sculpture department at St Martin's School of Art in London. From 1972 he 'gave up' making art, concentrating instead on performances. He began to draw again in the late 1970s, and on a scholarship year in Berlin in 1982 began making large-scale paintings in acrylic. These works were conceived as a somewhat ironic response to the New Image figurative painting which was gaining popularity, particularly in Germany and Italy, in the early 1980s.

Humour, irony and satire have been at the heart of McLean's work – whether perform-ance, painting or sculpture (he calls all his work 'sculpture') – while his subject matter often stems from issues of social behaviour and interaction. He has, for example, made a series of paintings about sunbathing, an activity which has much to do with status, sexual prowess and public posturing. The Gucci series of 1984 takes a similar point of departure, the obsession among certain people for designer labels which are signs of wealth, success, style and power. Here the two Gucci Girls, typifying the 1980s quest for visible display of success, wear handbags on their heads. The ladder hints perhaps at the social

ladder they are intent on climbing (or have climbed). The fact that it was this social group which also supported New Image painting was also relevant, for the painting is done in the same self-consciously dynamic, painterly manner. As with all McLean's paintings, the paints are unmixed and applied straight out of the tin or tube. Gabrielle Keiller bought the painting in New York in 1984.

59

DORA MAAR b.1909

Portrait of Georges Hugnet, 1934

Black and white photograph mounted on card,
23.1 × 17.5 (card 32 × 23.2)
Inscribed on card mount, bottom right: *Dora Maar*;
and on reverse in unknown hand: *G. Hugnet. Dora
Maar (1934)*
GMA 3999

This was purchased in London in February 1977 from the antiquarian book dealer, H. A. Landry at the same time as Man Ray's photo-graph of Hugnet (cat.63). Dora Maar partici-pated sporadically in the Surrealist movement from 1934 until the outbreak of the war, mainly through her photographs but occasionally by contributing collages, decalcomanias, etc. She became a close friend of Paul Eluard who introduced her to Picasso in 1935, and for the next eight years she was Picasso's companion, inspiring numerous works of art including *The Weeping Woman*, 1937 (Tate Gallery). She acted as Picasso's main photographer during their liaison, photographing the successive states of *Guernica* and collaborating with him on a series of photographic etchings published in *Cahiers d'Art* in 1937. After the war she gradually gave up photography for painting.

60

RENÉ MAGRITTE 1898–1967

Le Miroir magique
(The Magic Mirror), 1929

Oil on canvas, 73 × 54.5
Inscribed bottom right: *magritte*
GMA 3997

Colour plate 29

Acquired through the Mayor Gallery in April 1982. First exhibited in Magritte's one-man show at the Palais des Beaux-Arts, Brussels, in May 1933 (no.43), it was for many years in the collection of E. L. T. Mesens. (For its full history, see D. Sylvester and S. Whitfield, *René Magritte. Catalogue raisonné. Vol. I. Oil Paintings 1916–1930*, Menil Foundation, London, 1992, no.308.)

Le Miroir magique was painted during Magritte's three-year period of residence in the Parisian suburb of Le Perreux-sur-Marne, where he had moved in September 1927 in order to be in closer contact with the centre of Surrealist activities. Although he was gradually introduced to the leading poets and painters in the Parisian group, it took some time for Magritte, who lacked Dalí's charismatic personality, to make much impact. He was, however, represented by two paintings and a drawing in the special Surrealist number of *Variétés* (cat.442) published in June 1929; and in the final issue of *La Révolution Surréaliste*, which came out that December, he was at last given some prominence. Ironically, the magazine was published at the same time as his famous row with Breton; at a gathering of the group on 14 December Breton noticed that Magritte's wife was wearing a cross on a chain and demanded that she remove it. She refused, and for the next few years Magritte was estranged from Breton and many of the Parisian Surrealists. His full reintegration occurred only in 1933, by which time he had returned definitively to Brussels.

Magritte's most important contribution to *La Révolution Surréaliste* in December 1929 was 'Les mots et les images'. This consists of a series of illustrated propositions investigating the complex relationship between words and images and the things they denote. As such it is directly relevant to *Le Miroir magique*, which is a fine example of the long series of word paintings Magritte had inaugurated soon after he settled in France. In the Keiller painting the relationship between the image evoked by the words 'corps humain' and the thing depicted is typically ambiguous and baffling, the studiedly anonymous and dead-pan style of both painting and writing serving to deepen rather

than resolve the enigma. And in this case, as in some but not all Magritte's word paintings, the principal object itself cannot be identified despite the clarity of the presentation. Somewhat reminiscent of an upended bidet – and in this respect rather like Duchamp's notorious urinal (*Fountain*, 1917) – it also suggests a large hand-mirror.

61

RENÉ MAGRITTE 1898–1967

La Gâcheuse (The Bungler), 1935

Gouache on paper, 20 × 17.5
Inscribed top right: *Magritte*
GMA 3998

Colour plate 31

This gouache was for many years in the collection of George Melly who, when still not yet twenty, was involved with the Surrealist group in London in the late 1930s and became a fervent admirer of Magritte's work. He sold it to Mrs Keiller. (For full details of its history, see D. Sylvester and S. Whitfield, *René Magritte. Catalogue raisonné. Vol. IV. Gouaches, Temperas, Watercolours and Papiers Collés 1918–1967*, Menil Foundation, London, 1994, no.1110.)

La Gâcheuse was reproduced on the front cover of the Belgian edition of the *Bulletin international du Surréalisme*, 20 August 1935 (cat.410), and was painted in grisaille because it was intended for reproduction in black and white. Titles were always of great concern for Magritte – he did not consider his paintings complete until the right title had been 'found' – and according to Marcel Mariën it was named by Paul Nougé, Magritte's frequent collaborator in the 1930s. A good example of the macabre wit typical of Magritte in certain moods, the painting is also a Surrealist variant on the traditional *vanitas* theme of the beautiful young woman confronted by her inevitable fate.

62

RENÉ MAGRITTE 1898–1967

La Représentation
(Representation), 1937

Oil on canvas laid on plywood, 48.8 × 44.5 (frame 54 × 49.2)
Inscribed bottom right: *Magritte*
GMA 3546

Colour plate 30

This was one of three important works purchased by the Scottish National Gallery of Modern Art from Mrs Keiller in 1990 (see also cats.45 and 152). She bought it from Roland Penrose in September 1979. He in turn had

bought it in 1938 from Paul Eluard as part of his block-purchase of the latter's collection, Eluard himself having obtained it from Magritte in exchange for a painting by Max Ernst. *La Représentation* is mentioned in a letter to Breton postmarked 20 May 1937: Magritte hoped to include it in a one-man show at Gradiva, the Surrealist gallery Breton had recently opened in Paris. In the event the Gradiva show did not materialise and the painting was first exhibited in the Palais des Beaux-Arts, Brussels, in December 1937 in an exhibition Magritte shared with Tanguy and Man Ray (no.19). As was the case with *La Gâcheuse* (cat.61), the title was apparently 'found' by Paul Nougé. (For its full history, see D. Sylvester and S. Whitfield, *René Magritte. Catalogue raisonné. Vol. II. Oil Paintings and Objects 1931–1948*, Menil Foundation, London, 1992, no.434.)

The only shaped canvas in Magritte's oeuvre, *La Représentation* was cut down from a conventional rectangular format and a special frame was made for it. As Sylvester and Whitfield suggest, the idea of framing the torso in this way may have been suggested by Dalí's two-part *Couple aux têtes pleines de nuages* (Couple with Heads Full of Clouds) of 1936, which was painted for Edward James and which Magritte would probably have seen in London in February 1937 when he was invited to stay with James to execute a series of paintings for his London house.

Magritte himself, in the letter to Breton referred to above, described *La Représentation* as 'a rather surprising object', and clearly thought of it as belonging to a special category distinct from his usual paintings and connected with other objets he made in the 1930s, such as his painted masks and painted wine bottles. It can be seen as a development from another work he categorised as an object, *L'Evidence éternelle* of 1930, which represents a full-length standing female nude by means of five small, rectangular framed portions of her body (head, breasts, pubic area, knees and feet) mounted on glass at the appropriate intervals. Like this earlier work, *La Représentation* provides an ironic commentary on the whole tradition of illusionism in Western painting, and specifically on that branch of the tradition which provokes desire through the sensual and realistic treatment of the naked body. It may also be compared to Magritte's scandalous female face-torso, *Le Viol (The Rape)*, a drawing of which Breton chose as the illustration for the cover of *Qu'est-ce que le Surréalisme?* in 1934 (cat.201): in *La Représentation* the face is not depicted but is experienced subliminally by the spectator who is not used to seeing the genital area treated in this portrait-like fashion.

63

MAN RAY 1890–1976

Portrait of Georges Hugnet, 1934

Black and white photograph mounted on card,
22.9 × 17.7 (card 32.2 × 25.1)
Inscribed on card mount, bottom right: *Man Ray*.
Stamped on reverse: MAN RAY / 31 bis, RUE /
CAMPAGNE PREMIÈRE / PARIS 14e
GMA 4000

This intense and powerful portrait was
purchased in London in February 1977 from H.
A. Landry at the same time as the Dora Maar
photograph (cat.59). It was originally made for
L'Echiquier Surréaliste (Surrealist chessboard),
Man Ray's montage of current members of the
Surrealist group made in 1934, and was first
published in *Petite anthologie poétique du
Surréalisme* (Paris, Editions Jeanne Bucher).

Hugnet met Max Jacob in 1920 and through
him was gradually introduced to many avant-
garde artists and poets, including Picasso,
Tzara, Man Ray, Picabia and Ernst. He first met
Breton in 1932 when he was preparing a series
of essays on the history of Dada. (These essays
were published in their definitive form as
L'Aventure Dada in 1957, and remain essential
reading.) From 1932 until his violent quarrel
with Breton in 1938 he was a central figure
within the Surrealist movement.

Although he is known to English-speaking
people primarily as an enlightening historian
of the Dada and Surrealist movements, Hugnet
was a poet, critic and artist of great originality
(see cats.52–53). He was also a passionate
bibliophile: many of the rare books in the
Keiller collection come from his personal
library. In 1934 he opened a small bookbinding
shop in Paris where he created extraordinary,
one-off book-covers for his Surrealist col-
leagues, incorporating elements which evoked
the spirit of the text within. (The special cover
for Bellmer's *La Poupée* (cat.187), which Hugnet
made in 1937, included fragments of knicker
lace, suspenders and black stockings.) Given
the special designation *livres-objets* (book-

objects) and considered equal in value to other
kinds of Surrealist objects, some of them were
exhibited in the *Exposition Surréaliste d'objets* in
1936 and reproduced the following year in
Minotaure (no.10). Hugnet's addiction to fine
craftsmanship was particularly appreciated by
Duchamp with whom he formed a close and
fruitful alliance (see cats.28 and 251).

64

MAN RAY 1890–1976

Gisèle Prassinos Reading her Poems to the Surrealists, 1934

Black and white photograph mounted on card,
17.7 × 22.7 (card 18.7 × 24.5)
Inscribed on card mount, bottom right: *Man Ray
Paris*. Stamped on reverse: MAN RAY / 31 bis, RUE /
CAMPAGNE PREMIÈRE / PARIS XIVe
GMA 4001

Man Ray, as on many other occasions, acts
here as official photographer of the Surrealist
movement at an 'historic' moment. Fourteen-
year old schoolgirl Gisèle Prassinos is shown
reading aloud her poems to: (seated left to
right) André Breton and Paul Eluard; (standing
left to right) Jean-Mario Prassinos, Henri
Parisot, Benjamin Péret and René Char. Jean-
Mario Prassinos, Gisèle's older brother, had
discovered her poems and stories which,
according to her, were written 'automatically'
and without any knowledge of contemporary
poetry or Surrealism. He showed them to
Henri Parisot who, instantly recognising their
surreal quality, took them to Breton and
Eluard. A reading was immediately organised.
All doubts as to the authenticity of the writings
banished, a session in Man Ray's studio was
arranged and this photograph was taken then.
It was used as the frontispiece to her book of
poems, *La Sauterelle arthritique* (The Arthritic
Grasshopper), which was published in 1935
with a preface by Eluard (cat.371).

Breton used the case of Gisèle Prassinos as
confirmation that pure automatism was
possible and could produce marvellous results
in the conclusion to his essay 'La grande
actualité poétique', published in *Minotaure*,

no.6, 5 December 1934 (p.62). Selected poems
and stories by Gisèle, headed by a sober photo-
portrait by Man Ray, followed his essay and
introduced a group of automatic poems by
Breton, Eluard, Péret and others in the group.
Over the next few years she was an occasional, if
somewhat bemused, participant at Surrealist
gatherings, her writings often featuring in their
periodicals. Her collaboration with Bellmer is
discussed under cat.6.

65

MAN RAY 1890–1976

Studio Door, 1939

Oil on canvas, 65 × 49.7
Not inscribed
GMA 4002

Colour plate 33

This little-known painting was purchased from
Marlborough Fine Art in May 1973. It was
formerly in the collection of Georges Hugnet, a
close friend of Man Ray's (see cat.63). The
numbers '11112–39' inscribed on the satchel
hanging on the door are the artist's coded way
of recording the date of the painting. (He used a
similar code in other pictures around this time:
for instance, *Swiftly Walk Over the Western Wave* of
1940 is inscribed on the plinth in the fore-
ground '11112–40'.)

Man Ray is perhaps best known as one of the
most innovative and versatile photographers of
the twentieth century, and as the principal
portraitist of the Surrealist movement. However
he had been a prolific painter and maker of
objects since his Dada years with Duchamp in
New York during the First World War (see
cat.27). Like Picabia, another close friend from
the Dada period, Man Ray had a profound
contempt for style, and as a painter his work
was subject to many unpredictable shifts and
turns. The use of what appears to be casual
graffiti in this frankly iconoclastic picture is
somewhat reminiscent of Picabia's Dadaist
L'Oeil cacodylate, 1921, which was composed
almost entirely of inscriptions provided by
friends passing through his studio in Paris.

66

MAN RAY 1890–1976
& TRISTAN TZARA 1886–1976

Tristan Tzara and Jean Cocteau, c.1922

Black and white photograph (mounted on card) by
Man Ray, embellished by Tristan Tzara, 8.5 × 5.9
(card 8.8 × 13.9)
Inscribed on reverse (unknown hand): *T. Tzara et
Cocteau / embelli par Tzara*. Stamped: MAN RAY / 31 bis,
RUE / CAMPAGNE PREMIÈRE / PARIS XIVe
GMA 4004

64

Man Ray left New York for Paris in July 1921 and by the end of the year had established himself in the Hôtel des Ecoles in Montparnasse where he took numerous portraits. In his autobiography he describes the network of contacts he quickly built up: 'The Dadaists came around often to visit me in my hotel room, overcoming their aversion to what they considered too arty and bohemian a quarter. Tristan Tzara returned to Paris and took a room in my hotel. We became close friends. There were rivalries and dissensions among the avant-garde group but I was somehow never involved and remained on good terms with everyone – saw everyone and was never asked to take sides. My neutral position was invaluable to all; with my photography and drawing, I became an official recorder of events and personalities. Picabia gave me an introduction to Jean Cocteau as someone who knew everybody in Paris, was a social idol, and a poet, although despised by the Dadaists' (Self Portrait, Boston, 1988, p.99). From other sources we know that Man Ray's first meeting with Cocteau occurred in October 1921 and that Tzara moved into the Hôtel des Ecoles in January 1922. A beautiful, posed double portrait of the two poets, draped in dark-coloured cloaks (probably photographic black-out material) and linked by Man Ray's scroll-like sculpture, Lampshade (1919), is believed to have been taken in 1922. This very informal snapshot was probably taken at much the same time. Since it is stamped on the reverse '31 bis rue Campagne-Première' it must, at all events, have been taken in or after July 1922 when Man Ray began renting a studio at that address. As he suggests in the passage quoted above, Man Ray's neutrality made it possible for him simultaneously to frequent people who, in theory at least, belonged to enemy groups. In 1922 Tzara and Breton had become alienated and it is therefore not so

surprising that Tzara should have been on friendly terms with Cocteau, whom Breton loathed and missed no chance of insulting. Nevertheless Tzara's embellishments to the photograph, which were presumably made at the time, may suggest a certain irony on his part.

67

HENRI MATISSE 1869–1954

Jeune fille assise au bouquet de fleurs (Seated Girl with Bouquet of Flowers), 1923

Lithograph on paper, 27.4 × 19 (paper 43.4 × 28.2)
Inscribed below image: 15 / 60 Henri Matisse
GMA 4005

Purchased from Colnaghi's in June 1973 at the same time as the Kandinsky drypoint (cat.54). It is no.438 in Marguerite Duthuit-Matisse and Claude Duthuit, Henri Matisse. Catalogue raisonné de l'oeuvre gravé (vol. II, Paris 1983), and is there dated 1923. The model is Henriette Darricarrère who first began to pose for Matisse in the autumn of 1920 and who remained his principal model for the next seven years. Of all his models during his early years in Nice, where this lithograph was made, she was apparently the most receptive to his work and was happy to play a variety of roles in the many pictures he made of her. When Matisse first met her she had a part dancing in a film. He encouraged her to keep up her dancing and also to paint and play the violin and the piano. She is seen performing these activities in some of his paintings of her. Wearing the same printed dress, by turns reading, pensive or, as here, simply looking straight back at the artist, Henriette Darricarrère was the subject of several other lithographs in 1923.

68

MATTA b.1912

Untitled, c.1938

Coloured crayon on cut-out card, 18.5 × 9.8
Not inscribed
GMA 4006

One of Mrs Keiller's final purchases acquired from the Mayor Gallery in June 1988. Born in Chile, Matta spent much of the period from 1933 to 1936 travelling all over Europe and in between times training as an architect in Le Corbusier's office in Paris. In 1937, through Lorca and Dalí, he met Breton and joined the Surrealist movement, giving it a much needed boost. A few months later he was represented by four drawings in the International Surrealist Exhibition at the Galerie des Beaux-Arts which opened in Paris in January 1938, Breton regarding him as a valuable new recruit and much appreciating the automatism of his 'inscapes'. In 1939 Matta left for New York where he was an active member of the Surrealist group that reformed around Breton when he settled there in 1941.

This humorous and grotesque cut-out of a decrepit former beauty is thought to date from about 1938 – a dating which fits well with its markedly Picassoesque qualities. In 1937 Matta had worked on the Spanish Republican Pavilion at the International Exhibition in Paris for which Picasso painted his great mural Guernica. He met Picasso at this time and became fascinated by his painting. He would not only have known the studies for Guernica, but very probably also the often outrageously distorted and brilliantly coloured heads of women in extravagant hats which were inspired by Dora Maar. Furthermore, some of the large Surrealist drawings Matta made in 1937 employ the bright, coloured crayons used in the Keiller cut-out.

66

69

JOAN MIRÓ 1893–1983

Le Cri (The Cry), 1925

Oil on canvas, 89 × 116
Inscribed bottom right: *Miró. / 1925*; and on reverse:
Joan Miró / 1925
GMA 3995

Illustrated on p.25, fig.30

Le Cri is dated 1925 both on the front and the back, but appears as 1926 in the standard catalogue (J. Dupin, *Joan Miró. Life and Work*, New York, 1962, no.168). A preparatory pencil sketch for the composition is preserved in the Fundació Joan Miró in Barcelona (FJM 717). Among the painting's former owners were Paul Eluard, an ardent early supporter, and E. L. T. Mesens who included it in Miró's one-man show at the London Gallery in April 1939 (no.12). *Le Cri* was the one major work of art to be seriously damaged in the fire at Mrs Keiller's house at Kingston-upon-Thames in 1986. So far it has proved impossible to remove the soot deposits and staining.

Miró first visited Paris in 1920 and from then on spent part of every year there and the remainder in his native Catalonia. On his first visits Miró made contact with Picasso and took an interest in Dada activities, and by 1922 had made friends with André Masson, who was a neighbour at 45 rue Blomet where Miró had his studio. During the course of that year and the next he drew close to other future founder-members of the Surrealist group, including Georges Limbour, Antonin Artaud, Michel Leiris and Robert Desnos, but did not meet Breton until early in 1925 by which time the latter was already an admirer of his paintings. From then on Miró was featured regularly in *La Révolution Surréaliste* and his one-man exhibition at the Galerie Pierre in Paris in June 1925 was presented as a Surrealist event with an invitation card signed by the principal members of the group. Buoyed up by his recent successes in Paris, stimulated by his close contacts with so many poets, and confirmed in his dependence on the effects of chance and the workings of his own unconscious by the Surrealists' dual commitment to the dream and to automatism, Miró returned to Catalonia in July 1925 and embarked on his great series of 'dream' paintings, filling his notebooks with quick sketches and executing what are often very large canvases with great rapidity. To prompt his visionary, shamanistic powers he would sometimes resort to devices such as

self-starvation. *Le Cri* was made during this intensely creative period and, like the other works in the series, combines spontaneous gesturalism with precision and control, and a large field of empty, abstract space with conventionalised signs (coloured circles, dotted lines, etc.) which are equivalents for elements in the outside world.

70

JOAN MIRÓ 1893–1983

Peinture (Painting), 1927

Oil on canvas, 33 × 24.1
Inscribed bottom right: *Miró / 1927*; and on reverse:
Joan Miró / 1927
GMA 4007

Colour plate 34

Gabrielle Keiller acquired this painting in 1973 through the Mayor Gallery. It is no.221 in Jacques Dupin's *Joan Miró. Life and Work* (New York, 1962). A preparatory pencil sketch closely corresponding to the finished painting is preserved in the Fundació Joan Miró, Barcelona (FJM 777). Although diminutive in scale it is very characteristic of Miró's more abstracted works of 1925–27, relating especially closely to *Peinture sur fond blanc* (Painting on a White Ground), 1927 (Dupin 233). In its combination of calligraphic precision with great spontaneity it has some points of contact with the automatic drawings of Masson, one of Miró's closest friends among the Surrealists.

During the mid-1920s Miró had developed his own sign language and the principal elements scattered over the surface of the present painting have close equivalents in other works. For example, the 'pin-woman', in the bottom left quarter of the composition is reminiscent of the mother in *Maternité* (Maternity), 1924 (also in the Scottish National Gallery of Modern Art's collection, but not in the Keiller bequest), and the black dot sprouting hairs in the top left quarter belongs to the same family as the black dots with sprouting hairs in *Le Cri* (cat.69). Like his Surrealist colleagues, Miró was deeply interested in primitive art of all kinds. His personal vocabulary of forms is often particularly reminiscent of painted symbols dating from the Neolithic period, and the way in which the various signs in *Peinture* are painted over the deep blue priming of the relatively coarse canvas is very like the way the prehistoric figures and symbols are painted on the stone walls of caves.

71

HENRY MOORE 1898–1986

Figures in Settings, 1949

Colograph on paper, 58 × 41.2
Inscribed in the print bottom right: *Moore*; and bottom left: *For Gabrielle with warm regards from Henry Moore*
GMA 4009

By 1949, the date of this print, Moore was already regarded by many as Britain's leading sculptor, having exhibited the previous year in the British Pavilion at the Venice Biennale. However this print (and cat.72) are among Moore's earliest printed works; *Figures in Settings* is preceeded by two woodcuts dating from 1931, a lithograph of 1939 and an etching with aquatint of 1946.

Moore began the practice of dividing the sheet into sections, each containing a separate study, in his drawings of the 1930s, often picturing his own or imagined sculptures in landscape settings. The figure groups in this print relate to, but do not exactly reproduce, sculptures already made by Moore.

This five-colour colograph was issued in an edition of 75 plus some artist's proofs in 1951 by Ganymed Original Editions Ltd, London. With colography, the artist draws directly onto a transparent, plastic sheet (one sheet for each colour) and these are then transferred onto sensitised lithographic plates by exposure to light. They are then printed by the normal lithographic process.

72

72

HENRY MOORE 1898–1986

Standing Figures, 1949

Colograph on paper, 47 × 57.2
Inscribed bottom left: *For Gabrielle with best wishes from Henry Moore*; and bottom right: *Moore*
GMA 4008

This is a three-colour colograph (yellow, blue-grey and black), and like cat.71 was published in an edition of 75. The print relates to several drawings dating from 1946 onwards. The drawings do not replicate any particular sculptures made by Moore, though the figures in the lower half in particular are in the style of the *Three Standing Figures*, carved in stone in 1947–48 for the Battersea Park Open Air Sculpture exhibition. The central pair in the top row are subtitled 'Figures for Metal', though in 1949 Moore was still inexperienced with large-scale metal sculpture. His first large bronze, the *Family Group* made for a school in Stevenage, Herts., was only cast in 1950.

73

EDVARD MUNCH 1863–1944

Eifersucht (Jealousy), 1896

Lithograph on Japan paper, 47 × 56.5 (paper 55.5 × 71.1)
Inscribed bottom right: *E. Munch*
GMA 4010

Colour plate 32

This print relates to a painting (Bergen, Rasmus Meyer Collection) of 1895, though in the print the composition is reversed. As in so many of Munch's works, the imagery deals with themes of love, jealousy and anguish. The figure in the foreground seems to be modelled on Munch's Polish friend, the writer Stanislaw Przybyszewski. In the painting the tree is more clearly recognizable as an apple tree, from which the woman plucks a fruit. It probably refers to Munch's affair with Przybyszewski's wife, Dagny Juell, the couple in the background being Juell and Munch. Tall and attractive and a believer in free love, Juell cast a spell over Munch and many of his friends. Tragically she was murdered in 1901 by a fanatical supporter of Przybyszewski. Another, smaller variant of the lithograph concentrates more fully on the face in the foreground, with the couple visible only from the waist up. Munch later wrote about the painting, and specifically about the gaze of the figure in the foreground: 'In these two piercing eyes are concentrated as many mirror images as in a crystal. There is something warning of hate and death. There is a warm glow that recalls love, an essence of her, something they all

three have in common, a wisp of the woman they shared. The gaze is searching, filled with hate and filled with love.'

In making this and other prints, Munch would paint large areas of the lithographic stone with black 'tusche' (a greasy ink wash) and draw into it with a needle. It was printed by Auguste Clot in Paris. Gabrielle Keiller purchased the print from Colnaghi's in 1974. She bought a colour woodcut by Munch, *Zwei Menschen: Die Einsamen* (Two People: The Lonely Ones), in 1976 but seems subsequently to have sold it.

74

EDUARDO PAOLOZZI b.1924

Self Portrait, c.1935

Pencil and blue crayon on paper, 25 × 20.5
Inscribed top left: *Edward Paolozzi*
GMA 4064

The son of Italian immigrants, Paolozzi was born in Leith, on the outskirts of Edinburgh, in 1924. This drawing, perhaps the artist's earliest surviving work, shows Paolozzi at the age of about eleven, when he was a pupil at Leith Walk School. Drawn on the cover of a book of nursery rhymes, it is signed 'Edward Paolozzi', the name he was accorded at the school. During the war, the sixteen-year-old Paolozzi was briefly interned as an enemy alien. Following his release he attended evening classes at Edinburgh College of Art, and worked during the day in the family's ice-cream and confectionery shop in Leith.

Paolozzi met Gabrielle Keiller in 1960 and she began collecting his work shortly afterwards, finally amassing an unrivalled group of more than seventy of his works. A number of the sculptures were sold to museums, including the Scottish National Gallery of Modern Art in the the late 1980s and early 1990s, while the other works, such as this drawing, form part of Mrs Keiller's bequest. This particular drawing was given by the artist to Mrs Keiller in 1962.

The entries which follow are based on conversations with the artist, and also, principally, on the following: Edward Middleton, *Eduardo Paolozzi*, Methuen, London, 1963; Diane Kirkpatrick, *Eduardo Paolozzi*, Studio Vista, London, 1970; Uwe Schneede, *Eduardo Paolozzi*, Thames and Hudson, London, 1971; Victoria and Albert Museum, *The Complete Prints of Eduardo Paolozzi*, London, 1977; Winfried Konnertz, *Eduardo Paolozzi*, DuMont, Cologne, 1984; Serpentine Gallery, London, *Eduardo Paolozzi: Sculptures from a Garden*, exhibition catalogue, 1987; British Council, *Eduardo Paolozzi: Artificial Horizons and Eccentric Ladders*, catalogue of touring exhibition, 1996; and the unpublished typescript of a long interview between Frank Whitford and Paolozzi, 1993.

75

EDUARDO PAOLOZZI b.1924

Copies from Rembrandt, Ashmolean Museum, Oxford, 1945

Pen and ink on paper, 35.5 × 25.8
Inscribed bottom right: *Copies from Rembrandt Ashmolean Museum Oxford 1945 / Eduardo Paolozzi*
GMA 4011

Early in 1944 Paolozzi joined the Ruskin School of Art, which was based within the Ashmolean Museum, Oxford. By chance, the Slade School of Fine Art, which formed part of London University, had also moved into the Ashmolean for the duration of the war. Paolozzi actually lived at the Ashmolean for part of his time in Oxford, since he was one of the students who volunteered for fire duty at night. This sheet of studies was made in the Ashmolean's library, and features copies from facsimile reproductions of Rembrandt's etchings. The pair of heads in the top left of the sheet are after *The First Oriental Head* of 1635 (Barsch 286); the profile centre left is after *The Second Oriental Head*, c.1635 (B.287); the man wearing a cap is after *The Fourth Oriental Head*, c.1635 (B.289); and the two heads at the bottom of the sheet seem to be loose variants of *Pieter Haaringh*, 1655 (B.275). Another sheet of studies after Rembrandt, again done in the Ashmolean, is in the Arts Council Collection

and is dated January 1945. At the same time Paolozzi made similar studies after Dürer and after works in the ethnographic collections at the Pitt Rivers Museum, Oxford. About the end of the year he decided to study sculpture and transferred to the Slade School, where the sculpture department had a strong reputation (the Ruskin had no sculpture department). In 1945 the Slade returned to its base in London, and Paolozzi thus left Oxford for the capital. Paolozzi gave this drawing to Gabrielle Keiller in 1962.

76

EDUARDO PAOLOZZI b.1924

Bull, 1946

Bronze, 19.5 × 44 × 17
Not inscribed or stamped
GMA 4059

Paolozzi moved to London and to the Slade in 1945, working in the sculpture department. This work, modelled in clay at the Slade, is one of the artist's earliest surviving sculptures. It derives from his great passion for Picasso, who had made numerous studies of bullfights, and also from his interest in Ernest Hemingway's writing. He made a number of pen drawings of bullfight scenes (see, for example, *The Picador* sold at Sotheby's, London, 5 April 1978, lot 229); the sculpture of the *Horse's Head* (cat.77) also relates to this theme. *Bull* was included in Paolozzi's exhibition in the British Pavilion at the Venice Biennale in 1960.

77

EDUARDO PAOLOZZI b.1924

Horse's Head, 1946

Bronze, 69 × 35 × 46
Inscribed on right side of base: SLADE 1947 and stamped *Morris / Singer / FOUNDERS*; inscribed on back of base: *Eduardo Paolozzi*; and on left side of base: *Gabrielle Keiller*
GMA 3698

Like Bull (cat.76), this work may be related to Paolozzi's interest in Picasso and Hemingway. It, or a slightly different version, was shown in Paolozzi's first one-man exhibition at the Mayor Gallery, London, in June 1947. A similar work is illustrated in the magazine *Horizon*, Vol. XVI no.92, September 1947, in conjunction with an article by Robert Melville. Entitled *Horse's Head* and dated 1946, that work was modelled in red concrete and stood on a triangular base; another version in white concrete is also illustrated. Melville wrote that: 'His horses' heads, for instance, constructed out of a selection of their features, establish a relationship with half the animal styles of the past without a sign of conformism; I find the large empty rings for nostrils, hanging out like fabulous circular bones from a central stem, quite unforgettable, and throughout all his work in concrete, warm, active, friendly forms are coming into existence' (p.213). At that time Paolozzi was living in student halls of residence at 28 Cartwright Gardens, near King's Cross. Much of his work was made there, rather than at the Slade, in a disused basement area. They were made in concrete obtained from a builders' yard, mixed and buttered on to iron armatures, and then 'engraved' with a knife. Another cast is in the Edinburgh City Art Centre, though it has a supporting bar connecting neck and head, which the Keiller cast does not. The Keiller bronze was cast in the 1970s, specifically for Gabrielle Keiller, and was incorrectly inscribed with the date '1947'. The Scottish National Gallery of Modern Art purchased the sculpture from Mrs Keiller in 1993.

78

EDUARDO PAOLOZZI b.1924

Head, 1946

Pen and ink and collage on paper, 38 × 28.4
Inscribed bottom centre: *June 1946*
GMA 4013

There is a brown chalk sketch of a life model on the reverse.

79

EDUARDO PAOLOZZI b.1924

Crab Fishermen, 1946

Ink on paper, 48 × 57
Inscribed bottom right: *Eduardo Paolozzi 1946*
GMA 4014

This work was illustrated in the September 1947 issue of *Horizon* (see cat.77), where it was classified as belonging to the Mayor Gallery. It was probably shown in Paolozzi's one-man exhibition at the Mayor Gallery in June 1947, when the artist was just 23 years old. The present drawing and several similar works were inspired by the fishermen of Newhaven, a small fishing port a mile west of the artist's birthplace in Leith. Paolozzi also made concrete sculptures of similar subject matter, *Blue Fisherman*, and *Seagull and Fish*, both of 1946, which are also illustrated in the afore-mentioned issue of *Horizon* (both are now lost). In the accompanying text Robert Melville wrote that: 'The privilege of a childhood spent in a fishing village near Edinburgh has given him fishermen, little boats, gulls, fish, ships' lanterns and oil lamps with tall glass chimneys to work upon, and – along with the heads of horses and bulls – they will probably last him a lifetime, for he sees them as endlessly trans-formable objects with an immutable fetishistic significance. ... His sculpture is, so far, crude in facture, although I have no doubt that it is the field in which his originality will find its greatest scope' (pp.212–213).

77

78

79

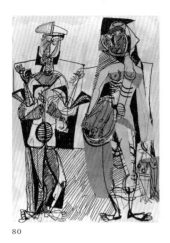

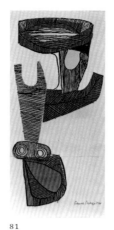

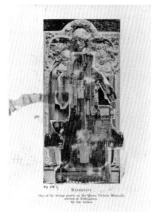

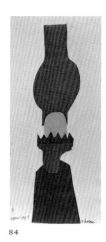

80 81 83 84

80

EDUARDO PAOLOZZI b.1924

Fisherman and Wife, 1946

Pen and ink, collage and pencil, 29.1 × 22.1
Not inscribed
GMA 4018

See cat.79 for reference to the subject matter. A similar 1946 ink and collage work, *Fisherman and Wife*, is in the Tate Gallery, London, having been purchased by E. C. Gregory from the Mayor Gallery in December 1947 and then purchased by the Tate from the Gregory Estate in 1959. That work, which is inscribed 'June 1946', shows the woman carrying the cocks and the man carrying the fish. The heads of the cocks in both drawings derive from Picasso's drawings of the same subject dating from 1938. In Paris Paolozzi made a sculpted version of the head of the man featured in the Keiller drawing, though this is now lost. Gabrielle Keiller bought the drawing from the Mayor Gallery in 1978.

81

EDUARDO PAOLOZZI b.1924

Head, 1946

Pen and ink and collage on paper, 49.5 × 24
Inscribed bottom right: *Eduardo Paolozzi 1946 / EP Sept.46*
GMA 4012

This is one of a group of drawings, made with a reed pen, while Paolozzi was at the Slade in 1946–47. The drawings relate to Picasso's

82

drawings of the late 1930s. Picasso's work could be seen at the London Gallery and also in the collections of Peter Watson, and Roland Penrose (see cats.148–151), Picasso's friend and future biographer whom Paolozzi met at the time. The present drawing is particularly close to the *Horse's Head* sculpture (cat.77). The coloured paper used in these collages was bought at Kettle's art suppliers shop, which was near the Central School of Art and Design.

82

EDUARDO PAOLOZZI b.1924

Fish, 1946

Collage and ink on paper, 32.1 × 54.9
Inscribed bottom right: *Eduardo Paolozzi / EP Sept.46*
GMA 4061

This drawing closely relates to a lost concrete sculpture Paolozzi made in 1946, *Seagull and Fish* (see cat.79). The bony structure of the fish finds an echo in several of Paolozzi's sculptures of the late 1940s, for example *Table Sculpture (Growth)* of 1949 (cat.92). Gabrielle Keiller bought the drawing from the Mayor Gallery in 1970.

83

EDUARDO PAOLOZZI b.1924

Untitled (Maternity), 1946

Collage on book illustration, 19.5 × 13.8
Printed text: *Fig. LIX.* MATERNITY */ One of the bronze panels on the Queen Victoria Memorial, / erected at Nottingham. / By the Author*
GMA 4052

Paolozzi made collage scrapbooks from an early age in Edinburgh, using magazines, comic books, advertisements and other scraps. At the time he did not regard these works as artworks that might be exhibited, though retrospectively they have assumed a great signficance within his oeuvre and in terms of the development of Pop Art in general.

Paolozzi's father ran an ice-cream and confectionery shop in Leith and the young artist therefore grew up surrounded by advertising for the various products sold there.

This book illustration comes from Albert Toft's *Modelling and Sculpture* (London 1911), a sourcebook on the traditional techniques of sculpture making, and depicts Toft's own bronze panel on the Queen Victoria Memorial in Nottingham. Toft's book was still a standard instruction manual when Paolozzi entered the Slade, where this work was made, but it was probably one of the many war-damaged books that Paolozzi picked up cheaply from Lewis's bookshop in Gower Street (near Paolozzi's student halls) or from Foyle's bookshop on the Charing Cross Road. Other collages composed from the same book are dated 1946.

The method of combining a conventional 'artistic' image with a machine diagram derives from Ernst and Picabia (see cats.32 and 152), artists whose work Paolozzi would have seen in the original or in reproduction in Roland Penrose's collection and library. Paolozzi remembers in particular seeing Penrose's copy of the Max Ernst collage book *Une Semaine de bonté* (cat.272), while a close friend at the Slade, Nigel Henderson, even had a copy of Duchamp's *Green Box* (cat.249). Paolozzi has recently commented on his 'discovery' of the collage process in 1946: 'My anxiety and anguish in 1946 was resolved by this magic process of picture making. Of introducing strange fellows to each other in hostile landscape or placing objects amongst the rubble of a bombed church without recourse to standard drawing and painting practice [...] Unlike the world of school where the universe was systematized in a certain order, the reassembly of this disparate material reflected a true state, both autobiographic and dynamic' (British Council, *Eduardo Paolozzi: Artificial Horizons and Eccentric Ladders*, p.10).

84

EDUARDO PAOLOZZI b.1924

Oil-Lamp, 1947

Collage on paper, 48.9 × 22.9
Inscribed botton left: *april 1947*; and bottom right: *E. Paolozzi*
GMA 4019

This collage was executed in April 1947, before Paolozzi left London for Paris that summer, and it was probably among the works shown in his exhibition at the Mayor Gallery in June of that year. A watercolour of three lamps, dating from March 1947, was offered for sale at Sotheby's, London, on 24 August 1985. The lamps were bought at a chandler's shop in Leith docks, and were used by Paolozzi in his student accommodation at Cartwright Gardens in London.

85

EDUARDO PAOLOZZI b.1924

Head, 1947

Ink, gouache and collage on paper, 25.4 × 19.2
Inscribed bottom left: *April 1947*; and bottom right: *E. Paolozzi*
GMA 4020

86

EDUARDO PAOLOZZI b.1924

Shooting Gallery, 1947

Ink, gouache, black chalk and collage on paper, 26.5 × 35.3
Inscribed bottom centre: *Eduardo Paolozzi*; and bottom right: *August 1947*
GMA 4015

Colour plate 35

Paolozzi left the Slade without taking his teaching diploma and, armed with £75 earned from sales from his exhibition at the Mayor Gallery in June, moved to Paris in the summer of 1947. He stayed there until 1949. Paris acted like a magnet for many young artists born in the 1920s who had not had the opportunity to travel abroad owing to the war; William

Turnbull (see cat.164), Lucian Freud (see cat.42), William Gear and Raymond Mason were among a number of British artists who moved to Paris soon after the war.

In his first months in Paris Paolozzi stayed near Place Denfert-Rochereau, Montparnasse, where an English artist whom he had met by chance lent him a studio. Paolozzi has always been as much, if not more, attracted to science museums, scrapyards, shop displays and fairgrounds as he has to art galleries, so the permanent fair at Denfert-Rochereau, which boasted colourful shooting stalls, lottery booths and other attractions, immediately appealed to him, striking a contrast with ration-book London. His first exhibition at the Mayor Gallery had been principally of fishermen scenes (see cats.79–80), and his object in Paris was to make work for a second show of drawings, which would take place in February 1948; this consisted primarily of these fairground drawings.

Paolozzi subsequently moved to accommodation on the Ile St Louis and then to a studio at 16 rue Visconti, very close to the Ecole des Beaux-Arts where he was officially registered as a student from October 1947. He did not, however, attend the school. Gabrielle Keiller purchased this drawing from the Mayor Gallery in 1970.

87

EDUARDO PAOLOZZI b.1924

Booth, 1947

Ink and gouache on paper, 28.5 × 31
Inscribed bottom right: *November. Eduardo Paolozzi.47.*
GMA 4016

88

EDUARDO PAOLOZZI b.1924

Fair Drawing, 1947

Ink, gouache and collage on paper, 20.3 × 25.6, laid on paper 27 × 32.9
Inscribed bottom right: *E. Paolozzi*
GMA 4017

87

89

EDUARDO PAOLOZZI b.1924

Hanging Forms (Study for 'Two Forms on a Rod'), 1948

Watercolour, ink and pastel on paper, 26.2 × 32.8
Inscribed bottom right: *EP. 48*
GMA 4021

This is a study for the sculpture *Two Forms on a Rod* (cat.90).

90

EDUARDO PAOLOZZI b.1924

Two Forms on a Rod, 1948–49

Bronze, 51 × 65 × 32.5
Stamped on top of base: EDUARDO PAOLOZZI LONDON; and on side of base: CAST BY MORRIS SINGER CO LONDON SW8
GMA 3398

Paolozzi made this sculpture in plaster in his room at 16 rue Visconti in Paris. Six casts were later made (sand-cast by the Morris Singer Foundry, London), one of which is in the Tate Gallery, London. The two hanging objects are cast from the same plaster form, though one hangs upside-down. The work shows Paolozzi moving away from the rough, crude sculpture of the Slade years, and reflects instead the influence of Giacometti's Surrealist work of the late 1920s and early 1930s (see cat.45). Paolozzi got to know Giacometti well while living in Paris, being introduced to him through Isabel Delmer (later Isabel

88

90

Rawsthorne), an English woman who was portrayed by Giacometti, Derain, Bacon and Epstein among others. The sculpture was purchased by the Scottish National Gallery of Modern Art from Mrs Keiller in 1988, together with cats.92 and 115.

91

91

EDUARDO PAOLOZZI b.1924

Paris Bird, c.1948–49

Silvered bronze, 33.5 × 34.5 × 15.5
Not inscribed or stamped
GMA 4022

Like cat.90, this sculpture was made in Paris and was sand-cast in bronze at the Morris Singer Foundry, London, at a later date. There is an edition of six casts. The vertical, support-ing element comes from a piano while the perforated elements are cast from pieces of wood. The 'head' of the bird was modelled in plaster. The other casts from the edition have a conventional brown-green patina, but this particular cast was given a silvered finish in the mid-1960s, at a time when Paolozzi was making works in chromium-plated steel and polished bronze and was also painting his large sculptures. This sculpture is perhaps identical with the sculpture *Bird*, which was shown in the exhibition of work by Paolozzi and Turnbull at the Hanover Gallery, London, in February 1950. It has, since, however, assumed the title *Paris Bird*.

92

EDUARDO PAOLOZZI b.1924

Table Sculpture (Growth), 1949

Bronze, 80 × 60.5 × 39
Stamped on top of 'table' element: 3 / 6 EDUARDO PAOLOZZI
GMA 3399

Colour plate 37

Like cats.90 and 91 this sculpture was made in plaster when Paolozzi was living in Paris, and was sand-cast in bronze in England at a later date. There are six bronze casts, and there is also a similar sculpture of the same date, *Icarus*. A sheet of studies relating to this sculpture (sold Sotheby's, London, 6 February 1985, lot 505), is marked 'Rue Visconti 1947' but this inscription may be later and incorrect, for the sculpture is normally dated to 1949. The drawing, and a *Fish* drawing in the Keiller collection (cat.82) do indicate, however, that the forms may derive in some way from the bone structure of a fish, the central 'table' form standing for the backbone while smaller bones spring from it. Cut-away botanical models in science museums may also have helped suggest the motif.

93

EDUARDO PAOLOZZI b.1924

Mr Cruickshank, 1950 (or 1959)

Bronze, 27 × 28.2 × 20
Stamped on back of left shoulder: MORRIS / SINGER / FOUNDERS / LONDON; and inscribed on back of right shoulder: 1959 E. *Paolozzi*
GMA 4057

William Johnstone, the head of the Central School of Art and Design in London, had been impressed by Paolozzi's exhibition at the Mayor Gallery in February 1948, and had invited him to teach sculpture at the school. Preferring to stay in Paris and reluctant to teach, Paolozzi had procrastinated in his response, but a year later, when funds were running out (his third show at the Mayor Gallery in May 1949 had not sold well), he accepted the post. By that date the position had already been filled, but he was offered a

93

position in the textile department instead. Paolozzi returned to London in the autumn of 1949 and took up the new job. Turnbull, Alan Davie and Patrick Heron were among those who taught at the Central School at that time or shortly afterwards.

Paolozzi made comparatively few sculp-tures in the period 1950–55 (most that he did make were in terracotta), concentrating instead mainly on collage. The present sculpture is considered to be among the first he made after his return to Britain. The subject derives from a magazine illustration of 1950 showing an experiment at the Massachusetts Institute of Technology in which a dummy head, christened 'Mr Cruickshank' by the technicians, was subjected to massive X-ray treatment in order to study the treatment of brain tumours. Film was placed inside the head and analyzed after the experiment; the text caption under the illustration informed the reader that the head 'has been the target of more X-rays than any other human form in the world.' Paolozzi's three-dimensional variant of the dummy head features the same segmented areas which would be prised open to permit analysis of the film.

The original magazine illustration of the head features in a collage of 1950 by Paolozzi (see Konnertz, op. cit. under cat.74, p.60). The sculpture itself seems first to have been exhibited or recorded in Paolozzi's Tate Gallery retrospective of 1971 (no.30), where it was dated 1950; and a cast presented by the artist to the Victoria and Albert Museum in 1971 (and subsequently transferred to the Tate Gallery) is said to be inscribed with that date. However the Keiller cast is clearly marked '1959', though this could conceivably be the casting date. Whatever the case, the smooth forms of the sculpture are unlike Paolozzi's other bronzes of the 1950s.

94

EDUARDO PAOLOZZI b.1924

Aquarium, 1951

Screenprint with white gouache on paper,
55.8 × 65.9
Inscribed bottom centre and right: AQUARIUM – E. *Paolozzi* 1951
GMA 4024

Paolozzi made a large number of screenprints at the Central School of Art and Design, where he taught in the textile department from 1949–55. In contrast to his screenprints from the mid-1960s onwards, which were produced by photo-mechanical means after collages (see for example cat.130), these early screenprints were done either by painting directly onto the

94

screen mesh or, as here, by painting onto a very thin sheet of paper. A 'contact print' of the drawing would then be made on sensitized gelatine-coated film and this would be transposed onto the fine silkscreen mesh for printing.

This is one of several works by Paolozzi from the early 1950s which take fish, animal and insect life as their subject matter (a colour lithograph of 1950, *Marine Composition*, is in the Gallery's permanent collection). These were partly inspired by visits to London Zoo and its aquarium, but on a more general level this was an interest shared by a number of the young artists associated with the Institute of Contemporary Arts at that time, an interest which culminated in the exhibition *Growth and Form*, held at the ICA in 1951. Much of the work in that exhibition was indebted to Paul Klee, and an affinity with Klee can be seen in this print. However, Paolozzi was also interested in the inter-relationship between animal forms and the machine: the grid-like structure of his works of this period echoes transistor lay-outs. No other copy of this print is recorded.

Gabrielle Keiller purchased this work, together with cat.95, from Marlborough Fine Art in 1977.

95

EDUARDO PAOLOZZI b.1924

London Zoo Aquirium, 1951

Ink and watercolour on paper, 56 × 76.2
Inscribed bottom centre and right: LONDON ZOO AQUIRIUM E PAOLOZZI 1951
GMA 4023

Colour plate 36

96

EDUARDO PAOLOZZI b.1924

Collage, 1953

Collage with silkscreen and watercolour, ink and gouache on paper, 53.5 × 69
Inscribed bottom centre: *Eduardo Paolozzi 1953*.
GMA 4026

The present collage is composed of fragments of screenprints Paolozzi had made at the Central School, as well as tickets and scraps of magazines and drawings. Several of the tickets are from Hamburg, where the artist spent several weeks early in 1953 (see below, cat.97). The German artist Kurt Schwitters (see cat.158) had made a similar use of collage from the late 1910s.

Collage has been of crucial importance in Paolozzi's art; many of his sculptures and prints are made in a collage fashion, being accretions of different imprints or layers of objects and images. It is a supremely twentieth-century medium, providing an analogue to the way we flick through magazines, past articles and advertisements dealing with all sorts of subjects, or switch television channels. Paolozzi made a number of collages in the late 1940s and early 1950s composed of pictures of glamorous 'pin-ups' counterpointed with illustrations of food and consumer durables; this is an area of Paolozzi's art unrepresented in the Keiller collection. In 1952 he delivered a celebrated 'lecture', *Bunk*, to the newly-formed Independent Group at the Institute of Contemporary Arts: this consisted of projections of all kinds of images, shown in a random sequence with no rational links or explanation, conjuring up what the artist refers to as 'the schizophrenic quality of life'.

The present collage featured in the exhibition at the Museum of Modern Art, New York, *The Art of Assemblage*, 1961; the artist gave it to Mrs Keiller the following year. Paolozzi made a similar, but very much larger collage for the office of the architects Maxwell Fry and Jane Drew in 1952.

96

97

EDUARDO PAOLOZZI b.1924

Diana und Aktaeon, 1953

Collage on book illustration, 26 × 18.9
Inscribed along bottom edge: *E. Paolozzi 1953*. Printed text: *Diana und Aktaeon. Metope vom Heratempel in Selinus. Zweites Viertel des V. Jahrh. vor Chr. Palermo.*
GMA 4027

In 1951 Paolozzi had made a large scaffold sculpture for the Festival of Britain. Photographs of this had attracted the attention of Werner Haftmann, the art historian who was then teaching in Hamburg. He invited the artist to make a fountain for the Hamburg Garden Festival, *Planten un Bloomen* of 1953. In the event, Paolozzi made three separate 'scaffolding' works which were constructed by an engineer following his models. Paolozzi spent several weeks in Hamburg (probably around February in advance of the spring-summer Festival) preparing the works, and at this time he made a number of collages from damaged or second-hand books picked up in the city (cats.97–103). These generally feature illustrations of antique sculptures counterpoised with machine elements taken from specialist manuals, thus engineering a mysterious and suggestive collision of cultures. Paolozzi deliberately abraded the surfaces of many of these collages, in an effort to homogenize the different elements and give a hand-made, rather than purely reproductive, appearance.

98

EDUARDO PAOLOZZI b.1924

Myron, Athena, 1953

Collage on book illustration, 26 × 18.8
Inscribed along bottom edge: *E. Paolozzi Winter Hamburg 1953*. Printed text: *Myron, Athena. (Von einer [erased] Marsyas.) Frankfurt a. M. Städt. Skulpturensammlung.*
GMA 4028

99

EDUARDO PAOLOZZI b.1924

Thronende Göttin, 1953

Collage on book illustration, 26 × 18.7
Inscribed along bottom edge: *Winter Hamburg 1953 E. Paolozzi*. Printed text: *Thronende Göttin. Ende des VI. Jahrh. vor Chr. Berlin.*
GMA 4030

100

EDUARDO PAOLOZZI b.1924

Weibliche Figur, 1953

Collage on book illustration, 26.5 × 19
Inscribed along bottom edge: *Hamburg 1953 E. Paolozzi*. Printed text: *Weibliche Figur. Akropolis. Athen. Ende des VI. Jahrh. vor Chr. Athen.*
GMA 4031

101

EDUARDO PAOLOZZI b.1924

Athena Lemnia von Phidias, 1953

Collage on book illustration, 26.5 × 19
Inscribed along bottom edge: Hamburg 1953 E.
Paolozzi. Printed text: ATHENA LEMNIA VON
PHIDIAS. UM 450. Marmorkopie. Das Haar oberhalb der
Binde Gipsabguß von dem Kopfe in Bologna. Dresden.
GMA 4032

102

EDUARDO PAOLOZZI b.1924

Athena Lemnia von Phidias, 1953

Collage on book illustration, 26 × 18.7
Inscribed along bottom edge: Hamburg Winter 1953 E.
Paolozzi. Printed text: Athena Lemnia von Phidias. Um
450 vor Chr. Marmorkopie. Dresden.
GMA 4033

103

EDUARDO PAOLOZZI b.1924

Hermes von Praxiteles, 1953

Collage on book illustration, 26.4 × 18.7
Inscribed along bottom edge: Hamburg 1953 E.
Paolozzi. Printed text: Hermes von Praxiteles. IV. Jahrh.
vor Chr. Olympia.
GMA 4034

104

EDUARDO PAOLOZZI b.1924

Beaujon Hospital, Paris, 1953

Collage on book illustration, 24.7 × 19.7
Inscribed near bottom edge: E. PAOLOZZI 1953.
Printed text: Beaujon Hospital, Paris, Clichy, France ...
GMA 4029

105

EDUARDO PAOLOZZI b.1924

Castel del Monte, 1954

Collage on book illustration, 24.5 × 31.4
Inscribed along bottom edge: E. PAOLOZZI 1954.
Printed text: 200. Castel del Monte
GMA 4036

106

EDUARDO PAOLOZZI b.1924

Galerie des Vitrines, 1954

Collage on book illustration, 24.9 × 32.2
Inscribed along bottom edge: 1954 E. PAOLOZZI.
Printed text: INTÉRIEURS – VOLUME 5. Pl.28. Galerie
des vitrines, A. Porteneuve, architecte. Charles Moreau,
éditeur, 8 rue de Prague – Paris (XIIe)
GMA 4037

97

98

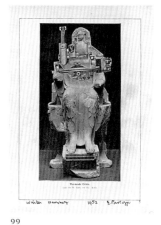

99

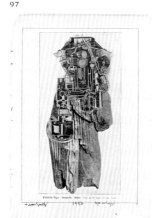

100

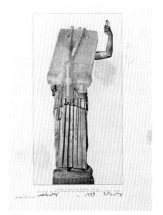

101

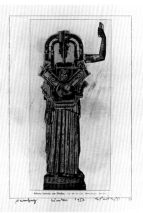

102

103

104

105

106

107

108

109

110

107

EDUARDO PAOLOZZI b.1924

Man Smoking, 1954

Gouache and ink on paper, 31 × 24.3
Inscribed bottom left: *Eduardo Paolozzi 1954*
GMA 4060

A number of Paolozzi's works of this period
feature a man smoking (see also cat.111).
Paolozzi smoked at the time and these works
may be seen as self-portraits. The drawing is
done on the back of an illustrated page from a
Romantic story, which has a small collage
element for 'Dr Scholl's Zino-pads' stuck to it.

108

EDUARDO PAOLOZZI b.1924

Head and Arm, c.1954

Bronze, 11.6 × 12.5 × 14.4
Not inscribed or stamped
GMA 4035

This was made in terracotta at the Central
School of Art and Design and then cast in
bronze at Wilkinson's Foundry in Tottenham
Mews. The features were incised into the clay
with a sharp instrument. An unusual effect has
been gained by twisting thread around the arm
of the terracotta, which appears in the cast
bronze as a kind of fine webbing (the same
technique is employed in cat.111). It is one of
only a handful of sculptures cast in bronze in
the 1949–55 period, when Paolozzi was
teaching at the Central School, and marks the
beginning of a new phase, when Paolozzi
began to make clearly recognizable male heads
and figures. A variant of the bronze was
illustrated in the catalogue of the exhibition
This is Tomorrow in 1956 (cat.174) with
Paolozzi's caption 'The head – for man himself
– his brain and his machine'.

109

EDUARDO PAOLOZZI b.1924

Head, 1955

Pen and ink on paper, 35.5 × 27.7
Inscribed along bottom edge: *E. Paolozzi August 9th
1955*
GMA 4038

110

EDUARDO PAOLOZZI b.1924

Siena, Church of Osservanza after Clearance of Rubble, 1955

Collage on book illustration, 24.9 × 32.2
Inscribed along bottom edge: *1955 E. Paolozzi.*
Printed text: *Siena, Church of Osservanza after Clearance of
Rubble.*
GMA 4039

111

EDUARDO PAOLOZZI b.1924

Man Smoking, 1956

Bronze, 46.5 × 16.5 × 14.5
Not inscribed or stamped
GMA 4065

111

In 1955 Paolozzi left the Central School of Art
and Design and took a teaching post in the
sculpture department at St Martin's School of
Art. At about the same date he moved into a
large house belonging to Dorothy Morland at
1 East Heath Road, Hampstead. Morland was
Director of the Institute of Contemporary Arts
during the 1950s. Paolozzi would spend the
weekdays in Hampstead and the weekends
with his wife and children at Thorpe-le-Soken,
a hamlet near Colchester in Essex. Most of his
sculptures were made in London but some
were made at Thorpe-le-Soken and brought
back to London for casting.

Dorothy Morland's son, Francis, had an
interest in sculpture, and he and Paolozzi
together constructed a bronze foundry in the
basement of the house, while the oven was in
the garden. This work was modelled in clay,
then reproduced in several pieces of wax via a
plaster cast. The wax was reassembled in an
intentionally crude fashion (the back of the
head does not fit onto the body) and then
heated in certain areas to melt the surface;
there are countless 'flashing' marks produced
by the casting process – marks which the
bronze founder normally files away. Paolozzi
bought the bronze ingots from a specialist
supplier. This very direct, hands-on approach,
which has certain parallels with Dubuffet's *Art
Brut* mentality, was exploited by Paolozzi in
subsequent bronzes in increasingly complex
ways. The sculpture was first exhibited in
Paolozzi's show at the Hanover Gallery,
London, in 1958.

112

EDUARDO PAOLOZZI b.1924

Shattered Head, 1956

Bronze, 30 × 24 × 19
Not inscribed or stamped
GMA 4056

112

Like *Man Smoking* (cat.111), this was made in Paolozzi's own, home-made bronze foundry in Hampstead. The sculpture was originally made in clay and then cast in wax. The wax was then deliberately smashed and the pieces put back together using a hot knife. This mismatched method of reassembly was deliberate, mimicking, for example, the way fragments of ancient sculptures and pots are dug up from the earth and then reassembled. This 'contemporary archaeology' – creating works which are symbols of the Machine Age and which embody all the fears that such an age offers – has been at the heart of Paolozzi's art. The original bronze was re-cast by *sur-moulage* in an edition of three unsigned casts by the Fiorini foundry in London. Six further casts were made by Susse Frères in Paris in 1958, at the request of the Hanover Gallery, where Paolozzi had an exhibition in November of that year. The present cast, which Mrs Keiller purchased from the Mayor Gallery in 1971, is un-numbered and is presumably one of the three Fiorini casts. Another Fiorini cast belongs to the Tate Gallery.

113

EDUARDO PAOLOZZI b.1924

Black Devil, 1956

Bronze, 47.4 × 21.5 × 7.8
Not inscribed or stamped
GMA 4058

This was shown in Paolozzi's exhibition in the British Pavilion at the thirtieth Venice Biennale in 1960. Victor Pasmore was the other British representative in the Pavilion. Paolozzi had been interested in comics and science fiction since his boyhood days in Scotland, and through his years as a student had been an avid cinema-goer. Such pulp fiction appears in his collages throughout the 1950s, and was a central part of his contribution to the famous exhibition of 1956, *This is Tomorrow* (see cat.174). There is an affinity between this work and, for example, 'Robby the Robot' from the 1956 film *Forbidden Planet*, a cut-out of which was shown in this exhibition. Although it originally had a dark patina (hence the title), Paolozzi gilded it in 1963.

114

EDUARDO PAOLOZZI b.1924

Icarus (Second version), 1957

Bronze, 144.5 × 60 × 35
Stamped on back of base: EDUARDO PAOLOZZI LONDON
GMA 3699

This sculpture was made at East Heath Road in Hampstead and, like most of the large-scale figures of the period, was cast by Paolozzi himself. The first version of *Icarus* was given to the Scottish National Gallery of Modern Art by the artist and Messrs. Lund Humphries in memory of the late E. C. Gregory, in 1962; and

the present sculpture was given by the artist to Mrs Keiller, again in 1962 (and was purchased from her by the Gallery in 1993). Both sculptures had featured in Paolozzi's exhibition at the Hanover Gallery in November 1958. A bronze of 1949, similar in form to *Table Sculpture (Growth)* (cat.92), is also titled *Icarus*.

Collage had been a central interest of Paolozzi's since the 1940s, and in some of his clay relief sculptures of the late 1940s and early 1950s he had pressed forms into the clay to leave imprints which suggest a lunar landscape. In 1956–57 he began to introduce the imprints of bits of machinery such as cogs, nuts and piano hammers. This was done in two principal ways. He would either press the objects into a wax sheet to leave an impression; or he would make a clay sheet, press the same types of objects into them to leave a negative imprint, and then pour hot wax over to leave a wax sheet with positive machine parts. The various wax sheets would then be bent, shaped and attached together using a hot knife, usually to form a head or figure. The wax sculpture would then be cast in bronze via the lost wax method, normally in three or four separate parts, depending on the size of the sculpture. Most were made as unique bronzes, though a few were subsequently cast by *sur-moulage* at the Susse Frères foundry in Paris, at the instigation of Paolozzi's then-dealer, Erica Brausen of the Hanover Gallery. In 1960 Paolozzi described the kind of elements that might be pressed into service: 'Dismembered lock, toy frog, rubber dragon, toy camera, assorted wheels and electrical parts. Clock parts, broken comb, bent fork, gramophone parts, model automobiles.' Such impressions, fossilised in crusty bronze and assembled into anthropomorphic form, gave the impression of a battered Machine-Age God, bruised and abused but still standing, perhaps a testament to the nuclear age.

115

EDUARDO PAOLOZZI b.1924

Krokadeel, c.1956–59

Bronze, 94 × 67 × 23
Stamped on back: EDUARDO PAOLOZZI LONDON
GMA 3400

This sculpture has almost invariably been dated to 1956. However, when it was first shown in the British Pavilion at the 1960 Venice Biennale and immediately afterwards at the Musée des Arts Décoratifs in Paris, it was dated 1959 in both catalogues. This later dating would accord better with the style of the work which is more complicated and sophisticated

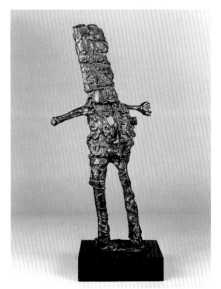

113

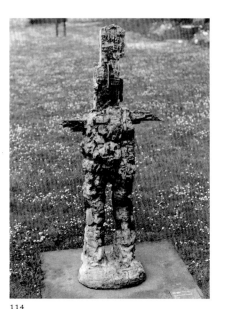

114

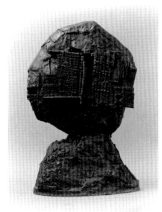

115

than other works of 1956; and the works it
most resembles are: *Head*, 1957 (Hanover
Gallery catalogue no.4), *Very Large Head* and
EXF8, 1958 and 1958 / 9 respectively (see
Middleton, 1963, op. cit. under cat.74). Had
Krokadeel been completed in 1956 it might well
have featured in the Hanover Gallery exhibition
of 1958, but it does not appear in the catalogue.

Other casts are in the Edinburgh College of
Art collection and the Wilhelm Lehmbruck
Museum in Duisburg. The Gallery's cast was
purchased from Mrs Keiller in 1987. It has
been exhibited as *Krokadeel* and *Krokodeel*, but in
the 1960 catalogues the former spelling was
employed. This title is perhaps a pun on
'crocodile'; the impression of a plastic
crocodile was incorporated into the sculpture
Frog Eating a Lizard of 1957.

116

EDUARDO PAOLOZZI b.1924

St Sebastian I, 1957

Bronze, 214.5 × 72 × 35.5
Stamped on back of base: EDUARDO PAOLOZZI
LONDON
GMA 3700

Colour plate 38

St Sebastian II, also of 1957, is in the Solomon R.
Guggenheim Museum, New York, having been
bought from the artist's Venice Biennale
exhibition of 1960. *St Sebastian III* is in the
Rijksmuseum Kröller-Müller, Otterlo. The
catalogue of Paolozzi's Hanover Gallery
exhibition of 1958 illustrates two other
versions, *St Sebastian First* and *St Sebastian Fourth*,
both of 1957 (Hanover Gallery nos.8 and 28).
There are also several drawings of the subject:
one is in the Guggenheim and another belongs
to the British Council. The Guggenheim
sculpture is pierced by a number of holes in the
torso area and in the forehead, a reference to
the arrows which struck the eponymous saint.
Our version has little rings in the upper torso
area, indicating the nipples of the tied-up,

nearly naked Saint Sebastian. Paolozzi named
many of his works of this period after mytho-
logical or early historical figures (they are
invariably male; not until recently has he made
female figures), and in doing so suggests their
heroic status and marks them out as survivors.
Apparently wobbly on their thin legs and of
precarious construction, they seem to have
been dug up by archaeologists of the future,
having survived some terrible holocaust.

117

EDUARDO PAOLOZZI b.1924

Jason II, 1957

Bronze, 107.3 × 25 × 13.2 (including base)
Inscribed on back of base: E. PAOLOZZI AUG 1957
GMA 4040

This work does not appear in any of the
Paolozzi literature, and in the absence of an
original title the artist named it *Jason II*. The
first *Jason*, of 1956, was purchased by the
Museum of Modern Art, New York in 1958.

118

EDUARDO PAOLOZZI b.1924

Pieve Santo Stefano, 1957

Collage on book illustration, 24.7 × 15.4
Inscribed bottom right: E. Paolozzi 1957.
Printed text: *Pieve Santo Stefano showing the della Robbia
relief untouched amid the rubble.*
GMA 4041

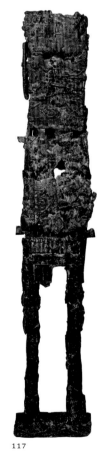

117

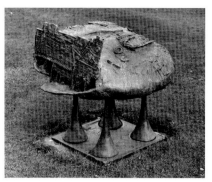

119

119

EDUARDO PAOLOZZI b.1924

Large Frog (New Version), 1958

Bronze, 72 × 82 × 79
Stamped on right side of base: EDUARDO PAOLOZZI
LONDON; and inscribed: 5 / 6
GMA 3701

Most of Paolozzi's bronzes of the 1950s are
unique casts, but this work was issued in an
edition of six. Other casts are in the British
Council collection and the Arts Council
collection, bought from the artist in 1959 and
1963 respectively. The present cast was
purchased from Mrs Keiller by the Gallery in
1993. The first version of the sculpture (which
is very similar to the present work) is illus-
trated in the catalogue of Paolozzi's Hanover
Gallery exhibition of 1958. Both sculptures
incorporate the impression of a substantial
number of piano hammers, as do *Krokadeel*
(cat.115) and *St Sebastian I* (cat.116).

118

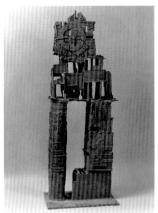

120

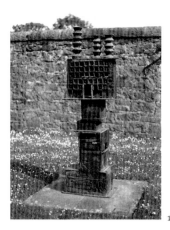

121

120

EDUARDO PAOLOZZI b.1924

His Majesty the Wheel, 1958–59

Bronze, 183 × 70 × 50
Stamped on front of base: EDUARDO PAOLOZZI
LONDON
GMA 3449

The title alludes to a story published in *Time* magazine about the powerful US trade-union leader, Jimmy Hoffa, who was involved with the Mafia and was referred to as a 'Big Wheel'. The sculpture was formerly in the collection of Sir Edward and Lady Hulton, from whom Gabrielle Keiller acquired it. It was purchased by the Gallery from Mrs Keiller's collection in 1989.

121

EDUARDO PAOLOZZI b.1924

Tyrannical Tower Crowned with Thorns of Violence, 1961

Bronze, 183 × 70 × 50
Not inscribed or stamped
GMA 3449

The sculpture was exhibited in Paolozzi's second exhibition in the United States, at Betty Parsons' Gallery in New York in April-May 1963 (the first show was at the same gallery in 1960; in the second this work was illustrated on the catalogue cover), and was shown at the Battersea Park Outdoor Sculpture Exhibition

later in the year. Gabrielle Keiller bought it from the latter show; she sold it to the Gallery in 1989.

Tyrannical Tower Crowned with Thorns of Violence occupies an important place in Paolozzi's oeuvre, standing as it does on the border between the crusty, lost-wax bronzes of the 1950s, and the constructed aluminium works of the 1960s, which are more architectural in appearance. Although made from wax sheets assembled together, just as the works of the late 1950s had been, the forms in the present sculpture are more symmetrical and the surface is much smoother. The waffle form in the head area was made by pressing the end of a square piece of wood into a clay bed, casting this in plaster and then re-casting it in the form of a wax sheet cast. The 'thorns' on top of the figure were cast from a funnel-shaped electrical appliance. The wax was made at Paolozzi's studio in Dovehouse Street, South Kensington, where he moved in 1960. The bronze was cast by the Fiorini foundry in London, and like almost all of Paolozzi's large bronzes of the period, is a unique cast. Two other versions of the sculpture, *Town Tower* and *Konsul*, both made in 1962, were constructed entirely from pre-cast bronze sheets welded together.

From 1960 to 1962 Paolozzi was Visiting Professor at the Staatliche Hochschule für

Bildende Künste in Hamburg, and the pre-fabricated machine elements he discovered in the shipyards there influenced him in this change of direction. In a statement made in Hamburg in December 1961, he writes: 'THE PAST: pressing objects into a clay bed, pouring wax ... THE PRESENT: wooden shapes cast in gun metal by engineers' foundries assembled like ships by bolt and weld ...' (Middleton, *Eduardo Paolozzi*, 1963, op. cit. under cat.74).

122

EDUARDO PAOLOZZI b.1924

Professor Dr Oskar Strnad – Wien. "Glasschrank für Feine Wäsche", 1961

Collage on book illustration, 29.5 × 21
Inscribed beneath text: HAMBURG E. PAOLOZZI 1961.
Printed text: PROFFESSOR DR OSKAR STRNAD – WIEN. "GLASSCHRANK FUR FEINE WÄSCHE". S. SEITE 88
GMA 4025

This collage was made in Hamburg, where Paolozzi was Visiting Professor from 1960–62 (see above, cat.121). While in Hamburg he completed a film, *The History of Nothing*, 1960, which is informed by the same kind of collage mentality and is composed of images of collages which succeed one another in a non-narrative sequence.

123

EDUARDO PAOLOZZI b.1924

Untitled, 1961

Collage on book illustration, 30.4 × 22.5
Inscribed bottom right: E. PAOLOZZI 1961
GMA 4043

124

EDUARDO PAOLOZZI b.1924

Untitled, 1961–62

Collage on book illustration, 31.9 × 23.3
Inscribed along bottom edge: HAMBURG E. PAOLOZZI 1961–62
GMA 4044

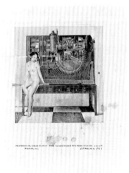

122

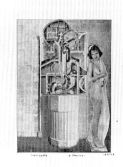

123

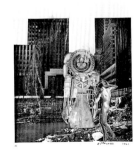

124

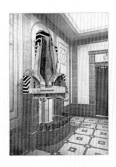

125

125

EDUARDO PAOLOZZI b.1924

Untitled, c.1961–62

Collage on book illustration, 31.9 × 23.3
Not inscribed
GMA 4048

The illustration is from the same book as
cat.124, a German book of architectural
interiors. The striped, yellow and black collage
element is from a page in the magazine *Art
International* and is collaged onto the back of
the sheet which has been cut to allow it to
show through.

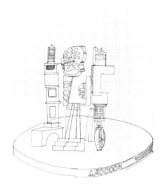

126

126

EDUARDO PAOLOZZI b.1924

Laocoon, c.1961–63

Pen and ink on paper, 32.5 × 23.9
Not inscribed
GMA 4050

This drawing relates to the welded aluminium
sculpture *Towards a New Laocoon* of 1963.
Although undated, it has strong similarities
with drawings dated 1961; in that year Paolozzi
made a work titled *Laocoon* out of a car-owner's
instructions manual, collaged together with a
line drawing of the Laocoon sculpture. The
type of constructed sculpture indicated in the
drawing dates from 1962–63.

127

EDUARDO PAOLOZZI b.1924

Dachgartenanlage des Warenhauses Karstadt, 1962

Collage and coloured pencil on book illustration,
31.9 × 23.3
Inscribed along bottom edge: HAMBURG E.
PAOLOZZI 1962. Printed text: *Dachgartenanlage des
Warenhauses Karstadt, 1929*
GMA 4045

128

EDUARDO PAOLOZZI b.1924

Canal Maritime / See-Kanal, c.1962

Collage on book illustration, 25.8 × 32.7
Not inscribed. Printed text: *Canal Maritime / See-Kanal*
(and Russian captions)
GMA 4049

The original illustration is taken from a
Russian-language book.

129

EDUARDO PAOLOZZI b.1924

The Bishop of Kuban, 1962

Aluminum, 210 × 93 × 60.7
Not inscribed or stamped
GMA 3566

Paolozzi's position as Visiting Professor in
Hamburg ended in 1962. During his time there
he had been impressed by the pre-fabricated
machine elements he had seen in the ship-
yards, and in a 1962 radio interview with Jacob
Bronowski, mentioned his desire to make
sculpture in collaboration with engineering
firms. Jim Thackeray wrote to him, offering his
services. Thackeray's business was in making
designs and models for machine elements
which could be cast in metal by industrial
workshops. Paolozzi would provide either
drawings or found objects or wooden
maquettes, and Thackeray would translate
them into three-dimensionsal templates ready
for casting in aluminium. Paolozzi had the
elements cast by the Ipswich firm of Juby's. He

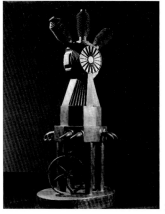

129

worked in the welding shop at Juby's for nearly
ten years, going there most weeks on Thurs-
days and Fridays, and working with a techni-
cian named Len Smith.

The three horn elements in this sculpture
are variants of a cylinder head, while the
segmented wheel element in the centre of the
head is a device used in mass-production
baking for the marking out of sections of a
cake. The large, key-hole shape was designed
by Paolozzi in wood. The wheel is a variant of
the wheel of a wheelbarrow. These same forms
appear in other of Paolozzi's aluminium
sculptures, and his approach, over the years,
was to accumulate a dictionary of interchange-
able forms which could be swapped about and
welded together. Building on the collage
method that has informed so much of his art,
Paolozzi would combine variants on industri-
ally made objects with entirely invented
objects, assembling them into roughly
anthropomorphic forms. He painted this
sculpture yellow in c.1964–65 (a number of his
aluminium sculptures were painted during this
period), but subsequently had the colour
removed. The title alludes to the Cuban missile
crisis.

The sculpture was presented to the Scottish
Sculpture Trust by Gabrielle Keiller, and was
purchased from the Trust by the Gallery in
1990.

127

128

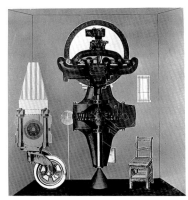

130

130

EDUARDO PAOLOZZI b.1924

Metallization of a Dream, 1963

Screenprint on paper, 50.7 × 48.6
(paper 59.5 × 54.4). Not inscribed
GMA 4046

This is the first occasion that Paolozzi made a
collage specifically for translation into an
editioned screenprint; as such it holds an
important place in Paolozzi's oeuvre and in the
history of screenprinting, which was still not
seen as a fine art medium in the early 1960s.
The original collage was made in 1962 in
Hamburg, using illustrations Paolozzi had
acquired some years earlier. The object on the
left is from the sales catalogue of a firm called
Slingsby, which sold equipment such as
trolleys and movable ladders (part of the firm's
name is printed above the wheel). The chair,
which hinges for tranformation into a set of
library steps, comes from a mail-order
catalogue published in 1939.

The collage was transferred photolitho-
graphically onto silkscreen by Chris Prater at
Kelpra Studios and was printed in four
different colours, using one screen for each
colour. Furthermore the edition of forty prints
(plus some artist's proofs) each had different
colour variations. Paolozzi and Prater had
previously worked together on a few prints but
this was by far the most sophisticated to date.

The title comes from a sentence in
Paolozzi's book *Metafisikal Translations* of 1962
(cat.349), in which he wrote of 'The search for
arch-types to aid the metallization of the
"Dream".' The following year Paolozzi
produced a second book, *The Metallization of a
Dream*, which included a commentary by
Lawrence Alloway (cat.350). A sketch relating
to the present print is reproduced on p.21 of
that book.

131

EDUARDO PAOLOZZI b.1924

Chord, 1964

Painted aluminium, 180 × 56 × 49
Not inscribed or stamped
GMA 3703

Paolozzi made *Chord* at Juby's workshops in
Ipswich (see cat.129). It was first shown in
Paolozzi's solo exhibition at the Robert Fraser
Gallery, London, in September-October 1964,
and in the accompanying catalogue was
reproduced in an unpainted state. When the
sculpture was shown in September 1966, again
at the Robert Fraser Gallery in the show *Recent
Sculpture*, it was painted white. Gabrielle Keiller
purchased the work from the 1964 exhibition

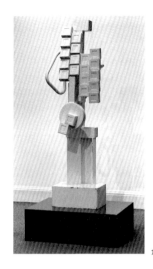

131

and it is likely that the artist painted it shortly
after she acquired it. All the aluminium
elements are invented, rather than found,
objects. *Chord* was purchased by the Gallery
from Mrs Keiller in 1993.

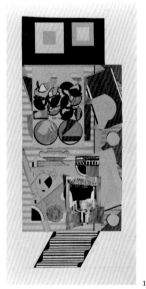

132

132

EDUARDO PAOLOZZI b.1924

Tafel 16, 1964

Collage on card, 64.5 × 27 (card 76.5 × 36.5)
Inscribed bottom right: *Eduardo Paolozzi 1964*
GMA 4047

This is the original collage from which the
screenprint *Tafel 16* was made. The screen-
print, which was produced in an edition of 80
(sold as 40 pairs in different colour variations)
was subtitled *Colour Combination in Paris*. It was
printed by Chris Prater at Kelpra Studios,
London. *Tafel 16* – meaning 'Plate 16' – is the
title of the enigmatic cut-out card object in the
upper centre of the collage; it may be part of a
child's model-making kit.

133

133

EDUARDO PAOLOZZI b.1924

Olio, c.1965

Chrome-plated steel, 29.2 × 93.3 × 65.5
Not inscribed or stamped
GMA 3953

In 1965 Paolozzi began making small, table-
top 'object-sculptures'. These were made by
cutting out pieces of sheet metal and welding
the cut sheets together. So *Olio*, for example, is
made from six separate parts: the flat base, the
undulating, ribbon-like edge, the top surface
and the top element which comprises three
sides. Most of the works were chromium
plated, allowing the sculpture to reflect the
colour of the room in which it was placed (an
aim which relates to the artist's painting of
many of his larger sculptures at this date). Like
the larger aluminium sculptures of the 1960s,
these smaller, chrome-plated works were
made by the artist at Juby's workshops in
Ipswich. Gabrielle Keiller placed the sculpture
on loan to the Hunterian Art Gallery, Glasgow,
in about 1972, and although it now forms part
of the Scottish National Gallery of Modern Art
collection, it remains on loan there.

134

EDUARDO PAOLOZZI b.1924

Kimo, 1967

Chrome-plated steel, 36.7 × 33.3 × 20.5
Not inscribed or stamped
GMA 4066

134

135

EDUARDO PAOLOZZI b.1924

Mickey Mouse, 1967

Tapestry, 160 × 170.5
Initialled in tapestry top left: FM / DG / MH
GMA 4067

This was a preliminary essay for a larger tapestry, measuring more than 2 × 4 metres, which was commissioned by the Whitworth Art Gallery, Manchester, in celebration of the opening of their reconstructed galleries in March 1968. While working on the Whitworth tapestry Paolozzi decided to produce a smaller tapestry in order to test the ways in which his design would translate into the different medium. The imagery is based on a section of the screenprint *A Formula That Can Shatter into a Million Glass Bullets* from the series *Universal Electronic Vacuum*, 1967. *Mickey Mouse* was the first large tapestry Paolozzi had made in Britain though he had made others in France. The tapestry was woven at Dovecot Studios, Edinburgh, by Fred Mann, Douglas Grierson and Maureen Hodge, under the direction of Archie Brennan. The warp is ten knots to the inch. Gabrielle Keiller presented another Paolozzi tapestry, similar in size to the present work, to the Tate Gallery in 1967.

136

EDUARDO PAOLOZZI b.1924

Domino, 1967–68

Aluminium, 9 elements in variable arrangement.
Maximum length of each: 310; 217; 163; 135; 127; 102; 94; 69; 69
Not inscribed or stamped
GMA 2826

The principle of interchangeability recurs in Paolozzi's work and is an extension of the collage principle which informs the artist's entire oeuvre. For example, screenprints have been editioned in different colour combinations (see cat.130); the *Bunk* 'lecture' of 1952 (see cat.96) projected images in a completely random order, encouraging the viewer to impose his or her own narrative structure on the given sequence; and the 100 screenprints which comprise the series *Moonstrip Empire News* of 1967, can be shuffled about and presented in any order. The same principle informs *Domino*, a sculpture of nine welded aluminium elements which can be presented in any number of ways; the pieces can, for example, be laid out in a line or stacked on top of each other or grouped close together. A precedent for the sculpture lies in Paolozzi's maquette for a children's playground of 1951, in which building blocks were scattered about for children to climb on and possibly manoeuvre. Indeed, *Domino* and other related works were based on objects in a children's toy kit.

The individual straight and curved units which make up *Domino* were fabricated in Juby's workshops (see cat.129) according to Paolozzi's designs, and constitute the building blocks of the artist's sculpture during this period. Using this repertoire of forms, Paolozzi would 'collage' the various parts together.

Gabrielle Keiller presented *Domino* to the Scottish National Gallery of Modern Art in 1984, to mark the Gallery's move from its former building in Edinburgh's Botanical Garden, to larger premises in Belford Road on the west side of the city.

137

EDUARDO PAOLOZZI b.1924

Plate (Variations on a Geometric Theme), 1968–69

Bone china, 27 diameter
Printed underneath: *Wedgwood / Bone China / MADE IN ENGLAND / Variations on a Geometric Theme / Eduardo Paolozzi*
GMA 4068

In 1968 Paolozzi was appointed to the ceramics department at the Royal College of Art, London. Shortly afterwards he was invited to make a set of plates by the firm of Wedgwood. The prototypes were made with the assistance of David Queensberry, Professor of Ceramics at the College. Paolozzi's geometric designs were made in the lithographic studios at the College and transferred onto the plates at the Wedgwood factory. There were six different plates, each a variant on the same geometric theme, issued as a boxed set.

138

EDUARDO PAOLOZZI b.1924

[Title unknown], c.1968

Polished bronze, 13.3 × 13.6 × 9.5
Not inscribed or stamped
GMA 4063

139

EDUARDO PAOLOZZI b.1924

Maquette for 'Osaka Steel', 1969

Polished bronze, 10.6 × 15.1 × 10.5
Not inscribed or stamped
GMA 4062

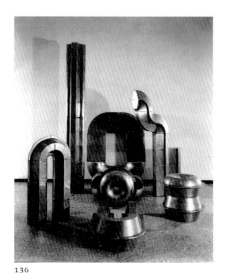

136

138

139

In 1969 a number of European and American sculptors were asked to produce large sculptures in collaboration with the Japanese steel industry, for display at the *Expo 70* exhibition in Osaka. This is a small-scale version of the work Paolozzi made; the full-size version is large enough for a child to walk through the central tunnel. This study or maquette was made by the technique known as 'sledging' in which a shaped template is dragged along the side of the clay original to produce a consistent profile. The clay was then cast in plaster for subsequent editioning in bronze. The full-size sculpture is now at the Hakone Open-Air Museum in Japan.

140

EDUARDO PAOLOZZI b.1924

Crash Head, 1970

Bronze, 36 × 26.5 × 21 (measured to top of ring)
Inscribed on back of base: EP 1970 2/4
GMA 4055

The sculpture was inspired by a magazine photograph of a dummy crash head, used for safety testing in the motor car industry. When not in use the heads were hung from the ceiling by a chain. Paolozzi used a similar image in the screenprint series *Conditional Probability Machine*, also of 1970. *Crash Head* was, however, cast from an educational toy called 'The Visible Head' which Paolozzi found at Hamley's toyshop in London's Regent Street. The transparent, plastic head was designed to show the interior workings of the head; replica models of the brain and other organs could be purchased separately for insertion into the head. A second version of Paolozzi's head is called *Sam II*.

141

EDUARDO PAOLOZZI b.1924

Mr Peanut, 1970

Screenprint on paper, 69.8 × 48.5
(paper 80.5 × 55.5)
Not inscribed
GMA 4051

The print was commissioned by the Württembergischer Kunstverein in Stuttgart.

The geometric background is based on an image Paolozzi found in a German children's magazine of the 1920s called *Kosmos*. The illustration was intended to give a visual equivalent of a piece of organ music. The figure of Mr Peanut, from an advert for Planter's Peanuts, appeared in one of Paolozzi's collages of 1949, and in another of 1950 called *What a Treat for a Nickel*. The present print was published in an edition of 150 plus 25 artist's proofs; the background of each copy was printed in a different colour. Paolozzi subsequently developed the image of the organ music in his sculptures (see cat.144).

142

EDUARDO PAOLOZZI b.1924

Pop Art Redefined, 1970

Screenprint with collage on paper, 35.4 × 19 (paper 55.7 × 39.9)
Inscribed lower edge: For Gabrielle A / P 1970 Eduardo Paolozzi
GMA 4054

This is an original working collage for a print published in 1971 in an edition of 100 by Bernard Jacobson Ltd, London, and printed by Advanced Graphics, London. The image of the monkeys is taken from a children's colouring book sold at Woolworth's, while the abstract image is a reproduction of a painting by Frank Stella. In the present work the two elements have been screenprinted to the desired size and collaged together prior to production of the final screenprint. The title is taken from the Hayward Gallery's exhibition *Pop Art Redefined*, 1969.

143

EDUARDO PAOLOZZI b.1924

Cloud Atomic Laboratory: Science and Fantasy in the Technological World, 1971

Portfolio of eight photogravures (sixteen images printed in pairs on eight sheets), title-page and text introduction, each sheet 36 × 53 or 53 × 36
Each sheet inscribed bottom right: *Eduardo Paolozzi / 1971 AP8*
GMA 2230

The portfolio presents eight pairs of images, ranging from 'a chimpanzee in a test box designed for space', to robots, a child's bedroom and a gigantic advertising hoarding of a pin-up. In the text introduction which accompanies the prints, Paolozzi writes that the images are: 'accurate translations of paintings based on photographs spanning a period of time from 1952 to the present. The collecting of material from magazines, books and newspapers has been a continual search for meaning starting from early school days. [...] Within the grand system of paradoxes, the theme of this portfolio is the Human Predicament. Content enlarged by precision. History shaded into the grey scale as in the television tube.' Four of the images were originally shown in Paolozzi's *Bunk* 'lecture' at the ICA in 1952 (see cat.96).

The portfolio was commissioned by British Olivetti and printed at Alecto Studios, London, in an edition of 75 plus 10 artist's proofs. It was presented to the Gallery by Gabrielle Keiller in 1980.

144

EDUARDO PAOLOZZI b.1924

Kreuzberg, 1974

Bronze, 299 × 111.5 × 16
Inscribed bottom left: E. PAOLOZZI / BERLIN 1974; and stamped: H. NOACK BERLIN
GMA 3704

The complex geometric forms, which appear to be analogues for computer-generated matrixes of some sort, are instead inspired by an old magazine illustration purporting to portray the visual equivalent of a piece of organ music (see cat.141). Paolozzi introduced this

141

142

143 / Plate C, right

imagery into his sculpture in a series of nine ceiling reliefs made for Cleish Castle in Scotland in 1972–73 (these panels in resin with metallic finish had been commissioned by the castle's owner, the architect Michael Spens).

The present relief was made in West Berlin in 1974, during a scholarship year offered by the DAAD (German Academic Exchange Service). Paolozzi was given the entire second floor of a disused garment factory off the Kottbusserdamm in the Kreuzberg area of Berlin, and he worked there from May 1974 to May 1975. This bronze relief (one of three such large reliefs, all cast by the Noack foundry in Berlin) was made from sections of plywood cut out and 'collaged', and then cast in plaster. Each of the bronze casts is unique. The Gallery purchased the present work from Mrs Keiller in 1993.

144

145

145

EDUARDO PAOLOZZI b.1924

Kreuzberg, 1974

Bronze, 59.5 × 108.5 × 11
Stamped top left (upside-down): NOACK-BERLIN
GMA 3705

The larger *Kreuzberg* bronze (cat.144) is composed of five smaller units welded together. This single unit was made as an independent work.

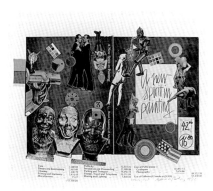

146

146

EDUARDO PAOLOZZI b.1924

A New Spirit in Painting, 1983

Screenprint on paper, 49 × 64
Inscribed bottom right: *artist's proof Eduardo Paolozzi 1983*
GMA 4053

The print is a Hogarthian comment on the exhibition *A New Spirit in Painting*, held at the Royal Academy of Arts in London in 1981. The various accounts report the costs of mounting the exhibition. These figures are counterpointed with the 'knock-down', bargain price of the exhibition catalogue, which Paolozzi found in a remainder bookshop in Germany just two years later. Paolozzi had been elected a Royal Academician in 1979.

147

EDUARDO PAOLOZZI b.1924
& R. B. KITAJ b.1932

Work in Progress, 1962

Paper and tin collage in painted wooden frame, 85.3 × 100
Not inscribed
GMA 4069

Colour plate 39

The large central panel and the small photographic panel in the top right are by R. B. Kitaj, using material supplied by Paolozzi (the text in the central panel is an old, hand-written transcription of a story 'The Road to Broody' by Isaac Babel). The smaller, surrounding panels, which are all in tin and imitate the predella panels on early Italian altarpieces, are by Paolozzi. Three of these smaller parts feature Italian olive oil cans, in reference to the artist's ancestry, while the others are components of toys. The frame was made by a carpenter to Paolozzi's instructions. This is not a unique instance of Paolozzi collaborating with another artist; in the mid-1960s he collaborated with Jim Dine on a number of works. Gabrielle Keiller purchased *Work in Progress* from Marlborough Fine Art in 1963.

148

ROLAND PENROSE 1900–84

Untitled, 1937

Collage, gouache and pencil on card, 80.5 × 54.5
Inscribed bottom right: *R. Penrose.37*
GMA 4070

Colour plate 40

Roland Penrose was the leader of the English branch of the Surrealist movement and the person most responsible for ensuring that it never lost contact with activities in Paris. He first went to Paris to study painting in 1922; by 1930, when he had a walk-on part in *L'Age d'or*, the second scandalous film made by Buñuel and Dalí, he had formed close friendships with many of the leading Surrealist poets and painters and had begun to work in a Surrealist vein himself. Always eager to facilitate new creative enterprises, he organised the publication of Ernst's latest collage novel, *Une Semaine de bonté* (cat.272), in 1934. The following year, when he was on the point of returning to London, he met David Gascoyne and together they determined 'to make clear to Londoners that there was a revelation awaiting' (Penrose, *Scrapbook, 1900–1981*, London 1981, p.60; and see cat.280). This took the form of *The International Surrealist Exhibition* which opened with a fanfare of publicity in June 1936 and attracted so many visitors that it made a profit. In 1937 Penrose and E. L. T. Mesens took over the London Gallery and set about turning it into a centre for Surrealist art. The following year he helped launch *London Bulletin* (cat.424). For the rest of his life he remained a committed Surrealist at heart, forming one of the greatest collections of Surrealist art anywhere in the world, writing numerous essays for retrospective exhibitions of Surrealist artists, and still finding time to make Surrealist works himself. Penrose's vision and profound, insider understanding of the movement undoubtedly exerted a major influence on Gabrielle Keiller, who became a close friend.

This untitled collage representing a dancing female figure and reflecting the direct influence of Miró, is one of the first Penrose made using a new procedure which involved quantities of picture postcards collected on his travels – in this case to the south of France. He used the method sporadically for the rest of his life (see cats.150–151). As he wrote in his autobiography: 'Attracted by the vivid colour of the picture postcards on sale everywhere, I began to experiment with them in collages. Sometimes I found that repetitive clusters could take the effect of a spread of feathers or a single image cut out and set at a peculiar angle could

transform completely its original meaning' (*Scrapbook*, op. cit., p.108). Two years later in 1939 Magritte and Paul Nougé published their appreciation of the radical implications of these works in 'Colour-colours, or an experiment by Roland Penrose' (*London Bulletin*, no.17): 'Roland Penrose has thought of formulating the problem [of colour] in entirely new terms: up till now, he says, colour has been used for no other purpose than the creation of the image of objects. *But what if we tried to use the image of the objects to create colours? …* The event has far-reaching implications. It means that there is a functional dependence of the colour and the form: sometimes it is the colour and sometimes it is the form that carries it.' And they went on to praise the way that the image of a given, often banal object 'gives place to an unknown and totally unforeseeable substance.'

149 / Front

149 / Back

149

ROLAND PENROSE 1900–84

Attention le Vide!!, 1938

Collage on paper, 15 × 20
Extensive inscriptions
GMA 4071

Penrose made this humorous collage-mask as a gift for Marcel Mariën, who confirmed the year was 1938. The text reads (in literal translation): 'Dear friend, I know you only by the unique vision of your poems but the faithful snails of intuition are never wrong, one DAY we will see the same SUN. Wearing this MASK [loup] is very agreeable but I don't

recommend it. You might begin to resemble me like my father who is dead. Wolves [loups] fear the fire of dances.' The two images of a bespectacled man collaged within the lenses on the back of the mask have been cut from the image entitled 'VIVE LA FRANCE (au phonoscope)' which appears as an ironic illustration to 'La prière du soldat', an anti-militaristic text published in the final issue of *La Révolution Surréaliste*, December 1929 (p.21). The black mask itself may allude to the famous, fictional 'master of disguises', Fantômas, who was the subject of a veritable cult within Surrealist circles, especially in Belgium.

Mariën himself was a prolific maker of collages and objects, as well as being a poet and critic. He joined the Surrealist group in Brussels in 1937 when he was seventeen years old, and rapidly became one of its most energetic and intransigent members, contributing to the Surrealist section of the exhibition *Young Belgian Painters* at the London Gallery in 1937, writing regularly for Surrealist reviews thereafter, and generally agitating for an interventionist, pro-revolutionary stance within the movement as a whole. He later became the unofficial historian and archivist of Belgian Surrealism, publishing and republishing all its most important documents.

150

ROLAND PENROSE 1900–84

La Fornarina Visits London, 1982

Collage with crayon, pencil and gouache, 80 × 54.5
Inscribed bottom right: *Penrose '82*; and on backboard: *La Fornarina visits London / '82`
GMA 4072

In 1980 Penrose was the subject of a major retrospective exhibition organised by the Arts Council and the following year he published his illustrated autobiography, *Scrapbook 1900–1981*. These two events appear to have coincided happily to prompt a new burst of creativity, and during the remaining years of his life – he died in April 1984 – he made several extended series of collages using tourist postcards bought in quantity on his travels. This work, which is dominated by postcards of Raphael's famous painting of *La Fornarina* in the Borghese Gallery in Rome, was included in an exhibition of his recent collages at the Galerie Henriette Gomès, Paris, in November-December 1982 (no.18), and illustrated as the colour frontispiece in the catalogue. Gabrielle Keiller bought it at that time.

151

151

ROLAND PENROSE 1900–84

Untitled, 1983

Collage and gouache on paper, 46.2 × 60.9
Inscribed lower centre right: *for Gabrielle Roland Penrose.*
GMA 4073

In 1983 Penrose went on a trip to Kenya with Diane Deriaz, his companion during the last years of his life. This collage is one of a series he made at the time using tourist postcards of wild animals in the game reserves. It appears in the album of photographs recording the holiday (Scottish National Gallery of Modern Art, Penrose Archive). On his return, Penrose gave the collage to Gabrielle Keiller, an old and close friend.

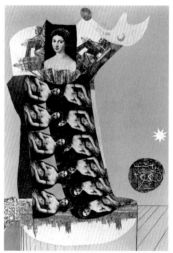

150

152

FRANCIS PICABIA 1879–1953

Fille née sans mère (Girl Born without a Mother), c.1916–17

Gouache and metallic paint on printed paper, 50 × 65
Inscribed bottom left: FILLE NÉE SANS MÈRE; and bottom right: BARCELONE *Picabia*; and along top, apparently painted over but now faintly visible: CETTE MACHINE A LE POUVOIR
GMA 3545

Colour plate 41

Gabrielle Keiller purchased this much reproduced and exhibited picture from John and Paul Herring and Co., New York in 1977. The Scottish National Gallery of Modern Art purchased it from her in 1990. Its first owner was Josep Dalmau, a friend of Picabia's and the proprietor of the principal avant-garde gallery in Barcelona during and after the First World War. Picabia, who had been a leading activist in Dada circles in New York since 1915 and who contributed regularly to 291 while living there (cat.440), returned to Barcelona in July 1916. He remained there for almost a year, publishing the first four issues of 391 (cat.438), his own Dada magazine, from that city and producing a great quantity of drawings and paintings. Given the inscription on the front, *Fille née sans mère* was certainly executed during this period and was probably left with Dalmau when Picabia returned to New York in the late spring of 1917. It has sometimes been published as *Voilà la fille née sans mère* (Here is the Girl Born without a Mother) – which is the title of another exactly contemporary painting of a pseudo-machine (collection Musée National d'Art Moderne, Centre Georges Pompidou, Paris) – but Picabia evidently tried to paint out the words 'Voilà la' on the present work to leave the shortened title.

Fille née sans mère is adapted from a large printed fold-out describing – in French, Spanish and English – the mechanism of a two-cylinder stationary steam engine. Picabia's intervention involves, in the first place, the application of emerald green, black and white gouache to the diagram of the machine and metallic gold paint to the background to obliterate all the text etc., and in the second the addition of the title, his signature and the place of execution. This method of appropriating a technical illustration and systematically perverting its original meaning is absolutely typical of his Dadaist work during the war, and parallels the adoption of ordinary manufactured objects as readymades by his close friend Marcel Duchamp and the German Dadaists' appropriation of printed and photographic material. (See, for instance, Ernst's 1921 collage, cat.32.)

In a letter dated 22 April 1997, D. W. Hopkin, Head of Library and Archive Collections of the National Railway Museum, York, and Richard Gibbon, Head of Engineering Collections, have provided a detailed commentary on the engineering drawing Picabia has appropriated here, and we are grateful to them for allowing us to quote from their letter. 'The basis of the work is a published general arrangement engineering drawing of a two-cylinder stationary steam engine. It is probably from the French equivalent of a professional magazine such as 'The Engineer' which featured many such drawings as fold-out plates in the late nineteenth and early twentieth century. Alternatively it could have been published as a separate print for purchase. It is not a locomotive but most probably a stationary winding engine – the sort of thing that was used by a number of railways to pull trains up steep gradients. Alternatively it could be an engine for powering other machinery in a workshop. Both could easily have been used by the French Lyon Railway. A possible reconstruction of the text at the top of the piece is "MACHINE A VAPEUR DESSIN DE M. M. A ... S A PARIS DA(NS) LE(S) (ATELIE)RS DU CHEMIN DE FER DE LYON", ie., "a steam engine to drawing of Mr M ... at Paris in the workshops of the Lyon Railway." This would support the second suggestion as to the subject of the drawing. The drawing appears to have originally shown a sectioned view of the left-hand side and depicted the right-hand side cylinder in full. The artist has erased the valve gear of the left-hand side cylinder, and almost completely obliterated the cylinder, mounting and frame of the right-hand side while leaving the valve gear intact. (They can be just seen vestigially despite the over-painting.) The artist has added on the right-hand side a strange sort of surrogate motion arrangement which could not have worked in engineering terms. This is a reproduction from the centre of the wheel. The whole assembly stands on a brick or ashlar block bed which the artist has obliterated to suspend the half machine in mid-air. [...] The results of his changes are that he destroyed the symmetry of the machine represented in the printed drawing. It would only work with two cylinders so removing one destroys the balance of the machine, removes half of the motive force, and takes away its ability to function. The addition on the right-hand side is perhaps an attempt to provide an alternative mechanism for the machine to drive from which would never have worked in engineering terms.'

Picabia's machine drawings were first published in 291 in 1915–16. While some were 'portraits' of fellow Dadaists, others developed to a new level of explicitness the metaphors of man / woman-as-machine and the sex act as a mechanised coupling which had been suggested more discreetly in his slightly earlier paintings. Among them was a drawing also called *Fille née sans mère* (291, no.4, June 1915), which is, however, more organic in style than the Keiller picture. Picabia used this enigmatic phrase yet again for a book of poems and drawings published in Lausanne in 1918, *Poèmes et dessins de la fille née sans mère* (cat.366), and in this context the 'Girl Born without a Mother' seems explicitly to be an alter-ego. The phrase itself, like certain other titles Picabia gave to his Dadaist machine works, is an ironic derivation from the pages of 'Locutions latines et étrangères' (Latin and foreign phrases) published on pink paper in the centre of the *Petit Larousse illustré* (Paris 1910, etc.), the most popular French dictionary. The phrase in question is 'Problem sine matre creatam', which is translated in the dictionary as 'Enfant né sans mère' (child born without a mother) and defined as ' ... an epigraph from Ovid's *Metamorphoses* which Montesquieu placed at the beginning of his *Esprit des lois* to signify that he had had no model for it' (op. cit., p.1089). Inevitably the phrase also suggests a miraculous virgin birth, so that Picabia's steam engine may be interpreted as a female divinity on a par with Christ (who had no human father), and the picture itself, with its shiny gold background, as a spoof Byzantine icon. Blasphemy, often, as here, coupled with sexual innuendo, was a constant element in Picabia's repertoire of insults; in 1920, in the twelfth issue of 391 (cat.438), he represented the *Sainte Vierge* (Holy Virgin) as an ink-blot / splash of blood.

153

FRANCIS PICABIA 1879–1953

Sotileza (Subtlety), c.1928

Gouache on paper, 75.7 × 55.7
Inscribed bottom left: *Francis Picabia*
GMA 4074

Colour plate 42

This was purchased from the Robert Fraser Gallery in July 1966. The handwritten text of a song inscribed bottom right reads: 'Tora Tora, niño y canta / y viva esa gracia y sal / Dale dale á la guitarra / que asi mis penas seván', which M. L. Borràs translates as: 'Play, play, child and sing and live this grace and charm. Keep on playing your guitar and banish my sorrows' (*Picabia*, London 1985, no.493).

Sotileza is a relatively early work in Picabia's so-called Transparency mode. Later works of this type sometimes involve more layers of ghostly superimposed images and it can be quite difficult for the eye to disentangle them. The complex spatial effect of the layering and interpenetration was perhaps intended to provide the visual equivalent to memory and the stream of consciousness, and the Transparencies may in general terms be compared to

the contemporary automatist works of the Surrealists (e. g. to Ernst's *grattage* paintings (see cat.34) and Masson's sand paintings). Picabia was not always on good terms with Breton but operated broadly within the orbit of Surrealism throughout the mid-late 1920s.

In *Sotileza* there are three interpenetrating but distinct layers, each one different in style. At the lowest stratum is the doe-eyed Spanish lady in a mantilla executed in the kitsch, idealised style familiar from popular tourist art. (Picabia had painted the odd picture in this style since 1902, but produced a series of them in the early to mid-1920s in reaction against the machine style of his Dada work.) Next comes a simplified outline drawing of a toreador in full costume who is associated with the bullfight poster rendered in a sketchy manner to the right; a similar toreador dominates two other contemporary works (Borràs, op. cit. nos.669 and 691). The top layer is a simplified representation of a Catalan Romanesque crowned Madonna which also appears elsewhere, for instance in *La Vierge de Montserrat*, another Transparency dating from 1928. The obvious connecting link between all three is their Spanishness. In 1925 Picabia, having inherited a small fortune from an uncle, settled into a brand new house on the Côte d'Azur, and in 1927 went to Barcelona for a summer holiday with his son and Olga Mohler. She described their many visits to the local museums and churches and Picabia's enthusiastic rediscovery of ancient Catalan art. The reference to the Romanesque Madonna should be understood in this context. The juxtaposition / blending of supposedly antithetical styles and sacred and profane themes is characteristic of his entrenched iconoclasm which was undimmed after the collapse of Dada.

154
ENRICO PRAMPOLINI 1894–1956
Donna (Woman), 1922
Lithograph on paper, 45.9 × 29.5
Inscribed in lithograph bottom centre: E. PRAMPOLINI / ROMA 1922; and bottom right: 3 / Enrico Prampolini
GMA 4076

154

Prampolini is best known as a Futurist – he produced his first Futurist-style works in 1912–13 – but he was by nature a restless enthusiast and, without renouncing Futurism, actively participated in a wide range of avant-garde groups from about 1917 onwards. Thus he met Tristan Tzara in Rome in 1916, exhibited with the Zurich Dadaists, and in 1917 founded his own Dada-style review called *Noi*. Two years later he joined the Berlin Novembergruppe, which brought together radical artists practising a variety of modern styles who were united in their concern with the role of art in society. In the early 1920s he was in contact with the Bauhaus. And in 1931, when he was living in Paris, he became a founder-member of Abstraction-Création. This lithograph, which Mrs Keiller bought from Colnaghi's in June 1973, reflects some of these contacts. There are obvious similarities in its abstracted representation of a nude woman with the contemporary work of Léger – Prampolini shared Léger's utopian faith in machines and technology – and with the figure style of Schlemmer. Indeed the print bears the blindstamp of the Weimar Bauhaus.

155
GEORGE ROMNEY 1734–1802
Satan and Death
Pencil on paper, 14 × 23.4
Not inscribed

This drawing was identified by a previous owner, Christopher Powney, as illustrating the figures of Satan and Death in Book II of Milton's *Paradise Lost*. 'So spake the grisly Terror, and in shape / So speaking, and so threatening, grew tenfold / More dreadful and deform. On the other side, / Incensed with indignation, Satan stood / Unterrified and like a comet burned.'

Numerous drawings by Romney of subjects

after Milton survive, most of them from the last years of the artist's life. They vary from substantial compositional studies in ink to spirited pencil sketches such as the present one. Romney appears to have been particularly encouraged to look to *Paradise Lost* for suitable material after the publication, in 1794, by Boydell and Nichol of an illustrated edition of the *Poetical Works of John Milton*. There is a pencil sketch of a male figure wearing a crown on the reverse.

156
HENRI ROUSSEAU 1844–1910
La Statue de Diane au parc, c.1909
Oil on canvas laid on board, 23.5 × 11.2
Inscribed bottom right: *H. Rousseau*
GMA 4078
Colour plate 43

A surviving invoice establishes that Gabrielle Keiller purchased this from Arthur Tooth and Sons, London, in November 1959. Whereas she later disposed of most of the pre-1914 pictures she bought around this time, she always kept the tiny Rousseau, possibly because he was revered so deeply by the Surrealists both for his 'naïvety' and the imaginative and oneiric character of his imagery. (André Breton, for example, hung the still-life by Rousseau he owned in a place of honour in his apartment at 42 rue Fontaine.)

The principal subject of Mrs Keiller's painting has been identified as a statue of the goddess Diana in the Tuileries Gardens (Jean Bouret, *Henri Rousseau*, Neuchâtel 1961, pl.61). If this is correct, the statue in question is probably the marble depicting a virtually naked Diana with a hound seated at her feet, which was executed by Louis Lévêque in 1866 and has been on show in the gardens since 1872. In any case it is likely that, as in many of his other paintings of parks and suburban landscapes, Rousseau used a picture postcard or a popular print as the source for his composition. Jean Bouret (op. cit.) believes the painting is a very early work by Rousseau and dates it to 1887. However, in iconography and style it appears to be close to much later works, in particular a view of the Monument to Chopin in the Luxembourg Gardens, Paris, which is dated 1909 (Pushkin Museum, Moscow).

155

157

OSKAR SCHLEMMER 1888–1943

Kopf nach links, mit schwarzer Kontur (Head in Profile, with Black Contour Line), 1928

Lithograph on paper, 40.8 × 31
Inscribed below image, right: *Oskar Schlemmer*
GMA 4080

This was purchased from Colnaghi's, London, in June 1973. Although it is dated 1920–21 in the standard catalogue raisonné of Schlemmer's prints (W. Grohmann and T. Schlemmer, *Oskar Schlemmer. Zeichnungen und Graphik. Oeuvrekatalog*, Stuttgart 1965, GL6), Karin von Maur has established that the portfolio in which it first appeared (*Die Schaffenden*, edited by Paul Westheim, Weimar, Euphorion-Verlag) was published in 1931 and that the date of the lithograph is 1928. The portfolio was issued in an edition of 130, of which 30 were de-luxe copies. There is a virtually identical drawing which should, according to von Maur, be dated 1922–23 on stylistic grounds; it is especially close to some of the artist's costume designs for the stage. (See her catalogue in Staatsgalerie, Stuttgart, *Oskar Schlemmer*, exhibition catalogue, 1977, no.509, and no.307 for the drawing.)

Throughout the 1920s Schlemmer was one of the most influential teachers at the Bauhaus. After successive stints as Master in the mural and sculpture workshops, he was appointed Director of the stage workshop in 1923, the year after the famous performance of his *Triadic Ballet* in Stuttgart. He remained a leading force in the Bauhaus after its move from Weimar to Dessau in 1925, but left in 1929 to take up his Professorship at the Breslau Academy of Fine and Applied Arts. In 1928 when this lithograph was made he received his most important mural commission, to decorate the Fountain Hall of the Folkwang Museum in Essen. The murals were finally installed in 1930.

158

KURT SCHWITTERS 1887–1948

Mz.299, 1921

Collage on paper, 20 × 16 (including mount)
Inscribed on the mount, bottom left: *Mz 299 / für V. J. Kuron*; and bottom right: *Kurt Schwitters 1921*
GMA 4081

Colour plate 44

Schwitters's first collages date from 1918, the year in which he met Arp and Hausmann and other members of the German Dada movement. In 1919 some were exhibited in Der Sturm gallery in Berlin. He remained closely allied with the various Dada groups in Germany but his own one-man movement, which he called *Merz* and ran from his home in Hanover, was distinct from Dada in that he insisted his work be understood as art, not as the negation of art. ('Merz means freedom from all fetters for the sake of artistic creation. Freedom must not be seen as a complete lack of restraint but as the result of strict artistic discipline', he wrote in a manifesto in 1920.) This attitude put his relationship with more 'orthodox' Dada iconoclasts under strain at times but enabled Schwitters to collaborate with other avant-garde artists committed, like him, to abstraction and influenced, like him, by the Cubist work of Picasso, Braque and Gris. (He collaborated, for example, with Van Doesburg and the Constructivists in the early 1920s.) In 1923 the first issue of his magazine, also called *Merz*, was published and he made progress on the creation of the first *Merzbau* (Merz-building) in Hanover – an extension of his construction methods onto an environmental scale and an expression of his commitment to the ideal of the *Gesamtkunstwerk* (Total artwork).

'Mz.' is the shortened form of 'Merz' which Schwitters began to use as the standard title for his works in 1919, differentiating them simply by the ensuing number. Mz.299 is a typical example of his early Merz pictures in its juxtaposition of variously coloured papers with printed papers employing different typefaces, its exploitation of different textures, and its use of a favourite structural device: thus the fragments are arranged in loose diagonal sequences so that they appear simultaneously to converge towards the bottom centre of the composition and to splay out fan-wise towards the top left and right corners, producing the effect of a controlled implosion-explosion.

Although Gabrielle Keiller did not acquire it until some years later, Mz.299 was exhibited in 1960 in the 30th Venice Biennale – an event

which was, in effect, an epiphany for her as a collector in that it was there that she first encountered the work of Paolozzi and began to take a keen interest in the Dada-Surrealist tradition.

159

GAVIN SCOBIE b.1940

Step, 1974

Aluminium, 204.5 × 110.5 × 32
Stamped on base: GAVIN SCOBIE / 74
GMA 2950

Scobie was born in Edinburgh and studied painting at Edinburgh College of Art. He began making sculpture in 1966. In 1973 he won the Century Aluminium Award (administered by the Scottish Arts Council) which provided him with a studio for a six-month period at the company's aluminium smelting plant at Sanquhar, near Dumfries. He produced a few small works at the factory but eventually had a large supply of pre-fabricated aluminium tubes and other elements transported to his new home at Tarvie in Ross-shire. *Step*, made in spring 1974, was one of Scobie's first large-scale welded aluminium sculptures, made simultaneously with a related work, *Turn* (artist's collection), but preceded by a much larger work, *Iris* (Scottish Arts Council collection). While his previous work was indebted to Judd and LeWitt, being hermetic and abstract, these three works marked a move towards a more personal, almost figurative mode. *Step* was partly inspired by Rodin's *Walking Man* in the sense of a figure having a strong forward movement, yet being lightly balanced on two scissor-like legs; *Step* carries a related sense of movement and precarious balance.

Step was shown in Scobie's solo exhibition of 1974 (which toured to Glasgow, Aberdeen and Edinburgh), and again in an exhibition of

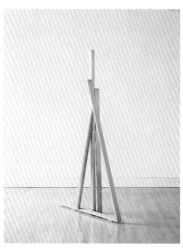

159

work by three Scottish sculptors, Scobie, Andrew Mylius and Gerald Laing at Cleish Castle, Kinross, in August 1975. The castle belonged to the architect Michael Spens, who had recently commissioned a group of ceiling panels by Paolozzi (see cat.144). Gabrielle Keiller visited the exhibition and purchased *Step*, later siting it in her garden at Telegraph Cottage. She presented it to the gallery in 1985 to mark the gallery's move into new, larger premises at Belford Road in Edinburgh.

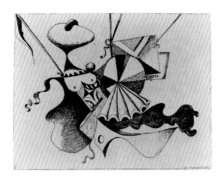

160

KURT SELIGMANN 1901–62

La Parachûtiste (The Parachutist), 1934

Etching on paper, 24.7 × 31.8 (paper 37.2 × 48.7)
Inscribed within the plate, bottom right: LA PARACHUTISTE; along left side, reading downwards: *Kurt Seligmann*; and right: *"La Parachûtiste"*.
GMA 4082

Born in Basel, Seligmann moved to Paris in 1927 and for the next three years studied in the studio of André Lhote. Initially attracted to abstraction, he gravitated towards the Surrealists in the early 1930s and scored a *succès de scandale* in the International Surrealist Exhibition in Paris in 1938 with his fetishistic *Ultrameuble* – a stool mounted on three lifelike women's stockinged, high-heeled legs. He moved to New York in 1939 and participated in Surrealist activities there during the war.

This etching, which is typical of Seligmann's graphic work in the 1930s, was purchased by Gabrielle Keiller from Colnaghi's in June 1973, at the same time as the Schlemmer lithograph (cat.157). It is no.38 in R. M. Mason, *Kurt Seligmann. Oeuvre gravée* (Geneva, Cabinet des Estampes, 1982). The second of a suite of fifteen etchings, it was made for the book *Les Vagabondages héraldiques*, published in 1934 (Editions des chroniques du jour, Paris), with texts by Pierre Courthion. This was a luxury, limited edition of only 105 copies (plus an un-numbered edition of individual prints available separately, as here), but in 1936 the book was republished in a

photomechanically reduced format as *Métiers des hommes* (cat.229).

Les Vagabondages héraldiques is a sustained Surrealist essay in the traditional genre of the book describing trades and crafts – a genre which had enjoyed great popularity in Europe especially in the seventeenth and eighteenth centuries. While many of these publications provided accurate and naturalistic illustrations of the various types dressed and equipped for their work, others were more fantastic and represented them as elaborate and precarious constructions assembled entirely from the tools of their trade and their products. The Surrealists had always been fascinated by the latter images; examples were reproduced in *La Révolution Surréaliste* and included in the section devoted to precursors in Alfred Barr's exhibition *Fantastic Art, Dada, Surrealism*, held at The Museum of Modern Art, New York, 1936–37. Seligmann and Courthion adapted the traditional formula with great wit and imagination, providing portraits of fifteen types, including 'The Buccaneer', 'The Hermit', 'The Bird Charmer' and 'The Witch', as well as 'The Lady Parachutist'. And however bizarre they may look, Seligmann's illustrations invariably provide the appropriate settings and details. Thus *La Parachûtiste* is flying in mid-air, the cords of her parachute clearly delineated.

Text and image are well matched in their fairy-tale whimsicality. Courthion describes how, even as a schoolgirl, his fictional character, Simone Heutebise, was fascinated by the idea of flight and stared enviously at the birds overhead: 'And her body, little by little, became as light as a feather, her flesh took on an ethereal appearance. The pretty clouds which unfold over the hills, between sunshine and rain, draped her breasts with their floating sashes.' One windy day her daydream became reality and she was swept up into the sky: 'As she passed she caressed the weathercocks on the bell towers, caught the flags on the rooftops of palaces, and – so perfect was her balance – the birds came to lay their eggs on her head.'

161

TAKIS b.1925

Signals, c.1956–59

Painted steel construction, 223.5 tall
Not inscribed
GMA 4083

Takis was born in Athens. He made his first sculptures – plaster busts – shortly after the war. From 1954–59 he lived in France, and it was on an early trip to Paris, when he was

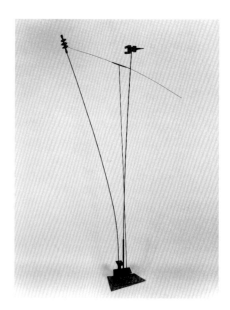

forced to wait several hours at a railway station, that he first became entranced by signals: 'It was a vast railway station […] I looked around me: it was a forest of signals. These monstrous eyes flashed on and off, and all around were rails, tunnels, a jungle of iron. Multicoloured signs, railings, passages. I took out a pencil and began to draw it all on the ground'. He began to work in welded steel and forged iron in Paris in 1955, the year he met Jean Tinguely and first saw works by Alexander Calder (the leading exponents of assembled metal sculpture). In the 1960s he introduced coloured electrical lights into his signal sculputres, and also made sculptures incorporating magnets, music and electrical appliances. During the 1970s he made steel signal sculptures very similar to those of the 1950s, but they are more refined in manufacture. Takis's first solo exhibition was at the Hanover Gallery in London, and he lived in London briefly from 1964–65; however it is not known when Gabrielle Keiller acquired this work.

162

YVES TANGUY 1900–55

Le Ruban des excès (The Ribbon of Excess), 1932

Oil on wood, 35 × 45.2
Inscribed bottom right: YVES TANGUY 32.; and on reverse: Yves TANGUY 1932 / "Le ruban des exces"

Colour plate 45

This was purchased through the Mayor Gallery in October 1984. It is one of Tanguy's best-known paintings, having been published for the first time in the final issue of *Le Surréalisme au Service de la Révolution*, 15 May 1933 (p.64), and shown for the first time in the *Exposition*

Surréaliste, Paris, Galerie Pierre Colle, in June 1933 (no.65). It has frequently been exhibited and reproduced since then. The first owner of the painting was Paul Eluard. He sold it to Marie-Laure, Vicomtesse de Noailles, one of the foremost patrons of the Surrealists, and from her it passed to Roland Penrose who kept it in his collection until his death.

Tanguy's family came from Finistère and the prehistoric menhirs and extraordinary geology of Brittany exercised a lasting influence on his imagination, as did his early experiences in the French merchant marines. His decision to become a painter is part of Surrealist mythology: in 1923 he was standing on the platform of a bus when he happened to catch sight of two paintings by de Chirico in the window of Paul Guillaume's gallery in Paris. His admiration for de Chirico's early work never wavered after this epiphany and he soon began making tentative, very naïve-looking drawings and eventually paintings. Excited by the first issue of *La Révolution Surréaliste* (December 1924), he met Breton the following year and immediately began to participate actively in the Surrealist movement. Breton was especially delighted by his work because of its 'purity' – it was uncontaminated either by any formal training or by any earlier flirtation with another style – and he wrote the preface to Tanguy's first one-man show at the Galerie Surréaliste in May 1927.

Le Ruban des excès has been described by historians of Tanguy's oeuvre as initiating a new phase in his development which lasted until the outbreak of the war when he moved definitively to the United States. Thus José Pierre points to the way the small, individualised biomorphs occupy the frontal plane from left to right just as if they were actors taking their final bow on stage, how they appear to proliferate as if by a process of continuous and spontaneous generation, and how the middle and back planes of the picture are relatively free of incident and the definition of distance vague (Musée National d'Art Moderne, Centre Georges Pompidou, Paris, *Yves Tanguy. Rétrospective*, 1982, p.54). Tanguy had been fascinated by the rock formations he saw on a trip to Africa in 1930 and these may have contributed to the changes in his style. But his increased contact with practising sculptors was probably just as significant, and may help to explain the emphatic three-dimensionality of each individual biomorph and the overall effect of a sculpted frieze that they create *en masse* in the Keiller picture. For on his return to Paris from Africa, Tanguy moved into a studio close to Giacometti's and made friends with

Jacques Hérold, then acting as assistant to Brancusi. Furthermore, it was in 1930 that his old friend Arp began to make sculpture in the round.

163
YVES TANGUY 1900–55
Plus Jamais (Never Again), 1939

Oil on canvas, 92 × 73
Inscribed bottom right: YVES TANGUY 39; and along top edge of canvas turnover: YVES TANGUY Avril 1939 "PLUS JAMAIS"
GMA 4085

Colour plate 46

Gabrielle Keiller purchased this picture in April 1966 from the Robert Fraser Gallery. It is an excellent example of Tanguy's highly refined and meticulous style of the 1930s, in which abstract biomorphic forms, as three-dimensional in effect as tiny sculptures, are presented in a deep but vague illusionistic space which evokes simultaneously a beach or desert and the sea-bed. It was painted shortly before Tanguy set sail for New York at the beginning of November 1939 and probably travelled with him, since it was sold through his New York dealer, Pierre Matisse, to an American collector.

Tanguy remained wholly committed to Surrealism for the rest of his life, participating fully in the activities of the Surrealist group which, still masterminded by Breton, reformed in New York after the Occupation. However, his hitherto close relationship with Breton turned sour in the late 1940s and they had no contact in the last years of Tanguy's life.

164
WILLIAM TURNBULL b.1922
Metamorphosis I, 1980

Bronze, 33.5 × 33 × 5.8
Inscribed at bottom of back: 80 T [monogram in circle] 1 / 9
GMA 4086

Of the same generation as Freud and Paolozzi, Turnbull emerged as one of Britain's leading artists of the post-war period, known not only for his sculpture, but also for his painting. His sculptures contained strong echoes of ancient, primitive idols, while the paintings stood comparison with works by the American Abstract Expressionists.

Following his retrospective exhibition at the Tate Gallery in 1973, Turnbull stopped making sculpture. Then in 1976 he began to model small clay figures, trying, as he had in his work of the early 1950s, to empty his mind of stylistic considerations and avoid making

164

conscious decisions. The small scale of the works was partly a reaction to the enormous size of much contemporary British sculpture, and even to his own steel sculptures of the early 1970s. Using a type of clay that remained hard and permanent once dry, he took small lumps, modelled it quickly with his fingers, and then stored the works. This was virtually the first time he had used clay; previously he had preferred to model in plaster. From 1977–78 he began sorting through the clay studies, casting some directly in bronze and developing others into slightly larger forms. The works of this period have a very primitive aspect, resembling arrow-heads and axe-heads or ancient Venus figures which seem to have been pulled out of the ground in a battered limbless state. Often they are a strange combination of tool shape and torso shape, in a way that fragments of Cycladic art so often are (see cats.169–171). The scale and hand modelling gives the works a very tactile feel, inviting the viewer to touch and hold the sculpture.

This series of bronze sculptures (including the present work) was first shown at the Waddington Galleries, London, in March 1981. Gabrielle Keiller purchased the work from the Gallery the following year.

165
LAURENCE VAIL 1891–1968
Seascape, 1943

Collage of printed paper on glass wine-bottle with painted plastic stopper, 35.3 × 8.1
Not inscribed
GMA 4092

This was purchased from the Mayor Gallery, London, in July 1987. It was formerly in the collection of Clover Vail, the artist's daughter by his second wife, Kay Boyle. Over the years the paper cut-outs stuck to the bottle have darkened considerably.

Laurence Vail was Peggy Guggenheim's first husband. They met in Paris where he was,

according to her, 'the King of Bohemia' and someone who knew everyone worth knowing (*Confessions of an Art Addict*, London 1960, p.39). They married in 1922 but although the marriage lasted only seven years they remained lifelong friends, and in July 1941 left Europe by the same flight to settle in New York. Peggy Guggenheim was by this time living with Max Ernst and soon after her arrival in New York set about creating a collection and gallery of modern art. It opened in October 1942 as 'Art of this Century' and had a strong bias in favour of Surrealism or art influenced by Surrealism. Vail began making his collage-covered bottles in 1941, later progressing to complex mixed-media objects. His most important exhibition in *Art of this Century* was held in February-March 1945 and displayed over fifty of his bottles. The advertisement on the back cover of the catalogue described them as: 'Bottles illustrated with collages, that will serve as containers for liquid as well as for decorative purposes', and invited orders. In his whimsical introduction Vail conceded: 'I still occasionally, and quite frequently, and very perpetually, empty a bottle', but went on: 'Why cast away the empty bottle? The spirits in the bottle are not necessarily the spirit of the bottle. […] Why not exteriorise these spirits on the body of the bottle … Hence these bottles. The glee in fizz, the melancholy in rouge, the sin in absinthe, the fun in rum, the pain in champagne, should not be relegated to remorse, billiousness, sewer. The soul of sap should flourish on the bark. I will not throw away the skirt of my lost girl. I prefer to embroider.'

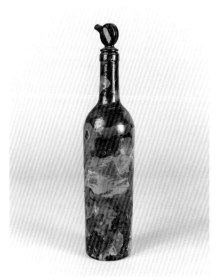

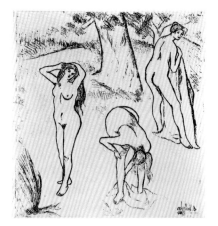

166
SUZANNE VALADON 1865–1938

Femmes nues sous les arbres (Nude Women under the Trees), 1904

Soft-ground etching on paper, 23.9 × 22.4 (paper 34.8 × 31.3)
Inscribed in plate, bottom right, in reverse: *S. Valadon 1904*; below image, bottom left: 5 / 20; bottom right: *Suzanne Valadon*; and bottom right of sheet: *version noire*
GMA 4093

This was executed in soft-ground etching on zinc. It is catalogued in Paul Pétridès, *L'Oeuvre complet de Suzanne Valadon*, Paris 1971 (E9), and is one of several highly simplified, rather primitive-looking prints Valadon made around 1905. Mrs Keiller purchased it from the Colnaghi gallery, London, in June 1973, at the same time as the Kandinsky drypoint (cat.54) and the Matisse lithograph (cat.67).

Suzanne Valadon had been an artist's model for several years – posing for, among others, Renoir, Puvis de Chavannes and Toulouse-Lautrec – before she took up drawing seriously herself in about 1883. Using members of her family as models, including her son Maurice Utrillo (born 1883), she made numerous boldly executed figure drawings which she began to exhibit in 1894. Degas bought one of her drawings of children at this time and they became close friends. The following year he taught her soft-ground etching on the press in his studio. Degas's influence, together with that of Renoir, can clearly be detected in the figure style of this etching which is typical of her work before she began to concentrate on oil painting in about 1910.

Valadon's favourite subject throughout her life was the female nude and she often reused motifs drawn from life in her imaginative compositions. Here she has combined three poses that recur in a significant number of

works executed in various media over many years. Thus the standing bather seen from the back is a reprise of a life drawing dated 1896 (Pétridès, D65); the whole composition, with slight modifications to the landscape, was repeated in an important pastel of c.1913–14 (Pétridès, D185); and the three figures in combination with several others recur in an Arcadian bather painting dated c.1928 (Pétridès P362). This synthetic mode of composition was one used constantly by Degas himself in the latter part of his career and also by Gauguin, whose work Valadon admired.

167
ISABELLE WALDBERG 1917–90

[Title unknown], c.1958–62

Bronze, 51.3 × 49.7 × 34
Inscribed on front right top of base: 1 / 3 ISABELLE WALDBERG
GMA 4094

Isabelle Waldberg's initial training as a sculptor took place in her native Switzerland, but in 1936 she moved to Paris where she met Giacometti and Arp and began to move in avant-garde circles. Two years later she met her future husband, the writer Patrick Waldberg, and through him became involved both in Breton's Surrealist movement and in the Acéphale group centred on the dissident Surrealist Georges Bataille, who became a close friend. In 1942 she joined the Surrealists 'in exile' in New York, sharing with them their deep interest in Eskimo and American Indian art. Encouraged by Breton and Duchamp, she exhibited her latest abstract constructions made with flexible wood batons at Peggy Guggenheim's Art of this Century gallery, later translating many of them into the less fragile medium of iron wire. These 'drawings in air' reflected the profound impact Giacometti's *Palace at 4am* had made upon her when she saw

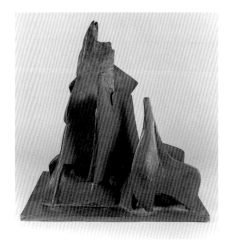

it in his studio in 1936, her interest in the wire constructions of Picasso and Calder, and above all perhaps her knowledge of various forms of Eskimo and Oceanic art. On her return to Paris after the war she continued to associate with the Surrealists and was represented in *Le Surréalisme en 1947* at the Galerie Maeght. In the early 1950s she returned to modelling in plaster, her preferred material in the early part of her career, and her sculpture immediately became more volumetric and substantial, and although still essentially abstract in form now tended to suggest a distant source in the real world. From this time on her reputation as a sculptor grew steadily, and she exhibited widely and frequently in the 1960s and 1970s.

The circumstances in which Gabrielle Keiller acquired this sculpture are unclear. The work is undated, but on stylistic grounds almost certainly belongs to the period 1958–62.

168

ANDY WARHOL 1928–87

Portrait of Maurice, 1976

Oil and silkscreen on canvas, 65.8 × 81.4
Inscribed on canvas turnover: *Andy Warhol 76*
GMA 4095

Colour plate 47

A surviving invoice from Andy Warhol Enterprises Inc., New York indicates that in July 1977 this picture was paid for by exchange with Mrs Keiller's set of Warhol's ten silkscreen prints of Marilyn Monroe (1967). Warhol had always actively solicited commissions, and if clients did not want a portrait of themselves he would propose a portrait of their favourite pet as an alternative. With a view to attracting new clients, in the summer of 1976 he had two exhibitions devoted to his animal pictures, *Andy Warhol Animals* at the Arno Schefler Gallery in New York, followed by *Cats and Dogs* at the Mayor Gallery in London. Mrs Keiller saw the show at the Mayor Gallery and immediately commissioned a picture of her beloved pet dachshund, Maurice. Warhol went to visit her at Telegraph Cottage, Kingston-upon-Thames, and himself took photographs of Maurice which he used when making this picture back in New York. He shared her fondness for the breed and owned two pet dachshunds himself; he was, it has been said, one of the few strangers to get on well with the subject of this portrait.

169

ANONYMOUS

Marble 'Folded Arm' Female Figure

Cycladic (Spedos type), *c*.2600–2300 BC
Marble, 33 × 10.6 × 4.2

The piece belongs to the classic (or 'canonical') stage of naturalistic Early Cycladic sculpture. Earlier figures were differently conceived (some had only stumps for arms) and / or were more awkwardly proportioned. Later works had much more sharply angled contours. In this piece, the parts of the legs below the thighs are missing; the head is slightly pitted.

Here, as is usually the case with Early Cycladic sculpture, the profile is shallow and the nose and lightly modelled breasts are the only plastic features. The head has a characteristic lyre shape. Important divisions and features of the figure are marked by grooves or incisions. On this example the incisions of the pubic triangle have been worn away, perhaps by handling. Although no traces of paint survive on this piece, other details (hair etc.) were often painted.

The majority of such figures were manufactured on the Cycladic islands of Naxos and Paros which had the best marble sources. The Cyclades had other natural resources which would have been useful in marble working: emery (Naxos), pumice (Thera) and obsidian (Melos). Experimental work (reported by E. Oustinoff in *Cycladica*, pp.38–47; see below) suggests that the marble block was detached and roughly shaped by pounding with a harder stone, such as emery. The basic structure of the figure was laid out using a rule, simple compasses, and some kind of protractor since the same angles are consistently repeated. The surface was shaved with obsidian and finer details were cut with obsidian, or possibly bronze tools. Smoothing and polishing were done with abrasives (powdered emery or pumice). Other details might then be painted. Some groups are thought to represent the work of individual sculptors (P. Getz-Preziosi, *Sculptors of the Cyclades: Individual and Tradition in the Third Millennium B. C.*, University of Michigan Press, Ann Arbor, 1987; see p.16 and index for the Spedos type. Plate 34, no.27, a work of the Goulandris Master, has many features in common with our figure).

Both the identities and the functions of the figures have been the subject of much inconclusive speculation. Although the female folded-arm figure is the commonest type,

some pieces are male and others portray musicians and a hunter-warrior type. Any conclusion about function (see articles in J. L. Fitton (ed.), *Cycladica*, British Museum Publications, London 1984) must take into account the fact that, while most provenanced finds have come from tombs, fragments are also found in settlements. Only about 10% of tombs contain such objects, although it is possible that similar figures were also made of perishable materials (e. g. wood) and have not survived. Female figures, some of which are visibly pregnant, may be connected with individual hopes for fertility; others with important occasions in the lives of those to whom they belonged. Some religious significance seems unavoidable and it is conceivable that the pieces were originally dedicated in household shrines or public sanctuaries and transferred to the graves of the dedicators at the time of death.

Gabrielle Keiller purchased this figure and the two more fragmentary works (cats.170 and 171) from B. C. Holland Inc., Chicago, in 1981.

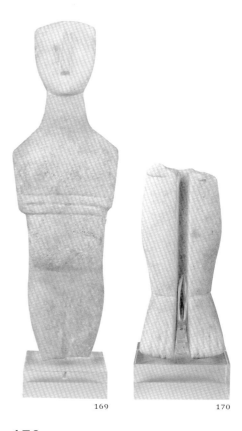

169 170

170

ANONYMOUS

Legs (only) of Marble 'Folded-Arm' Female Figure

Cycladic (probably Spedos type), *c*.2600–2300 BC
Marble, 16.6 × 7.7 × 5.2

The upper body is broken off at the point where incisions mark the knees. The legs are separated incompletely by a deep channel at both front and rear. The ankles and toes are defined by incisions. The form and position of the feet are typical and show the fact that these figures were not made to stand upright. The reason for this is unclear but may be because their ultimate destination was to lie in the grave.

171

ANONYMOUS

Torso (only) of Marble 'Folded-Arm' Female Figure

Cycladic (Spedos type), c.2600–2300 BC
Marble, 12.3 × 11.4 × 4.2

The head has been broken off, and the body below the folded arms is missing. In contrast to cat.169, the breasts are more distinctively marked and the back more fully modelled. The spine is indicated by a thin incision.

172

ANONYMOUS

Terracotta Rhyton, the Lower Part in the Form of a Bovine Head

Greek, c.4th century BC (?)
Terracotta, 30.2 × 25 × 25.5

The right ear and tip of one horn have been broken and reattached. There is some patchy blackening on the surface.

A rhyton is a ritual vessel for pouring liquid offerings or drinking. The work is Greek, perhaps made in Southern Italy in about the 4th century BC. Most, though by no means all, rhyta are decorated, usually in the Greek red-figure technique. A proportion are plain. The closest parallels (all decorated) for this example are illustrated in: H. Hoffmann, *Tarentine Rhyta*, von Zabern, Mainz, 1966,

no.526, plate LX, 3,4, South Italian imitating Attic, mid 5th century BC; and H. Hoffmann, *Attic Red-Figured Rhyta*, von Zabern, Mainz, 1962, no.112, plate XXII, 1, late 5th century BC.

In ancient Greek, the adjective 'rhytos' means 'flowing' or 'liquid'. The noun 'rhyton' particularly signifies a drinking vessel or horn, of metal or terracotta, pierced to allow liquid to flow from it in symbolic connection with the blood flowing from a sacrificed animal.

Many classical rhyta are in the form of animal heads, although most terracotta examples are unpierced. These vessels were simply for drinking, but the symbolism of the shape was such that they would have been used exclusively at formal ritual banquets. Rhyta are particularly associated with banqueting in honour of heroes and the God Dionysos (H. Hoffmann, 'Rhyta and Kantharoi in Greek Ritual' in *Greek Vases in the J. Paul Getty Museum*, vol.4 (Occasional Papers in Antiquities 5), Malibu, 1989, pp.131–166).

Hoffmann's analysis makes a number of suggestions. First, that recalling shared participation in sacrifice, by the use of rhyta, was appropriate to formal communal meals, which themselves reinforce bonds between members of the same group. Secondly, that the frequent appearance of rhyta in scenes of hero banquets can be explained by a combination of factors: a) in Greek religion, blood offerings were particularly appropriate to heroes (mortals who were accorded semi-divine status and had the ability to aid the humans and communities with which they were connected; b) heroes were thought of as eternally banqueting; c) the history of pierced vessels in animal forms in Greece goes back to the prehistoric period to which many heroes belonged. And thirdly, that the particular connection of Dionysos with rhyta may lie in their symbolic use in relation to true Dionysiac ritual which involved the ecstatic dismemberment and consumption of animals and their blood.

172

173

ANONYMOUS

Stone Head from Statue of a Cow Goddess

Probably Egyptian, c. XVIII Dynasty, 1567–1320 BC (?)
Stone, 26.6 × 30.9 × 29

This is presumably from a large-scale statue. The neck has been reconstituted below the break so that the head will stand upright. Fine striations suggest modern cleaning. The surface is waxed. It is not known when or where Gabrielle Keiller acquired this work or the terracotta rhyton (cat.172), listed above. The authenticity of these two works is unconfirmed.

The cow was a powerful symbol in ancient Egyptian religion and cow goddesses are relatively common in ancient Egyptian art (cf. C. Bleeker, *Hathor and Thoth: Two Key Figures of the Ancient Egyptian Religion*, Brill, Leiden, 1973, pl. IIIa) but the details of the representation in this case are hard to parallel in combination. W. C. Hayes (*The Scepter of Egypt*, Harvard University Press, Cambridge Mass., 1959, vol. II, p.239) illustrates a figure (14th century BC) of the most important, Hathor, which has a similar, lightly incised veil, but also the more usual sun disc and powerful horns. Also see J. Vandier, *La statuaire Égyptienne III*, Paris, 1958, plate XCIII, 5 (Middle Kingdom) for a similar form and style of headdress; and plate CXXIV 1, 3 (Anubis), 2 (Hathor) in Hayes, op. cit. p.239; all late XVIII Dynasty, 14th century BC.

Books, Manuscripts & Periodicals Colour Plates

48 *Georges Hugnet, Untitled (Page 1 from a Suite of 42 Collages), (cat. 53)*

49 *Marcel Duchamp, La Mariée mise à nu par ses célibataires, même* [Boîte verte / Green Box], *published 1934 (cat.249)*

50 Max Ernst, Une Semaine de bonté ou Les Sept Eléments capitaux, published 1934 (cat.272)

51 *Georges Hugnet and Hans Bellmer, Œillades ciselées en branche, published 1939 (cat.300)*

Que dit-il ce con si adorablement bercé par le
foutre

ce con vierge ce beau bordel

53 *André Beaudin,* Untitled frontispiece *(etching), in Georges Hugnet,* Oiseaux ne copiez personne,
published 1946 (cat. 306)

2/28 max ernst

54 Max Ernst, Untitled frontispiece *(etching)*, in Tristan Tzara, Le Cœur à gaz, published 1946 *(cat.392)*

ICI LA VOIX

à Hélène
à Georges
à leur hospitalité princière
et simple
à la rue Guénégaud
où voisinent caviar et colle forte
vodka et vernis
le travail et la joie
à l'amitié vraie

GEORGES
HUGNET
Juin 1954

55 *Georges Hugnet, Untitled collage, in Georges Hugnet and Pablo Picasso, Ici la voix, published 1954 (cat.307a)*

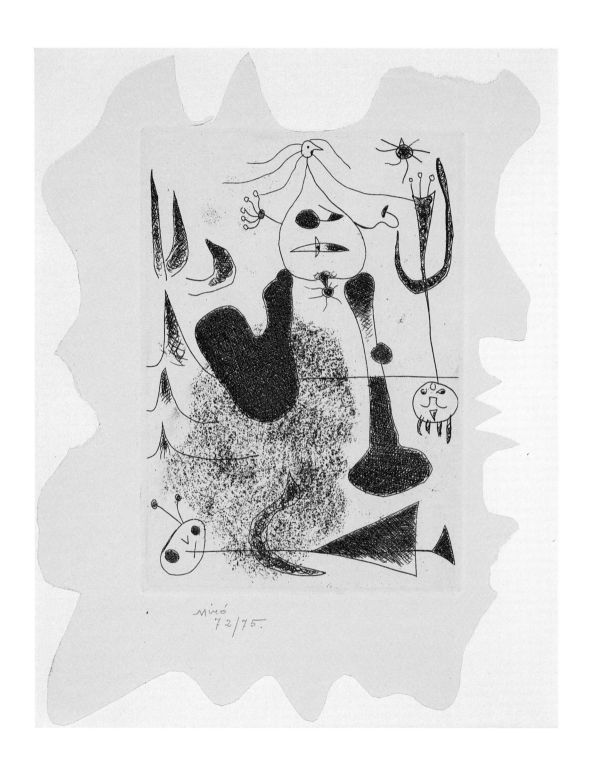

56 Joan Miró, Untitled frontispiece (etching), in Alice Paalen, Sablier couché, published 1938 (cat.347)

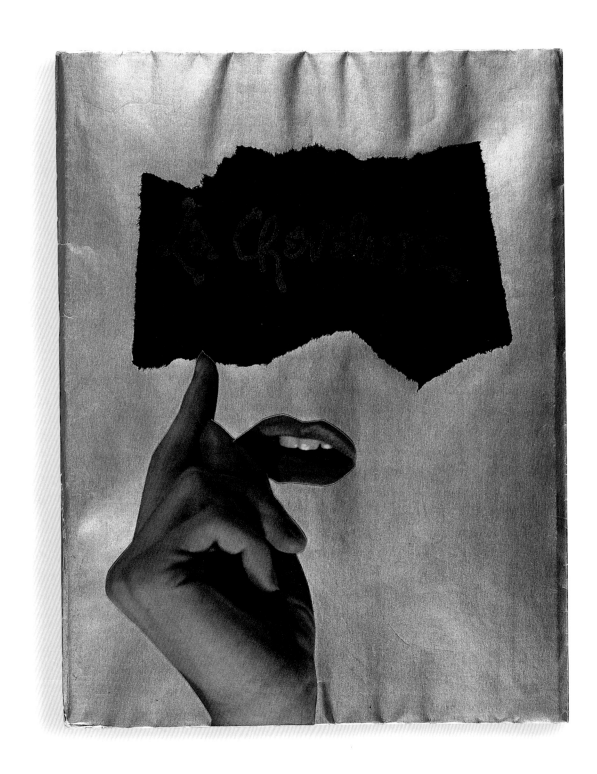

57 *Georges Hugnet, cover for* La Chevelure, *published 1937 (cat.298)*

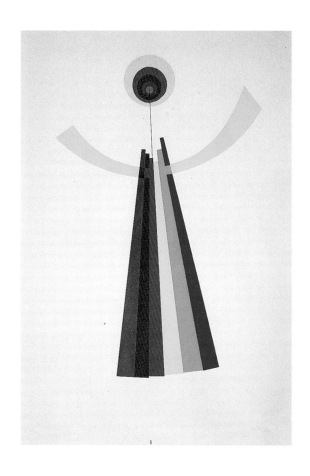

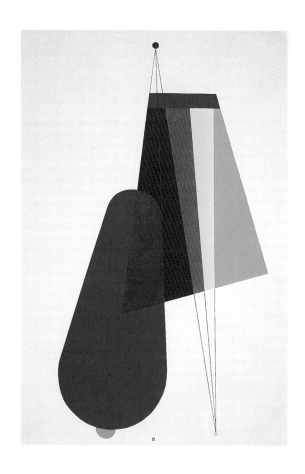

58 Man Ray, Revolving Doors, plates I, II, III and IV (*from the portfolio of ten pochoir prints*), published 1926 (*cat. 330*)

59 Tita, Untitled drawing, in *Marc Patin*, L'Amour n'est pas pour nous, suivi de Femme Magique, published 1942 (cat.353)

60 *Pablo Picasso, La Mort de Marat (The Death of Marat) (coloured drypoint), in Benjamin Péret, De Derrière les Fagots, published 1934 (cat. 361)*

61 *Pablo Picasso, Untitled (colour lithograph), in Georges Hugnet, Non vouloir, published 1942 (cat.302)*

Books, Manuscripts & Periodicals Catalogue

ABBREVIATIONS

The following abbreviations have been used in this section: hb., hardback; ms., manuscript; pb., paperback; pp., pages; ts., typescript; GMA.A. refers to the Gallery's archive number.

Books & Manuscripts

174

LAWRENCE ALLOWAY, RAYNER BANHAM AND DAVID LEWIS

This is Tomorrow

London, Whitechapel Art Gallery, 1956

Exhibition catalogue with introduction by Lawrence Alloway, Rayner Banham and David Lewis, edited by Theo Crosby, Whitechapel Art Gallery, London, 9 August – 9 September 1956
Format: 128pp.; illustrated; pb. with spiral binding; 16.5 × 16.5
GMA.A.42.0975

The exhibition *This is Tomorrow*, held at the Whitechapel Art Gallery, London, in 1956, was designed to unite the work of architects, painters and sculptors. A number of the exhibitors were connected with the Independent Group, a splinter group of the Institute of Contemporary Arts. The ICA, founded by Roland Penrose (see cats.148–151) and Herbert Read (see cats.372–373), amongst others, held exhibitions which were much indebted to the ideals of French Surrealism, whereas the younger artists and writers, such as Paolozzi, Turnbull, Richard Hamilton, Rayner Banham and Lawrence Alloway, had developed an altogether different interest in the popular culture of television, film, magazines, advertising and science fiction. The Independent Group, which developed out of this difference of interest, has often been seen as the germinating seed of the British Pop Art movement which emerged in the early 1960s.

The exhibition *This is Tomorrow* is sometimes cited as the precise point from which Pop Art developed, but it was far more wide-ranging than this; the British Constructivist movement in the form of Victor Pasmore, Kenneth Martin and Anthony Hill was an equally important facet of the exhibition. The pocket-sized, spiral-bound catalogue was edited by the writer on architecture, Theo Crosby. It features an introduction by Alloway (who had been appointed Assistant Director at the ICA in July 1955) and additional introductions by Rayner Banham and David Lewis. Nearly 20,000 people saw the show and the print-run of 1300 catalogues sold out.

175

GUILLAUME APOLLINAIRE

Les Epingles
Contes

Paris, Editions des Cahiers Libres, 1928

With text by Apollinaire, introduction by Philippe Soupault; with a reproduction of a portrait of Apollinaire by Alexandre Alexeieff
Edition of 835; this copy no. XXVI of 30 numbered I–XXX
Format: 65pp.; illustrated; hb.; 19 × 14
Binding: orange marbled paper with black leather spine and corners, and orange marbled endpapers
GMA.A.42.0346

Apollinaire, who died prematurely in the influenza epidemic in 1918, was one of the poets of the pre-war generation who had most influence on the development of Surrealism. This is a collection of three of his short stories, 'Les Epingles', 'Chirurgie esthétique' and 'La Plante', and is published with an introduction by Philippe Soupault. The profile portrait of Apollinaire is by Alexandre Alexeieff, a Russian painter and engraver who settled in Paris and was a friend of Soupault's.

176

GUILLAUME APOLLINAIRE

Contemporains pittoresques
En frontispiece un portrait de l'auteur par Picasso

Paris, Collection 'Le Livre Neuf'. Aux Editions de la Belle Page, 1929

With a frontispiece etching by Pablo Picasso
Edition of 340; this copy no.277
Format: 108pp.; illustrated frontispiece; pb.; 18.6 × 11.6; etching: 11.2 × 7.8 (page size 18.5 × 11.5)
GMA.A.42.0328

The pen-portraits of Raoul Ponchon, Alfred Jarry, Ernest La Jeunesse, Remy de Gourmont and Jean Moréas gathered here were originally written in 1909–10. The 'Anecdotes de Willy sur Catulle Mendès' was written in 1914. Picasso's caricature of Apollinaire used for the frontispiece dates from 1905, the year the two men first met. (See C. Zervos, *Pablo Picasso*, Vol. XXII, no.294.)

177

LOUIS ARAGON

Les Aventures de Télémaque
avec un portrait de l'auteur par R. Delaunay

Paris, Editions Nouvelle Revue Française, 1922

With frontispiece reproduction of a portrait of Aragon by Robert Delaunay
Edition of 1000; this copy no.683
Format: 96pp.; illustrated frontispiece; pb.; 18.2 × 13
GMA.A.42.0356

The year 1922 was a time of upheaval and dissent within the Parisian Dada group as Breton and his supporters evolved the theories that would ultimately find expression in the first Surrealist Manifesto in 1924. During this transitional period their tastes in contemporary art were much less clear-cut than they had become by 1924, and they looked to Fauve and Cubist artists like Robert Delaunay, Fernand Léger and André Derain to be their principal allies. Delaunay, for example, was involved with Breton in the organisation of the abortive *Congrès International pour la Détermination des Directives et la Défense de l'Esprit Moderne* (International Congress for the Determination of Directives and the Defence of the Modern Spirit), planned for March 1922, and drew a portrait of Breton at that time. His rather dandified and Cocteau-esque drawing of Aragon appeared as the frontispiece to *Les Aventures de Télémaque* when it came out in late November.

178

LOUIS ARAGON

Celui qui s'y colle
Préface à l'exposition Pierre Roy

Paris, Galerie Pierre, [1926]

Exhibition catalogue, Galerie Pierre, Paris, 18–30 May [1926]
Format: 8pp.; illustrated, 1 plate; pb.; 23.4 × 18.2
GMA.A.42.0983

Aragon's essay is the preface to the catalogue of Pierre Roy's one-man exhibition in May 1926 at the Galerie Pierre (sometimes known as the Galerie Pierre Loeb). Roy, whose work was influenced by de Chirico's Metaphysical paintings but is more illusionistic in style, moved in the circle of Apollinaire before the war and was taken up by the Surrealists in the early 1920s. In 1925–26 several of his paintings were reproduced in *La Révolution Surréaliste* and included in the earliest exhibitions of Surrealist painting.

179

[LOUIS ARAGON & ANDRÉ MASSON]

Le Con d'Irène

Paris, [René Bonnel], 1928

With etchings by Masson and cover design by Aragon
Edition of 150; this copy no.127 of 125 copies numbered 11–135 on Arches paper with 5 etchings
Format: 96pp.; illustrated; pb. in red folded wrapper; 24.6 × 19.5; etchings: a. 15 × 12, b. 16.5 × 14.5, c. 17 × 13.5, d. 17.5 × 13.8 and e. 17 × 13.5
(all pages size 24.5 × 18.7), all unsigned
GMA.A.42.1003

179 / Frontispiece by Masson

This was purchased from John Armbruster, Paris, in 1981. A notorious piece of Surrealist pornography, *Le Con d'Irène* was published anonymously and clandestinely in Paris in 1928. Aragon designed the cover himself. Masson's five etchings depicting scenes of unbridled orgy are worthy of the Marquis de Sade. He provided the equally uninhibited (and unsigned) lithographs illustrating *Histoire de l'œil* by the dissident Surrealist Georges Bataille, which came out the same year under Bataille's pseudonym Lord Auch. Other similar publications with illustrations by Masson were planned at this time but were abandoned because of the danger of imprisonment. René Bonnel, who specialised in erotica, was the unnamed publisher. (For full details, see L. Saphire and P. Cramer, *André Masson. The Illustrated Books: Catalogue Raisonné*, Geneva, 1994, no.2.)

180

LOUIS ARAGON

La Grande Gaîté

Paris, Librairie Gallimard, 1929

With illustrations by Yves Tanguy
Edition of 240; this copy marked 'K' of 20 *hors commerce* copies
Format: 125pp.; illustrated, after 2 drawings by Yves Tanguy, tipped in at p.8 and p.123; 23.8 × 18.7
GMA.A.42.0108

181

LOUIS ARAGON

La Peinture au défi
Exposition de collages

Paris, Librairie José Corti, 1930

Exhibition catalogue, Galerie Goemans, Paris, March 1930
Edition of 1020; this copy unnumbered
Format: 32pp.; illustrated, 23 plates; loose-leaf in green marbled paper portfolio cover and slipcase; 19.6 × 14.6
GMA.A.42.0384

Mrs Keiller purchased this from John Armbruster, Paris, in April 1978.

In his celebrated text, expressed in hard-hitting prose and backed up by numerous examples, Aragon sketched the history of collage from its invention by Picasso and Braque during the Cubist period, by way of the work of Duchamp and the Dadaists, to its flowering as an agent of 'the marvellous' in the hands of the Surrealists. For him collage spelt the death of painting – hence his resounding title 'A Challenge to Painting'. According to Aragon: 'Once the principle of collage was admitted, painters had passed unaware from white to black magic. It was too late to retreat'. And he hailed the democratisation of art which the collage technique made possible: 'Painting turns to comfort, flatters the tasteful man who has bought it. It is a luxury. Painting is jewellery. Now it is possible for painters to free themselves from this domestication by money. Collage is poor. [...] From now on, why use pigments? A pair of scissors and some paper – there's the only palette that doesn't lead back to the school bench. [...] The marvellous must be made by all, and not by one alone.' (Quoted from the translation in L. Lippard (ed.), *Surrealists on Art*, Englewood Cliffs, New Jersey, 1970, p.40 ff.).

182

LOUIS ARAGON

Persécuté persécuteur

Paris, Éditions Surréalistes, 1931

Edition of 101; this copy no.33 of 30 numbered 16–45 on Hollande paper
Format: 86pp.; pb.; 26.2 × 22.4 overall (pp. of various sizes)
GMA.A.42.0109

Persécuté persécuteur opens with 'Front Rouge', the militant Communist poem Aragon wrote in Moscow in the autumn of 1930. The poem caused a furore in France when it was published in this collection, and set in motion the so-called *Affaire Aragon* which ultimately led to his acrimonious exit from the Surrealist movement in 1932 in favour of the official Communist Party. (See also cat.197.)

183

NOËL ARNAUD, J-F. CHABRUN & ALINE GAGNAIRE

L'Illusion réelle
ou les apparences de la réalité

Paris, Éditions de la Main à Plume, 1942

With text by Noël Arnaud and J-F. Chabrun (Certificat de Lecture); illustrated by Aline Gagnaire
Edition of 270; this copy no.1 on Hollande paper

contains a decalcomania and an original drawing by Gagnaire, and mss. of the text by Arnaud and Chabrun
Format: 16pp.; illustrated (2 plates p.3 & p.7); pb.; 19.3 × 14.4; inscribed: on title-page in red ink: *A Georges Hugnet / dont le cœur est à la fois une lampe votive / et un foyer d'incendie, / qui veille aux frontières de l'amitié et / qui attend les premières gouttes de / pétrole de l'aube / son ami / Noël Arnaud* & at bottom of page in green ink: *Ex. Hollande No.1*
Enclosed at front: a. decalcomania signed bottom right *Aline Gagnaire 1942*, 19 × 13; b.2 sheets [4pp.] ms. text *Certificat de Lecture* by Chabrun; c.6 sheets [12pp.] ms. poems by Arnaud (note title of poem 3 – *La Preuve*, differs from printed version – *Château d'Orage*); d. pen & ink drawing signed bottom right: *Aline Gagnaire 1942*, 18.4 × 14
GMA.A.42.0083

Arnaud and Chabrun were leaders of the Main à Plume group which was formed to keep Surrealism alive in Paris during the Occupation, in the absence of Breton and many of the old guard who had sought refuge in the United States. Although forced to live and work under the constant threat of – at the very least – censorship, and therefore unable to sustain a regular review, they contrived to bring out a number of review-style collective publications as well as small-scale collaborative ventures such as this. Aline Gagnaire contributed illustrations to various Main à Plume publications. Although Hugnet had quarrelled with Breton before the war, he collaborated with and supported Arnaud throughout this period, his apartment and bookshop on the boulevard du Montparnasse serving as the depository for underground publications. The dedication of this special copy of *L'Illusion réelle* to him is testimony to his importance to the whole Main à Plume venture. (See also cats.222 and 398–399.)

184

AUDIBERTI

Elisabeth-Cécile-Amélie
Repères 16

Paris, G. L. M., August 1936

With a frontispiece after a drawing by Jean de Bosschère
Edition of 70; this copy no.10
Format: 20pp.; illustrated frontispiece; loose-leaf in red cover; 25.3 × 19.5; inscribed on colophon: *Guy Lévis-Mano*
GMA.A.42.0136.05

185

FRITZ VON BAYROS

Im Garten der Aphrodite

Privatdruck, n.d.

Portfolio with marbled paper cover containing title and contents page and reproductions from 18 etchings by Fritz von Bayros; 32 × 26
GMA.A.42.0993

186

HANS BELLMER

Die Puppe

Karlsruhe, 1934

Format: 38pp., 16pp. text on papier rose; illustrated with 10 photographs by Bellmer on yellow paper tipped in to pp.17–35; pb.; 12 × 9; inscribed on flyleaf: *A Guy Lévis-Mano / Hans Bellmer*
GMA.A.42.0459

Bellmer had been working mainly as a commercial artist when, in the summer of 1933, he decided to 'construct an artificial girl with anatomical possibilities which are capable of re-creating the heights of passion even to inventing new desires' (quoted in P. Webb and R. Short, *Hans Bellmer*, London, 1985, p.29). A catalyst to this decision was a performance of Offenbach's *Tales of Hoffmann* in which one of the characters is a doll that comes to life. Bellmer's brother Fritz, who was a trained engineer, gave up work to help him build the Doll, which was a life-size, complex, articulated affair, requiring very detailed plans and made with wood, metal, plaster, hair, and so on. Bellmer took many photographs of the Doll under construction and in various erotically suggestive positions, with and without bits of clothing. In 1934 he published ten photographs in this small booklet, which was printed at his expense in Karlsruhe. The book bears a general dedication to his cousin Ursula Naguschewski, the type of provocative, flirtatious, young girl for whom he had a special penchant.

In addition to the black and white photographs, *Die Puppe* contains a preface in the form of an intricately phrased prose poem which draws upon Bellmer's childhood memories and adolescent sexual fantasies, and describes the kinds of toys with which, as a child, he created an imaginative world apart and which directly influenced the conception of the Doll. The main purpose of the text, however, is to evoke the impulses that led him to construct the Doll and thus achieve the total 'erotic liberation', in an atmosphere of 'vice and enchantment', impossible in real life. It thus provides the context for the photographs that follow it. Bellmer dedicated this copy of *Die Puppe* to Guy Lévis-Mano, the eponymous director of Editions G. L. M. and publisher of the French translation (cat.187).

187 / Plate 9

187

HANS BELLMER

La Poupée

Paris, G. L. M., 1936

Translated by Robert Valançay
Edition of 100; this copy no.80, of 80 printed on papier rose and numbered 26–100
Format: 36pp.; illustrated with 18 photographs by Bellmer; pb.; 16.9 × 12.6
GMA.A.42.0439

This is the French edition of *Die Puppe* (cat.186). According to Philip Webb's account (*Hans Bellmer*, London, 1985, pp.38–9), in the summer of 1934 Bellmer's cousin Ursula – one of the chief inspirations behind the Doll – went to Paris to study at the Sorbonne. Bellmer sent her a photograph of the Doll and asked her to seek out the Surrealists. The reaction was immediate: that winter eighteen of Bellmer's photographs were published on a double-page spread in *Minotaure*, no.6, under the title 'Doll – Variations on the Assemblage of an Articulated Minor'. And in the next issue of the magazine, published in June 1935, four of Bellmer's photographs appeared as illustrations to a tale by Eluard entitled 'Appliquée'.

Bellmer visited Paris early in 1935 and, with Henri Parisot and Robert Valançay acting as his interpreters, was introduced to his Surrealist admirers. Eluard became an especially close friend and persuaded Guy Lévis-Mano to agree to publish a French edition of *Die Puppe*. The full translation – by Robert Valançay – of Bellmer's text took a long time to prepare because Bellmer was determined that the character of the original should be preserved. When it finally came out at the beginning of June 1936, *La Poupée* contained eighteen of Bellmer's photographs – not ten, as in the original German edition – and reproduced them in a somewhat larger format, which tends to diminish the intensity of their impact.

188a / Prospectus

188

HANS BELLMER

Les Jeux de la poupée

Miscellaneous items, 1938 – 1939

Prospectus for the book, typescript of Bellmer's text, and mss. of Hugnet's translation, with Bellmer's draft design for the prospectus
a. Prospectus for *Les Jeux de la poupée; illustrés de textes par Paul Eluard*
[Paris, Editions 'Cahiers d'Art', 1939]; 1 sheet, 2pp. illustrated
b. Typescript of Bellmer's text in German; 6 sheets of typescript on pink paper; 1 sheet of pencil ms. in Bellmer's hand; 2 sheets of pencil notes in Hugnet's hand
c. Ms. of Georges Hugnet's translation; 42 sheets of ink ms. with corrections by Bellmer; plus 1 sheet ink ms. in French in Bellmer's hand; p.3 has Bellmer's design for the prospectus in pencil and gouache; p.5 is written on reverse of prospectus for *Œillades ciselées en branche*
GMA.A.42.1007.01–03

Les Jeux de la poupée was eventually published in a limited edition in Paris in 1949 (Editions Premières), but was prepared for publication a decade earlier. The publishing house involved at that time was Christian Zervos's Editions 'Cahiers d'Art', but the outbreak of war put a stop to the project. The book as published in 1949 includes fifteen tinted photographs of Bellmer's second Doll – which he constructed with the help of his brother over the summer of 1935 – and fourteen prose poems by Eluard. These were composed in the winter of 1938–39 in response to the new photographs, which Bellmer had brought with him when he left Berlin and settled in Paris in 1938. In addition there is a long introductory text by Bellmer himself, translated into French by Hugnet.

Although Mrs Keiller did not acquire a copy of the published book of *Les Jeux de la poupée*, she was able to purchase the manuscript material associated with the preparation of Hugnet's translation. These manuscripts include draft translations in Hugnet's hand,

annotated and corrected by Bellmer, and the much corrected typescript – on pink airmail paper – of the original German text. Among the other items in this collection of papers is the draft design for the Editions 'Cahiers d'Art' prospectus, decorated with an original coloured drawing of the Doll by Bellmer. The published prospectus indicates that a total edition of 356 copies was envisaged.

While collaborating on *Les Jeux de la poupée*, Bellmer and Hugnet also worked together on *Œillades ciselées en branche* (cat.300). The close friendship that united them was fuelled by their shared tastes and obsessions. Aside from a common interest in sexuality in its more perverse forms, both were, for instance, passionately committed to time-consuming craftsmanship and were ardent connoisseurs of bizarre toys, trinkets, ephemera, etc. Hugnet's attraction to Bellmer's work is expressed not only in the books they worked on together but in the elaborate mixed-media bindings he made for his own copies of both *Die Puppe* (cat.186) and *La Poupée* (cat.187).

189

RENÉ BERTELÉ

Le Jugement du vent

Repères 17

Paris, G. L. M., August 1936

With a frontispiece after a drawing by Brian Gysin
Edition of 70; this copy no.10
Format: 20pp.; illustrated frontispiece; loose-leaf in red cover; 25.3 × 19.5; inscribed on colophon: *Guy Lévis-Mano*
GMA.A.42.0136.06

190

MAURICE BLANCHARD

Les Barricades mystérieuses

Repères 25

Paris, G. L. M., August 1937

With frontispiece after a drawing by Lucien Coutaud
Edition of 70; this copy no.10
Format: 20pp.; illustrated frontispiece; loose-leaf in yellow cover; 25.3 × 19.5; inscribed on colophon: *Guy Lévis-Mano*
GMA.A.42.0136.14

191

ANDRÉ BRETON
& PHILIPPE SOUPAULT

Les Champs magnétiques

Paris, Au Sans Pareil, 1920

Illustrated by Francis Picabia with portraits of Breton and Soupault
Edition of 180; this copy no.75
Format: 120pp.; illustrated; pb.; 19.5 × 14.3
GMA.A.42.0359

Les Champs magnétiques is the most celebrated Surrealist text to be produced before the foundation of the Surrealist movement proper. Breton and Soupault were introduced to each other by Apollinaire in 1917, and, with Aragon, founded *Littérature* (cat.421) two years later. Both were fascinated by the theories of Freud and had read Pierre Janet's *L'Automatisme psychologique*, in which automatic writing is advocated as a means of exploring the functioning of the human mind. Under these influences they agreed to collaborate on a series of 'chapters', to be written 'automatically' over a period of a week, and published as they were, without censorship, rearrangement or correction. As Breton later remarked, their aim was to create a 'dangerous book'.

This experiment in sustained automatism took place in May 1919 and was conducted in a state of intense elation, the two authors spending up to ten hours a day writing and then reading the day's results out to each other. Over the allotted period they tested out various different methods and writing speeds: sometimes, for instance, they wrote separately, but at others they sat opposite each other; sometimes they wrote alternately in a form of automatic dialogue, and sometimes they intermixed randomly chosen fragments of their texts using a simple cut-and-paste method. The result was *Les Champs magnétiques*. It was published on 30 May 1920 with portraits of both authors by Picabia, and a dedication to the memory of Jacques Vaché, whose death in January 1919 – probably by suicide – had deprived Breton of the friend whom he regarded as his mentor in revolt.

In 1985 David Gascoyne (see cat.281) published an English translation of *Les Champs magnétiques* (*Magnetic Fields*, London, Atlas Press). He dedicated a copy to Gabrielle Keiller which she also bequeathed to the Gallery.

192

ANDRÉ BRETON

Légitime défense

Paris, Editions Surréalistes, September 1926

Format: 28pp.; pb.; 17.6 × 11.5
GMA.A.42.0040

Published as a pamphlet at the end of September 1926, *Légitime défense* is an analysis of the relationship between the Communist Party and the Surrealist group during the previous year. Although affirming the Surrealists' 'enthusiastic' endorsement of the 'Communist programme', Breton advocates the principle of total freedom from any external control, 'even that of Marxism'. In this refusal to submit to

the dictates of the Party lay the seeds of many of the future crises and rifts within the movement, as Breton's profound suspicion of Stalin – and admiration for Trotsky – grew apace. The text was reprinted in *La Révolution Surréaliste*, no.8, in December 1926.

193

ANDRÉ BRETON

Nadja

Paris, Librairie Gallimard, 1928

Edition of 905, of which 750 numbered 11–750 were printed for the Amis de l'Edition; this copy no.82
Format: 218pp.; illustrated; pb.; 18.8 × 12.2
GMA.A.42.0048

194

ANDRÉ BRETON & PAUL ELUARD

L'Immaculée conception

Paris, Editions Surréalistes, 1930

Edition of 2111, of which examples 1–111 contain an etching by Dalí; this copy no.1646 without etching
Format: 130pp.; illustrated on title-page, repeated on front cover; pb.; 23.6 × 18.5
GMA.A.42.0274

L'Immaculée conception was written collaboratively by Breton and Eluard during a two-week period in September 1930 when both were neighbours at 42 rue Fontaine. Part prose poem, part manifesto, it is among other things a sustained attack on Catholic morality – hence the title. Divided into four sections, it is best known for the second of these in which the authors attempted to simulate as closely as possible the delirium of the insane. Their purpose was to demonstrate that the boundary between the language of madness and of true poetry was fluid, if not illusory – an idea which had been central to Surrealism since its inception. 'L'Homme', the first section of the book, was published in October 1930 in *Le Surréalisme au Service de la Révolution*, no.2. But Breton and Eluard had difficulty in persuading José Corti, their usual publisher, to print the book because he considered it much too disorientating. In the end the Vicomte de Noailles and Valentine Hugo between them raised the necessary money and the book was published on 24 November 1930.

This return of Breton's and Eluard's intense fascination with insanity and the art of the insane had a good deal to do with the presence of Salvador Dalí in their midst. At about this time Dalí was developing his so-called 'paranoiac-critical method' (see cat.239), which he later defined as 'a spontaneous method of irrational knowledge based on the critical and systematic objectification of

delirious associations and interpretations'. He was the inevitable first choice as illustrator of *L'Immaculée conception* and provided a meticulous pen and ink drawing of an eroticised male hand for reproduction on the dark pink cover and on the title-page. The de-luxe copies of the book were further enriched by a frontispiece by Dalí reproducing a drawing of a sexually aroused, semi-naked woman accompanied by two seemingly impotent men. However, the Keiller copy lacks this frontispiece. It was purchased through Tony Reichardt at an unknown date.

195

ANDRÉ BRETON, RENÉ CHAR & PAUL ELUARD

Ralentir Travaux

Paris, Editions Surréalistes, 1930

Edition of 300; this copy no.259
Format: 48pp.; pb.; 28.8 × 20.1; inscribed in ink on half-title: *Exemplaire de Marcel Mariën / son ami / Paul Eluard*
GMA.A.42.0103

Each author provided a brief signed preface, but the thirty short poems contained in this collection were composed collaboratively, in the best Surrealist manner, between 25 and 30 March 1930 (as is stated clearly on the final page). Breton, Char and Eluard were staying together in Avignon and touring by car in the vicinity at the time. They composed the poems spontaneously at spare moments, often collaborating on a single text in the approved manner of the *cadavre exquis* (see cat.9), as the surviving manuscript reveals. The title, which may be translated as 'Reduce speed: Road Works Ahead', was 'found' by chance when they came upon a road sign warning of construction work ahead. The book appeared with a general dedication to their fellow Surrealist, Benjamin Péret. Mrs Keiller purchased this copy from John Armbruster, Paris, in April 1978.

196

ANDRÉ BRETON & SALVADOR DALÍ

Correspondence

Unpublished manuscripts 1930–1939

27 sheets; 15 items, manuscript letters and postcards, bound in hb. leather cover with slipcase; 36.6 × 28.8
GMA.A.42.1013

This is a highly important collection of fifteen letters and postcards from the correspondence between Breton and Dalí. The letters from Breton are those he actually sent to Dalí. The letters from Dalí are apparently drafts, mostly in his hand with some pages in Gala's transcriptions; the letters he actually sent to Breton are in the collection of the latter's heirs. The correspondence has been bound in a black leather album, complete with slipcase, which is stamped on the inside front cover with the name of the noted Paris bookbinder Mercher, and on the inside back cover with the date 1959.

The earliest item is a tourist postcard of bathers sent by Dalí from Carry-le Rouet, near Marseilles, on 3 March 1930, which he has adapted appropriately and inscribed: 'SEURAT – Etude pour "la Grande Jatte"'. The latest is a letter from Breton, written on the headed notepaper of FIARI (Fédération Internationale de l'Art Révolutionnaire Indépendant) and dated 6 January 1939, in which he wearily regrets that communications between them are now mainly 'from afar', and states that a true exchange of ideas would necessitate 'a meeting of the kind we used to have nearly ten years ago'. Most of the remainder of the letters date from January 1934 to March 1935.

The most interesting of the letters belong to the early months of 1934: Dalí's sayings and doings, and especially his avowed fascination with Hitler, his questionable attitude to Lenin, his reported racist and anti-proletarian comments, and his explicit preference for 'academic' art above 'modern' art, had been causing the gravest concern to Breton and the other Surrealists. Breton's letters reflect his strenuous efforts to make Dalí conform to Surrealist orthodoxy and to contribute more regularly to the activities and publications of the official Surrealist group. Dalí's lengthy and colourful replies contain protestations of 'unconditional' adherance to Surrealism, but fiercely defend his absolute right – he invokes the name of the Marquis de Sade at one point – to express himself verbally and in his writings and paintings in accordance with his unique inner compulsions and 'perversions'. In the letter dated 3 February 1934, Breton informs Dalí that the decision has just been taken at a 'general assembly' of the Surrealists to exclude him from the group because he has been found 'guilty of counter-revolutionary acts tending to the glorification of Hitlerian fascism'. Breton then invites him to mount his self-defence in person. In the event Dalí managed to defuse Breton's anger by his lengthy explanations and comical behaviour; the decision was revoked, and cordial relations were re-established. Other more general subjects raised in Breton's letters include the need for coherent and uniform group action on all fronts, plans for new issues of *Minotaure* (cat.426) and for Surrealist exhibitions in Paris and abroad, and accounts of the 'considerable success' of his and Eluard's lecture tour to Prague in 1935 (see cat.437).

For a more detailed analysis of this correspondence, see K. von Maur, 'Breton et Dalí, à la lumière d'une correspondance inédite', *André Breton. La beauté convulsive*, Musée National d'Art Moderne, Centre Georges Pompidou, Paris, 1991, pp.196–202.

197

ANDRÉ BRETON

Misère de la poésie

'L'affaire Aragon' devant l'opinion publique

Paris, Editons Surréalistes, 1932

Format: 31pp.; pb.; 22 × 13.5; pasted into back page newscutting inscribed in ink: L'Humanité / 10 Mars 1932
GMA.A.42.0016

In January 1932 Aragon was indicted and charged with having 'demoralised the army and the nation' in 'Front rouge', the militant Communist poem he had published towards the end of the previous year (see cat.182). Breton was fundamentally opposed to propagandist poetry and therefore disapproved of 'Front rouge'. But in *Misère de la poésie* (published in March 1932) he defended Aragon, while at the same time making explicit his belief that poetry should always be free and never the servant of political doctrine. In the collective pamphlet *Paillasse! Fin de 'l'Affaire Aragon'* (also published in March), Crevel, Char, Dalí, Eluard, Ernst, Tzara, Tanguy, Péret and Thirion expressed their support for Breton's position, but Sadoul, Buñuel and Unik followed Aragon into the Communist Party. Thus the long and close friendship between Breton and Aragon came to a bitter end and with it another chapter in the ongoing saga of Surrealism's tortuous relationship with the Party.

There is a second copy of *Misère de la poésie* in the Keiller Bequest, printed, unlike this, on airmail-type paper.

198 / Drawing by Dalí

198 / Frontispiece by Dalí

198

ANDRÉ BRETON

Le Revolver à cheveux blancs

Paris, Editions des Cahiers Libres, 1932

Edition of 1010 of which nos.1–10 are printed on Japon nacré paper and contain an etching by Salvador Dalí; this copy no.10
Format: 76pp.; illustrated, frontispiece etching by Dalí; pb.; 19.7 × 15; etching: 14.7 × 11.6 (page size 19 × 14), printed below image left: *imprimé par Lacourière*, inscribed in pencil below image left: *S. Dalí*
Enclosed, 4 items: a. inside front cover, publisher's leaflet for Les Editions Cahiers Libres; b. between frontispiece and title-page, pencil drawing by Dalí, 13.7 × 12.5; at back mss. of 'Façon' and 'C'est moi ouvrez' in Breton's hand
GMA.A.42.0299

This was published by René Laporte's Editions des Cahiers Libres in June 1932. The title, which may be translated as 'The White-Haired Revolver', is a line from an automatic text dating from 1924, and the book itself is an anthology of Breton's poems dating from 1915 to 1932. It includes one of his most admired poems 'L'Union libre', which was inspired by his passionate but tormented on-off love affair with Suzanne Muzard, and was first published anonymously as a pamphlet in June 1931. The poems are prefaced by an essay entitled 'Il y aura une fois' (Once upon a time to come), first published in *Le Surréalisme au Service de la Révolution*, no.1, in June 1930, in which Breton famously defines 'the imaginary' as 'that which tends to become real'. The book is dedicated to Paul Eluard with whom, in the aftermath of the 'Aragon affair' (see cat.197), Breton was on particularly close terms.

The Keiller copy of *Le Revolver à cheveux blancs* is one of the ten de-luxe copies; it formerly belonged to Georges Hugnet. It has a frontispiece in heliogravure by Salvador Dalí (R. Michler and L. W. Löpsinger, *Salvador Dalí. Catalogue Raisonné of Etchings and Mixed-Media Prints, 1924–1980*, Munich, 1994, no.6), reproducing a pen and ink drawing. The

imagery has significant points of contact with that of *Le Signal de l'angoisse* (cat.17). With the book came an original drawing by Dalí which is an early preparatory study for *Gala et L'Angélus de Millet précédant l'arrivée imminent des anamorphoses coniques*, 1933 (National Gallery of Canada, Ottawa). It is further enriched by Breton's original manuscripts of two of the poems, 'Façon' and 'C'est moi ouvrez'.

199

ANDRÉ BRETON

Les Vases communicants

Paris, Editions des Cahiers Libres, 1932

With cover design by Max Ernst
Edition of 2025; this copy unnumbered
Format: 174pp.; pb., illustrated cover; 18.3 × 13.1; inscribed in ink on half-title: *A Albert Thibaudet / respectueux hommage / André Breton*
GMA.A.42.0044

Les Vases communicants was published at the end of November 1932, but largely composed in the summer of the previous year when Breton was staying in Provence at Castellane. The title 'The Communicating Vessels' alludes to a scientific experiment in which liquids or gases pass back and forth between two joined receptacles until they reach equilibrium. Breton chose the title because he believed it was the perfect metaphor for the relationship that ought to exist between the dreaming and waking states – the central theme of the book. A constant interplay between dream experience and prosaic, waking reality is, Breton argues, essential to the accomplishment of a total revolution of heart, mind and world. Breton regarded this book as one of his most important achievements and like the Surrealist Manifestos it was intended to reach a relatively wide audience.

200

ANDRÉ BRETON

Point du jour

Paris, Gallimard, 1934

Format: 254pp.; pb.; 18.7 × 12; presentation copy inscribed on half-title: *Mademoiselle Eve Maret / hommage très respectueux / et reconnaissant d' / André Breton*
GMA.A.42.0087

201

ANDRÉ BRETON

Qu'est-ce que le Surréalisme?

Brussels, René Henriquez, 1934

Edition of 1070
Format: 30pp.; illustrated title-page and front cover; pb.; 24.6 × 15.8
GMA.A.42.0010

201 / Cover by Magritte

This is the text of the lecture on Surrealism Breton delivered on 1 June 1934 in Brussels at the time of the *Exposition Minotaure* (cat.276). In it he insisted on the threat posed by Fascism and the duty of intellectuals and artists to fight for the liberation of man, but not through the creation of a would-be proletarian art. The lecture was published in Brussels on 15 July with a cover by Magritte. This reproduces a gouache version of *Le Viol*, 1934, the painting which had caused a sensation at the *Minotaure* exhibition and had been hung in a space apart from the other works. Breton was delighted with Magritte's design and thanked him effusively in a letter written on 1 July: 'I am full of enthusiasm for your drawing, it is a marvellously vital and disturbing piece of work, hard to put out of one's mind. Nothing could more successfully combine all the elements likely to suit me and charm me.' (Quoted in D. Sylvester and S. Whitfield, *René Magritte. Catalogue Raisonné, Vol. II, Oil Paintings and Objects 1931–1948*, Menil Foundation, 1993, p.30). For David Gascoyne's translation of Breton's lecture, see cat.206.

This was purchased from H. A. Landry, London, in August 1975.

202

ANDRÉ BRETON

Cycle systématique de conférences sur les plus récentes positions du Surréalisme

Paris, 1935

Subscription form with illustrations
Format: card folded into 4pp.; 24.1 × 15.3 (folded)
GMA.A.42.0989

Printed from Breton's neat, handwritten text, this is the prospectus (complete with detachable subscription form) for a cycle of four conferences on Surrealism to be held in Paris in June 1935. The stated purpose of the conferences was: 'to undertake in public an up-to-date investigation into Surrealist ideas'. The

202 / Front

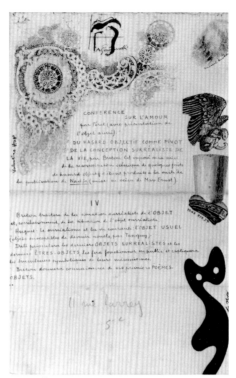

202 / Back

four proposed themes were: 'I. Why I am a Surrealist; II. Will Surrealism disappear with bourgeois society?; III. The evidence of poetry; IV. The object'. Decorating the margins of the prospectus are reproductions of signed drawings by Man Ray, Arp, Domínguez, Dalí, Valentine Hugo, Ernst, Giacometti, Tanguy, Marcel Jean, and Duchamp (represented by a thumbprint). Readings, illustrated lectures and performances were promised, with participation from all the leading members of the movement. In the event the whole programme was abandoned because of lack of funds, but the desire to inform and convert a wider public is typical of Surrealism in the mid- and late 1930s.

203

ANDRÉ BRETON

Du temps que les surréalistes avaient raison

Paris, Editions Surréalistes, 1935

Pamphlet by Breton, with 23 counter-signatories
Format: 15pp.; pb.; 24.5 × 15.6
GMA.A.42.0981

This tract is one of many relics of the tempestuous relationship between the Surrealist movement and the French Communist Party. It was composed by Breton in July 1935 at the apartment of Maurice Heine (see cat.223) and in the presence of most of the members of the Paris group. Countersigned by Dalí, Domínguez, Eluard, Ernst, Heine, Henry, Hugnet, Itkine, Marcel Jean, Dora Maar,

Magritte, Léo Malet, Marie-Louise Mayoux, Mesens, Nougé, Meret Oppenheim, Parisot, Péret, Man Ray, Singer, Souris, Tanguy and Valançay, it was published at the beginning of August. The tract finalised the rupture between the Surrealists and the Party, and articulated in particular their total rejection of Stalin's repressive policies on art and personal morality. It was precipitated by the Surrealists' opposition to the signing of the Franco-Russian Mutual Aid Treaty on 2 May 1935, but above all by Breton's treatment by Party officials at the time of the Congrès des Ecrivains pour la Défense de la Culture at the end of June. The Congrès was a Communist-sponsored initiative to form a common front against Fascism and Breton was billed to address the assembly. In the event he was denied the right to deliver his lecture, and although, following protests by the Surrealists, Eluard was permitted to read out Breton's text, the conditions in which he did so amounted to a form of deliberate sabotage.

This was purchased from John Armbruster, Paris, at an unrecorded date.

204

ANDRÉ BRETON (pref.)

Exposición Surrealista

Tenerife, Ateneo de Santa Cruz, [1935]

Exhibition catalogue with preface by André Breton, Ateneo de Santa Cruz, May 1935
Format: 21pp.; illustrated; pb.; 21 × 16
GMA.A.42.0982

Breton's catalogue preface was based on the lecture on the Surrealist object he had delivered in Prague at the end of March 1935 (see cat.437). At the invitation of the painter Oscar Domínguez, a native of Tenerife who had first made contact with the Surrealists in Paris in 1934, Breton, his wife Jacqueline and Benjamin Péret went to Santa Cruz for this event.

205

ANDRÉ BRETON

Position politique du Surréalisme

Paris, Editions du Sagittaire, 1935

Format: 178pp.; pb.; 18.4 × 12; with pencil marginalia in an unidentified hand
GMA.A.42.0041

Published in November 1935, this is a collection of Breton's recent political writings. It appeared at the same time as the tract Du temps que les surréalistes avaient raison (cat.203), and includes the text of the Discours (speech) Breton had been prevented from delivering at the Congrès des Ecrivains pour la Défense de la Culture at the end of June 1935. Like the tract, Position Politique... confirms the final parting of the ways of the Surrealists and the official Communist Party after a decade of disputes and temporary rapprochements. The Keiller copy is annotated with drawings, underlinings and comments in Spanish, but the author of these marginalia remains unidentified.

206

ANDRÉ BRETON

What is Surrealism?

Criterion Miscellany – No.43

London, Faber & Faber, 1936

Translated by David Gascoyne and with cover design by Hans Arp
Format: 90pp.; illustrated; pb.; 20.5 × 13.5
GMA.A.42.0019

This is David Gascoyne's translation of the text of Breton's Qu'est-ce que le Surréalisme?, which was first delivered as a lecture in Brussels on 1 June 1934 and published immediately by Editions René Henriquez, Brussels, (cat.201). The translation was timed to coincide with The International Surrealist Exhibition at the New Burlington Galleries, London, in June 1936, and includes additional texts by Breton. (On Gascoyne, see cat.281.)

207

ANDRÉ BRETON

L'Amour fou

Paris, Gallimard, Collection Métamorphoses III, 1937

With photographs by Man Ray , Dora Maar, Brassaï, Rogi-André and Cartier-Bresson
Edition of 1979; this copy unnumbered
Format: 172pp.; illustrated, 20 photographic plates; pb.; 19.3 × 14.3; inscribed in ink on half-title: *A mes Amies / Claude Cahun / et Suzanne Malherbe, / affectueux hommage d' / André Breton*
Enclosed at front is errata slip and inside back cover newscutting and 2 ms. sheets
GMA.A.42.0038

L'Amour fou was not published until the beginning of February 1937 but was composed largely of essays Breton had published earlier in *Minotaure* (cat.426), beginning with *La Beauté sera convulsive* (Beauty will be convulsive) which appeared in the fifth issue in May 1934. One of Breton's most celebrated books, its primary inspiration and theme was his passionate and exalted love for Jacqueline Lamba – called Ondine in the text – whom he encountered by chance at the end of May 1934 and married a few months later. The book ends with a long letter addressed to Aube, their infant daughter (born in December 1935), and with the ringing words: 'Je vous souhaite d'être follement aimée' (I wish you to be loved madly). It is illustrated throughout with photographs – most of them the work of Brassaï, Dora Maar, Cartier-Bresson and above all Man Ray – which are related to specific passages in the text identified by quotations and page references. Breton had long believed that photography, like film, had the potential to be a perfect visual medium for Surrealism, and *L'Amour fou* reflects that conviction.

Breton presented this copy to Claude Cahun and Suzanne Malherbe, two writers attached to the Surrealist group. Slipped into it are two manuscript sheets in an unknown hand consisting of quotations on the irresistible power of love from Victor Hugo's *Les Misérables*. It was purchased from John Armbruster, Paris, at an unknown date.

208
ANDRÉ BRETON
Yves Tanguy
Paris, Galerie Jeanne Bucher-Myrbor, 1938
Exhibition card with introduction by André Breton, Galerie Jeanne Bucher-Myrbor, May 1938
Format: 1 sheet folded into 4pp.; illustrated; 14.3 × 11.1; enclosed is ms. sheet inscribed in ink: *Wolfgang Paalen / pour le catalogue / Souffre sublime / écume de la solitude / titres des / dessins / 1) l'amour vainqueur. / 2) variétés de la pluie. / 3) la vie à campagne*
GMA.A.42.0472

Breton's 'Prologue' is dated April 1938 and was written during his journey to Mexico. It ends with the famous lines: 'Yves Tanguy, the painter of appalling, ethereal, subterranean

and maritime elegances, the man in whom I see the moral costume of this age: my adorable friend.' Slipped into this copy of the catalogue is a manuscript note in an unidentified hand concerning a forthcoming exhibition of work by Wolfgang Paalen, an artist prominent in the Surrealist movement in the later 1930s.

209
ANDRÉ BRETON
Fata Morgana
Paris, Editions des Lettres Françaises, 1942
With illustrations by Wifredo Lam
Edition of 520
Format: 30pp.; illustrated, 6 plates by Wilfredo[sic] Lam; 27.2 × 18.4
GMA.A.42.0102

Breton wrote this text in December 1940 in Marseilles, while he was anxiously awaiting a visa for America and Mexico. It is dedicated to his second wife, Jacqueline Lamba. He attempted to publish it in Paris the following March, but the censors intervened and only five copies were printed. The Keiller copy belongs to what is, strictly speaking, the second edition which, despite the details on the title-page, was published in Buenos Aires in July 1942. Formerly in the collection of Marcel Mariën it was purchased from John Armbruster, Paris, in April 1978.

Wifredo Lam was part of the Surrealist group that had gathered in Marseilles in the winter of 1940–41 following the Occupation; he made the drawings reproduced in *Fata morgana* while there. Lam had been introduced to Breton by Picasso in 1938 but became much closer to him at this time, joining in the collective Surrealist games and fully sympathising with Breton's fascination with the primitive and the occult. In 1941 they travelled to Martinique together, accompanied by Masson and Claude Lévi-Strauss, but whereas the others went on to New York, Lam spent the rest of the war in his native Cuba. Breton met up with him again in Haiti in December 1945, and after the war his work was regularly included in Surrealist exhibitions.

210
ANDRÉ BRETON
Situation du Surréalisme entre les deux guerres
Paris, Editions de la Revue Fontaine, 1945
Format: 38pp.; pb.; 21.5 × 15.9
GMA.A.42.0037

This is the text of the lecture Breton delivered to students of French at Yale University on 10 December 1942, his stated objective being to

summarise the main tenets of Surrealism at that critical historical moment. The lecture was first published in New York in *VVV* (cat.445), nos.2–3, in March 1943, but appeared in France for the first time in this pamphlet, which was published on 30 April 1945.

211 / Cover by Duchamp

211
ANDRÉ BRETON
Young Cherry Trees Secured against Hares
New York, View Editions, 1946
Translated by Edouard Roditi, with cover design by Marcel Duchamp and 2 original drawings by Arshile Gorky
Edition of 1000 copies of which I–XXV have 2 drawings in colour by Gorky signed by author and artist; this copy no.20 signed by author only
Format: 56pp.; illustrated, including 2 ink and gouache drawings (facing *Le Sphinx Vertebral* and *Guerre*); hb. with illustrated cover; 23.6 × 16
GMA.A.42.0187

This is Edouard Roditi's translation of *Jeunes cerisiers garantis contre les lièvres*. The cover depicting Breton as the Statue of Liberty was designed by Duchamp with whom Breton had been in close contact since his arrival in New York in 1941, while the illustrations inside are testimony to the sympathy which had sprung up between Breton and Gorky. The latter two met for the first time in New York in 1944, and the following year Breton provided an enthusiastic preface for Gorky's exhibition at the Julien Levy Gallery (March 1945), which was reprinted almost immediately in the expanded edition of *Le Surréalisme et la peinture* published by Brentano's. He experienced Gorky's death by suicide in 1948 both as a severe personal loss and an irreparable loss for Surrealist painting.

This copy is from the library of Georges Hugnet. Mrs Keiller purchased it from H. A. Landry, London, in January 1975.

212

ANDRÉ BRETON

Yves Tanguy

New York, Pierre Matisse Editions, 1946

Translated by Bravig Imbs, with book design by
Marcel Duchamp and an original drawing by Yves
Tanguy
Edition of 1150; this copy no.234
Format: 94pp.; illustrated, including original pen,
ink and watercolour drawing by Tanguy on half-title;
hb.; 30.4 × 23.1; watercolour: 8.8 × 5.5; inscribed on
half-title: *exemplaire de Marcel Duhamel | très
affectueusement | YVES TANGUY 1947 | amitiés à Germaine*;
enclosed is information poster
GMA.A.42.0294

This fully illustrated monograph was pub-
lished to coincide with Tanguy's retrospective
exhibition at the Pierre Matisse Gallery in New
York in November 1946, and was designed by
Duchamp. It gathers together the principal
texts Breton had devoted to Tanguy between
1928 and 1942, and is prefaced by a brief
foreword written for the occasion and dated
May 1946. The texts appear both in the original
French and in English translation by Bravig
Imbs. Throughout they are interspersed with
reproductions of drawings by Tanguy.

Tanguy presented this copy to his old friend
Marcel Duhamel, and embellished the
dedication with an original drawing.
Duhamel's house at 54 rue du Château in Paris
had been a centre of Surrealist activity during
the mid-1920s and home to several of the more
impoverished members of the group, includ-
ing Tanguy himself. Slipped into the book is
the folded information poster issued by the
Pierre Matisse Gallery which also served as the
exhibition list (see cat.382).

213

ANDRÉ BRETON

Ode à Charles Fourier

Paris, Aux Editions de la Revue Fontaine, 1947

Designed by Frederick J. Kiesler
Edition of 1025 of which nos.1–175 printed on
Marais crève-cœur paper, signed by the author; this
copy no.6
Format: 48pp.; illustrated with in-text diagrams;
loose-leaf in paper cover; 28.1 × 17
GMA.A.42.0039

Charles Fourier (1772–1837) evolved a theory
of utopian socialism based on the exercise of
personal freedom which, in its attack on the
existing capitalist system, foreshadowed
certain theories of Karl Marx. Unlike Marx,
however, Fourier focused on agrarian rather
than industrial society. Although he attracted
some followers in his native France, no lasting
Fourierist colony was established there. In

America, on the other hand, a number of such
cooperatives were successfully set up in the
mid-nineteenth century, and it was while
Breton was living in America during the war
that he became fascinated by Fourier's writings
and began writing his *Ode*.

The architect Frederick Kiesler had first
made contact with the Surrealists in 1937.
Breton was impressed by his work and it was at
his urging that Peggy Guggenheim commis-
sioned Kiesler to design the interior of her New
York gallery, Art of this Century, in 1942. In
1947 Breton invited him to design the installa-
tion of the exhibition *Le Surréalisme en 1947* at
the Galerie Maeght in Paris. He was also
particularly keen that Kiesler should design a
striking and original lay-out for his *Ode à
Charles Fourier*. Kiesler's design is indeed
unconventional, for although the book has the
expected vertical format, the text is printed
horizontally so that one has to turn it on its
side in order to read it. This copy was formerly
in Hugnet's collection. It was purchased
through Tony Reichardt at an unknown date.

214

ANDRÉ BRETON

La Hampe dans l'horloge

Avec une lithographie originale de Toyen

*Paris, Edition Robert Marin, Collection l'Age
d'Or, 1948*

With original lithograph by Toyen
Publisher's edition with lithograph; this copy no.206
Format: 71pp.; illustration, loose-leaf colour
lithograph inserted as frontispiece; pb.; 19.8 × 23.6
overall (pp. uncut and of various sizes); lithograph:
19 × 11.3
GMA.A.42.0018

Toyen was a leading painter of the Czech
Surrealist group which was officially launched
in Prague in 1934 (see cat.437). Following
Breton's and Eluard's triumphant lecture tour
to Prague in 1935, which coincided with the
first exhibition of Czech Surrealism, she visited
Paris herself. In 1947 she settled there
definitively, becoming a crucial ally for Breton
in his attempt to reanimate the movement in
the aftermath of the war.

215

ANDRÉ BRETON & ANDRÉ MASSON

Martinique charmeuse de serpents

avec textes et illustrations de André Masson

Paris, Editions du Sagittaire, 1948

With texts by Breton and Masson, and 1 lithograph
and other illustrations by Masson
Edition of 625, nos.13–107 on Marais crève-cœur
paper, with a lithograph by André Masson; this copy
no.38

Format: 116pp.; illustrated, lithograph printed in red
before half-title and seven other plates in blue or
black by Masson; pb., cover design by Masson;
19 × 14.2; lithograph 13 × 10.8, monogrammed in
the stone
GMA.A.42.0043

This opens with André Masson's 'Antille' and
his and Breton's 'Dialogue créole'. The latter
text was written in the spring of 1941 in
Martinique, where both men had stopped *en
route* for New York and which they explored
together, revelling in the unfamiliar beauty of
the landscape. Various other wartime texts by
Breton – most of which, like 'Le Dialogue
créole' had already been published elsewhere –
were added to make *Martinique charmeuse de
serpents* a more substantial book. Among these
texts are 'Des épingles troublantes', a collec-
tion of prose poems inspired by the beauty of
the island, and 'Un Grand Poète noir', Breton's
homage to the poet-diplomat Aimé Césaire,
who had accompanied him on trips into its
interior. The book is illustrated with an
original lithograph by Masson printed in red,
and reproductions of seven other drawings by
him all dating from 1941. Breton's relationship
with Masson had several violent ups and
downs, all occasioned by ideological differ-
ences, but his admiration for Masson's work
seems never to have wavered. They first met in
1924, but fell out five years later when Breton
denounced Masson in the Second Surrealist
Manifesto. They were reconciled in 1936, and
from then on until they quarrelled again in
New York in 1943 were very close. Ironically,
when *Martinique charmeuse de serpents* was
published in August 1948 they were no longer
on speaking terms. (For further details, see L.
Saphire and P. Cramer, *André Masson. The
Illustrated Books: Catalogue Raisonné*, Geneva,
1994, no.24.)

216

ANDRÉ BRETON & F-H. LEM

Océanie

Avant-propos et poèmes inédits d'André
Breton

Paris, Andrée Olive, 1948

Exhibition catalogue with preface and poems by
André Breton and introduction by F-H. Lem
Format: 46pp.; illustrated; pb.; 21.1 × 15.7
GMA.A.42.0017

Breton wrote the preface to this exhibition
catalogue, which also includes a group of short
poems dedicated to the Oceanic gods Tiki,
Dukduk, Rano Raraku, Korwar and Uli. He lent
many of the pieces on display from his
extensive personal collection. Breton acquired
his first Easter Island carving when he was still

only a boy and remained enthralled by primitive art for the rest of his life. In this essay he evokes his and the other Surrealists' passionate admiration for the 'marvellousness' of Oceanic art and their perpetual quest at home and abroad for yet finer or rarer examples of carvings which they considered authentically surreal in essence. And he explains that for him, at least, African art was too concerned with the representation of reality to exert anything like the same influence over his imagination and vision. F-H. Lem's catalogue introduction is a more conventional, ethnographic account of Oceanic art.

217

ANDRÉ BRETON

Flagrant délit

Rimbaud devant la conjuration de l'imposture et du truquage

Paris, Thésée, 1949

Format: 70pp.; pb., illustrated cover; 24 × 18.8
GMA.A.42.0009

In May 1949 Breton became involved in a raging literary debate over the authenticity of a poem attributed to Rimbaud entitled 'La Chasse spirituelle'. The poem was 'discovered' by the critic Pascal Pia and published by Gallimard in the spring of 1949 as a lost work by Rimbaud. Maurice Nadeau, author of the popularising *Histoire du Surréalisme* (first published in 1945–46), lent his support. Breton was, however, firmly convinced the poem was a fake, and he was soon proved right. In July 1949 he published *Flagrant délit*, in which he denounces the 'imposture' and defends Rimbaud's reputation against what he regarded as a calumny. The cover of the book reproduces the Douanier Rousseau's lithograph *La Guerre*, first published by Alfred Jarry, another of Breton's heroes, in *L'Ymagier* in January 1895.

218

ANDRÉ BRETON & BENJAMIN PÉRET

Almanach surréaliste du demi-siècle

La Nef. Calendrier tour du monde des inventions tolérables

Paris, Editions du Sagittaire, 1950

Format: 226pp.; illustrated; pb.; 23 × 14
GMA.A.42.0338

This was formerly in the library of Marcel Mariën.

219

ANDRÉ BRETON

Anthologie de l'humour noir

Paris, Editions du Sagittaire, 1950

Revised edition
Format: 354pp.; illustrated; pb.; 22.6 × 14.2
GMA.A.42.0343

220

ANDRÉ BRETON

Ce que Tanguy voile et révèle

Rome, Galleria dell'obelisco, 1953

Yves Tanguy exhibition catalogue, Galleria dell' obelisco, Rome, February 1953
8pp. fold-out sheet; illustrated; 22.3 × 16.5 (folded)
GMA.A.42.0294.1

221

MAX BUCAILLE

Les Cris de la fée

Seize collages de Max Bucaille

Paris, G. L. M., 1939

Edition of 650, with nos.51–650 printed on Normandy vellum; this copy no.522
Format: 18 sheets; illustrated with reproductions of 16 collages by Bucaille; loose-leaf in paper cover; 26 × 16.6 (sheet size)
GMA.A.42.0296

This collage picture-book reflects the profound influence of Max Ernst's collage novels on artists in the Surrealist orbit. Like Ernst, Bucaille has relied primarily on late nineteenth-century engravings from illustrated magazines and used the collage method to disclose their latent strangeness. The sequence of images is prefaced by a quotation from Novalis, the German Romantic poet much admired by the Surrealists: 'An image is not an allegory, is not a symbol standing for something else, it is the symbol of itself.'

222

J-F. CHABRUN, MARC PATIN & J-V. MANUEL

Les Déserts de l'enthousiasme

Avec un dessin de J-V. Manuel et un certificat de lecture de Marc Patin

Paris, Editions de la Main à Plume, 1942

Two copies
a. Edition of 20; with 1 example with an original drawing by J-V. Manuel and mss. numbered 1, 6 with a print by Manuel numbered 2–7 and 12 numbered 12–20; this copy no.1
Format: 16pp.; illustrated frontispiece by J-V. Manuel; pb.; 19 × 14
Enclosed at end, original ms. poems, *Les Déserts de l'enthousiasme / Février 1942 / JF Chabrun* and *Inutile Pitié* signed by Marc Patin, 16pp.; pen, ink and gouache drawing by Manuel, 19.2 × 14.3, signed in image bottom right *J-V. Manuel–42*

GMA.A.42.0080
b. A second unnumbered regular copy inscribed on half-title: *A Georges Hugnet / ce plan d'irrigation / Des déserts de l'enthousiasme / en toute sympathie / J-F. Chabrun*
GMA.A.42.0081

Patin and Manuel, like Chabrun, were active in the Main à Plume group which sought to ensure the survival of the Surrealist message during the Occupation. Like *L'Illusion réelle* (cat.183) by Arnaud, Chabrun and Gagnaire, this was published in February 1942 and has a similar format.

223

RENÉ CHAR

Artine

Paris, Editions Surréalistes, 1930

Edition of 215; this copy no.143 of 183 on Ingres rose paper numbered 31–215
Format: 33pp.; pb.; 23.5 × 18.6; inscribed on half-title: *à Maurice Heine / Très sincère sympathie / René Char*
Enclosed, publisher's notices for *Artine* and ms. letter from René Char dated 23 May 1933
GMA.A.42.0335

Char sent this copy of *Artine* to Maurice Heine, who was active in the Surrealist movement during the 1930s and who contributed several important essays to *Le Surréalisme au Service de la Révolution* (cat.434). Heine was the leading French scholar and editor of de Sade's works, publishing *inter alia* the first version of *Juliette*, under the title *Les Infortunes de la vertu*, in 1930 with a dedication to the memory of Apollinaire and to his Surrealist friends. Another major enterprise was his authoritative edition of *Les 120 Journées, ou l'école du libertinage*, which came out in two volumes in 1931–35. Char's formal letter to Heine accompanying the gift of his book is dated 23 May 1933 and expresses his ardent hope that they would meet one day: 'Thanks to you I have experienced unforgettable revelations. I have made progress through your advice. I have seen Sade.'

This was purchased from John Armbruster, Paris, at an unrecorded date.

224

RENÉ CHAR

Dépendance de l'adieu

Repères 14

Paris, G. L. M., May 1936

With a frontispiece after a drawing by Pablo Picasso
Edition of 70; this copy no.10
Format: 20pp.; illustrated frontispiece; loose-leaf in red cover; 25.3 × 19.5; inscribed on colophon: *Guy Lévis-Mano*
GMA.A.42.0136.03

225

RENÉ CHAR & VALENTINE HUGO

Placard. Pour un chemin des écoliers

Paris, G. L. M., 1937

With illustrations by Valentine Hugo
Edition of 334; this copy no.203
Format: 36pp.; illustrated, reproductions of 5
etchings; pb.; 25.2 × 19.3; inscribed on half-title: *A
Paul Nougé / Les buissonnées s'embrasèrent. / René Char / avec
ma / toujours vive sympathie / Valentine Hugo*
GMA.A.42.0375

Mrs Keiller purchased this from John
Armbruster, Paris, in April 1978. It was formerly
in the collection of Marcel Mariën. Char's
introductory text, dated March 1937, is dedi-
cated to the 'Children of Spain' massacred
during the Spanish Civil War. It is printed
opposite a drawing by Valentine Hugo which
depicts the child victims of these atrocities and
echoes in its inscription Char's exclamation of
horror, 'Honte! Honte! Honte!' (Shame!,
Shame! Shame!). Hugo was active in the
Surrealist movement during the 1930s,
financing various ventures, joining in collective
games such as the *cadavre exquis*, and above all
providing shadowy, Symbolist-style portraits
and illustrations for books of poems by her
Surrealist friends.

226

RENÉ CHAR

Le Marteau sans maître
suivi de Moulin premier 1927–1935

Paris, Librairie José Corti, 1945

With etching by Pablo Picasso
Edition of 985, with 25 copies on Vergé d'arches paper
numbered 1–25, each containing an etching by
Picasso; this copy no.4
Format: 108pp.; illustrated with etching inserted at
title-page; pb.; 23.2 × 14.5; etching 16.5 × 10.8 (sheet
size 22.6 × 14.2); signed on colophon by Picasso
GMA.A.42.0297

The first edition of *Le Marteau sans maître* was
published in 1934 (Paris, José Corti) with a
drypoint by Kandinsky as its frontispiece.
Picasso admired the book at the time and readily
agreed to provide an etching for the second
edition, which reprints the original five
collections of poems and adds a new group
entitled 'Moulin premier.' Picasso's etching
depicts a woman in a hat and is dated 9 January
1945 in the copperplate. (For full details, see B.
Baer, *Picasso. Peintre-graveur,Vol. III, Catalogue
raisonné de l'oeuvre gravé et des monotypes, 1935–
1945*, Berne, 1986, no.699; also S. Goeppert, H.
Goeppert-Frank and P. Cramer, *Pablo Picasso.
The Illustrated Books: Catalogue Raisonné*, Geneva,
1983, no.42.) This copy was purchased from
John Armbruster, Paris, at an unrecorded date.

227

JEAN PAUL COLLET

Flaques

Poèmes ornés de trois eaux-fortes originales de
Kurt Seligmann

Paris, Les Ecrivans Réunis, 1935

With etchings by Kurt Seligmann
Edition of 140, plus 5 examples marked A -E, on
Hollande van Gelder paper, with 3 etchings by
Seligmann; this copy no.55
Format: 32pp.; illustrated; pb.; 28 × 21.4 overall (pp.
of various sizes); etchings: 18 × 12.8 (page size
22.8 × 16)
GMA.A.42.0295

Seligmann's three etchings are quite close in
imagery and style to those in *Les Vagabondages
héraldiques*, 1934 (see cat.229), and particularly
to *La Parachûtiste* (cat.160). Mrs Keiller pur-
chased this copy through Tony Reichardt at an
unknown date.

228

PIERRE COURTHION

Bal

Paris, G. L. M., 1935

With a frontispiece by Kurt Seligmann
Edition of 125; this copy no.114
Format: 20pp.; illustrated frontispiece; pb.; 22.2 ×
16.1; flyleaf has book-plate printed with initials *j &g*
GMA.A.42.0358

This slim volume of poems by Courthion has a
frontispiece by his friend Kurt Seligmann in a
similar style to that of the etchings in *Les
Vagabondages héraldiques* (see cat.229).

229

PIERRE COURTHION
& KURT SELIGMANN

Métiers des hommes

Paris, G. L. M., 1936

Edition of 530 of which 500 numbered 31–530 were
printed on Vélin d'arches paper; this copy no.142
Format: 70pp.; illustrated with photo-reproductions
of 15 etchings by Seligmann; pb., bound with 3
butterfly clips; 25.2 × 18.8
GMA.A.42.0298

This is the renamed, photomechanically
reduced version of Pierre Courthion and Kurt
Seligmann, *Les Vagabondages héraldiques*, which
was published in 1934 in a total edition of 105
in Paris by Editions des Chroniques du Jour.
(Seligmann's *La Parachûtiste* was the second
etching in the series, see cat.160.)

Mrs Keiller purchased this copy from H. A.
Landry, London in August 1975.

230

RENÉ CREVEL

Dalí ou l'anti-obscurantisme

Paris, Editions Surréalistes, 1931

Edition of 616; this copy no.262
Format: 32pp.; illustrated with photo-reproductions
of works by Dalí; pb.; 22 × 15.8
Enclosed between text and plates is an exhibition
catalogue *Exposition Salvador Dalí*, Pierre Colle, Paris,
June 1931 (see cat.236)
GMA.A.42.0253

Published in late November 1931, this was the
first monograph devoted to Dalí's work and is
illustrated with photographs of ten recent
paintings, including the notorious *Jeu lugubre*
of 1929.

231

RENÉ CREVEL

Mr Knife, Miss Fork

Paris, The Black Sun Press, 1931

Translated by Kay Boyle, with photograms and cover
design by Max Ernst
Edition of 255; this copy no.12
Format: 46pp.; illustrated with 19 photograms after
frottages by Ernst; hb.; 18.5 × 12.5
GMA.A.42.1022

René Crevel was an important figure in the
Surrealist group from the time of the *époque des
sommeils* (1922–24) – when he rivalled Desnos
in his propensity to fall into a trance – until his
suicide in 1935. A prolific writer, he published
a series of Surrealist 'novels' in the 1920s,
including *Babylone* which first came out in
1927. The text of *Mr Knife, Miss Fork* is an
excerpt from the latter book, and was trans-
lated by Kay Boyle, the second wife of Laurence
Vail (see cat.165). Crevel's story revolves
around a child living in a bourgeois house and
the wild fantasies about sex, desire and death
which beset her as she daydreams about the
illicit love affair between her father and her
cousin Cynthia. In the extract published in the
present book she identifies her knife and fork
with the runaway couple – hence the pseudo-
nursery story title.

Taking his cue from passages in the text,
Ernst created a series of nineteen illustrations
which brilliantly evoke the prevailing atmos-
phere of hallucination and dream. Printed in
negative in white on black, these are reproduc-
tions of frottages taken from the embossed
surfaces of greetings cards, book covers, and
the like, and thus follow up the achievement of
Histoire naturelle (cat.269). Man Ray was
involved in the project and helped Ernst make
the reproductions of his drawings using a
technique close to *cliché verre*. Ernst made the
original drawings on thin, translucent paper so

that light could pass through them and expose the areas of photosensitive paper underneath, which were not blocked out by the drawn or rubbed design. Ernst also designed the elaborate cover in black with gold tooling which parodies the style of nineteenth-century book binding. (For further details, see A. Hyde Greet, 'Max Ernst and the Artist's Book: From *Fiat Modes* to *Maximiliana*', in *Max Ernst. Beyond Surrealism. A Retrospective of the Artist's Books and Prints*, New York and Oxford, 1986, pp.98–102 and no.30. The original frottages for *Mr Knife, Miss Fork* are nos.1724–1742 in W. Spies and S. and G. Metken, *Max Ernst. Werke 1929–1938*, Menil Foundation, 1979.) Mrs Keiller purchased her copy through Tony Reichardt, London, in March 1977.

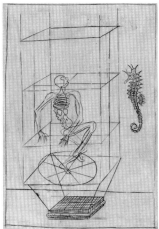

232 / Etching by Giacometti

232

RENÉ CREVEL

Les Pieds dans le plat

Paris, Editions du Sagittaire, 1933

Edition of 15 with an etching by Alberto Giacometti; this copy unnumbered
Format: 360pp.;illustrated with etching inserted at title-page; pb.; 18.5 × 12; etching: 12.5 × 8.8 (sheet size 18.9 × 12), inscribed in pencil below image left: *Epreuve d'essai* and below image right: *Alberto Giacometti / pour George Hugnet*; also enclosed is publisher's leaflet for the book
GMA.A.42.0086

Giacometti and Crevel were very close friends and it was therefore fitting that Giacometti should be asked to provide the frontispiece for the fifteen de-luxe numbered copies of *Les Pieds dans le plat*, Crevel's Surrealist anti-novel. The etching slipped into the unnumbered Keiller copy of the book is an early state. It differs very slightly from the etching included in the de-luxe copies. Preceded by a preparatory ink drawing (coll. Gottfried Keller Foundation), it is probably Giacometti's first published etching or engraving on a metal plate.

Giacometti was deeply saddened by Crevel's suicide in June 1935, which followed soon after his own acrimonious departure from the Surrealist group, and in 1965 provided an etching for Crevel's posthumously published *Feuilles éparses*.

233

NANCY CUNARD

Poems (Two) 1925

London, The Aquila Press, 1930

Cover design by Elliott Seabrooke
Edition of 150 printed by hand; this copy no.30 signed by the author
Format: 20pp.; hb.; 28.8 × 19.8
GMA.A.42.0252

The two poems published in this slim volume are 'Simultaneous', 1924, and 'In Provins,' 1925. The cover was designed by Elliott Seabrooke, a close friend of the author's. Nancy Cunard was an heiress of the Cunard shipping dynasty and a flamboyantly glamorous socialite, who was to be seen at all the most fashionable events in Paris in the 1920s. Somewhat to Breton's dismay – he feared the contamination of her wealth and worldly contacts – she embarked on a passionate affair with Aragon in 1926, but abandoned him two years later for the black American jazz pianist, Henry Crowder. Like Tristan Tzara, with whom she was on friendly terms, she was a keen collector of 'primitive' art. In 1928 she founded her own private press.

234

SALVADOR DALÍ

La Femme visible

Paris, Editions Surréalistes, 1930

Two copies
a. Edition of 175; this copy no.38, one of 10 numbered 31–40 on Ingres rose paper
Format: 76pp.; illustrated, including frontispiece etching by Dalí and 2 marginal drawings; bound into back are 7 plates on white hand-made paper (3 etchings and 4 photographs); pb. re-bound within hb. white leather cover; 28.5 × 22.5; etching: 24.6 × 20 (page size 27.8 × 22); inscribed on half-title: *A Paul Eluard avec toute l'amitié et admiration / Salvador Dalí*
GMA.A.42.0210
b. Edition of 175; this copy no.121
Format: 76pp.; illustrated, including frontispiece etching by Dalí; 28.5 × 22.5; etching: 24.6 × 20 (page size 28.2 × 21.8)
GMA.A.42.0211

La Femme visible was published in December 1930. It is a collection of recent texts by Dalí of which the most celebrated is 'L'Ane pourri' (The Stinking Ass) – his first account of the 'paranoiac-critical method'. (This had already

appeared in *Le Surréalisme au Service de la Révolution*, no.1, in July 1930.) The book bears a general dedication to Gala, whom Dalí had met the previous summer at Cadaqués and who left her husband, Paul Eluard, on his account. An arresting photograph of her as the artist's personal muse appears on a page to itself inside the front cover, and her presence is felt as an intense and pervasive 'aura' throughout everything that follows: Gala is clearly 'the visible woman' of the title, and would be the heroine of innumerable other works by Dalí. The frontispiece, on the other hand, is a heliogravure reproducing an elaborate pen and ink drawing of a pullulating mass of naked bodies engaged in uninhibited sexual acts (R. Michler and L. W. Löpsinger, *Salvador Dalí. Catalogue Raisonné of Etchings and Mixed-Media Prints.1924–1980*, Munich, 1994, no.4). This is presented as a pure masturbatory fantasy, and as such relates not to Gala herself but to the text entitled 'Le Grand Masturbateur' which is included in *La Femme visible*.

Mrs Keiller owned two copies of the book. One is of extreme historical interest because Dalí presented it to Paul Eluard, and not only dedicated it to him, but ornamented the margins of two pages of 'Le Grand Masturbateur' with highly erotic signed drawings, executed in the same bright pink ink he used for the dedication. Eluard's copy of *La Femme visible* is printed on pink Ingres paper, and bound in at the back is a second print of the frontispiece, reproductions of other drawings and photographs, and the publisher's 'puff' for the book signed by Breton and Eluard which praises Dalí in fulsome terms for his fearless exploration of desire and rejection of bourgeois morality.

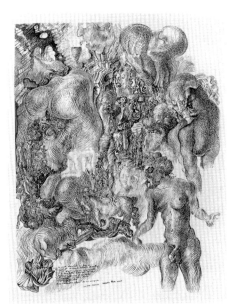

234 / Frontispiece by Dalí

235

SALVADOR DALÍ

L'Amour et la mémoire

Paris, Editions Surréalistes, 1931

Edition of 310; this copy no.202
Format: 27pp.; illustrated frontispiece; pb.; 19 × 14;
inscribed on half-title: *A George Hugnet très
amicallement* [sic] / *Salvador Dalí*
GMA.A.42.0357

Dalí's star was very much in the ascendant
when this was published in December 1931.
His various triumphs in Paris in 1929–30 were
consolidated by a one-man exhibition at the
Galerie Pierre Colle in June 1931 (see cat.236),
two important contributions to *Le Surréalisme au
Service de la Révolution*, nos.3 and 4 (both
published in December 1931), and by the
publication of *L'Amour et la mémoire*. His
breakthrough in New York came a month later
in January 1932 when *La Persistance de la mémoire*,
famous for its soft, melting watches, was
shown in a mixed Surrealist exhibition at the
Julien Levy Gallery. For its frontispiece *L'Amour
et la mémoire* has an arresting photomontage by
Dalí of himself with a shaven head leaning
against a wall and a smiling Gala framed by
cypress trees. Buñuel took the photograph of
Dalí in 1929, and Dalí took that of Gala in 1931.
Dalí presented this copy to Georges Hugnet,
who joined the Surrealist movement in 1932.

236

SALVADOR DALÍ

Exposition Salvador Dalí

Paris, Pierre Colle, 1931

Exhibition catalogue, June 1931
Format: 6pp. fold-out; illustrated; 14 × 10.5 (folded)
GMA.A.42.0253.1

This is the catalogue of Dalí's first one-man
exhibition at the Galerie Pierre Colle in Paris.
The show consisted of twenty-four recent oils
and pastels: some, like *Le Jeu lugubre* (The
Lugubrious Game) 1929, had already caused a
scandal because of their scatological content;
others, like *La Persistance de la mémoire* (The
Persistence of Memory), were brand new. Also
on show were 'three Art Nouveau objects'. In
his brief but ornately worded preface Dalí
dilated upon the 'oneiric', 'hallucinatory' and
'delirious' character of Art Nouveau decora-
tion, and Guimard's 'transcendental' en-
trances to the Métro in particular. Dalí's
Freudian interpretation of Art Nouveau – like
his Freudian reading of Millet's *L'Angélus* – was
not only a *leitmotif* of his critical writings in the
1930s but was echoed in his paintings, which
often incorporated explicit references to its
style and imagery. Art Nouveau was generally

despised and ridiculed at this period; Dalí's re-
evaluation of the style is typical of the Surreal-
ists' tireless efforts to counteract conventional
taste and promote a Surrealist conception of
the world at every level.

237

SALVADOR DALÍ

Unpublished film script, with
illustrations, for proposed
documentary on Surrealism

c.1931–1932

Thirteen pages of text with pen and ink drawings (on
pp.6,7,8 and 10) and 3 photographs including Man
Ray's *Indestructible Object* bound together in hb. cover;
inscribed: *Salvador Dalí*; 33 × 24
GMA.A.42.0471

This is the scenario of a film about Surrealism
which Dalí planned to make but which came to
nothing. The manuscript runs to thirteen typed
pages of text, has numerous handwritten
annotations and corrections, and is
ornamented with many pen and ink drawings
in the margins. On the first page the project is
described as a 'Film documentaire de Salvador
Dalí avec la collaboration effective du groupe
Surréaliste' (A documentary film by Salvador
Dalí made with the collaboration of the
Surrealist group); we are also informed that
'les documents surréalistes' (Surrealist
documents) will be essential for the comple-
tion of the film and its ultimate success.
Included with the manuscript are three
photographs: a photograph of six studies
revealing the layered, 'paranoiac' imagery of
Dalí's painting *Invisible Sleeping Woman, Horse,
Lion*, 1930; a black and white reproduction of
his *The Persistence of Memory*, 1931; and an
original photographic print of Man Ray's
Indestructible Object, 1923. These were, no doubt,
three of the 'Surrealist documents' Dalí
intended to use in the film. The episodes
planned include the recital of key definitions of
Surrealism (such as 'Surrealism can be
practised by everyone'), demonstrations of
automatic writing and the creation of *cadavres
exquis* (see cat.9); a discourse on Freud, with
particular reference to his concepts of the
unconscious and the pleasure principle, and an
account of Dalí's 'paranoiac-critical method'.
A final 'oration' was to be delivered by André
Breton.

Breton's involvement in this abortive
project can only be guessed at, but it is highly
likely – given the film's informative, not to say
didactic, character – that he had a very active
rôle. Quite possibly the whole thing was his
idea, and he chose Dalí as his *cinéaste* because

Dalí had some experience of making films. The
date of the script is not certain. Given the
reproduction of *The Persistence of Memory* and the
references to Dalí's 'paranoiac-critical
method', it cannot be earlier than 1931. On the
other hand it might be a few years later, since
Breton's determined efforts to open Surrealism
up to a significantly larger audience became
more noticeable around 1933–34. We might
compare this project for a film to Breton's –
equally abortive – efforts to put on a series of
public conferences about Surrealism in 1935
(see cat.202). Be that as it may, Dalí's own
fascination with film-making cannot be
doubted. Apart from his involvement in *Un
Chien andalou* (1929) and *L'Age d'or* (1930), there
is his film script for *Babaouo* (1932; cat.238). In
1936 came the unsuccessful attempt to make a
film with the Marx Brothers, but in 1945 he
successfully created the 'dream sequence' for
Hitchcock's *Spellbound*.

The present manuscript formerly belonged
to Georges Hugnet. Mrs Keiller purchased it at
an unknown date through Tony Reichardt,
London.

238

SALVADOR DALÍ

Babaouo
c'est un film surréaliste

Paris, Edition des Cahiers Libres, 1932

Edition of 623; this copy no.106
Format: 62pp.; illustrated; pb.; 19.3 × 14.5
GMA.A.42.0383

This contains three items, all springing from
Dalí's current obsession with the cinema as the
ideal vehicle for the expression of 'concrete
irrationality'. They are his 'Abrégé d'une
histoire critique du cinéma' (Abridged critical
history of the cinema); the scenario for
Babaouo, a new Surrealist film; and 'William
Tell. Portuguese ballet,' which is described as
an 'extract' from that film. A film of *Babaouo*
did not materialise, but photographs Dalí took
around this time give a good inkling of the
extraordinary effects he planned in what would
have been a follow-up to the sensational and
scandalous *Un Chien andalou* (1929) and *L'Age
d'or* (1930), made with Luis Buñuel.

Mrs Keiller purchased this from Hans
Bolliger, Zurich, in September 1975.

239

SALVADOR DALÍ

Metamorphosis of Narcissus

New York, Julien Levy Gallery, 1937

Translated by Francis Scarpe with cover design by
Cecil Beaton
Edition of 500 in French and 550 in English; this
copy unnumbered from American edition
Format: 30pp.; illustrated, 3 plates; pb. with dust-
jacket; 28.3 × 22.4
GMA.A.42.0213

Dalí published *Metamorphosis of Narcissus*
simultaneously in French (as *La Métamorphose
de Narcisse*, Paris, Editions Surréalistes) and in
English through the Julien Levy Gallery in New
York (translated by Francis Scarpe). It concerns
the important painting of the same title (now
in the Tate Gallery, London), and provides an
analysis of the layers of interconnected images
'obtained' by a sustained use of 'the paranoiac-
critical method'. Illustrated with photographs
of the picture in colour and black and white,
the book also contains Dalí's long poem on the
same theme which was composed using the
verbal equivalent of 'the paranoiac-critical
method'. The book was published with a
general dedication to Paul Eluard.

The cover of this, the American edition,
reproduces one of Cecil Beaton's photographs
of Dalí and Gala acting out a series of tableaux
vivants inspired by Millet's *L'Angélus*, and
posing with the pair of torso-shaped canvases
entitled *Couple with Heads full of Clouds* which are
another of Dalí's numerous homages to
Millet's famous painting.

240

SALVADOR DALÍ

Salvador Dalí

New York, Julien Levy Gallery, 1939

Exhibition catalogue, [March] 1939
Format: 2pp.; illustrated with photographic
reproduction of *The Endless Enigma* with transparent
overlays; pb; 32.1 × 25.4
GMA.A.42.0456

In this catalogue Dalí provided an account of
his 'paranoiac-critical method' and a detailed
analysis of the multi-layered 'paranoiac'
imagery of his painting *The Endless Enigma*
(*L'Enigme sans fin*). To do so he attached a series
of transparent overlays, each printed with the
schematic outline of one of the layers of
imagery, on a photograph of the painting. This
copy belonged formerly to the Belgian
Surrealist Marcel Mariën; Mrs Keiller pur-
chased it from John Armbruster, Paris, in April
1978.

By 1939 Dalí was already a celebrity and this
exhibition of recent paintings at the Julien Levy

Gallery, which opened on 21 March, attracted a
constant stream of bewildered spectators. The
crowds were drawn by colourful press reports
of a fracas on 16 May when Dalí, who was
designing an elaborate décor, involving a fur-
lined bath and shop mannequins for the
Bonwit Teller store on Fifth Avenue, became
enraged by changes which had been made
without his consent and crashed through the
shop window onto the street. His subsequent
arrest by the police, followed by his immediate
release, made him a household name and the
show was an instant sell-out. To crown this
success came commissions to design a stand
for the amusement park of the World's Fair in
New York – Dalí responded by creating *The
Dream of Venus* – and to design the curtain and
décor for a production of Wagner's *Tannhaüser
'Bacchanale'* for the Metropolitan Opera House.

241

TONI DEL RENZIO

Manifesto ... incendiary innocence
An Arson Pamphlet

London, Toni del Renzio, The Favil Press, 1944

Format; pamphlet 8pp.; illustrated cover; pb.;
21 × 13.4
GMA.A.42.0988

Toni del Renzio joined the English Surrealist
group in the latter part of 1940, immediately
becoming an active and vocal figure. In March
1942 he published *Arson* (cat.403), and at the
end of that year organised a Surrealist exhibi-
tion at the International Arts Centre. E. L. T.
Mesens, who had hitherto been a driving force
behind all the Surrealist exhibitions in
England, had no part in this event and a fierce
rivalry between the two men developed which
led to divisions within the group of Surrealists
in London. *Incendiary Innocence*, which came out
in April 1944, was Toni del Renzio's riposte to
Idolatry and Confusion published by Mesens and
Jacques Brunius in March.

242

ROBERT DESNOS

Deuil pour deuil

Paris, Editions du Sagittaire, 1924

Edition of 750; this copy unnumbered
Format: 102pp.; pb.; 15.6 × 11.8; inscribed in ink on
flyleaf: *à Charles Duhamel | ce livre à Colin Maillard | Paris
4.2.24 | Robert Desnos*
GMA.A.42.0034

Desnos was one of the most prominent poets
in the Surrealist movement during the *époque
des sommeils* (period of trances), which pre-
ceded the publication of Breton's first Mani-
festo in October 1924. He was particularly

famed for the extraordinary stories he re-
counted 'automatically' while asleep or in a
mediumistic state of trance. In a letter dated 18
March 1924 to his wife Simone Collinet, Breton
excitedly described a new development in his
friend's powers: 'Desnos has discovered a new
and marvellous faculty which consists in being
able to tell stories in the dark without having
fallen asleep, splendid stories, very compli-
cated and long, which are in no way compro-
mised by contradiction or hesitation. It's more
alarming than ever, and his state of mind is
very troubling: he has predicted his death
within three months.' In an article on Desnos
published in *Le Journal littéraire* in July 1924,
Breton praised him as the equal of Freud and
Picasso in his 'fanaticism'. (Both these texts
are reprinted in *André Breton. La beauté convulsive*,
Centre Georges Pompidou, Musée National
d'Art Moderne, Paris, 1991, pp.170–171.)

Deuil pour deuil, an automatic text dated April
1924, belongs to this period of Desnos's
ascendancy within the group. Having contrib-
uted regularly to *La Révolution Surréaliste*
(cat.432) in 1924–28, Desnos was, however,
one of those Breton expelled during the savage
purge of 1929.

243

ROBERT DESNOS

Corps et biens

*Paris, Librairie Gallimard, Editions de la
Nouvelle Revue Française, 1930*

Format: 193pp.; pb.; 18.7 × 12
GMA.A.42.0077

244

ROBERT DESNOS

The Night of Loveless Nights

Antwerp, 1930

With illustrations by Georges Malkine
Format: 40pp.; illustrated with 3 reproductions of 3
etchings by Georges Malkine; pb. rebound in blue
cloth; 31.2 × 24.5; inscribed on flyleaf: *à Marcel — | à
la tienne Etienne | à la tienne mon vieux | à la tienne Etienne
| Marcel | Duhamel | le charmeur de gazelle | son ami |
Robert Desnos | 12 Fevrier 1930*
GMA.A.42.0304

Desnos gave this copy of his book of poems to
Marcel Duhamel who had associated closely
with the Surrealists in the mid- and late 1920s.
It then passed into Hugnet's collection. Mrs
Keiller bought it from John Armbruster, Paris,
at an unknown date.

Desnos was a founder-member of the
Surrealist movement but was among those
severely criticised by Breton in the Second
Manifesto in December 1929. He counter-
attacked in *Un Cadavre* (A Corpse), the jointly

written and extremely vitriolic pamphlet denouncing Breton which was published in January 1930 and which set the seal on the schism within the movement. Malkine had also been involved in Surrealism from the start, but not long after his exhibition at the Galerie Surréaliste in 1927 set off on prolonged travels in the South Seas, thus effectively cutting himself off from group activities.

245

ROBERT DESNOS

Le Vin est tiré... roman

Paris, Gallimard, 1943

Format: 206pp.; pb.; 18.7 × 12; inscribed inside front cover: *à Monsieur et Madame Cognet | en témoignage de dix ans | de vie dans ce même village | leur ami | Desnos*
GMA.A.42.0078

246

ROBERT DESNOS

Contrée

Paris, Robert-J. Godet, 1944

25 poems by Desnos with illustrations and etching by Picasso
Edition of 213; this copy no.51 with an etching by Picasso
Format: 61pp.; illustrated, etching inserted as frontispiece and 23 reproductions of different parts of the etching; pb. with transparent paper jacket embossed with spider and web motif.; 28.4 × 19.3; enclosed at front is etching: 24.6 × 13.2 (paper 29 × 19), inscribed in plate top right with inverted signature and date: *Picasso 23. D.43*
GMA.A.42.0268

Desnos and Picasso had known each other since the early 1920s but became much closer during the Occupation when both were living in Paris and frequenting the same circle of poets and artists, many of whom, like Eluard and Desnos himself, were involved in the Resistance. In December 1943 Desnos published an album of colour reproductions of Picasso's wartime paintings (*Seize peintures 1939–1943*, Paris, Editions du Chêne), and in the same month Picasso made the etching depicting a seated female nude which served as the frontispiece to *Contrée*, a collection of twenty-five of Desnos's recent poems. The text is illustrated with twenty-three reproductions of different sections of the etching, so that the reader discovers more and more of its complex linear structure as he or she turns the pages. (For full details see B. Baer, *Picasso. Peintre-graveur*, Vol. III, *Catalogue raisonné de l'oeuvre gravée et des monotypes, 1935–1945*, Berne, 1986, no.689; also S. Goeppert, H. Goeppert-Frank and P. Cramer, *Pablo Picasso. The Illustrated Books: Catalogue Raisonné*, Geneva, 1983, no.39.) Most of the poems in *Contrée* are militant in

tone, and in late February 1944, before the publication of the book on 31 May, Desnos was arrested by the Gestapo and deported to Czechoslovakia. He died in June 1945 as a result of his maltreatment during the previous fifteen months. The book is published with a general dedication to Youki, Desnos's companion from 1930 onwards.

247

Dictionnaire Abrégé du Surréalisme

Paris, Galerie des Beaux-Arts, 1938

Edited by André Breton and Paul Eluard, with cover design by Yves Tanguy
Format: 76 pp.; illustrated; pb.; 24.1 × 15.6; inscribed inside front cover in pencil: *Joe Tilson*
GMA.A.42.0280

This was published to coincide with, and be in effect the catalogue of, the current *Exposition Internationale du Surréalisme* which Breton and Eluard organised at the Galerie des Beaux-Arts in Paris in January-February 1938. The exhibition was designed to be a spectacular 'happening' and to reveal the international spread of the movement; over 60 artists from 15 different countries were represented, and the dramatic installation, which was stage-managed by Duchamp and featured a 'street' of fantastically dressed Surrealist mannequins, was as important to its impact as the 300-odd works on display. The *Dictionnaire* parodies the ever-popular *Petit Larousse illustré* in its lay-out and in the eclectic mix of texts, images and quotations, definitions of words and bio-graphical entries.

Mrs Keiller purchased this copy through Tony Reichardt at an unknown date.

248

KATHERINE S. DREIER

Western Art and the New Era

New York, Brentano's, 1923

Format: 140pp.; illustrated; hb.; 26 × 18; inscribed in ink on flyleaf: *For | Moholy-Nagy & his wife | In memory of a delightful afternoon in The Ha... . [?] where | both spent the day with me | Cordially | Katherine S. Dreier | August 4th | 1938*
GMA.A.42.0374

Katherine Dreier was the President of the Société Anonyme Inc., which was founded in New York in April 1920 by herself, Duchamp and Man Ray. The purpose of this pioneering organisation was to assemble a large perma-nent collection of modern art, to present exhibitions, and to sponsor lecture series and publications. Dreier herself became a major collector, owning *inter alia* Duchamp's masterpiece *The Large Glass*. After her death in

1952, with Duchamp acting as executor, her collection was divided between several American museums, including the Philadel-phia Museum of Art, the Museum of Modern Art, New York, and Yale University Art Gallery.

249

MARCEL DUCHAMP

La Mariée mise à nu par ses célibataires, même
[Boîte verte]

Paris, Editions Rrose Sélavy, 1934

De-luxe edition of 20 copies, signed and numbered in Roman numerals, with initials M D in copper on box; this copy no. XIII, signed and dated by the author
Format: 93 assorted documents and 1 colour plate mounted under glass; in green box, with initials M D marked out recto and verso in copper strip, with title punched in mirror image in small holes on front; interior lined with green flocked paper, inscribed on spine inside: *cette boîte no. XIII | XX doit contenir 93 documents: photos, dessins et notes des années 1911–1915 | ainsi qu'une reproduction en couleurs sous verre et une page de manuscrit*; signed in blue ink *Marcel Duchamp 1934*; inside back has coloured plate under glass, inscribed: *neuf moules mâlic (verre – 1m- long. - 1913 –14) coll. H. P. Roché*, and POUR HUGNET in punched holes in flocking; 33 × 28
GMA.A.42.1012

Colour plate 49

Usually referred to as the *Boîte verte* (*Green Box*), this is the essential companion piece to Duchamp's masterwork *La Mariée mise à nu par ses célibataires, même* (The Bride Stripped Bare by her Bachelors, Even or Large Glass), which was abandoned as 'definitively unfinished' in 1923 (Philadelphia Museum of Art). In an interview towards the end of his life, Duchamp ex-plained: 'I wanted that album to go with the "Glass", and to be consulted when seeing the "Glass", because as I see it, it must not be "looked at" in the aesthetic sense of the word. One must consult the book, and see the two together. The conjunction of the two things entirely removes the retinal aspect [i. e. the appeal to the eye] that I don't like' (Pierre Cabanne, *Dialogues with Marcel Duchamp*, London, 1971, pp.42–43). Ironically, when Duchamp made the *Boîte verte* – he published it through his own Editions Rrose Sélavy in September 1934 – the *Large Glass* was inaccessi-ble, having been badly damaged in 1931. (He did not repair it until 1936.)

The *Boîte verte* gets its name from the slim, green flocked cardboard box into which Duchamp packed the contents of his 'album'. Within each copy are 93 facsimiles of the manuscript notes, preparatory drawings, and photographs Duchamp made between 1911 and 1915 when he was planning the *Large Glass*, plus

one colour plate of 9 *Moules Malic* (9 Malic Moulds) 1914–15, mounted under glass on the inside lid. In preparing these facsimiles in 1934, Duchamp adopted the most time-consuming and meticulous methods, scouring the specialist suppliers in Paris for papers that were exactly like those on which he had orginally made his notes, and for lithographic inks of exactly the same colour as the inks, etc. he had used. He then made a template for each note – they had been written for the most part on stray scraps of paper – and, once printed, the facsimiles were torn by hand around the templates. Since the *Boîte verte* was issued in a total edition of 320, this meant that each note had to be torn 320 times. The notes, etc. are not numbered and their order within each *Boîte* was always random: the 'reader' therefore has to rummage around and create his or her own sequence. There is no correct order; no once-for-all interpretation of what are in any case extremely cryptic notes and plans is possible (or desirable). With characteristic irony, Duchamp pretends to provide us with the key to his complex, symbolic masterpiece, but in fact presents us with an additional, unsolvable puzzle. In this way he ensures that we keep thinking.

There were twenty de-luxe copies of the *Boîte verte*, and most of them contained one of the original documents reproduced. The de-luxe copies were further distinguished from the regular ones, first by having thin copper strips pasted on the front and back of the box forming the initials M and D, and secondly by having the full title *La Mariée mise à nu par ses célibataires, même* formed in capital letters and in mirror image by punching small holes into the front cover. The present copy was made for Hugnet, and the words POUR GEORGES HUGNET are punched in the inside back cover. Mrs Keiller purchased it from John Armbruster, Paris, in October 1975. Some years later she was able to acquire from the same source Hugnet's copy of the *Boîte-en-valise* (cat.28), which Duchamp began working on in 1935 shortly after completing the *Boîte verte*.

250

MARCEL DUCHAMP

Rrose Sélavy

Paris, Editions G. L. M., 1939

Edition of 515 with nos.1–15 printed on Vieux Japon paper and nos.16–515 on Vélin blanc paper; this copy no.32
Format: 16pp.; pb.; 15.7 × 11.8; inscribed in ink on half-title: *très cher et très merci / Henri Parisot / Marcel Duchamp*
GMA.A.42.0062

Rrose Sélavy was Duchamp's feminine alter-ego; 'she' was 'born' in New York in the winter of 1920–21. A famous photograph by Man Ray of Duchamp as Rrose Sélavy dates from this period and 'she' henceforth lent her name to published puns and readymades. The present small volume gathers together the often elaborate puns Duchamp had invented to date. The first of them reads: *Rrose Sélavy trouve qu'un insecticide doit coucher avec sa mère avant de la tuer; les punaises sont de rigueur* (Rrose Sélavy thinks that an insecticide must sleep with his mother before killing her; bed bugs are *de rigueur*). Duchamp presented this copy to Henri Parisot, the editor of the collection in which it appeared. It was published in April 1939 when Duchamp was living in Paris. (He returned to America in June 1942.)

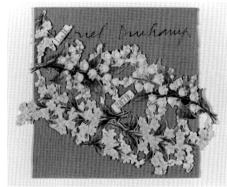

251 / Paper scrap sent by Duchamp to Hugnet

251

MARCEL DUCHAMP

Manuscript letters from Marcel Duchamp to Georges Hugnet 1941; receipt 1941; paper scrap and card sent to Hugnet 1953

4 ms. letters relating to the preparation of the *Boîte-en-valise* (cat.28); receipt from Lucien Lefèbvre-Foinet, 15 Octobre 1941; a deep-pink card with paper scrap and envelope, card signed in ink across top: *Marcel Duchamp*, envelope adressed: to *M. Hugnet / 9 ter Boul. du Montparnasse / Paris VII*, postmark *Paris 91 / Rue Cujas / 3. xi.1953*
GMA.A.42.1008

The four letters from Duchamp to Hugnet are undated but from the postmarks on two of them (24 March and 1 April 1941) we can situate them precisely. All of them concern the assemblage of two of the earliest of Duchamp's *Boîtes-en-valises*, one for Hugnet himself (cat.28) and the other for Mary Reynolds (alluded to simply as 'Mary' in the correspondence). Both *Boîtes* were completed except for their valises and a few finishing touches, and the letters are mainly concerned with arrangements with the saddler (Vilain, 25 rue Charlot, Paris) who was to cover the cases

in leather, and with the difficulties Duchamp was encountering in obtaining a *laisser-passer* to move in and out of the occupied zone. (Duchamp dated both completed *Boîtes* May 1941.) The fifth item is a receipt for 500 francs, dated 15 October 1941, on the headed paper of the artists' supplier Lucien Lefèbvre-Foinet; this presumably records Hugnet's payment to Duchamp for the one he acquired.

With these wartime documents is a hand-made greetings card from Duchamp to Hugnet (the envelope is postmarked 3 November 1953), consisting of a readymade paper scrap of flowers on a deep pink paper card.

252

MARCEL DUCHAMP

Lettre de Marcel Duchamp (1921) à Tristan Tzara

Paris, Pab, 1958

With a frontispiece by Tristan Tzara
Edition of 25; this copy no.17 signed on colophon by Marcel Duchamp
Format: 14pp.; illustrated, frontispiece celluloid etching by Tristan Tzara, 1958; pb.; 12.2 × 12.6; 9 pp. overall (various sizes); etching: 6.2 × 6.1 (page size 11.9 × 11) inscribed in pencil below image left: *17 / 25* and right: *TZARA*; inscribed at front: *pour Georges Hugnet / contrefacteur de marque / et affectueusement / Marcel Duchamp / 1961*
GMA.A.42.0460

Mrs Keiller purchased this rare item from John Armbruster, Paris, but the date is unrecorded. It was originally in Hugnet's collection – a gift to him from Duchamp in 1961. Tzara was the author of the frontispiece, an etching on celluloid which is dominated by Duchamp's name written in a deliberately childish script. The *Lettre* was published at the moment when Duchamp was fast becoming a cult figure within the avant-garde, and interest in the history of Dada was gathering momentum.

From its content it is clear that the original letter was written at the height of the period of internal squabbling within the Parisian Dada group which led first to splits and then to the formation of the Surrealist movement. Although Tzara and Duchamp ascribed it to 1921, various references Duchamp makes suggest that it was actually written during the autumn of 1922, after he had returned to New York from a six-month stay in Paris (June 1921–proposal to make money by marketing an insignia consisting of the four letters D A D A, to be worn 'as a bracelet, badge, cuff-links, or tie-pin', the cost to the purchaser being determined by the type of metal used. 'The act of buying the insignia will consecrate the buyer as Dada', Duchamp announces, and the

insignia would be a sort of: 'universal panacea, a fetish in a sense, something like Little Pink Pills.' It would be marketed globally, and Duchamp offers to 'take care of the United States' if Tzara handles Europe. 'Of course', he continues, 'this could cause a real controversy on the part of the True Dadas but all that could only be helpful for the financial return.' (For the translation of the full text, see M. Sanouillet and E. Peterson, *The Essential Writings of Marcel Duchamp*, London, 1975, pp.180–181.)

253

MARCEL DUCHAMP

Manuscript card to Bernard Reis from Marcel Duchamp

Concertina fold card dated 20 January 1964 with 14 portable plastic chess pieces stuck onto the card in 2 × 5 and 1 × 4 rows with strips of sellotape; 11.1 × 11.7 (folded), 11.1 × 46.2 (open); inscribed in biro: *Dear Bernard I have not forgotten your / black Rook- But / it has proliferated! / Belated wishes for 1964 / for Becky and yourself / Marcel Duchamp / 20 Jan.1964*; printed inside opposite chess pieces: MARCEL DUCHAMP: *Designs for Chessmen (1922) / Pen and ink, each panel 8 5 / 8 × 2" / The Museum of Modern Art, New York. Katherine S. Dreier Bequest.*; envelope for card addressed to *Mr Bernard Reis / 252 East 68th Street / New York City*; postmarked on envelope: *Jan 20 1964*; address on back: *Duchamp / 28 W.10 / N. Y. C*
GMA.A.42.1010

Duchamp was passionately devoted to the game of chess, which he had first learned to play as a boy. In 1918–19 when he was in Buenos Aires the game became a consuming obsession and he carved his own wooden chess set, relying only on a local artisan to make the knights; in 1943 he designed a pocket chess set especially for travellers. This folding card, sent as a belated New Year's greeting to Bernard Reis, a fellow enthusiast, is printed with the designs for chessmen Duchamp made in 1922 and has fourteen of his portable chess pieces stuck inside. Reis was the accountant and legal advisor to the art community in New York. During the war his home was a favourite meeting place for the Surrealist exiles and he was one of the sponsors of *First Papers of Surrealism* (cat.278), the exhibition organised by Breton and Duchamp in 1942. A keen collector of modern art, he commissioned a *Boîte-en-valise* from Duchamp (see cat.28).

254

PAUL ELUARD & MAX ERNST

Les Malheurs des immortels; révélés par Paul Eluard et Max Ernst

Paris, Librairie Six, 1922

Format: 42pp.; illustrated with reproductions of 21 collages by Ernst; pb.; 24.7 × 19; inscribed on half-title: *exemplaire de René Laporte / ce vieux livre est / encore assez montagnard / – malgré tout- / Paul Eluard*; frontispiece inscribed: *Portrait de Paul Eluard*
GMA.A.42.0340

Les Malheurs des immortels was the second book to result from the mutual sympathy between Eluard and Ernst. The two men had become close friends on their first meeting in Cologne in November 1921 when Eluard selected six recent collages to accompany his volume of poetry, *Répétitions*. (Eluard was already an admirer of Ernst's Dada work which had been exhibited at the Au Sans Pareil gallery in Paris in May 1921.) As soon as *Répétitions* came out in March 1922 they embarked on the more complete collaboration which resulted in *Les Malheurs des immortels*, published at the end of June. Together these astounding little books marked Ernst's triumphant entry into what would soon be known as the Surrealist movement, and in August 1922 he left Germany for good and settled in Paris.

In *Au-delà de la peinture*, an autobiographical essay written in 1936, Ernst describes the revelation of the collage technique which he used to such brilliant effect in *Les Malheurs des immortels*: 'One day in 1919, finding myself in rainy weather in a town on the banks of the Rhine, I was struck by the obsession exercised on my excited gaze by an illustrated catalogue containing objects for anthropological, microscopic, psychological, mineralogical, and palaeontological demonstration. There I found such distant elements of figuration that the very absurdity of this assemblage provoked in me a sudden intensification of the visionary capacities and gave birth to a hallucinating succession of contradictory images, of double, triple and multiple images, which were superimposed on each other with the persistence and rapidity characteristic of amorous memories and of hypnagogical visions. These visions called up new levels for their meetings in a new unknown (the unsuitable plane). Then it sufficed simply to add to these catalogue pages, by painting or drawing, and thus only docilely reproducing what was visible within me [...] to obtain a set and faithful image of my hallucination; to transform into dramas revealing my most secret desires that which had been nothing more than banal pages of advertising.' (Quoted from the translation in L.

Lippard (ed.), *Surrealists on Art*, Englewood Cliffs, New Jersey, 1970, p.128.)

Eluard dedicated this copy to René Laporte, a poet and friend who ran the short-lived publishing house Editions des Cahiers Libres. Among the important Surrealist texts Laporte published was Eluard's *La Vie immédiate* (1932) and Dalí's *Babaouo* (cat.238). Mrs Keiller bought this copy through Tony Reichardt at an unknown date.

255

PAUL ELUARD & BENJAMIN PÉRET

152 proverbes mis au goût du jour

Paris, La Révolution Surréaliste, 1925

Format: 29pp.; pb.; 18.4 × 13.4
GMA.A.42.0278

This booklet was published in January 1925. The authorship of the individual 'proverbs' is not given but can be deduced from a study of Eluard's surviving manuscript. Apparently, the two authors composed a large number of proverbs independently, pooled them, and then decided which ones to include and in what order. (For an analysis of Eluard's manuscript, see M. Dumas and L. Scheler (eds.), *Paul Eluard. Oeuvres complètes*, Vol. I, Paris, 1968, pp.153–161 and 1363–1367.) In form the booklet parodies anthologies of popular sayings and was cheaply produced as if for the mass market. The following are three typical examples (by Eluard): 'A naked woman is soon in love', 'Deaf as the ear of a church bell' and 'When an egg breaks eggs it is because it does not like omelettes.'

Mrs Keiller purchased this copy from H. A. Landry, London, in August 1975.

256

PAUL ELUARD & MAX ERNST

Au défaut du silence

Paris, [1925]

Edition of 50; this copy no.12
Format: 42pp.; illustrated with reproductions of 20 sheets of pen and ink portrait drawings of Gala Eluard by Ernst; pb.; 28.4 × 22.6
GMA.A.42.0273

Formerly belonging to Georges Hugnet, this rare book was purchased from John Armbruster, Paris, but the date is not recorded in his letter offering it to Mrs Keiller. It was published, anonymously, and undated early in 1925. The subject of Ernst's obsessively repetitive ink drawings is Gala, Eluard's dark-haired Russian wife and the inspiration of his early love poetry. On Ernst's first meeting with the Eluards in November 1921 he was instantly captivated by this powerful and charismatic

woman and a passionate affair soon developed, which was tolerated and even encouraged by Eluard himself as a means of drawing closer to the man whom he thought of as his ideal twin-brother and creative accomplice. Ernst's first marriage broke up and a *ménage à trois* was established when he moved to Paris in August 1922. At the end of that year Gala was the only woman depicted in *Au rendezvous des amis*, Ernst's 'family portrait' of the current members of the Surrealist group. The affair lasted for several more years but in 1927 Ernst married Marie-Berthe Aurenche. In the summer of 1929 when the Eluards went to stay with Dalí in Cadaqués, Gala fell in love with Dalí; her marriage to Eluard did not survive that encounter.

257

PAUL ELUARD

Défense de savoir

Paris, Editions Surréalistes, 1928

With a frontispiece by Giorgio de Chirico
Edition of 100; this copy no.77
Format: 44pp.; illustrated frontispiece; pb., rebound in hb.; 26 × 21.6; inscribed on half-title: *à P. G. van Hecke / souvenir amical / Paul Eluard*. Binding: cream leather with blue, brown and green leather pattern inset
GMA.A.42.0369

This is a collection of fifteen short poems gathered into two sections, and was published in February 1928. The eight poems of the first section had already appeared in *La Révolution Surréaliste*, nos.9–10, in October 1927. For the frontispiece Eluard chose a drawing by de Chirico entitled *Le Poète et le philosophe*.

Eluard was an ardent admirer of de Chirico's Metaphysical paintings and went to Rome in 1923 in order to meet him and to make purchases: by the mid-1930s he had amassed some thirty paintings by the Italian. But like Breton and the other Surrealists, Eluard was angered and disillusioned by the major changes in de Chirico's work during the 1920s, especially by his return to 'classicism' and 'order' and his obsessive interest in the techniques of the old masters. The Surrealists' hostility to these later works, which were exhibited in Paris at the Galerie Paul Guillaume, took the form of published insults and, inevitably, led to a breakdown of relations with the artist himself. Meanwhile, however, their admiration for his Metaphysical work remained undimmed. Eluard's choice of an early drawing to illustrate *Défense de savoir* was, therefore, a calculated act – a clear statement of the Surrealists' partisan position in the controversy that surrounded de Chirico's work in the 1920s.

258

PAUL ELUARD

A toute épreuve

Paris, Editions Surréalistes, 1930

Format: 1 sheet, 16pp. uncut; pb.; 11 × 7
GMA.A.42.0032

A tiny booklet of recent poems printed on a single sheet of pale-pink paper, *A toute épreuve* was published on 15 October 1930. This copy was purchased from John Armbruster, Paris, at an unrecorded date.

259

PAUL ELUARD

Comme deux gouttes d'eau

Paris, Editions Surréalistes, 1933

Edition of 175; this copy no.31
Format: 14pp.; hb.; bound in at half-title is the original cover design, 1 sheet with pencil notes verso; 18.7 × 14; inscribed on half-title: *à Georges Hugnet / en toute amitié / Paul Eluard*
Binding: black leather embossed with red stars and with decalcomania endpapers
GMA.A.42.0347

Eluard dedicated this copy to Hugnet who had recently joined the Surrealist movement. The fine leather binding was almost certainly designed by Hugnet himself, who opened his bookbinding studio in Paris in 1934, but is much less extravagant and complex than those he created for his *livres-objets*. The endpapers were made using the Surrealist version of the decalcomania technique (see cat.52) – a favourite procedure with Hugnet. The original design for the regular cover of *Deux gouttes d'eau* is bound into the book.

260

PAUL ELUARD & MAN RAY

Facile

Poèmes de Paul Eluard
Photographies de Man Ray

Paris, G. L. M., 1935

Edition of 1220; this copy no. LI of 200 *hors commerce* copies numbered VI–CCV
Format: 28pp.; illustrated with 12 in-text photographs by Man Ray; loose-leaf in pb. binder; 24.2 × 18.4; inscribed at back: *à Monsieur Zwemmer / très amicalement / Man Ray*; with pen and ink drawing by Man Ray, 2.5 × 1.8
GMA.A.42.0435

Eluard and Man Ray first met in 1921 when the latter settled in Paris and, introduced by Duchamp, immediately joined the Dada group. They became much closer friends in the mid-1930s and collaborated on several important *livres d'artistes* at that time. *Facile*, which was published in late October 1935, is the second and perhaps the most enduringly successful of these joint ventures, uniting as it does some of Eluard's most intense and beautiful love poems with some of Man Ray's most hauntingly seductive photographs of the naked body. The relationship between text and image is perfectly harmonised in the lay-out of the pages, but is never repetitive and always surprising. The photographs use some of Man Ray's favourite hallmark techniques, including solarisation and double exposure. The inspiration for both poet and photographer was Nusch (real name Maria Benz), whom Eluard met in May 1930 and married four years later. She was the subject of many other photographs by Man Ray and of several portraits by Picasso.

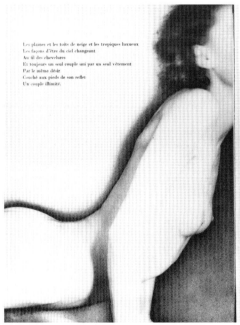

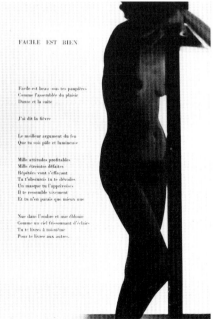

260 / Pages 12–13

This copy of *Facile* was a gift from Man Ray to Anthony Zwemmer, whose gallery and bookshop in London was a rallying-point for the English Surrealists. Man Ray's dedication is completed with a small humorous drawing of a mask-like face. Mrs Keiller purchased it through Tony Reichardt at an unknown date.

261

PAUL ELUARD

Quelques-uns des mots qui jusqu'ici m'étaient mystérieusement interdits

Paris, G. L. M., 1937

Edition of 346; this copy no.21
Format: 32pp.; pb.; 18.9 × 14.5
GMA.A.42.0277

This was one of two collections of poetry Eluard published in 1937, the other being *Les Mains libres* (cat.332). *Quelques-uns des mots...* is usually regarded as the more significant in literary terms, and is remarkable for its dramatic and inventive typography and layout.

262 / Frontispiece by Ernst

262

PAUL ELUARD & MAX ERNST

Chanson complète

Paris, Gallimard, 1939

Special edition of 20 with 4 lithographs by Max Ernst signed by Paul Eluard & Max Ernst; this copy no.13 on Vergé d'arches paper
Format: 70pp.; illustrated; hb.; 25.5 × 20; lithographs 25.2 × 19.3
Binding: black and maroon leather with black cloth slipcase edged in maroon leather and lined with black and maroon fabric; brown hand-coloured endpapers
GMA.A.42.0465

Chanson complète is a collection of recent poems and was published not long after Eluard's definitive break with Breton following his decision to publish several poems in the Communist periodical *Commune*. Ernst's

relationship with Eluard survived this traumatic schism, although he did not leave the 'official' Surrealist movement as did others who, like Hugnet, took Eluard's side. The lithographs Ernst created for the book imitate the effects of the frottage technique the artist had used to such brilliant effect many years before in *Histoire naturelle* (cat.269). This beautifully bound copy was formerly in Hugnet's collection.

263

PAUL ELUARD

Poésie et verité 1942

Paris, Editions de la Main à Plume, 1942

Format: 28pp.; pb.; 13.3 × 10.5
GMA.A.42.0031

This cheaply produced booklet of some of Eluard's early Resistance poems opens with one of the best known, *Liberté*. It was published at the beginning of April 1942. Mrs Keiller purchased her copy from John Armbruster, Paris, but the date is unrecorded. (See also cat.267.)

264

PAUL ELUARD & MAX ERNST

Misfortunes of the Immortals

New York, The Black Sun Press, 1943

Translated by Hugh Chisholm; designed by Caresse Crosby
Edition of 610 with nos.1–110 numbered copies on Strathmore Rag Paper, bound in special covers and signed by the artist with reproductions of 3 added drawings by Ernst titled *Twenty Years After*; this copy no.11
Format: 42pp.; illustrated, reproductions of 21 collages by Ernst plus 3 extra plates at back on pink paper; hb. cover of pink card with celluloid print of inset on front cover; 25.6 × 19.8
GMA.A.42.0430

This is the authorised translation, by Hugh Chisholm, of *Les Malheurs des immortels*, 1922 (cat.254), and was published when Ernst was living in America during the war and when interest in Surrealism was increasing rapidly in the English-speaking world. Ernst designed a special cover for the book and, in order to update it, added three drawings at the back quite different in style from the collages of the original edition. A second French edition of *Les Malheurs des immortels* was published in Paris at Eluard's instigation in 1945 (cat.268).

Mrs Keiller purchased her copy through Tony Reichardt, London, in March 1977.

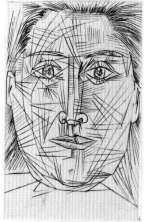

265 / Frontispiece by Picasso

265

PAUL ELUARD

Au rendez-vous allemand

Paris, Editions de Minuit, 1944

With etching by Pablo Picasso
Edition of 120, nos.1–20 with a frontispiece etching; this copy no.14 signed on colophon by Picasso
Format: 62pp.; pb.; 21.3 × 14.7; etching: 13.9 × 9 (page size 20.8 × 14); inscribed on title-page: *à mon ami Georges Hugnet / au détour d'un jour d'amitié / jour parmi les jours / comme une feuille dans un / arbre / Paul Eluard*
GMA.A.42.0020

This is a collection of Eluard's writings from the Occupation years when he was involved in the Resistance and forced to live in hiding at various times. Some had already been published clandestinely, under various pseudonyms. The book was published in December 1944 a few months after the Liberation. The Keiller copy was a gift to Hugnet from Eluard.

Picasso was one of Eluard's closest friends and they saw each other constantly in Paris during the war. From an inscription on a trial proof in the Musée Picasso, Paris (MP 2738), we know that the etching he provided as the frontispiece for *Au rendez-vous allemand* was executed on 21 April 1942. Brigitte Baer has suggested that it may be a portrait of Eluard (*Picasso. Peintre-graveur*, Vol. III, *Catalogue raisonné de l'oeuvre gravée et des monotypes, 1935–1945*, Berne, 1986, no.681). But it more closely resembles Picasso's contemporary pictures of his lover Dora Maar, such as the well-known half-length portrait of her in a striped dress painted in October 1942 (collection Stephen Hahn, New York; Z.XII.154). Dora would have been an appropriate subject for the frontispiece because it was through Eluard that Picasso first met her in the autumn of 1935. (For full information about the etching, see Baer, loc. cit., and S. Goeppert, H. Goeppert-Frank and P. Cramer, *Pablo Picasso. The Illustrated Books: Catalogue Raisonné*, Geneva, 1983, no.40.)

266

PAUL ELUARD

Médieuses

Poèmes de Paul Eluard illustrés par Valentine Hugo

Paris, Gallimard, 1944

With illustrations by Valentine Hugo
Edition of 915; this copy no.33
Format: 23pp. loose-leaf; illustrated; pb.; 45 × 31
GMA.A.42.0275

This is the second edition of *Médieuses*, the first edition having been published in 1938. The title is a neologism – *mes dieuses* – which invents a feminine form of the word *dieu* (god), and Eluard's long poem was intended to be the equivalent of a mythology for and about women. It was, of course, appropriate that the book be illustrated by a woman artist, and Eluard duly chose Valentine Hugo to be his interpreter. He apparently gave her quite precise instructions about his requirements, and the drawings she made are atypical of her style in that they are executed in pure line. The printed text reproduces Eluard's own handwriting.

Valentine Hugo had a love affair with Breton in 1931–32 and was attached to the Surrealist movement during the 1930s. On a number of occasions she rescued her Surrealist friends from financial disaster by supporting their publications and purchasing works of art. She was a particularly close friend of Eluard's until his death in 1952, and from 1937 onwards he chose her to be his illustrator on a number of occasions.

267

PAUL ELUARD

Poésie et vérité 1942
Poetry and Truth 1942

London, London Gallery Editions, 1944

Translated by Roland Penrose and E. L. T. Mesens; illustrated with a portrait of Eluard by Man Ray
Edition of 500; this copy no.86, signed on colophon by Penrose and Mesens
Format: 47pp.; illustrated; pb.; 21 × 14.5; first published in Paris, 1942
GMA.A.42.0361

The wartime poems by Eluard collected here were first published in Paris by Editions de la Main à Plume in 1942 (cat.263). They were translated into English by Roland Penrose and E. L. T. Mesens, both close friends of the poet. The book was the second in the series of recent French poetry published by London Gallery Editions, the first being Mesens's own collection of war poems, *Troisième front* (cat.339). Man Ray's frontispiece drawing of Eluard was executed in 1936 and was not reproduced in the original French edition.

268 / Frontispiece by Ernst

268

PAUL ELUARD & MAX ERNST

Les Malheurs des immortels

Paris, Editions de la Revue Fontaine, 1945

Edition of 1812; this copy no.1204, one of 1300 copies on Vergé crème paper numbered 1–1300
Format: 46pp.; illustrated by Max Ernst; pb. bound within half- leather and oil-painted board cover; 22 × 16.2
GMA.A.42.0997

This is the second edition of the book which was first published in 1922 (cat.254). It was published in October 1945 just after peace was declared. This copy has been specially bound and the covers hand-painted in thickly applied oil-paint. Mrs Keiller purchased it from John Armbruster, Paris, at an unrecorded date.

269

MAX ERNST

Histoire naturelle

Paris, Editions Jeanne Bucher, 1926

Portfolio of 34 collotypes by Max Ernst, with preface by Hans Arp
Edition of 306; this copy no.119 of 250 examples on Vélin paper numbered 51–300, signed by the author on colophon
Format: 8pp. (title, introduction and contents pp.) and 34 collotypes loose-leaf in black and grey card portfolio with blue cloth spine; portfolio 52.8 × 35; text 43 × 23; collotypes 49.8 × 32.5 (paper size)
GMA.A.42.0451

Histoire naturelle is a portfolio of thirty-four collotype reproductions of frottages Ernst had made in 1925. Collotype was chosen as the reproductive method because it guaranteed a sufficiently subtle range of grey-to-black tones. The portfolio was accompanied by a surreal prose poem by Arp, a close friend of Ernst's since 1914. They had collaborated in Cologne during the Dada period on a photo-collage series entitled *Fatagaga*.

In *Au-delà de la peinture* (1936), Ernst describes the 'discovery' of the frottage

technique, which was his answer to Breton's call for 'pure psychic automatism' in the 1924 *Manifeste du Surréalisme*: 'On August 10, 1925 […], finding myself one rainy day in an inn by the seacoast, I was struck by the obsession exerted upon my excited gaze by the floor – its grain accented by a thousand scrubbings. I then decided to explore the symbolism of this obsession and [...] took a series of drawings from the floorboards by covering them at random with sheets of paper which I rubbed with a soft pencil. When gazing attentively at these drawings, I was surprised at the sudden intensification of my visionary faculties and at the hallucinatory succession of contradictory images being superimposed on each other with the persistence and rapidity of amorous memories. As my curiosity was now awakened and amazed, I began to explore indiscriminately, by the same methods, all kinds of materials – whatever happened to be within my visual range – leaves and their veins, the unravelled edges of a piece of sackcloth, the brushstrokes of a modern painting, thread unrolled from the spool, etc., etc.' (Quoted from the translation in L. Lippard (ed.), *Surrealists on Art*, Englewood Cliffs, New Jersey, 1970, pp.120–121.)

The strange, antediluvian beasts, birds, plants and landscapes which come into being through Ernst's adventurous manipulation of the frottage technique are his equivalent to the creatures illustrated in the natural history books which had fascinated him since childhood, and which sometimes furnished him with the source material he used in his collages; the title *Histoire naturelle* spells out this parallel. The original drawings survive, but have been widely dispersed; the Scottish National Gallery of Modern Art owns one (*Elle garde son secret*), which formerly belonged to

269 / Plate XX

Roland Penrose (see W. Spies and S. and G. Metken, *Max Ernst. Werke 1925–1929*, Menil Foundation, 1976, nos.790–823).

Mrs Keiller purchased her copy of the portfolio from Hans Bolliger, Zurich, in October 1978.

270 / Last chapter, plate 2

270

MAX ERNST

La Femme 100 têtes

Paris, Editions du Carrefour, 1929

With an introduction by André Breton
Edition of 1000, 12 examples on Japon impérial paper numbered 1–10, 88 on Hollande Pannekoek paper numbered 13–100, 900 on Vélin teinté paper numbered 101–1000; this copy no.946
Format: 328pp.; illustrated with reproductions of 147 collages with captions by Max Ernst; pb. with cover by Ernst; 25 × 19
GMA.A.42.0427

La Femme 100 têtes was Ernst's first collage novel and was published with a preface by Breton, who was thrilled by the sense of total disorientation the images provoked and described Ernst as 'the most magnificently haunted mind of today'. This copy was formerly owned by Marcel Mariën. Mrs Keiller purchased it from John Armbruster, Paris, in April 1978.

The 147 collages which make up this picture-novel were created in a burst of activity in the summer of 1929 from illustrations culled from nineteenth- and early twentieth-century magazines which Ernst had gradually accumulated during his years in Paris. A single magazine illustration formed the basis of each image and was rendered extraordinary and disturbing by the simple expedient of adding a few 'alien' elements, carefully placed to create the maximum impact. (For Ernst's account of his 'discovery' of the hallucinatory properties of the collage technique, see cat.254.) The photo-reproductive process Ernst chose for printing the plates so effectively masked his

cutting and pasting procedures that each image appeared uncannily 'real' and 'true', and hence, as it were, irrefutable. (For the original collages, see W. Spies and S. and. G. Metken, *Max Ernst. Werke 1925–1929*, Menil Foundation, 1976, nos.1417–1563.)

The title of *La Femme 100 têtes* puns on the similarity of sound in French of the words *cent* (100) and *sans* (without), and establishes the infinitely changeable character of the main heroine of the novel, who, like a figure from myth, is both 'headless' and 'one hundred-headed'. Her fantastic adventures, told in nine 'Chapters', represent the Surrealist answer to the nineteenth-century realist novel which was so despised by Breton and his followers. Ernst completed the images with enigmatic captions which, far from explaining them, added further layers of ambiguity. (For a fuller discussion, see E. Maurer, 'Images of Dream and Desire: The Prints and Collage Novels of Max Ernst', in *Max Ernst. Beyond Surrealism. A Retrospective of the Artist's Books and Prints*, New York and Oxford, 1986, pp.63–69 and no.21.)

271 / Chapter II, plate 21

271

MAX ERNST

Rêve d'une petite fille qui voulut entrer au Carmel

Paris, Editions du Carrefour, 1930

Edition of 1040, plus 20 hors commerce copies; this copy no.203
Format: 176 pp.; illustrated with reproductions of 79 collages, with captions by Ernst; pb., with cover illustration; 23.8 × 18.8
GMA.A.42.0161

La Femme 100 têtes (cat.270) was followed rapidly by this, Ernst's second collage novel, which was published in December 1930. This copy was formerly in the collection of Marcel

Mariën. Mrs Keiller purchased it from John Armbruster, Paris, in April 1978.

Comprising 79 collages with captions created from the same kinds of sources as its predecessor, *Rêve d'une petite fille …* is organised into four chapters, and is preceded by an introduction written by Ernst himself. More explicitly than *La Femme 100 têtes*, the book is concerned to expose the evil effects of the repressive doctrines of the Church, especially with regard to sexuality, and like a high proportion of Ernst's other works reveals the transformative power of liberated desire and passionate love. Profoundly influenced by his study of the writings of Freud, *Rêve d'une petite fille* is also a sustained attempt to reproduce the quality and experience of the dream process; the final collage bears the caption, '"Monster! Do you realise I'm in love?!" – End of dream'. (For an interesting discussion, see E. Maurer, 'Images of Dream and Desire: The Prints and Collage Novels of Max Ernst', in *Max Ernst. Beyond Surrealism. A Retrospective of the Artist's Books and Prints*, New York and Oxford, 1986, pp.69–78 and no.22. For the original collages, see W. Spies and S. and G. Metken, *Max Ernst. Werke 1929–1938*, Menil Foundation, 1979, nos.1587–1666.)

272

MAX ERNST

Une Semaine de bonté ou Les Sept Eléments capitaux

Paris, Editions Jeanne Bucher, 1934

Edition of 812; this copy no.612 of 800 copies numbered 13–812 on Navarre paper
5 vols. with coloured card covers in illustrated slipcase; 28 × 22.5
Premier Cahier. Dimanche. Elément: La Boue. Exemple: Le Lion de Belfort
Format: 40pp.; illustrated; purple cover
Deuxième Cahier. Lundi. Elément: L'Eau. Exemple: L'Eau
Format:32pp.; illustrated; green cover
Troisième Cahier. Mardi. Elément: Le Feu. Exemple: La Cour du dragon
Format:48pp.; illustrated; red cover
Quatrième Cahier. Mercredi. Elément: Le Sang. Exemple: Œdipe
Format: 32pp.; illustrated; blue cover
Dernier Cahier. Jeudi. Elément: Le Noir. Exemple: Le Rire du coq. L'Île de Pâques. Vendredi. Elément: La Vue. Exemple: L'Intérieur de la vue. Samedi. Elément: Inconnu. Exemple: La Clé des chants
Format: 66pp.; illustrated; yellow cover
GMA.A.42.0450

Colour plate 50

Une Semaine de bonté, Ernst's third collage novel, is divided into five separate, paperbound volumes. They were issued individually at intervals from April to December 1934, in

imitation of the serialisation of popular novels in the nineteenth century. The twenty de-luxe copies of each volume appeared with frontispieces in the form of original etchings by Ernst. (The Keiller *Semaine de bonté* is from the regular edition and lacks these etchings.) Unlike the earlier collage novels (cats.270–271), *Une Semaine de bonté* appeared without a preface.

In total the book comprises reproductions of 182 collages, which were created in an astonishing burst of energy during a three-week holiday in Italy in 1933. As the title suggests, the 'novel' spans a week – the seven days of Creation – and the original intention was to publish seven separate volumes, one for each day. But money was desperately short and it proved necessary to cut costs by compressing the final three days (Thursday to Saturday) into a single volume divided into three sections. (Roland Penrose subsidised the whole venture, and stepped in with extra money when it seemed that the editor, Jeanne Bucher, would have to abandon the project when still incomplete because her funds had been exhausted.) Unlike the earlier collage novels, *Une Semaine de bonté* has no written captions, but the title-pages of each volume provide detailed, if disorientating, indications of the content (e. g. *First Volume. Sunday. Element: Mud. Example: The Lion of Belfort*). Furthermore, Ernst uses consistent settings and characters to establish some sort of continuity within the narrative that unfolds, and publishes the collages on both sides of each double-page spread to encourage the viewer to respond exactly as if he or she were reading a conventional novel.

As in the earlier collage novels, the raw material was banal and old-fashioned and was intended to provoke memories and associations on the part of the reader. Ernst's favourite sources were engravings from melodramatic late nineteenth-century pulp fiction, scientific journals, natural history magazines, popular encyclopaedias, and so forth; as in his earlier collage novels, he transformed the plates into disturbing and disorientating images through the addition of just a few alien elements. (For an illuminating discussion, see E. Maurer, 'Images of Dream and Desire: The Prints and Collage Novels of Max Ernst', in *Max Ernst. Beyond Surrealism. A Retrospective of the Artist's Books and Prints*, New York and Oxford, 1986, pp.78–91 and no.33. For the original collages, see W. Spies and S. and G. Metken, *Max Ernst. Werke 1929–1938*, Menil Foundation, 1979, nos.1904–2085.)

273 / Cover by Ernst

273

MAX ERNST & PAUL ELUARD

A l'intérieur de la vue.
8 poèmes visibles

Paris, Pierre Seghers Editeur, 1948 [1947]

Edition of 610; this copy no.6
Format: 132pp.; illustrated with reproductions of 39 collages some in colour; pb. with illustrated cover; 21.4 × 14.1; inscribed on half-title: *à Georges Hugnet / ce livre de distances vaincues / très affectueusement / Paul Eluard*
GMA.A.42.0159

Despite the date on the title-page, this book came out in December 1947. The colophon explains the nature of the collaboration on this occasion: 'The 8 visible poems composed by Max Ernst in 1931 have been illustrated as faithfully as possible in 8 visible poems by Paul Eluard in 1946'. The entire suite of 39 original collages by Ernst was in the collection of their friend, Valentine Hugo (see W. Spies, *Max Ernst. Oeuvre-Katalog. Werke 1929–1938*, Menil Foundation, 1979, nos.1808–1846). The Keiller copy was dedicated to Hugnet by Eluard. Hugnet had supported Eluard when he quarrelled definitively with Breton in 1938 and they were in frequent contact during the Occupation.

274

MAX ERNST

Sept microbes
vus à travers un tempérament

Paris, Editions Cercle des Arts, 1953

Edition of 1100, 100 examples on Marais pur fil trois fleurs paper containing a colour etching by Yves Tanguy, and 1000 copies on Marais une fleur paper numbered 101–1100; this copy no.561 without etching
Format: 76pp.; illustrated; pb.; 18.5 × 13.1; inscribed inside front cover: *Joe Tilson*
GMA.A.42.0336

Ernst returned permanently to Paris in 1953. *Sept microbes* was published at the end of June soon after his arrival, and reproduces gouaches he made in America using the decalcomania technique in *c*.1947–51. All small and some of them minute, the gouaches are reproduced life-size and stuck individually onto the pages of the book. The full title alludes to Emile Zola's famous definition of painting as 'un coin de la nature vu à travers un tempérament' (a corner of nature seen through a temperament). (For the original paintings, see W. Spies and S. and G. Metken, *Max Ernst. Werke 1939–1953*, Menil Foundation, 1987, nos.2926–2957.) This copy, which formerly belonged to Joe Tilson, was purchased through Tony Reichardt at an unknown date.

275

MAX ERNST

Ecritures

Paris, Le Point Cardinal, 1970

Edition of 100 with a tipped-in frontispiece etching with aquatint by Ernst; this copy no.43
Format: 450 pp.; illustrated, etching and 25 reproductions of works by Ernst; pb. with original lithographic cover by Ernst; 22.2 × 17; etching: 19 × 14.2 (paper 21.6 × 16), inscribed in pencil bottom left: *43/100* and bottom right: *Max Ernst*; inscribed at front in pencil: *Joe Tilson* with printed address
GMA.A.42.0158

Ernst was a prolific and gifted writer. This anthology of his most important writings has an original etching as its frontispiece. The imagery of the frontispiece and the cover of the book reflect Ernst's lifelong fascination with the fusion of word and image in traditions of picture-writing. That fascination received its most complete expression in *Maximiliana*, the book he created with the Russian printer and publisher Iliazd (Ilia Zdanevitch) in 1964 and for which he invented his own hieroglyphic 'language'. (For a full analysis, see A. Hyde Greet, 'Max Ernst and the Artist's Book: From *Fiat Modes* to *Maximiliana*', in *Max Ernst. Beyond Surrealism. A Retrospective of the Artist's Books and Prints*, New York and Oxford, 1986, pp.126–155 and no.82.) This copy of *Ecritures* formerly belonged to Joe Tilson. Mrs Keiller purchased it through Tony Reichardt at an unknown date.

276

Exposition Minotaure

Brussels, Skira, 1934

Exhibition catalogue, Palais des Beaux-Arts, Brussels, May-June 1934
Format: 28pp.; illustrated; pb.; 22.1 × 16.2
GMA.A.42.0184

This is the catalogue of a mixed exhibition of work by artists featured in the periodical *Minotaure* (cat.426) during its first year of publication. Many, but not all, of the participants were Surrealists. The show was organised by E. L. T. Mesens and Albert Skira, the editor of the review. The Keiller copy was formerly in the collection of the Belgian Surrealist Marcel Mariën, and was purchased from John Armbruster, Paris, in April 1978.

277

La Feuille Chargée

Brussels, March 1950

Edited by René Magritte
Format: 8pp. news-sheet format; illustrated;
27.1 × 21
GMA.A.42.0008

This pamphlet was edited by Magritte and contains contributions by himself and the other leading members of the Surrealist group in Brussels – Paul Colinet, Marcel Mariën, Paul Nougé and Louis Scutenaire. Mrs Keiller purchased it from H. A. Landry, London, in September 1974.

278

First Papers of Surrealism

New York, Co-ordinating Council of French Relief Societies Inc., 1942

Exhibition catalogue, October-November 1942, with cover design by Marcel Duchamp
Format: 50pp.; illustrated; pb. with perforated paper front cover; 26.7 × 18.3
GMA.A.42.0417

This is the catalogue of the Surrealist exhibition organised in New York in the Whitelaw Reid Mansion on Madison Avenue and sponsored by the Co-ordinating Council of French Relief Societies. One of the sponsors was Bernard Reis (see cat.253.) Many of those involved were, like Breton himself, exiles from occupied France, and had only relatively recently arrived in America: the title of the exhibition alludes to an immigrant's first naturalisation papers. The cover of the catalogue was designed by Duchamp, who had returned to New York in June 1942. On the front is a detail of a photograph of the wall of Kurt Seligmann's barn pitted with five rifle shots fired by Duchamp, the cover being perforated to conform to the shots; on the back is a close-up photograph of a piece of gruyère cheese. Breton also entrusted Duchamp with the installation of the exhibition. He created an immense and tangled spider's web of miles of white string, stretching from room to room and masking not only the nineteenth-century

interior of the mansion but also the Surrealist works on display. To add further to the confusion, Duchamp urged the children of Sidney Janis (the New York art dealer who was also involved in the organisation of the show) to play energetic games throughout the opening.

Mrs Keiller purchased this copy from H. A. Landry, London, in December 1977.

279

DAVID GASCOYNE

A Short Survey of Surrealism

London, Cobden Sanderson, 1935

Second issue, with dust-jacket designed by Max Ernst
Format: 162pp.; hb. with illustrated dust-jacket; 21.3 × 13.5; inscribed at front: *David Gascoyne / May 1935*
Enclosed is a typed poem, 'Future Reference' by David Gascoyne which he sent to Georges Hugnet
GMA.A.42.0341

This was purchased from John Armbruster, Paris, at an unrecorded date. It was formerly in the collection of Georges Hugnet.

280

DAVID GASCOYNE

Man's Life is this Meat

London, Parton Press, 1936

Format: 44pp.; hb.; 19.4 × 14.2; inscribed on inside cover page: *à Georges Hugnet, / grand amitié toujours / David Gascoyne / Oct.15th '36*; back page inscribed with ms. poem 'Eau sifflée' by Gascoyne, dated 15. IX.36
GMA.A.42.0070

Gascoyne became an activist in the Surrealist movement in 1935 (see cat.281). As a prefatory note to *Man's Life is this Meat* proudly explains: 'With the exception of nos.1–6, the poems in this collection are Surrealist poems.' He dedicated this copy to Hugnet with whom he had collaborated on the organisation of *The International Surrealist Exhibition* which opened in London in June 1936. As an additional mark of friendship, he included the manuscript of a short poem in French entitled 'Eau sifflée' which is not included in the collection.

281

DAVID GASCOYNE

Scrapbook

Unpublished, c.1940–1944

Contains various collages, catalogues, prospectuses, texts and photographs; 96pp., plus loose material; hb.; 25.5 × 19
GMA.A.42.1014

Despite his youth – he was born in 1918 – David Gascoyne was one of the most influential members of the English Surrealist group

during the 1930s. Living in Paris and fluent in French, he began writing Surrealist verse in about 1933, and in 1935 attempted to launch an English branch of the movement by publishing 'the first English manifesto of Surrealism' – in French – in the well-known art journal, *Cahiers d'Art*. It was around this time that Eluard introduced him to Roland Penrose, with whom he instantly struck up a friendship; together they determined to take active measures to convert England to Surrealism. As Penrose himself put it: 'It was the encounter of two explorers who had discovered independently the same glittering treasure' (Roland Penrose, *Scrapbook, 1900–1981*, London, 1981, p.56). Since England needed educating first, Gascoyne published his *A Short Survey of Surrealism* (cat.279) in November 1935 – an exceptionally lucid historical account of the movement from its origins to the present, which terminated with his own translations of poems and texts by Breton, Eluard, Péret, Dalí and others. The book's cover was designed by Ernst – a sure sign that this brilliant young Englishman was an accepted insider.

Gascoyne was just as phenomenally active in 1936; in January he published texts simulating madness in *Janus*, and followed this in February with his collection of poems, *Man's Life is this Meat* (cat.280); he produced an excellent English version of Breton's own popularising text, *Qu'est-ce que le Surréalisme* (cat.206) and published further translations of poems by Eluard and Péret. And he assisted Penrose with the organisation of the epoch-making *International Surrealist Exhibition* which opened in London at the New Burlington Galleries in June 1936. To quote Penrose again: 'Centred round Herbert Read, … a small group came to life which included Humphrey Jennings, Henry Moore, Paul Nash, Hugh Sykes-Davies, Eileen Agar, all stimulated by the

281 / First page

visionary presence of the young David' (op. cit., p.60). Gascoyne was represented in the London exhibition with an *Object-Poem* dedicated to Breton, three collages and a Surrealist object, all of them made specially for the occasion.

The scrapbook in the Keiller collection is a fascinating compendium of miscellaneous photographs, catalogues, prospectuses, published and manuscript texts, press cuttings, and so forth, together with several original collages and painted ornaments by Gascoyne himself. This material has evidently been ordered thematically, so that there are, for instance, sections devoted to the 1936 London exhibition, the International Surrealist exhibition held in Paris two years later, and to leading figures in the movement, including Gascoyne's hero, Breton, and Dalí, Ernst and Magritte. The scrapbook contains a few Dada items, several cuttings from *La Révolution Surréaliste* and a few items from the early 1940s, but most of the material belongs to the 1930s. Gascoyne himself has explained that he compiled several of these scrapbooks, not all of them devoted to Surrealism, at spare moments during 1940–44. He writes: 'During the War, my base was my family's home at Teddington, but I was there only intermittently.... All the surrealist material I had collected while preparing my Short Survey of Surrealism ... ended up in the drawers of a tallboy in my parents' Teddington house. Whenever I was at home, I spent some time trying to preserve these ephemerae by pasting them into a series of scrapbooks' (letter dated 16 May 1988 in the Archive, Scottish National Gallery of Modern Art). Gascoyne gave the Keiller scrapbook to Anthony Zwemmer, the London book dealer, just after the war in payment for books he had purchased. Mrs Keiller acquired it through John Armbruster, Paris, in the late 1970s or early 1980s.

282

YVAN GOLL

Le Mythe de la roche percée
Poème

Paris, Editions Hémisphères, 1946

With illustrations and etching by Yves Tanguy
Edition of 400, of which numbers I–C have 3 etchings by Tanguy, nos.101–400 reproductions of the etchings; this copy unnumbered but contains 1 etching by Tanguy
Format: 28pp.; illustrated, 2 colour plates; pb.; 25.3 × 20; the etching has been tipped in between pp.16 & 17, and replaces plate no.2; etching: 17.3 × 12.5 (page size 25.4 × 19.7), signed in pencil below image left: *Yves Tanguy*
GMA.A.42.0027

Yvan Goll had been an active sympathiser with Dada in Paris but did not join the Surrealist movement. Indeed in 1924 he was a would-be rival of Breton's. That October he published what turned out to be the single issue of a literary magazine entitled *Surréalisme*, hoping thereby to lay claim to the all-important term which Apollinaire had coined during the war, and whose meaning he believed Breton had perverted. But Breton proved too powerful for him; in the same month, October 1924, the *Manifeste du Surréalisme* was published and from then on the term belonged to Breton and his followers. During the Second World War Goll was in America along with Tanguy and the other Surrealist exiles, and their former differences were buried.

In his prefatory note to *Le Mythe de la Roche Percée*, Goll describes the extraordinary geology of the Roche Percée, which is on the coast of the Gaspé Peninsula on the Gulf of Saint Lawrence, Quebec. Tanguy, whose own fascination with geology dated back to his childhood in Brittany, was the ideal choice of artist, and provided three illustrations depicting strange structures that somewhat resemble precipitous rock formations. This copy was formerly in the collection of Georges Hugnet. Mrs Keiller purchased it through Tony Reichardt, London, at an unknown date.

283

ENRIQUE GÓMEZ-CORREA

Mandrágora Siglo XX

Santiago (Chile), Ediciones Mandrágora, n.d.

With illustrations by Jorge Cáceres
Edition of 500; this copy no.13, signed by the author
Format: 39pp.; illustrated; pb.; 28 × 19.5; inscribed on flyleaf by the author to Gilbert Senecaut
GMA.A.42.0287

This has illustrations by Jorge Cáceres which are in the tradition of Ernst's collage novels. The Mandrágora movement, founded in Santiago in 1937 by Braulio Arenas and Enrique Gómez-Correa, was closely allied to Surrealism. The book was formerly in the collection of Marcel Mariën. Mrs Keiller purchased it from John Armbruster, Paris, in April 1978.

284

ROBERT GUIETTE

Mort du fantôme
Repères 24

Paris, G. L. M., August 1937

With a frontispiece after a drawing by Fernand Léger
Edition of 70; this copy no.10
Format: 24pp.; illustrated frontispiece; loose-leaf in yellow cover; 25.3 × 19.5; inscribed on colophon: *Guy Lévis-Mano*
GMA.A.42.0136.13

285

RICHARD HAMILTON

The Bride Stripped Bare by her Bachelors Even Again

Newcastle-upon-Tyne, Department of Fine Art, 1966

Reconstruction by Hamilton of Marcel Duchamp's *Large Glass*
Edition of 25; this copy no.7
Format: 32pp.; illustrated; hb. in green pseudo-suede slipcase with title in brown leather; 30.8 × 20.9; signed on colophon by Marcel Duchamp and Richard Hamilton
GMA.A.42.0235

This is a record of Richard Hamilton making a replica of Duchamp's *Large Glass* in the Fine Art Department of the University of Newcastle-upon-Tyne, and reproduces the principal blueprints, etc. Hamilton's replica was made specifically for the Duchamp retrospective exhibition held at the Tate Gallery in 1966 and is now in the Tate's permanent collection. Duchamp gave his full support to the venture and, alongside Hamilton, signed the twenty-five copies of this book that were published at the time. (See also cat.249.)

286

ERIC DE HAULLEVILLE

Le Genre épique. Autobiographie.

Illustré avec 4 eaux-fortes par Kristians Tonny

Paris, Editions de la Montagne, 1930

With four etchings by Kristians Tonny
Edition of 500, 10 examples numbered 1–10 on Japon impérial paper with ms. page by the author, 25 examples numbered 11–35 on Hollande van Gelder paper, 64 examples numbered 36–100 on Vélin d'arches paper, all with 4 etchings, and signed by author; this copy no.14 signed by author and artist on colophon
Format: 100pp., some uncut; illustrated; pb.; 22.6 × 16.9; etchings: 19.6 × 13.8 (page size 22 × 16)
GMA.A.42.0021

Eric de Haulleville was a Belgian poet who wrote the texts gathered here between 1924 and 1926. The Dutch-born artist Kristians Tonny was self-taught, and the etchings made for this book reveal his familiarity with the recent work of Masson. *Le Genre épique* was published by Editions de la Montagne which Hugnet had founded in 1929. (This copy comes from his library.) Hugnet was on friendly terms with both author and artist and provided a poetic, stream-of-consciousness style preface for an exhibition of Tonny's work held at the Galerie Th. Briant in February 1929.

287

LISE HIRTZ & JOAN MIRÓ

Il était une petite pie

7 chansons et 3 chansons pour
Hyacinthe

avec 8 dessins en couleur par Joan Miró

Paris, Editions Jeanne Bucher, 1928

Edition of 200; this copy no.19 of 20 on Japon paper
Format: 14 leaves plus 3 inserted leaves; 8 colour
pochoirs and 8 black and white pochoirs from
gouaches by Miró; loose-leaf in clothbound portfolio
with cover design by Miró; 32.5 × 25 (page size),
34 × 26 (portfolio size); signed on colophon at back:
Joan Miró and Lise Hirtz
GMA.A.42.1004

Anne-Marie (Lise) Hirtz is better known by her
married name as Lise Deharme. She first made
contact with the Surrealists in December 1924
and remained on the fringes of the movement
thereafter, publishing quite extensively in the
1930s. Breton was hopelessly in love with her
from their first meeting until her marriage to
Paul Deharme in the autumn of 1927 and a
bronze glove she owned became one of his
talismans; he illustrated it in *Nadja* in 1928
(cat.193) and she eventually gave it to him.
Breton encouraged her to write and asked Miró
to provide illustrations for the whimsical,
child-like songs which are published in this
portfolio in her ornate handwriting. Miró sent
Breton the eight gouaches in October 1927 –
the final one in the suite is signed and dated
'10–27' – and Breton responded enthusiasti-
cally on 1 November: 'Your drawings have
arrived and I do not know how to thank you.
They could not be better suited to the work I
entrusted to you. They are admirably beautiful
and stunning' (letter quoted in C. Lanchner,
Miró, New York, Museum of Modern Art, 1993–
94, p.326.). In style the drawings are close to
Miró's contemporary paintings, some of which
incorporated his own poetic texts. *Il était une
petite pie* was his first illustrated book (see P.
Cramer, *Joan Miró. The Illustrated Books: Catalogue
Raisonné*, Geneva, 1989, no. I); his gouaches
were reproduced in pochoir by Saudé, each one
twice – in black only and in colour – the fourth
also serving as the design for the portfolio's
cover. The book came out with a general
dedication to the composer Georges Auric, a
member of the avant-garde group known as
Les Six.

Mrs Keiller purchased this copy through
Tony Reichardt at an unknown date.

288

GEORGES HUGNET
& EUGÈNE BERMAN

Le Droit de Varech. Précédé par Le Muet ou Les Secrets de la vie

Lithographies par Eugène Berman

Paris, Editions de la Montagne, 1930

Edition of 502 with 10 examples on Japon impérial
paper numbered 1–10, 25 examples on Hollande van
Gelder paper numbered 11–35 and 65 examples on
Vélin d'Arches paper numbered 36–100, with 5
lithographs by Berman, all signed by the author and
artist; this copy no.27
Format: 228pp. some uncut; illustrated, lithographs;
pb.; 22.7 × 16.8; lithographs: 22 × 16 (page size);
signed by Georges Hugnet and Eugène Berman on
colophon
GMA.A.42.0022

Hugnet describes both *Le Muet ou Les Secrets de la
vie* and *Le Droit de Varech* as melodramas;
Berman's brooding, shadowy lithographs
depicting arcaded classical buildings, statues
and wraith-like figures provide an appropri-
ately theatrical parallel while striking an
audibly de Chiricoesque note. Editions de la
Montagne was Hugnet's own publishing
house, which he founded in 1929. The Keiller
copy belonged to Hugnet.

Russian by birth, Berman settled in Paris
after the war and by 1930 had joined the group
of painters, which included Tchelitchev and
Christian Bérard, surrounding the critic
Waldemar George. George had supported
Cubism initially, but after the war moved
steadily to the right, and in his journal *Formes*
(1930–33) defended traditional 'classical'
values against what he had come to believe was
the dangerously undermining impact of
Cubism, Dada and Surrealism. In 1930 when *Le
Droit de Varech* came out Hugnet had not yet
become involved in the Surrealist movement,
but frequented the more fashionable, monied
wing of the Parisian avant-garde.

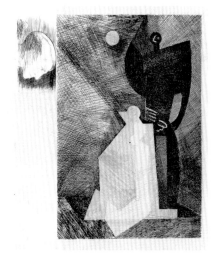

289 / Etching no.3 by Marcoussis

289

GEORGES HUGNET
& VIRGIL THOMSON

La Belle en bois dormant

Poèmes de Georges Hugnet
pour voix de mezzo-soprano ou baryton

Unpublished manuscript, after 1931

Manuscript by Thomson, bound by Hugnet, with
etchings by Marcoussis
Format: 14pp. original music manuscript by Virgil
Thomson, inscribed on title-page: *histoire d'amitié /
pour Georges Hugnet / son fidèle / Virgil*; tipped in at front
are 3 original etchings by Marcoussis (3 states), hb.;
35 × 27.5; etchings: a.24 × 20.4 (paper size
27.3 × 21.7), inscribed in pencil below image left: *1er
état 1/4* and right: *Marcoussis*, and bottom right: *à
Georges Hugnet en très amical / souvenir / L. M*; b. and c.
both 24.3 × 20.2 (page size 34.8 × 27.2)
Binding: pink cloth binding with leather title label
and decalcomania endpapers by Georges Hugnet,
signed in ink on front paper: *G. H.1933*
GMA.A.42.0420

This is one of the most precious items which
Gabrielle Keiller acquired from Hugnet's
private collection. It consists of four poems by
Hugnet himself which have been set to music
by the American composer and pianist Virgil
Thomson. From the inscriptions on
Thomson's manuscript we know that he
composed the songs in Villefranche-sur-Mer
on 20 August and 1 October 1931. They have
never been published or publicly performed,
but Thomson intended them to be sung either
by a mezzo-soprano or a baritone. The four
poems Thomson set to music were first
published in Hugnet's collection *La Belle en
dormant* (Paris, Cahiers Libres) in 1933, with a
frontispiece etching by Louis Marcoussis.
Hugnet bound three states of this etching with
Thomson's handwritten music into this special
book, for which he created handsome
decalcomania endpapers each inscribed *G.
H.1933*. This date may, however, relate to the
publication of the poems in *La Belle en dormant*
rather than to the making of the binding.

Hugnet first met Virgil Thomson in Paris in
the winter of 1926–27; they quickly struck up a
close friendship which occasionally, as here,
took the form of an artistic collaboration
involving poetry set to music. Gertrude Stein
was an intimate friend, and in a memoir first
published in *Le Figaro littéraire* in 1954 Hugnet
describes how he witnessed Thomson
composing the opera which took Stein's *Four
Saints in Three Acts* as its libretto and which
caused a scandal when it was first performed in
America in 1934. Although Thomson spent
increasing amounts of time in America from
the mid-1930s onwards, he retained a studio-
apartment in Paris which, until the Occupa-

tion, was a meeting-place for many writers, artists and musicians, including Picasso, Miró, Eluard and Arp, as well as Hugnet himself.

290

GEORGES HUGNET
& STANLEY WILLIAM HAYTER

Ombres portées

Paris, Editions de la Montagne, 1932

Edition of 79, examples 6–55 on Hollande van Gelder paper with 5 etchings by Hayter, inscribed and signed by the author; this copy no.13
Format: 60pp.; illustrated.; pb.; 26.2 × 16.7; etchings: 15.4 × 9.4 (page size 25.3 × 15.9); inscribed in ink on half-title: *à mon cher papa / que j'aime plus qu'il / ne le croit / que j'aime vraiment / dans mes souvenirs et / dans le présent, à mon papa / de tout mon coeur, / Juin GEORGE H 1932*
GMA.A.42.0012

According to the entry against his name in the *Dictionnaire abrégé du surréalisme* (Paris, 1938), Hugnet 'rallied definitively to Surrealism in 1932'. *Ombres portées*, which has an *achevé d'imprimer* of 25 April 1932, heralded that turning-point. In 1926 Hayter had embarked on what would be a brilliant career as a printmaker in Paris, and within a few years had struck up friendships with some of the leading artists in the Surrealist group; many of them came to rely upon his invaluable combination of technical mastery and willingness to experiment. Hayter's *Atelier 17* rapidly became established as a major centre for innovative printmaking and his own work was included in various Surrealist exhibitions in the 1930s. In *Ombres portées* Hayter responded to Hugnet's poems by providing appropriate illustrations. But in their other joint venture of the same year, *Apocalypse* (cat.297) the roles were reversed, Hugnet composing a text directly inspired by Hayter's engravings. This type of creative collaboration between poets and artists was a cherished ideal throughout the lifetime of the Surrealist movement.

Formerly in the collection of Georges Hugnet, Mrs Keiller purchased this copy through Tony Reichardt at an unknown date.

291 / Frontispiece by Miró

291

GEORGES HUGNET

Enfances

Orné de trois eaux-fortes de Joan Miró

Paris, Editions 'Cahiers d'Art', 1933

With 3 etchings by Joan Miró
Edition of 100 with 5 numbered 1–5 on Japon impérial paper, 95 numbered 6–100 on Vélin d'arches paper, signed by the author and illustrator with 3 etchings by Joan Miró; this copy no.12 signed on half-title
Format: 41pp.; illustrated; pb.; 29 × 22.8; etchings: each 23.8 × 14.9 (page size 28.4 × 22.2)
GMA.A.42.0107

Hugnet was a great admirer of what he termed the 'purity' of Miró's work and in 1931 published a substantial essay entitled 'Joan Miró, ou l'enfance de l'art' (*Cahiers d'Art*, Vol.6, nos.7–8). For his part, Miró appreciated Hugnet's poetry and in December 1932 presented him with a preparatory drawing for the first of the etchings in *Enfances*, dedicating it affectionately 'to my dear friend and poet, Georges Hugnet.' The book itself was published in July 1933. (It is no.2 in P. Cramer, *Joan Miró. The Illustrated Books: Catalogue Raisonné*, Geneva, 1989.) According to Hugnet, only fifty suites of Miró's etchings were actually printed, less than half the number originally envisaged. (See *Pérégrinations de Georges Hugnet*, Paris, Centre Georges Pompidou, Cabinet d'Art Graphique, 1978, nos.24–26.) An English language edition, translated by Gertrude Stein, was to appear, but her text became so different (and her arguments with Hugnet so acrimonious) that it was published under a different title, *Before the Flowers of Friendship Faded Friendship Faded*.

292

GEORGES HUGNET

Onan

Paris, Editions Surréalistes, 1934

With frontispiece etching by Salvador Dalí
Edition of 277; this copy no.9, one of 7 on Montval à la cuvée paper
Format: 30pp.; illustrated frontispiece; pb.; 34 × 29.20verall (pp. of various sizes); frontispiece etching inscribed in pencil bottom left: *Salvador Dalí* and bottom right: 9 / 77 (for inscription in plate see below)
GMA.A.42.0457

Hugnet's text is dedicated to Onan, the second son of Judah, after whom onanism is named (*Genesis*, ch.38, 8–10). Dalí's obsession with masturbation was well known (see cat.234) and he was therefore the perfect choice of illustrator for *Onan*. His etching with aquatint is inscribed in a suitably shaky script:

'"Espasmo-grafifisme"' obtenu avec la main gauche pendant qu'avec la main droite je me masturbe jusqu'au sang, jusqu'au l'os, jusqu'aux hélices du calice' ('Espasmo-grafifisme' obtained with the left hand while with the right hand I masturbate myself to bleeding-point, to the bone, to the helices of the calix!'). Presumably, the 'stain' at the centre of the plate is intended to record the outcome. The *achevé d'imprimer* of *Onan* is 10 June 1934; it therefore appeared just seven weeks before the famous edition of Lautréamont's *Les Chants de Maldoror* illustrated with Dalí's suite of etchings (cat.320).

293

GEORGES HUGNET

Petite anthologie poétique du surréalisme

Paris, Editions Jeanne Bucher, 1934

Format: 170pp.; illustrated; pb.; 19.2 × 14.2
GMA.A.42.0085

Hugnet provided the preface for this selection of poems and texts by the current members of the Surrealist group. (Major figures who, like Aragon, had left or had been ejected are notable by their absence.) The book was illustrated with Surrealist paintings, etc. and contains Man Ray's montage of photographic portraits entitled *L'Echiquier Surréaliste* (Surrealist chessboard). In the 1930s the Surrealists were consciously seeking a broader base for the movement and hoped to carry their revolution to all corners of the world through international exhibitions, translations of key texts, lecture tours and so forth. Hugnet's anthology was part of this programme.

292 / Frontispiece by Dalí

294

GEORGES HUGNET

La Hampe de l'imaginaire

Repères 12

Paris, G. L. M., 1936

With etching by Oscar Domínguez
Edition of 70; this copy *hors commerce* signed by Guy
Lévis-Mano
Format: 14pp.; illustrated with 4 states of etching;
pb. rebound in hb.; 26.3 × 20; etching: 24 × 17 (page
size 25 × 18); inscribed in ink on title-page: *à
Germaine / mon amour / le sex-appeal des crosses de fougère /
la fourrure pyriforme pyrogène / à l'âge des miroirs / Georges
/ Juillet 1936*; inscribed in pencil verso plate 1: *suite
comportant 4 états / 1 bleu / 1 rose / 1 vert / 1 jaune sur papier
noir / suite No.2 / 5 / nov.1935*; bound at front is 14pp.
ms. of the poem, dated 1933 enclosed in its own
cover designed and with collage by Hugnet;
inscribed: *à Germaine / mon amour / Georges / 1936*
Enclosed is pencil drawing by Domínguez;
18.7 × 13.4
GMA.A.42.0999

Hugnet dedicated this copy of *La Hampe de
l'imaginaire* to Germaine Pied, whom he
married four years later in 1940. Like the other
hors commerce copies of the book, it contains
four states of the etching by Domínguez which
illustrated the entire edition, plus an original
pencil drawing by him. But it is unique in that
it also contains an inserted gathering of pinky-
brown handmade paper. On the cover of this
insert is an erotic collage in Hugnet's typical
style: the handwritten title on the page beneath
is glimpsed through an irregular opening
formed by burning away a section of the
collage page; the manuscript of Hugnet's
poem, dated 1933 and written in red ink in his
elegant hand, follows. The red cloth binding,
on the other hand, is undistinguished and was,
as we know from a stamp on the inside cover,
the work of Louis Christy, not Hugnet himself.

Domínguez and Hugnet were close friends,
having committed themselves to Surrealism at
much the same time. (See also *Le Feu au cul,*
cat.304.) One of Domínguez's most haunting
Surrealist objects, created in 1935, is entitled
Pérégrinations de Georges Hugnet and incorporates
a toy bicycle through which a toy horse is
walking. This bizarre configuration is echoed
in the elongated bicycle featured in the etching
Domínguez made for *La Hampe de l'imaginaire*
and also in the original drawing inserted in the
present copy, which Mrs Keiller purchased
through Tony Reichardt, London, at an
unknown date.

295

GEORGES HUGNET

La Septième Face du dé
(poèmes-découpages)

Paris, Editions Jeanne Bucher, 1936

With 20 *poèmes-découpages* by Georges Hugnet and
cover design by Marcel Duchamp
Edition of 294; this copy unnumbered
Format: 88pp.; illustrated; pb.; 29.3 × 21.3
GMA.A.42.0453

The twenty *poèmes-découpages* (poem cut-outs)
reproduced in *La Septième Face du dé*, were
selected from the series of eighty such collages
Hugnet made the previous year. The original
collages were composed from fragments of
photographs, advertisements, old engravings
etc., interspersed with snippets of text in
different typefaces derived from newspapers
and magazines. The result is a visually
arresting hybrid in which word is inextricable
from image, and eye and mind are engaged
simultaneously. These collages are at one level
Hugnet's homage to the compositional and
typographic daring of Dada photomontage,
especially to the work of the Berlin Dadaists
Hannah Höch, Raoul Hausmann and John
Heartfield. But the compulsive emphasis on
sexuality and desire are characteristic of
Surrealism as a whole and Hugnet's work in
particular.

In the book as published, the collages are
printed on the right-hand pages and the left-
hand facing pages are given over to semi-
automatic poems printed in various typefaces
and with irregular spacing, so that they too
create an exciting visual effect. If the visual
ultimately dominates over the verbal in the
collages on the right, the opposite is true in the
poems on the left. But in any given double-
page spread the visual and verbal are equally
balanced. In *La Septième Face du dé* the Surrealist
ideal of *peinture-poésie* is thus fully realized.

Hugnet's great friend Duchamp designed
two different covers for the book. The regular
edition incorporated a reproduction of his
celebrated 'assisted readymade', *Why not sneeze
Rose Sélavy?*, a small metal birdcage filled with
marble cubes the size of sugar lumps, a
thermometer and a cuttlefish bone, which
Duchamp made in New York in 1921 and which
is truly proto-Surrealist in its irrationality. (For
the de-luxe edition, see the next entry, cat.296.)
The present copy is from the regular edition,
but is faulty in that the third collage is repro-
duced twice. It was no doubt for this reason
that although all copies of the book were
supposed to be numbered this one was not,
and instead remained in Hugnet's personal
collection.

296

GEORGES HUGNET

La Septième Face du dé

Dummy copy, 1936

Hugnet's own copy of the maquette, with annota-
tions, layouts and corrections in his own hand, and
with additional cover design by Marcel Duchamp for
the 20 de-luxe copies
Format: 50pp.; illustrated; pb. with additional cover;
29.2 × 21.3
GMA.A.42.0454

This is the printer's dummy for the book
described in the previous entry (cat.295), and
has many annotations in Hugnet's hand. For
the twenty de-luxe copies of the book
Duchamp created a special cover called
'Couverture-cigarettes': a celluloid outer cover
protects two colour photographs of greatly
enlarged cigarettes stripped bare. The dummy
has this cover, and like all the de-luxe copies is
bound together with rafia. Mrs Keiller bought
it from John Armbruster, Paris, who acquired it
directly from Hugnet's personal collection.

296 / Cover by Duchamp

297

GEORGES HUGNET
& STANLEY WILLIAM HAYTER

L'Apocalypse

Paris, G. L. M., 1937

Edition of 70, with etching by Hayter; this copy *hors
commerce*, signed by the author
Format: 16pp.; illustrated, frontispiece etching: pb.
with title in ms.; 15.3 × 10.5; foldout etching: 15 × 9
(page size 18.8 × 15.1); front cover inscribed by
author in light-red crayon: GEORGES HUGNET /
L'Apocalypse / S. W. HAYTER; signed in light-red crayon
on colophon: *Georges Hugnet*
GMA.A.42.0050

L'Apocalypse had first appeared in 1932 pub-
lished by Editions Jeanne Bucher. On that
occasion Hayter provided a suite of six
engravings, and Hugnet's text was written
specifically to accompany them – a clear-cut
case of a poet responding creatively to existing
images. In 1937, in the present edition of

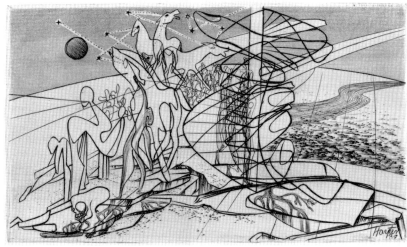

L'Apocalypse, the process was reversed; Hugnet reprinted the text he had written for Hayter in 1932, and Hayter created an entirely new fold-out etching to accompany it. The two friends were conducting an on-going dialogue.

This copy was purchased through Tony Reichardt at an unknown date.

298

GEORGES HUGNET

La Chevelure

Paris, Editions Sagesse, 1937

With a frontispiece by Yves Tanguy and cover by Georges Hugnet
Edition of 85; this copy example B of 15 copies numbered A-O, printed for the author on burgundy paper
Format: 12pp.; illustrated, frontispiece from etching by Yves Tanguy; pb. with gold paper and collage cover by Hugnet; 21.3 × 16.5; signed by the author and illustrator on colophon
GMA.A.42.0411

Colour plate 57

The publication of *La Chevelure* (*achevé d'imprimer* 10 February 1937) appears to have been delayed; Hugnet's text is dated 1934 and Tanguy's frontispiece, inscribed 'Pour ma petite Nusch / son ami Yves Tanguy', is dated 21 August 1934. Nusch was the second wife of Paul Eluard, and the book has a general dedication to her and her husband. Tanguy's drawing is relatively unusual for this period in being figurative; it depicts a woman's profile, with abundant waves of hair cascading down to form an enveloping cloak of drapery. The collage Hugnet created for the cover also celebrates the feminine allure for which Nusch was famed within the Surrealist group; a fascinating, Sphinx-like woman is evoked by an elegant hand, an open red-lipped mouth, and a black mask on which the title is inscribed in gold in Hugnet's script.

299

GEORGES HUGNET
& KURT SELIGMANN

Une Écriture lisible

Paris, Editions des Chroniques du Jour, XXe Siècle, 1938

With illustrations by Kurt Seligmann
Edition of 255; this copy unnumbered
Format: 42pp.; illustrated; pb.; 28.4 × 22.7; inscribed in ink on half-title: *à Jeanne Bucher / que la poésie retient / ces poèmes visibles / très amicalement / Georges / Hugnet / 1938 / Kurt Seligmann*
GMA.A.42.0455

The collaboration between Hugnet and Seligmann on *Une Écriture lisible* recalls that of Courthion and Seligmann on *Les Vagabondages héraldiques* in 1934 (see cat.229), in that text and image are printed opposite one another and given equal weight throughout. The bizarre, picaresque figures and the style of Seligmann's drawings are also reminiscent of the illustrations in the earlier book. The Keiller copy of *Une Écriture lisible* was originally a present to Jeanne Bucher, who often exhibited Surrealist art in her gallery and also published some major Surrealist books, including several by Hugnet himself (e. g. *Œillades ciselées en branche*, cat.300).

300

GEORGES HUGNET & HANS BELLMER

Œillades ciselées en branche

Paris, Editions Jeanne Bucher, 1939

Edition of 231; this copy among first 30 printed on perfumed azuré paper
Format: 48pp.; illustrated; pb.; 13.5 × 9.5; inscribed on colophon: EXEMPLAIRE *d'auteur / sur papier azuré ancien /* GEORGES HUGNET */ 1939*; inside front cover tipped-in paper label inscribed in ink: GH
For binding and book box see below
GMA.A.42.0461

Colour plate 51

Œillades ciselées en branche is generally acknowledged to be a perfect example of the Surrealist-style *livre d'artiste*, and bears witness to the sympathy and understanding which marked the relations between Hugnet and Bellmer in the late 1930s after the latter's move to Paris (see also cat.188). The book contains a prose poem by Hugnet in praise of adolescent girls, printed from the author's handwritten text, and inspired by Bellmer's famous articulated *Poupée* (doll). The text is complemented by twenty-four drawings by Bellmer, executed in his most exquisite, 'mannerist' style, and reproduced by means of the heliogravure process in delicate shades of pink, olive green, russet, mauve, etc. (The original preparatory drawing for one of these illustrations is cat.7.) Sometimes placed in the margins, sometimes interspersed with the text, these do not attempt to illustrate given passages, but explore themes which had obsessed Bellmer for years. Text and image are designed to reinforce each other, together conjuring up a perverse and secret fantasy world of extraordinary intensity.

Designed to be pocket-size and to be reminiscent of a Valentine card or some such love token, each copy of *Œillades* was covered in rose-pink paper on top of which was fixed a white paper doily from a candy box. It was finished off with a *fin-de-siècle* coloured paper scrap attached at the top right corner. Appropriately, the little book was dedicated to the women both men loved – to Germaine, Hugnet's future wife, and to Margarete Bellmer, whose death from tuberculosis in 1938 was still a source of acute distress to the artist. The de-luxe copies – of which the Keiller copy is one – were printed on special paper impregnated with perfume. (Sadly, with the passage of time, the paper has lost its scent.) The curious title was a *trouvaille*. According to Germaine Hugnet, they had been wracking their brains over what to call the book when a girlfriend announced she had 'found' it accidentally, in true Surrealist fashion, on the label of some fruit in a greengrocer's stall. The shop was offering bunches of grapes *ciselées en branche* (cut on the branch) – a method which preserves their flavour and prunes the vine in one action. (See P. Webb and R. Short, *Hans Bellmer*, London, 1985, p.102.) In combination with the word *œillades* (significant glances / come-hither looks), the phrase was suitably provocative.

This copy of *Œillades ciselées en branche* belonged to Hugnet and he had a special dark-pink leather box made for it. This is lined inside with a collage made from dried flowers, which are arranged in a formal diamond-

pattern design and held in place by varnish and a white silk mesh. The box was made to Hugnet's specifications by Henri Mercher, the Paris book-binder who worked for him quite often in the 1960s. (Mercher's stamp appears on the inside spine of the box.) Mrs Keiller purchased it through Tony Reichardt, London, at an unrecorded date.

301

GEORGES HUGNET, CHRISTINE BOUMEESTER & HENRI GOETZ

La Femme facile

Paris, Editions Jeanne Bucher, 1942

With lithograph illustrations by Boumeester and Goetz and cover design by Hugnet
Edition of 110; this copy unnumbered on Vergé d'arches paper
Format: 24pp.; illustrated; loose-leaf in paper cover; 16.5 × 23
Binding: cover of dark-red paper with orange flocking, with collaged marbled paper title
GMA.A.42.0440

In 1940 Hugnet took an apartment and opened a bookshop at 9, boulevard du Montparnasse immediately above the gallery of the legendary dealer Jeanne Bucher. *La Femme facile* was one of several ventures realised with her publishing house. Hugnet's handwritten text and the illustrations provided by the husband-and-wife team of Christine Boumeester and Henri Goetz were reproduced lithographically to achieve a totally integrated overall effect. Indeed, despite the lack of colour, 'illumination' may be a more appropriate word than 'illustration', given the similarity to Blake's *Songs of Innocence and Experience* in the structural relationship between text and image. Hugnet, who worked simultaneously as a writer and an artist, designed the cover for the book, inscribing the title on a leaf-shaped cut-out which is stuck onto the dark-red flock paper.

Mrs Keiller purchased this copy through Tony Reichardt at an unknown date.

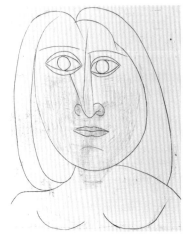

302

GEORGES HUGNET & PABLO PICASSO

Non vouloir

Paris, Editions Jeanne Bucher, 1942

Edition of 426, of which nos.1–20 on tinted Vergé d'arches paper have a suite of 4 colour versions of 4 lithographs reworked with engraving, and 2 versions of all 4 superimposed on black, and an etching by Picasso, signed by author and illustrator; numbers 21–420 were printed on Vélin bouffant paper; this copy no.25 but has the lithographs in 4 colours, and the etching added, unsigned
Format: 78pp.; illustrated, black and white reproductions of the lithographs, etching inserted before title-page; pb.; 19.3 × 14; etching: 15 × 11.8 (page size 18.9 × 14). Enclosed at back 18 lithographs each 19 × 14 (paper size)
GMA.A.42.0444

Colour plate 61

The first edition of *Non vouloir* was published privately in 1940 in an oblong pamphlet with a frontispiece by Miró. Only twenty-six copies were printed. In April 1942 Hugnet republished the poem, this time as part of a collection of some fifty poems written in 1940–41. He dedicated the book to Paul Eluard with whom he was on close terms during the Occupation when both were involved in the Resistance. It was published by Editions Jeanne Bucher; her gallery was in the same building as Hugnet's apartment and they had worked together on previous occasions (see cat.300).

Picasso provided four illustrations for this edition of *Non vouloir*, reworking the lithographic plates with a burin. The subject each time is a woman, depicted head only; full-length, nude and running; full-length, nude and standing; clothed and seated in an armchair. In the de-luxe copy purchased by Mrs Keiller, each of the four plates is printed four times in red, chartreuse green, turquoise blue and egg-yellow. In addition there are two plates with all four images superimposed in different colour-ways. Picasso also contributed an original etching of a woman's head (possibly Dora Maar) as the frontispiece. (See S. Goeppert, H. Goeppert-Frank and P. Cramer, *Pablo Picasso. The Illustrated Books: Catalogue Raisonné*, Geneva, 1983, no.36. For full details, see B. Baer, *Picasso. Peintre-graveur, Vol. III, Catalogue raisonné de l'oeuvre gravé et des monotypes, 1935–1945*, Berne, 1986, nos.677 and 721–724.)

This copy was purchased through Tony Reichardt at an unknown date.

302 / Frontispiece by Picasso

303

GEORGES HUGNET

La Chèvre-feuille

avec six gravures de Pablo Picasso

Paris, Robert-J. Godet, 1943

With illustrations by Pablo Picasso
Edition of 525, nos.1–25 on Vélin d'arches paper have suite of coloured etchings by Picasso signed by artist and author, nos.26–525 printed on Lafuma paper without the etchings; this copy no.55
Format: 72pp.; illustrated, 6 plates; pb.; 28.2 × 22.6; inserted after half-title leaflet by Paul Eluard: *Prière d'insérer. Pour Georges Hugnet*
GMA.A.42.0014

This collection of love poems, dedicated to 'she who will not recognize herself in it', was published in December 1943. The six full-page zincograph illustrations of female nudes by Picasso are reproduced in collotype in the book. The de-luxe copies – of which this is not one – include an original etching of the sixth illustration as the frontispiece. (For full details, see S. Goeppert, H. Goeppert-Frank and P. Cramer, *Pablo Picasso. The Illustrated Books: Catalogue Raisonné*, Geneva, 1983, no.38.)

304

GEORGES HUGNET & OSCAR DOMÍNGUEZ

Le Feu au cul

Paris, 1943

Edition of 53; this copy no.1, *exemplaire imprimé spécialement pour Georges Hugnet*
Format: 42pp.; illustrated, etchings by Oscar Domínguez and illustrations printed over text; hb. in slipcase; 10.4 × 15.6
Binding: original decalcomania endpapers by Hugnet, bound and cased in cream-coloured leather lined with brown suede to Hugnet's design by J. P. Miguet
GMA.A.42.0445

Colour plate 52

This was published anonymously during the Occupation when Hugnet was involved in the production of many clandestine publications, sometimes writing under the pseudonym Malo le Bleu. Hugnet's pornographic text was not, however, written during the war but when he first joined the Surrealist movement in 1932. It had remained unpublished and appears here ornamented by Domínguez's equally terse and explicit line illustrations which are printed in red over the dark-green text, the page design being perfectly judged to ensure absolute equality between word and image. Domínguez and Hugnet had long been friends and the book was evidently the product of a close and attentive collaboration. The end result achieves the Surrealist ideal of the reconciliation of

opposites – the 'opposites' in this case being brutally frank pornography and aesthetically pleasing, meticulous craftsmanship.

This copy of *Le Feu au cul* (which translates roughly as 'Fire in the Arse') belonged to Hugnet and was treated to a very special binding (described above, pp.29–30). Not the work of Hugnet's own hands – although the decalcomania endpapers are very probably by him – the binding and case were made to his specifications by J. P. Miguet whose name is impressed on the inside front cover. The date this was done is unknown but is likely to have been in the 1960s. In the latter part of his life, when his health was poor, Hugnet worked closely with master-binders in this way – a bibliophile to the end. Mrs Keiller purchased the book from John Armbruster, Paris, who obtained many rare items directly from Hugnet. The date is unrecorded.

305

GEORGES HUGNET & JEAN ARP

La Sphère de sable

Illustrations de Jean Arp

Paris, Robert-J. Godet Collection 'Pour Mes Amis' II, 1943

Edition of 199, 3 numbered A-C on Chine Marques paper reserved for the author, artist and editor; 20 examples numbered I–XX with relief cover by Arp; 176 examples numbered 1–176; this copy no.48
Format: 30pp. loose-leaf; illustrated, in-text illustrations by Arp; 21.2 × 16
GMA.A.42.0024

Some of Hugnet's poems in this collection had already been published elsewhere. Albeit very different in nature from *Le Feu au cul* (cat.304), *La Sphère du sable* is another example of a most successful collaboration between Hugnet and an artist friend. Arp's biomorphs are freely intermixed with Hugnet's text to produce page layouts which are endlessly varied and endlessly inventive in their configurations.

306

GEORGES HUGNET

Oiseaux ne copiez personne

Paris, Coulouma, 1946

With etchings by André Beaudin
Edition of 100; this copy no.27
Format: 44pp.; illustrated, 6 etchings by André Beaudin; pb.; 29 × 23.1; etchings: all 28 × 21.3 (page size 28 × 22.5); signed by the author and the artist on colophon
GMA.A.42.0013

Colour plate 53

Beaudin and Hugnet were united in their devotion to Eluard and were natural artistic allies in the post-1938 period following Hugnet's expulsion from the official Surrealist group. Beaudin himself had never been a member of the Surrealist movement although the obvious cubist influence on the style of the exquisite etchings he created for this book coexists with imagery which reveals a debt to the Dove and Loplop paintings Ernst executed in the late 1920s.

307

GEORGES HUGNET & PABLO PICASSO

Ici la voix

Paris, Pierre Seghers, 1954

Three copies
a. Edition of 600 with original edition of 60 examples on Vergé de Hollande paper numbered I–LX with *hors texte* frontispiece reproduction of drawing by Pablo Picasso, and 7 examples numbered A-G for author and editor; this copy number XXX
Format: 114pp.; illustrated, cover design lithograph by Picasso, original collage on half-title by Georges Hugnet, and frontispiece; hb. bound in black calf with red flock endpapers; 26.7 × 19.5; lithograph 20 × 14.8 (page size 25.6 × 18.4); collage: 19.2 × 7.5 overall; frontispiece: 29 × 19.4; inscribed on half-title: *à Hélène | à Georges | à leur hospitalité princière | et simple | à la rue Guénégaud | où voisinent caviar et colle forte | vodka et vernis | le travail et la joie | à l'amitié vraie | GEORGES | HUGNET | Juin 1954*
GMA.A.42.0011

Colour plate 55

b. Edition as above; this copy no. XXXVII
GMA.A.42.0025
c. Regular edition; this copy marked S. P
Format: 110pp.; pb.; 26 × 19.3; inscribed on half-title: *à R... [name scratched out] en témoignage de sympathie | Georges | HUGNET | Avril 54*
GMA.A.42.0345

The cover of this book, which was published in April 1954, reproduces the illustration of a woman seated in an armchair which Picasso had made for Hugnet's *Non vouloir* in 1942 (see cat.302; Baer, op. cit., no.724). In the preface, Hugnet explains that the first texts, entitled *Ici la voix*, were written during the Occupation in 1942–43, and that he published certain fragments clandestinely at the time under the pseudonym Malo le Bleu. Despite their 'profoundly anti-Nazi sentiments', they should not, he warns, be defined as Resistance pieces. Dedicated to Picasso, *Ici la voix* has as its frontispiece a reproduction of a wash drawing of a boy's head which Picasso gave to Hugnet on 6 September 1944.

The second text published here, *Les Revenants futurs*, is dated 1952–53, and is dedicated to Hugnet's second wife, Myrtille, and their son, Nicolas (born 1951). The frontispiece for this is Hugnet's own self-portrait drawing dated 15 December 1953.

Mrs Keiller owned three copies of *Ici la voix*. The most interesting is the copy Hugnet dedicated in June 1954 *à Helène, à Georges* (who are unidentified). This is decorated with an original collage in cut, torn and burned papers, depicting a flower which is also a human figure.

308

GEORGES HUGNET

L'Aventure dada (1916–22)

Paris, Galerie de L'Institut, 1957

With introduction by Tristan Tzara and cover design by Marcel Duchamp
Format: 114pp., illustrated, 32 plates; pb.; 24.2 × 17; inscribed on half-title: *à Maria | à Timour Néjad | l'une, l'éclat du regard | et l'autre, un peintre, | et je ne sais ce que je préfère, | de tout cœur leur ami | GEORGES HUGNET | 4 mai 1957*
GMA.A.42.0026

Hugnet had won the admiration of Breton in 1932 when he published the first of a major series of articles on Dada in *Cahiers d'Art*. He joined the Surrealist movement at this point. Subsequently he wrote many enlightening essays on Dada and Surrealism, often as prefaces for major exhibitions or anthologies. *L'Aventure Dada* is the revised version of the texts published originally in *Cahiers d'Art* in 1932–36 and remains an extremely valuable account by someone who was too young to participate himself but who received much of his information not long after the event from those who had. Tzara, who provided the introduction, and Duchamp, who designed the cover of the book, were among his informants.

309

GEORGES HUGNET

1961

Illustré de quatre photomontages

Paris, Chez l'Auteur, 1961

Edition: 500, plus 70 copies numbered I–X signed by the author, with photomontages hand-coloured by the author and an original collage, and XI–LXV signed by the author with photomontages hand-coloured by the author; 500 examples numbered 1–500 with 4 photomontages and 3 special author's copies; this copy no.18 with 4 photomontages
Format: 70pp. some uncut; illustrated; pb.; 23 × 14.5; inscribed on the half-title: *à Lorraine | parce qu'elle est belle | à John W Armbruster | parce qu'il est attentif | leur ami | GEORGES HUGNET | le 29 mai 1971*
GMA.A.42.0023

Hugnet continued to make and publish photomontages until the early 1960s, as before using magazines as his main source of imagery. He gave this copy of 1961 to the book dealer John Armbruster, Paris, who supplied Gabrielle Keiller with many of the rare publications in her collection.

310

LAURENCE ICHÉ & OSCAR DOMÍNGUEZ

Au Fil de vent

Paris, 1942

With ms. of poem by Iché and hand-coloured illustrations by Domínguez
Edition of 50; this copy no.0
Format: 13pp.; illustrated, with a frontispiece and 6 in-text illustrations by Domínguez; loose-leaf in paper cover; 20 × 14.6; inscribed: *à Georges Hugnet / L'éventail [mois ?] des quatre saisons / vient de trébucher / Très amicalement / Laurence*
Enclosed at front: loose single sheet title-page and irregular shaped sheet [part of brown envelope] inscribed by the author with poem *Préparer valises. . .*; tipped in at back are 8pp. (2 sets of 4pp.) of Domínguez's illustrations on white paper and hand-coloured in gouache, 16 × 12.9 (page size)
GMA.A.42.0082

This *hors commerce* copy of *Au fil de vent* contains the manuscript of a poem by Iché written on an envelope, and the original drawings by Domínguez in ink with gouache which were used as the illustrations for the book. It is typical of the slim but recherché illustrated books of Surrealist poems published in very small limited editions by the Main à Plume group during the Occupation (see also, e. g., cat.183). It belonged to Hugnet and is dedicated to him by the author.

311

MAX JACOB

Chemin de croix infernal

Repères 13

Paris, G. L. M., May 1936

With a frontispiece after a drawing by J-M. Prassinos
Edition of 70; this copy no.10
Format: 20pp.; illustrated frontispiece; loose-leaf in red cover; 25.3 × 19.5; inscribed on colophon: *Guy Lévis-Mano*
GMA.A.42.0136.02

312

MARCEL JEAN & ANDRÉ JEAN

Mourir pour la patrie

Paris, Editions 'Cahiers d'Art', 1935

With preface and illustrations by Marcel Jean and captions by André Jean
Edition of 210; this copy no.103
Format: 54pp.; illustrated, reproduced from 24 drawings; pb.; 33.1 × 25.4
GMA.A.42.0001

Published with a general dedication to André Breton, this is a book of pictures by Marcel Jean with captions by André Jean. (The division of labour is not, however, made explicit either on the title-page or in the preface.) The preface describes the creation of the book in some detail: the album was composed in 1930; the drawings themselves were inspired by a suite of texts and, although not automatic in technique, were executed without regard for reason or consistency; and the captions were derived haphazardly from the most diverse sources, occasionally modified to make them yet more resonant in effect. The only country worth dying for – *Mourir pour la patrie* – the preface continues, is 'the country of mental freedom', and the picture-book itself should be understood as an indictment of bourgeois morality which seeks to destroy that liberty by crushing the child's natural inclination to roam free in thought and deed. (On Marcel Jean, see cat.313.).

This was purchased through Tony Reichardt, London, at an unknown date.

313

MARCEL JEAN & GEORGES HUGNET

Pêche pour le sommeil jeté

Unpublished manuscript, 1935

Unpublished original manuscript with 2 etchings by Marcel Jean and original drawing on cover
Format: 5pp., 38pp. ink ms., 2pp. pencil ms., 2pp. ink ms. poems 'La Robe inachevée' and 'Pêche pour le sommeil jeté'; bound into front 4 states of first etching and at back 2 states of second etching; hb.; 32.5 × 24.7; inscribed, in ink on page before title-page: *A Georges Hugnet, / Entre les bouteilles de notre amitié, / les / conversations de nos souvenirs de nos / projets, les musiques que nous aimons, / ces poèmes qui ont passé sans que passeur / les privilèges de l'affection de / Marcel Jean / 8-I–1935*; title-page inscribed in ink: *Pêche pour le sommeil jeté*
Etchings: at front, first etching: 15.3 × 11.3 (page size 32.2 × 23.5), no.1 inscribed in pencil below image left: *premier état / ½ / Marcel Jean*; no.2 inscribed in pencil below image left: *deuxième état / ½ / Marcel Jean*; no 3 inscribed in pencil below image left: *troisième état / ½ / Marcel Jean*; no.4 inscribed in pencil below image left: *Marcel Jean* and right: *¹/12* and bottom right: *à Georges Hugnet / les dames de la forêt pour le grand veneur / – son ami / Marcel Jean.*; at back second etching: 6.4 × 9.3, no.1: (page size 31 × 23.2) inscribed in pencil below image left: *épreuve d'essai / ½ / Marcel Jean*; no.2: (page size 31.5 × 20.8), inscribed in pencil bottom left: *Bon à tirer / Marcel Jean* and bottom right: *à mon ami Georges Hugnet / avec la vraie amitié carthaginoise / du capitaine Bordure / Marcel Jean*
Binding: black and white diced cloth cover with brown leather title labels on spine, and front inscribed in ink: *Marcel Jean / Pêche pour le / sommeil jeté / (1935)*, with ink drawing, black on white decalcomania endpapers
GMA.A.42.0419

This was purchased through Tony Reichardt, London, at an unknown date. The volume contains the corrected manuscripts of the poems by Marcel Jean which were eventually published as *Pêche pour le sommeil jeté* in 1937 (Editions Sagesse, Paris). The handwritten title-page is dedicated to Hugnet, a close friend of Jean's, and is dated 8 January 1935, even though the penultimate poem, 'La Robe inachevée', is dated 27 March 1935, and the last, 'Pêche pour le sommeil jeté' 28 March 1935. Also included are two original etchings by Jean, the first in four states, the second in two. The special binding, which is noteworthy for its very fine decalcomania endpapers, was probably the work of Hugnet.

Marcel Jean was an active member of the Surrealist movement during the 1930s and practised simultaneously as a writer and artist. One of his best known Surrealist objects is *The Spectre of the Gardenia* 1936, a dummy-head with zipper eyes and a roll of film wound round its neck. He is perhaps most familiar to the English-speaking world for his excellent books *The History of Surrealist Painting*, 1960 and *The Autobiography of Surrealism*, 1980, both of which are translations of studies which appeared originally in French.

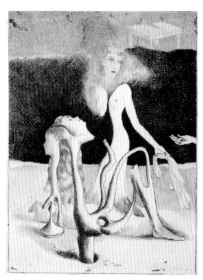

313 / Etching No.1 (second state) by Jean

313 / Cover with drawing by Jean

314

PIERRE JEAN JOUVE

Urne

Repères 18

Paris, G. L. M., September 1936

With a frontispiece after a drawing by Balthus
Edition of 70; this copy no.10
Format: 20pp.; illustrated frontispiece; loose-leaf in
red cover; 25.3 × 19.5; inscribed on colophon: *Guy
Lévis-Mano*
GMA.A.42.0136.07

315

FRANZ KAFKA

La Tour de Babel

Repères 22

Paris, G. L. M., February 1937

Translated by Henri Parisot with frontispiece after a
drawing by Max Ernst
Edition of 70; this copy no.10
Format: 20pp.; illustrated frontispiece (image tipped
in); loose-leaf in yellow cover; 25.3 × 19.5; inscribed
on colophon: *Guy Lévis-Mano*
GMA.A.42.0136.11

316

ED KIENHOLZ & NANCY REDDIN

Souvenir for Eduardo [Paolozzi]

Unpublished scrapbook, 1978

Black plastic folder with document wallets contain-
ing photographs, newscuttings with ms. additions,
typed text
Format; 88pp.; 32 × 26.5; inscribed on frontispiece:
*I know this book has taken years, but thanks for the loan of
your body, love Nancy and Many smiles on you, Berlin '78*
folder inscribed: *Paolozzi*
GMA.A.42.1019

This album contains photographs (mainly by
Nancy Reddin Kienholz) of Ed Kienholz and
his assistants taking direct plaster casts of
Paolozzi for inclusion in the installation
sculpture *The Art Show*. The sculpture was
largely made in Berlin, where Kienholz and
Reddin – who were married in 1972 – spent a
year on a DAAD grant in 1973 and where they
continued to live for six months of each year
until Kienholz's death.

Kienholz had the idea for *The Art Show* in
1963. The work would recreate a commercial
art gallery in New York or Los Angeles, peopled
with clothed plaster-casts of well-known
figures from the art world, as well as friends
and family. He only began making the figures
in October 1973, in Berlin; tape recorders and
other consumer objects are built into the heads
and bodies of each figure. Paolozzi 'posed' for
his cast on 20 December 1974, during his own
DAAD-sponsored year in Berlin (see cat.144).
The tape recorders function: Paolozzi's plays a

faked interview in which his responses to
typical queries about his work are joined with
randomly matched questions. Typed transcrip-
tions of segments of the 'interview' feature in
the album, along with documentation relating
to the exhibition of the work in Paris,
Düsseldorf and Munich in 1977. The finished
work was recently purchased by the Berlinische
Galerie, Berlin.

317

RUDOLF KLEIN

Félicien Rops

Paris, Librairie Artistique et Littéraire, n.d.

Format: 64pp.; illustrated; hb., half-leather and
marbled paper cover; 35 × 27
GMA.A.42.0994

318

JEAN LAUDE

Le Grand passage

*Paris, 'Instance' (Presses Littéraires de France),
1954*

With illustrations and 2 coloured etchings by Yves
Tanguy, and original collaged cover
Edition of 41, with 6 *hors commerce* copies; this copy
no. H. C.5 / 6
Format: 56pp.; illustrated, including 2 coloured
etchings; loose-leaf in folded blue paper cover,
collaged in black and white, within hb. cover;
28.3 × 22; etchings: 17 × 13.5 (page size 27 × 21),
inscribed bottom left: *H. C.5 / 6* and signed by the
artist bottom right
GMA.A.42.0028

The two original etchings by Tanguy were
printed in S. W. Hayter's famous Atelier 17 (see
cat.290). The drawings reproduced in the book
are dated 1953 and may have been executed
during Tanguy's return visit to Paris towards
the beginning of that year. This copy of the
book has an original collage cover and was
purchased by Mrs Keiller from Artco Inc.,
Zurich, in July 1977.

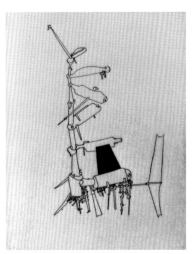

318 / Etching No.2 by Tanguy

319

LE COMTE DE LAUTRÉAMONT
(ISIDORE DUCASSE)

Les Chants de Maldoror

Paris and Brussels, 1874

Format: 332pp.; hb.; 19 × 12; ex libris Jacques
Bettendorf
GMA.A.42.0045

320

LE COMTE DE LAUTRÉAMONT
(ISIDORE DUCASSE) & SALVADOR DALÍ

Les Chants de Maldoror

Paris, Skira, 1934

With heliogravure etchings by Dalí
Projected edition of 270; this copy no.28
Format: 212pp.; illustrated with 42 etchings; loose-
leaf in paper cover inside hb. binder and slipcase;
33 × 25.5; etchings: 22 3 × 17 (paper size 33.2 ×
25.3); inscribed in pencil on page facing title:
Salvador Dalí
GMA.A.42.0015

Mrs Keiller purchased this from the London
print dealer Frederick Mulder, in October 1976,
three years after she had acquired two of the
plates (cats.15–16).

On 28 January 1933 Dalí wrote to his
patron, Charles de Noailles, to announce that
he was about to sign a contract with the Swiss
publisher Albert Skira to provide illustrations
for a new edition of Lautréamont's *Les Chants de
Maldoror*. He was delighted: 'illustrating
Lautréamont has always seemed to me the
most satisfying thing to do'. It was, apparently,
Picasso who had recommended Skira to use
Dalí for this project. The pre-publication
'advertisement to subscribers' put out in May
1933 envisaged a total edition of 270 and fifty-
two etchings in all. When published the
following year the book contained only forty-
two etchings and the imprint had been reduced
to 210. But partly because Skira was in financial
difficulties, partly because the response from
bibliophiles was disappointing, in the end only
sixty copies of the book were printed and forty
suites of the etchings. (See R. Michler and L.
W. Löpsinger, *Salvador Dalí. Catalogue Raisonné
of Etchings and Mixed-Media Prints, 1924–1980*,
Munich, 1994, p.128.) The *achevé d'imprimer* for
the book is 31 July 1934, but the suite of
etchings together with the preparatory
drawings were exhibited earlier, in the Julien
Levy Gallery in New York in April and the
Galerie des Quatre Chemins in Paris in June.

Les Chants de Maldoror was the single most
important pre-Surrealist text as far as the
Surrealists were concerned. Isidore Ducasse,
the self-styled Comte de Lautréamont, had
published the full text of his extraordinary epic

prose poem in Brussels in 1869 and in Brussels and Paris in 1874 (cat.319). Nevertheless copies of it and his *Poésies* remained scarce until the future Surrealists launched their concerted campaign to establish his reputation. In 1919 Breton published the *Poésies* in *Littérature* (nos.2 and 3, cat.421), and from then on Lautréamont and his works were repeatedly praised, quoted and analysed. In 1925 Philippe Soupault edited his complete writings and in 1938 the Surrealists published a de-luxe edition of the complete works with illustrations by leading painters in the group, including Dalí. As Breton explained in a radio interview: 'For us there was no other genius who could stand comparison with Lautréamont' (*Entretiens 1913–1952 avec André Parinaud*, Paris, 1952, p.43).

Dalí's *Maldoror* etchings are among his most brilliant graphic works but are not illustrations to Lautréamont's text in the conventional sense. As he explained in the catalogue preface to the exhibition at the Galerie des Quatre Chemins mentioned above: 'It is glaringly obvious that the "act of illustration" could in no way restrict the course of my delirious ideas, but would, rather, encourage them to blossom. It could therefore only ever be a question of paranoiac illustrations'. And he went on to argue, with characteristically whimsical logic, that Millet's famous icon of piety, *L'Angélus*, was the ideal 'delirious' illustration to Lautréamont's most notorious simile, 'Beautiful as the chance encounter, on a dissecting table, of a sewing-machine and an umbrella'. Figures derived from *L'Angélus* were accordingly scattered throughout the etchings for the book. Millet remained a fixation with Dalí, both in his paintings and his writings.

320 / Etching by Dalí

321

MICHEL LEIRIS

Tauromachies

Repères 23

Paris, G. L. M., August 1937

With a frontispiece after a drawing by André Masson
Edition of 70; this copy no.10
Format: 20pp.; illustrated frontispiece; loose-leaf in yellow cover; 25.3 × 19.5; inscribed on colophon: *Guy Lévis-Mano*
GMA.A.42.0136.12

322

PERCY WYNDHAM LEWIS

The Apes of God

London, The Arthur Press, 1930

Edition of 750; this copy no.105
Format: 625pp.; illustrated; hb. with dust-jacket designed by Wyndham Lewis; 29.3 × 18.9; signed by the author on colophon
GMA.A.42.0289

The dust-jacket text, no doubt written by the author himself, informed the reader that: '*Apes of God* has for its setting London in the months preceding the General Strike (1926). It is by far the most important work of creative fiction that Mr. Wyndham Lewis has so far produced [...]. The author describes the book as "reflecting the collapse of English Social life in the grip of post-war conditions. Its theme is the confusion of intellect and of emotion as exhibited in a society beneath the shadow of a revolutionary situation." [...] The origin of the title is in the belief of the early Christians that the world swarmed with small devils who impersonated the Deity. These imitators of God they called Apes of God.' The enormous 625-page book, which took its author seven years to write, has been seen as Lewis's effort to surpass Joyce's *Ulysses* – a book Lewis vehemently criticised. His regular publisher, Chatto & Windus, declined to deal with it, having lost money on all his previous books, forcing Lewis to publish it himself under his own label, The Arthur Press. (See J. Meyers, *The Enemy: A Biography of Wyndham Lewis*, London, 1980, ch.10.)

323

PERCY WYNDHAM LEWIS

Enemy of the Stars

London, Desmond Harmondsworth, 1932

Format: 62pp.; illustrated title-page and frontispiece; hb.; 28.8 × 22.1
GMA.A.42.0349

This play, which has extensive and witty directions for the two actors, Hanp and Arghol, was first published in the first issue of

Blast in 1914 (see cat.407), and was republished here in a slightly altered form. The 1914 version was Lewis's first lengthy publication.

324

JACK LINDSAY & NORMAN LINDSAY

Homage to Sappho

London, Fanfrolico Press, 1928

With original etchings by Norman Lindsay
Edition of 70; this copy no.25
Format: 66pp.; illustrated with 15 etchings; hb.; 28.4 × 20.5; signed in ink on colophon: *Jack Lindsay*; vellum binding
GMA.A.42.0588

Norman Lindsay (1879–1969) was born in the state of Victoria in Australia. A painter and draughtsman of distinction, he is remembered mainly for his finely detailed etchings of buxom female nudes: fifteen such prints feature in this book. Lindsay's work was of such explicit sensuality that it was sometimes banned from sale or public exhibition. The author, Jack Lindsay (b.1901), was the artist's eldest son.

325

MARIETTE LYDIS & PIERRE MacORLAN

Criminelles

24 eaux-fortes de Mariette Lydis

Paris, n.d.

With 24 etchings, a frontispiece etching and a colour lithograph, by Mariette Lydis
Edition of 75; this copy no.52
Format: 4pp. text and 24 plates; loose-leaf in cloth folder with cover design of a door in black and blue; 30.3 × 24; each plate: 15 × 12 (page size 27.5 × 22.6); enclosed at front etching: 21.5 × 15.7 (page size 27.3 × 20.6) in paper folder with title *Petite Tzigane à Epsom* and colour lithograph: 27 × 20.4 in paper folder with title *Madina*
GMA.A.42.0266

The twenty-four etchings gathered in this portfolio are 'portraits' of murderesses whose appalling crimes are briefly summarised in the newspaper-style cuttings pasted underneath each image. Pierre MacOrlan has provided the short accompanying commentary. The fascination with violent crime, and specifically with the female criminal, was something Lydis shared with the Surrealists, who dedicated a whole publication to the convicted murderess Violette Nozière in 1933 (cat.397). In total contrast are the etching and colour lithograph enclosed in separate folders in the front of the portfolio. These are in the saccharine mode which Lydis practised on those occasions when she wished to charm rather than shock.

326

MARIETTE LYDIS

Sappho

Eaux-fortes de Mariette Lydis

Paris, J. J. Taneur, 1933

Quotations from *Sappho* edited by Théodore Reinach
and etchings by Lydis
Edition of 45; this copy no.41
Format: 72pp. including 4 illustrated contents pages;
illustrated, 15 etchings each signed by the artist,
enclosed within 1 folded sheet (4pp.); loose-leaf in
folded paper cover; 32.3 × 24.8; etchings various
sizes, 32 × 24.5(paper size)
GMA.A.42.0221

The lesbian scenes depicted in the etchings
gathered in this privately printed portfolio form
a piquant contrast to Lydis's contemporary
etchings of murderesses in cat.325. The brief
accompanying quotations from Sappho's
poetry (in the original Greek and in French
translation) were taken from the edition by
Théodore Reinach (Collection des Universités
de France).

327

MARIETTE LYDIS

Le Trèfle à 4 feuilles
Ou La Clef du bonheur

Paris, G. Govone Editeur, 1935

Edition: 250 of which 50 were *hors commerce*; this copy
no.61
Format: 72pp.; illustrated with 16 colour lithographs;
pb. with cover by Lydis; 16.7 × 12.8; plates: 16 × 12.5
GMA.A.42.0029

Mariette Lydis was born in Vienna but settled
definitively in Paris in 1927 where she was much
in demand as an illustrator. Her main subject
was women and a significant proportion of her
work was strongly tinged with eroticism.
However, in this attractively produced book of
popular sayings and superstitions relating to
the lives of women, she adopted a self-con-
sciously folkloric and naïve manner. The
lithographs were printed by the famous house
of Mourlot Frères, and were coloured by Saudé
who was responsible for the pochoir reproduc-
tions of Miró's gouaches illustrating Lise
Hirtz's *Il était une petite pie* (cat.287).

328

BRUCE MCLEAN & MEL GOODING

Dreamwork

London, Knife Edge Press, 1985

23 images screenprinted by Bruce McLean and
Michael Schönke at Druckwerkstatt, Künstlerhaus,
Bethanien, Berlin; text *Inventory* by Mel Gooding
Edition of 140; this copy no.11
Format: 66pp., 8pp. text, 23 images; hb. with
screenprinted dust-jacket in three colours and

screenprinted and laminated slipcase and cover;
42 × 31.5 (page size 40 × 30.4); central image fold-
out: 40 × 118; signed and numbered and dated inside
front jacket: *Bruce McLean / 11 / 140 / 1985*; signed on
colophon by artist and author
GMA.A.42.0584

The screenprints by McLean and three short
texts by Gooding, oppose imagery identified in
McLean's art with the cold north of Scotland
and Berlin (he was born in Glasgow and spent
a year on a DAAD scholarship in Berlin in
1982–83) with the warm south of Italy and
France. Thus we find the amphora, the
sunbather, Gucci shoes and handbags, mixing
with images which McLean developed in Berlin
or which remind him of his youth, such as the
ladder, the pipe smoker, socks and the
wagging finger. The Knife Edge Press, the
creation of McLean and Gooding, has since
published several other bookworks by McLean.

329

HUGH MCRAE

Idyllia

Sydney, N. L. Press, n.d.

With etchings by McRae
Edition of 133; this copy no.55 signed by the author
Format: 34pp.; illustrated, with 5 etchings tipped in,
signed by the artist below image right; hb. with half-
leather binding; 41 × 34.5; etchings: various sizes
(page 40.3 × 33.5)
GMA.A.42.0995

330

MAN RAY

Revolving Doors 1916 – 1917

Paris, Editions Surréalistes, 1926

Edition of 105; this copy no.6
Portfolio of 10 pochoir prints on paper, 56 × 38
(paper size); inscribed on colophon: *No.6 Man Ray*;
now separately mounted and framed
I. Mime; II. *Longue Distance*; III. *Orchestre*; IV. *La
Rencontre*; V. *Légende*; VI. *Carafe*; VII. *Jeune fille*; VIII.
Ombres; IX. *Mélanger de Béton*; X. *Libellule*
GMA.A.42.1011 [GMA3003]

Colour plate 58

328 / Cover by McLean

The ten pochoirs in *Revolving Doors* reproduce
ten collages Man Ray made with spectrum-
coloured papers in New York in 1916–17.
Described by Man Ray as 'pseudo-scientific
abstractions' (*Self Portrait*, Boston, 1988, p.61),
the original collages were derived from the
large, flat coloured shapes of his most
important painting to date, *The Rope Dancer
Accompanies Herself with Her Shadows*, 1916 (The
Museum of Modern Art, New York), which
itself was based on a collage of coloured
papers. At the time Man Ray intended to use
the collages as preparatory studies for a series
of large oil paintings, but only two of the
paintings were actually executed.

For their first installation at the Daniel
Gallery in New York in 1919, Man Ray framed
the collages separately and hinged them onto a
rotating support, so that the entire ensemble
could be spun around like a revolving door –
hence the title – and thus produce surprising
optical effects. The collages were accompanied
by what Man Ray later described as a 'long' and
'rambling' text (op. cit.) consisting of fanciful
and abstruse analyses of the individual
compositions. In March 1926 he exhibited the
collages again at his one-man show at the
Galerie Surréaliste. The portfolio of pochoir
reproductions was published by Editions
Surréalistes to coincide with that exhibition.
Mrs Keiller purchased her set from Harold
Landry, the London book dealer, in January
1977.

331

MAN RAY

La Photographie n'est pas l'art

Paris, G. L. M., 1937

With foreword by André Breton
Format: 17 sheets, 34pp.; illustrated, 12 photographs
by Man Ray; loose-leaf in black cut-out paper cover;
25 × 16.4
GMA.A.42.0436

This portfolio of twelve photographs by Man
Ray was published in May 1937 with a prefatory
text by Breton entitled 'Convulsionnaire' – an
allusion to his famous definition of beauty in
Nadja (1928), 'La beauté sera convulsive, ou ne
sera pas' (Beauty will be convulsive or will not
be). The text is aphoristic and staccato in style,
and complements the jolting and disturbing
contrasts which characterise the photographs
themselves. The mood and effect of the
portfolio are well described by Sandra Phillips:
'It seems a litany of what photography is, a
medium that can describe real things and also
transform them into appealing or appalling
objects, yet which cannot be "art". Many of the
images are hard, even brutal [...] The titles are

often laden with sarcasm [...] The whole book seems a despairing counterpoint to Franz Roh's idealism, a surrealist taint on the utopian Bauhaus faith in photography's liberating versatility' ('Themes and variations: Man Ray's photography in the twenties and thirties' in *Perpetual Motif. The Art of Man Ray*, New York, 1988, pp.221–222). This copy was formerly owned by Georges Hugnet. Mrs Keiller purchased it from H. A. Landry, London, in January 1975.

332

MAN RAY & PAUL ELUARD

Les Mains libres

Man Ray. Dessins. Illustrés par les poèmes de Paul Eluard

Paris, Editions Jeanne Bucher, 1937

With additional ms. poems by Man Ray
Edition of 675; this copy no.265
Format: 206pp.; illustrated; pb.; 26 × 22.5; inscribed on half-title: *à Jacques-Henry Lévesque / Hommage de Man Ray*; inserted between preface and illustrations are loose-leaf sheets with Man Ray (holograph) ms. poems
GMA.A.42.0438

Les Mains libres was published on 10 November 1937 by Editions Jeanne Bucher. Like *Facile* (cat.260), it arose from the close friendship that united artist and poet. In this case, however, the drawings came first and are undeniably the dominant partner. Almost all of them are dated 1936 and some of them are derived directly from Man Ray's own photographs. Man Ray left them with Eluard who, within a period of a few weeks, wrote the suite of short poems which, as the sub-title has it, 'illustrate' them. The date of composition can be established fairly precisely because on 21 June 1936 Eluard gave his wife, Nusch, the working manuscript of the poems for her birthday. To advertise the book, an exhibition of thirty-six of Man Ray's original drawings was held in Jeanne Bucher's gallery in Paris (5–20 November).

The title involves a pun on the artist's name – 'main' / Man – and alludes to his avowed

principles of liberty and pleasure. In a brief 'Preface' Eluard defines Man Ray's drawing as: 'always desire, not need. No down, not a cloud, but wings, teeth, claws,' and concludes: 'Man Ray draws in order to be loved'.

Mrs Keiller purchased her copy of *Les Mains libres* from H. A. Landry, the London book dealer, in January 1976. It was originally a gift to Jacques-Henry Lévesque, and although it is not one of the twenty-five de-luxe copies, it is of great importance because it contains the manuscripts of short poems by Man Ray himself which are his response to Eluard's response to his drawings. These poems are written in French on sheets of paper which are slipped in at the appropriate place in the book. The first of these insertions is a quip rather than a poem, and is inserted before Eluard's preface. It reads: 'à Paul Eluard pas besoin de vers libres. Quand on a les mains libres' (To Paul Eluard. No need for free verse when one has free hands).

333

MAN RAY

Alphabet for Adults

Beverly Hills, Copley Galleries, 1948

With text and illustrations by Man Ray
Format: 80pp.; illustrated, from 38 drawings by Man Ray; hb.; 29.6 × 22.1; inscribed on title-page: *à Néjad- / Man Ray / Paris 26–9–57*
GMA.A.42.0197

Following the outbreak of war, Man Ray returned to America and settled in Hollywood, where he remained until 1951. In 1946 he met the Surrealist dealer-collector Bill Copley, who organised an exhibition of his work at his Beverly Hills gallery in December 1948. *Alphabet for Adults* was published to coincide with this show. In a brilliant reversal of the traditional children's primer, it exploits the one-to-one relationship of text to image to multiply the range of possible meanings, instead of providing simple, reductive definitions. In his preface Man Ray writes: 'To make a new alphabet of the discarded props of a conversation can only lead to fresh discoveries in language. Concentration is the desired end, as in an anagram whose density is the measure of its destiny'.

This copy of the book was formerly in Hugnet's collection. Mrs Keiller acquired it through Tony Reichardt, London.

334

FERNAND MARC

Circonstances

Repères 21

Paris, G. L. M., February 1937

With a frontispiece after a drawing by Jean Marembert
Edition of 70; this copy no.10
Format: 22 pp.; illustrated frontispiece; loose-leaf in yellow cover; 25.3 × 19.5; inscribed on colophon: *Guy Lévis-Mano*
GMA.A.42.0136.10

335

JEHAN MAYOUX

Ma tête à couper

Paris, G. L. M., 1939

With an etching by Yves Tanguy
Edition of 300 with numbers 1–25 printed on Vélin d'arches paper and 5 *hors commerce* copies marked A–E, all containing an etching by Yves Tanguy; this copy no.22
Format: 54pp.; illustrated, etching inserted at title-page; pb.; 19 × 14.2; etching: 14.3 × 10 (page size 18.8 × 13.5); enclosed inside front cover publisher's leaflet for Alice Paalen's *A même la terre*
GMA.A.42.0279

This was published towards the end of April 1939, and has an etching by Tanguy as its frontispiece. Mayoux had been a member of the Surrealist group since the mid-1930s and rallied to Breton in 1946 when the latter was striving to reconstitute a cohesive group after his return to Paris from America. Mrs Keiller bought this copy through Tony Reichardt, London, at an unrecorded date. It came from Georges Hugnet's library.

336

E. L. T. MESENS

Alphabet sourd aveugle

Brussels, Editions Nicolas Flamel, 1933

With preface and note by Paul Eluard and frontispiece illustration by Mesens
Edition of 513; this copy no.309
Format: 38pp.; illustrated, frontispiece by the author; pb.; 27 × 21.3; inscribed in ink on half-title: *à Cecely[sic] et Humphrey / JENNINGS / en échange d'un beau / dimanche et avec toute / mon affectueuse attention. / London, 19 April 1936 / Mesens*
GMA.A.42.0267

In a bibliographical note provided in his collected *Poèmes 1923–1958* (cat.340, pp.179–80), Mesens explained the two dates that appear at the end of the text of *Alphabet sourd aveugle* in this, the first edition: the twenty-six poems were written – in true Surrealist fashion – at the Clinique Edith Cavell in Uccle-Bruxelles during a mere two afternoons in August 1930; the proofs were corrected at

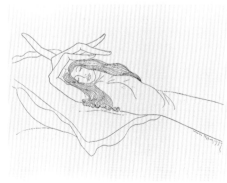

332 / Page 97 by Man Ray

Rixensart (south of Brussels) in June 1933. The frontispiece reproduces a collage by Mesens and the book has a preface and note by Eluard, a close friend.

This copy was presented to Humphrey Jennings and his wife Cicely in April 1936. Jennings was a prominent member of the English Surrealist group, active as a poet, theorist, painter, collagist and film-maker. He collaborated with Mesens and Penrose on the organisation of the Surrealist exhibition in London in June 1936, and was no doubt discussing arrangements for this momentous event with Mesens on the 'beau dimanche' (lovely Sunday) referred to in the latter's affectionate dedication.

337

E. L. T. MESENS

Trois peintres surréalistes.

Magritte, Man Ray, Tanguy

Brussels, Palais des Beaux-Arts, 1937

Exhibition catalogue, Palais des Beaux-Arts, Brussels, 11–22 December 1937
Format: 29pp.; illustrated; pb.; 27.8 × 21.8
GMA.A.42.0207

Although this functioned as the catalogue for the exhibition of works by Magritte, Man Ray and Tanguy which Mesens organised at the Palais des Beaux-Arts in Brussels in December 1937, it is a Surrealist document in its own right. Thus it has a preface by the Belgian Surrealist poet Jean (or Louis) Scutenaire and is interspersed throughout with Surrealist texts. The design, which involves the use of alternating turquoise, canary-yellow, orange, green, grey and cream paper, is both recherché and dramatic, and is also typical of Mesens who took great care over the presentation of every publication for which he was responsible. In December 1937 Mesens left Brussels for London, and a few months later became director of the London Gallery (see cat.338).

338

E. L. T. MESENS

Message from Nowhere

Message de nulle part

Collection of poetry, drawings & criticism edited by E. L. T. Mesens

London, London Gallery Editions, November 1944

Format: 24pp.; illustrated; pb.; 21 × 13.2
GMA.A.42.0987

Acting as the emissary of Breton and Eluard, Mesens arrived in London in June 1936 to mastermind the installation of *The International Surrealist Exhibition* and thus to ensure a properly 'convulsive' impact. With his immense knowledge of Surrealist poetry, art and theory, he became a vital source of information for the recently formed English Surrealist group and the principal intermediary between it and the groups in Brussels and Paris. At the end of 1937 he settled in London. The following spring he was appointed director of the London Gallery, which under him became the centre for Surrealist art in England, and also started up *London Bulletin* (cat.424) to provide English Surrealism with its own regular forum.

The war inevitably disrupted these activities and *London Bulletin* ceased publication in June 1940. But Mesens himself was adamant that the war should not be allowed to put an end to 'the Surrealist revolution'. With new and committed members, including Jacques Brunius and Conroy Maddox, to replace those who had drifted away, he issued a series of publications intended to keep the flame of 'true' Surrealism burning. *Message from Nowhere*, which contained both French and English texts and which Mesens prepared with the help of Brunius, was part of this campaign. It was published at a time of violent schism within the English Surrealist group between those headed by Mesens and Penrose, and those by Toni del Renzio (see cat.241).

339

E. L. T. MESENS

Troisième front suivi de Pièces détachées

Third front and Detached Pieces

London, London Gallery Editions, 1944

Edition of 500; this copy no.422, signed by the author on colophon
Format: 48pp.; illustrated; pb.; 21 × 15
GMA.A.42.0337

This is a collection of Mesens's *poèmes de guerre* (war poems) published in both English and French. The translations were the work of Roland Penrose and Mesens himself.

340

E. L. T. MESENS & RENÉ MAGRITTE

Poèmes 1923 – 1958

Dix dessins de René Magritte

Paris, Le Terrain Vague, 1959

Edition of 1100; this copy no. XLV, signed by the author
Format: 186pp.; illustrated, after 10 drawings by Magritte; pb.; 27.8 × 21.3; inscribed in pencil on flyleaf: *Joe Tilson / Antwerp.1974*
GMA.A.42.0264

Mesens and Magritte were lifelong friends and collaborated on many occasions. Thus in 1925 at the outset of their careers they published *Œsophage*, a latter-day Dada pamphlet, following it up in 1926 with *Marie*, a short-lived magazine closer to Surrealism in spirit. In 1927 when he became manager of P. G. van Hecke's Galerie L'Epoque in Brussels, Mesens's career as an art dealer took off and thereafter he assiduously promoted Magritte's work. When he moved to London in 1937 to manage the London Gallery, he did everything possible to raise the profile of Belgian Surrealism and Magritte in particular. As editor of *London Bulletin*, 1938–40 (cat.424), he ensured Magritte's work was well represented in the official magazine of the English Surrealist group. It was also Mesens who organised Magritte's first full-blown retrospective in 1954 (at the Palais des Beaux-Arts in Brussels), and wrote the fully documented catalogue. When this collected edition of Mesens's poetry was planned it was only fitting that Magritte be selected to provide a suite of drawings to illustrate it.

Mrs Keiller purchased this copy through Tony Reichardt at an unknown date.

341

JOAN MIRÓ

Joan Miró: Catalogue of an exhibition of selected early paintings and drawings by Joan Miró

London, Zwemmer Gallery, 1937

Exhibition catalogue with cover design and colour illustration by Miró, Zwemmer Gallery, London, June 1937
Format: 6pp.; illustrated; 25.8 × 19
GMA.A.42.0985

342

HENRI MICHAUX

Sifflets dans le temple

Repères 15

Paris, G. L. M., May 1936

With frontispiece by [J. L. G.] Bernal
Edition of 70; this copy no.10
Format: 20pp.; illustrated with a frontispiece after a drawing by Bernal; loose-leaf in red cover; 25.3 × 19.5; inscribed on colophon: *Guy Lévis-Mano*
GMA.A.42.0136.04

343

MAX MORISE

Le Mouvement

Poèmes (1920 – 1924) avec 2 dessins de Max Morise

Paris, Librarie Gallimard, 1926

Edition of 250, 150 numbered 1–150, and 20 *hors commerce* examples numbered A-T; 100 other examples numbered 151–250; this copy no.56
Format: 95pp., illustrated; pb.; 23.8 × 18.5; inscribed in black ink on back cover: *ses intestins grêlent / qu'ils brûlent / Alfred Jarry*
GMA.A.42.0036

Morise was an active member of the Surrealist group throughout the *époque des sommeils* (period of trances), 1922–24, and until the end of the decade when Breton rounded upon him in the Second Manifesto. Like Desnos, he counter-attacked in *Un Cadavre* (see cat.244). Known best for his writings, Morise was also very active as a painter and draftsman. The front cover of this book of his early poems requests the reader to see the *pensée* (thought) on the back; there, in a specially printed box, Morise and / or his friends handwrote a provocative quotation, so that each copy was unique. The handwritten quotation on the Keiller copy is from Alfred Jarry, and reads: 'Ses intestins grêlent, qu'ils brûlent' (His intestines hail, let them burn).

344

[PAUL NOUGÉ & RENÉ MAGRITTE]
Catalogue de la Maison Samuel
Pour l'année 1928 la Maison SAMUEL nous présente quelques manteaux
Brussels, Bischoftsheim, 1927

Format: 36pp.; illustrated, including 2 colour plates; pb.; 21.9 × 15.4
GMA.A.42.0441

This was purchased from Yves Gevaert, Brussels, in December 1979, with cat.345. It is the catalogue issued by Maison Samuel for the 1928 season, and was therefore published in

the autumn of 1927. The previous year Magritte had provided the illustrations for a catalogue for the same firm of Brussels furriers, but on that occasion the accompanying commentrary was written by Camille Goemans. This time Nougé wrote the brief poetic texts accompanying the plates and also the prologue and epilogue, but both his and Magritte's contributions appeared anonymously. The illustrations are reproductions (two in colour) of sixteen collages Magritte made in the summer of 1927 before he left Brussels that September to settle in the Parisian suburb of Le Perreux-sur-Marne, and ingeniously combine advertisements for the furs with dream-like Surrealist scenarios. (The original collages have disappeared.) Magritte's admiration for de Chirico's Metaphysical paintings and the early Surrealist work of Ernst is plain to see, but many specifically Magrittian motifs are present, including the curtain, framed mirror and turned wooden skittle or baluster, and in general the collages relate closely to his contemporary paintings. Magritte himself appears in one of the collages in the form of a photograph.

345

[PAUL NOUGÉ & RENÉ MAGRITTE]
Quelques écrits et quelques dessins de Clarisse Juranville
Brussels, A. Foulon, 1927

Edition of 100 on Arches paper and 10 *hors commerce* copies; this copy no.99
Format: 32pp.; illustrated, reproductions of 5 drawings by Magritte; pb.; 15.9 × 12.3; published under the name of Clarisse Juranville
GMA.A.42.0415

This was purchased from Yves Gevaert, Brussels, in December 1979, with the Maison Samuel catalogue (cat.344).

Nougé's foreword is dated 7 September 1927 and the booklet itself was printed at the end of the same month. It is a spoof on the writings of Mlle Clarisse Juranville, whose popular school manual on the conjugation of verbs (*La Conjugaison enseignée par la pratique*) was first published in Paris in c.1880 and reprinted several times thereafter. Nougé had discovered a copy among his wife's belongings and parodied Miss Juranville's style, and the style of grammar textbooks in general, in the eleven poems published here. Magritte provided five full-page drawings of blatantly Surrealist character which incorporate passages of automatic scribbling – a relative rarity for him. André Souris, another leading member of the Belgian Surrealist group, kept the joke alive by composing 'a few airs', supposedly under the direction of Clarisse Juranville herself. The first public performance of this composition took place at the Salle du Conservatoire Royal de Bruxelles on 23 April 1928. (For full details, see D. Sylvester and S. Whitfield, *René Magritte. Catalogue raisonné*, Vol. I, Menil Foundation, 1992, pp.75–76.)

346

ALICE PAALEN
A même la terre
Paris, Éditions Surréalistes, 1936

With etchings by Yves Tanguy
Edition of 235 with nos.1–10 on Japon impérial paper each with an etching by Tanguy; this copy no.6 contains two versions of Tanguy's frontispiece etching
Format: 100pp.; illustrated, frontispiece etching in brown and black versions; pb.; 19.2 × 21.9 overall (pp. of various sizes); etching: 10.3 × 6.4 (page size 14 × 9.8); inscribed in ink on half-title-page: *à Roland Penrose / l'ambre séduit par les / fougères / avec toute l'affection / fidèle de son amie / Alice Paalen / le nord bâtit l'hiver / avec les abeilles noires / et des ailes blanches*
GMA.A.42.0179

This de-luxe copy of *A même la terre* contains Tanguy's etched frontispiece in two different states, one printed in reddish-brown, the other in black. Alice Paalen presented it to Roland Penrose, very probably at the time of *The International Surrealist Exhibition* in London in which her husband, Wolfgang Paalen, was represented by twelve works. (The book was published at the end of June 1936 when the exhibition still had a few days to run.) Mrs Keiller purchased it through Tony Reichardt, London, but the date is unrecorded.

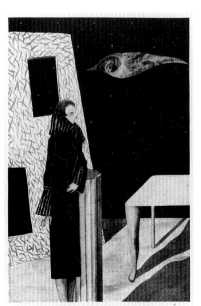

344 / Plate 8 by Magritte

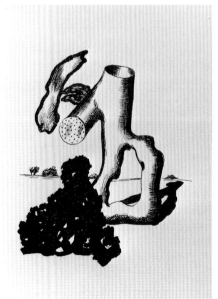

345 / Plate 2 by Magritte

347 / Drawing by Miró

347

ALICE PAALEN

Sablier couché

Paris, Editions Sagesse, 1938

With a proof copy of frontispiece etching in black and white, collage frontispiece etching and an original drawing in pencil and crayon on front paper by Joan Miró
Edition of 75; this copy no.72
Format: 16pp.; illustrated; pb.; 21.8 × 17; etching: 14 × 9.8 (page size 21 × 16.4), signed by Miró and numbered: *épreuve rayée 1 / 5*; collage frontispiece etching in red on yellow paper: 19.8 × 15.5 overall, signed by Miró and numbered 72 / 75; drawing: 21.2 × 16.4, inscribed in ink above: *à Georges Hugnet / rayant les robes des comètes noires / très affectueusement / Alice Paalen*; below; *la grande moisson des orages est proche / coupe les pas du cheval pour qu'il se ressemble*, and in pencil at left: *pour Georges Hugnet / avec la vieille / amitié / de Miró / 1 / 39.*; inscribed on colophon: *Alice Paalen*
GMA.A.42.0412

Colour plate 56

This was formerly in the collection of Georges Hugnet and is dedicated to him with an elaborate, poetic inscription by Alice Paalen and a finished pencil and crayon drawing by Miró dated 1.39. Miró's frontispiece etching is very eye-catching, being printed in red on canary yellow paper cut out to form an irregular 'splash' and pasted down on Arches laid paper. Also inserted in this copy of the book is the first of five impressions of the etching pulled from the cancelled plate and printed in black on white paper. (See P. Cramer, *Joan Miró. The Illustrated Books: Catalogue Raisonné*, Geneva, 1989, no.5.) Alice Paalen was the wife of Wolfgang Paalen, a prominent Surrealist painter from about 1935 onwards.

The book was purchased from John Armbruster, Paris, at an unknown date.

348

EDUARDO PAOLOZZI

Kex

London, Lund Humphries for the William and Noma Copley Foundation, [1966]

Edited by Richard Hamilton and Percy Lund Humphries
Format: 44pp.; illus; hb.; 21.5 × 21.5; inscribed in pencil at front: *For G from Richard Hamilton / & A / 24. XI.75*
GMA.A.42.0353

349

EDUARDO PAOLOZZI

Metafisikal Translations

London, Kelpra Studio Limited, 1962

Edition of 100; this copy no 2 signed and numbered by the artist
Format: 48pp.; illustrated, screenprinted by Kelpra; pb. in slipcase; inscribed in ink at front: *To Gabrielle / Eduardo*
GMA.A.42.0150

In the manner of Paolozzi's *Bunk* 'lecture' of 1952, which presented a panoply of images delivered in a random order, *Metafisikal Translations* features an accumulation of texts and images drawn from a wide range of sources, though connected in their reference to machinery and popular imagery. The book was screenprinted in December 1962 at Kelpra Studios, London, where Paolozzi would subsequently make many of his most important screenprints, including *Metallization of a Dream* (cat.130). The metamorphic chair / library steps featured in that print first appeared as a full-page illustration in the present book.

350

EDUARDO PAOLOZZI &
LAWRENCE ALLOWAY

The Metallization of a Dream

London, Lion and Unicorn Press, Royal College of Art, 1963

With a commentary by Lawrence Alloway
Format: 64pp.; illustrated, including 4 coloured photo-lithographs; hb., embossed brown boards with black leather spine; 26.6 × 21.7
GMA.A.42.0331

351

EDUARDO PAOLOZZI

Abba-Zabba

Cologne, Editions Hansjörg Mayer, 1970

Edition of 500; this copy no.1, signed by the artist
Format: 66pp.; illustrated; hb.; 26 × 19.5; inscribed in pencil by the artist at front: B*A*S*H / BAROK ALL STYLE HIGH; designed, edited and printed at Watford School of Art
GMA.A.42.0350

352 / Drawing by de Chirico

352

HENRI PASTOUREAU

Le Corps trop grand pour un cercueil

Paris, Editions Surréalistes, 1930

With a preface by André Breton, and frontispiece by Giorgio de Chirico; mss. for text by Breton and poems by Pastoureau and original drawing for frontispiece
Edition of 150 plus 50 *hors commerce* copies; this copy no.1 of 2 printed on Japon nacré paper with a frontispiece by Giorgio de Chirico
Format: 30pp.; illustrated frontispiece; pb.; 25.3 × 15.7; original drawing by de Chirico for frontispiece: pen and ink on paper, 20.9 × 13.5; inscribed bottom centre in ink: *Le Rêve mystérieux* [removed from book and framed by Mrs Keiller; GMA.3949]; enclosed is ms. of the preface by André Breton and the original mss. of the poems by Pastoureau
GMA.A.42.0418 WITH GMA.3949

This copy of *Le Corps trop grand pour un cercueil*, which Mrs Keiller bought through Tony Reichardt, London, at an unrecorded date, contains the manuscripts of all twenty-one of Pastoureau's poems and also the manuscript of Breton's preface. All are very carefully written and were, probably, neat copies for the printer. Thus the layout of the printed texts of the poems exactly conforms to the layout of the manuscript, and a correction in pencil to the manuscript of the first poem is copied on the corresponding printed text. (This correction is signed illegibly and dated '16–3–70'.)

The frontispiece to the book is a reproduction of a drawing by Giorgio de Chirico entitled *Le Rêve mystérieux*. The original drawing in pen and ink is also included in this copy of the book. Although undated, it can be ascribed with confidence to 1913–14, on analogy with many other similar drawings de Chirico made in Paris before the First World War, which later entered the collections of his Surrealist admirers. Thus a contemporary drawing entitled *La Grande Place*

mystérieuse, which Picasso bought from Paul Eluard between 1936 and 1940, has similar iconography and includes the same sleeping dog (Musée Picasso, Paris; MP 3590. IV). Although drawings such as these relate closely to de Chirico's contemporary paintings, they were independent compositions rather than preparatory sketches. Unlike the paintings they are quite casual in execution and often, as here, strike a gently humorous note. The present drawing may possibly have come from Breton's own collection in which pride of place was given to de Chirico's famous canvas *Le Cerveau de l'enfant* (The Child's Brain) of 1914.

Henri Pastoureau was a twenty-year-old philosophy student when he was welcomed into the Surrealist group in 1932. He had gained Breton's trust by demonstrating against a lecture on Rimbaud given by a parish priest; the spectacle of the Catholic church attempting to appropriate one of the Surrealists' adopted forefathers was not something they could let pass without protest. By 1951, however, Pastoureau's relationship with Breton had gone sour. Like Patrick Waldberg, Marcel Jean (see cat.313) and several others who had joined in the 1930s, he believed Breton had gone soft since his return to France from America, and was no longer upholding the pure principles of the Surrealist revolution. The famous *affaire Pastoureau* (also known as the *affaire Carrouges*) erupted and led to a new spate of recriminations and defections.

353

MARC PATIN

L'Amour n'est pas pour nous, suivi de Femme magique

Paris, Edition de la Main à Plume, 1942

With text by Patin and a 'Portrait automatique de l'auteur' by Noël Arnaud, original wash drawings by Tita and mss. of Patin's text
Edition of 20; this copy no.1
Format: 16pp.; illustrated, 2 plates and original wash drawings by Tita; pb.; 19.3 × 14.5; enclosed is ms. of Patin's texts, 16pp.; inscribed on half-title: *à l'ami de Paul Eluard / l'ami de Georges Hugnet / Marc Patin*
GMA.A.42.1001

Colour plate 59

353 / Drawing by Tita

Marc Patin was one of the foremost poets and Tita one of the foremost artists in Noël Arnaud's Main à Plume group. This special copy of *L'Amour n'est pas pour nous* includes the manuscripts of Patin's texts. Its most remarkable feature, however, is the original watercolour drawings, all erotic in character, with which Tita ornamented several of the pages and which are much more striking than her two illustrations printed in the book. Like many of the rare books in the Keiller Bequest, this formerly belonged to Georges Hugnet.

354

OCTAVIO PAZ & MARCEL DUCHAMP

Marcel Duchamp ou Le Château de la pureté

Geneva, Editions Claude Givaudan, 1967

Translated from Spanish by Monique Fong-Wust and with a suite of *Ombres Transparentes* by Marcel Duchamp
Edition of 606; this copy no.85 signed by author and artist
Format: 2 vols.; vol.1: 105pp.; illustrated; pb; vol.2: *Suite d'Ombres Transparentes*, 16 sheets by Duchamp; pb. in hb. slipcase; 23.8 × 17.8
GMA.A.42.0276

This influential account of the symbolic world of Duchamp's work was published in 1967 just a year before the artist's death. The text is a translation from the Spanish. Both Paz and Duchamp signed this copy. The second 'volume' consists of Duchamp's *Suite d'ombres transparentes* (Series of Transparent Shadows), sixteen sheets of clear celluloid printed with abstract designs in solid white. Paz, a Mexican poet who had met Péret in Mexico during the war, was a prominent figure in the Surrealist group in Paris in the late 1940s and '50s.

355

ROLAND PENROSE

The Road is Wider than Long
An Image Diary from the Balkans, July – August 1938

London, London Gallery Editions, 1939

With photographs by Roland Penrose and cover design by Hans Bellmer
Edition of 510; this copy no. ∞
Format: 52pp.; illustrated; hb.; 21 × 17; inscribed on half- title: *for my adorable / Gabrielle / with a long stretch of love / Roland*
GMA.A.42.0996

Subtitled *An Image Diary from the Balkans, July-August 1938*, this was published in June 1939. It is dedicated to Lee Miller, Penrose's future wife. Extracts from the book were published in *London Bulletin* (cat.424), no.7, December 1938-January 1939.

In *Scrapbook, 1900–1981* (London, 1981, p.116), Penrose describes the expedition to the Balkans with Lee which inspired this book. Their guide in Rumania was Harry Brauner, younger brother of Victor Brauner, the Surrealist painter: 'Festivals in remote monasteries in the Carpathians, wild authentic gipsies in the plains, performing bears that could cure rheumatism by walking delicately over their patients and the passionate songs of a peasant woman in the open-air night club in a narrow street behind the north station kept us in a continuous state of excitement'. Lee Miller was a distinguished photographer and recorded the trip herself, but the photographs in *The Road is Wider than Long* are Penrose's own. Early in 1939, having bound the manuscript in 'thick shoe leather', and armed himself with 'an exact copy of a pair of handcuffs in gold, complete with keys and signed "Cartier"' as an additional love token for her, Penrose set off for Egypt where she had gone to rejoin her then husband, Aziz Eloui Bey. 'She greeted me warmly', he recalls, 'and said she found both presents thoroughly captivating' (ibid., p.118).

356

VALENTINE PENROSE

Le Nouveau Candide

Paris, G. L. M., 1936

With a frontispiece by Wolfgang Paalen
Edition of 200; this copy no.36
Format: 28pp.; illustrated frontispiece; pb.; 19.4 × 14.2
GMA.A.42.0362

Valentine Penrose (née Boué) met Roland Penrose when he was living in France and they married in 1924. The couple soon became close friends of Ernst and his second wife Marie-Berthe Aurenche and thus became involved in the activities of the Surrealist group in Paris. Another close friend was Eluard who greatly admired Valentine Penrose's highly original writing, and in 1934 wrote the preface for her first book of poems, *Herbe à la lune*. *Le Nouveau Candide* was published shortly after her return from a prolonged visit to India which she felt was her spiritual home. The Viennese painter Wolfgang Paalen was a relatively recent recruit to Surrealism when he provided the frontispiece, but quickly established himself as a major force within the movement. In February 1940 he organised an international Surrealist exhibition in Mexico and from there published the Surrealist review *Dyn* (1942–44).

357

VALENTINE PENROSE

Sorts de la lueur

Repères 19

Paris, G. L. M., February 1937

With a frontispiece after a drawing by Wolfgang Paalen
Edition of 70; this copy no.10
Format: 20pp.; illustrated frontispiece; loose-leaf in red cover; 25.3 × 19.5; inscribed on colophon: *Guy Lévis-Mano*
GMA.A.42.0136.08

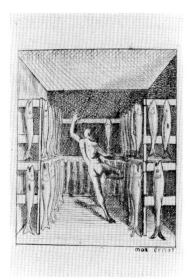

358 / Frontispiece by Ernst

358

BENJAMIN PÉRET

Au 125 Boulevard Saint-Germain

Paris, Les Presses du Montparnasse, Collection Littérature, 1923

With a frontispiece by Max Ernst
Edition of 181 with a drypoint by Max Ernst tipped in as frontispiece; this copy marked P, one of 50 examples for the press
Format: 60pp.; illustrated, frontispiece and reproductions of 3 drawings by the author; pb.; 15.9 × 11.2; drypoint: 6.3 × 5.2 (paper size 8.7 × 6), signed below image right: *Max Ernst*; inscribed in ink on flyleaf: *A René Coroller / Viens me voir un jour sauf le / soir en me prévenant à l'avance / Un samedi après-midi par exemple / A toi très affectueusement / Benjamin Péret / 21 rue Lechesse [?] (17)*and on title-page inscribed in ink: *Reçu à Nantes, le 8 Septembre 1923 / R. Coroller*
GMA.A.42.0051

Ernst made very few original prints in the 1920s, the tiny drypoint for the frontispiece of this book being one of them. Depicting a nude man running inside a small room lined with racks from which huge fish are suspended, it resembles the dream-like scenarios of the collages Ernst had made for *Répétitions* and *Les Malheurs des immortels* (cat.254) in 1922, and parodies the hatched lines of the popular engravings which were his primary source in

making those collages. Anne Hyde Greet argues that the drypoint also relates closely to the spirit and imagery of Péret's mysterious and darkly comic Surrealist tale, even though it does not illustrate any particular episode ('Max Ernst and the Artist's Book: From *Fiat Modes* to *Maximiliana*', in *Max Ernst. Beyond Surrealism. A Retrospective of the Artist's Books and Prints*, New York and Oxford, 1986, p.98, and no.16). A small drawing by Ernst is reproduced on the cover of *Au 125 du Boulevard Saint-Germain*, but the three Picabia-esque drawings reproduced inside were by Péret himself.

359

BENJAMIN PÉRET

Immortelle maladie

Paris, Collection 'Littérature', 1924

With frontispiece by Man Ray
Two copies
a. Edition of 201; this copy no.46
Format: 16pp.; illustrated, including frontispiece; pb.; 21 × 16.5; inscribed on flyleaf: *A Monsieur Monny de Boully / C'était du ciel d'affiche / que [...]. les alcools / absurdes / Benjamin Péret / 13 juillet 1925*
GMA.A.42.0360
b. Edition of 201; this copy no.20
Format: 16pp.; illustrated; hb.; 21.4 × 17.1; inscribed at front: *A Georges Hugnet / qui casse les pierres où je dors / avec son foie, avec ses dents / avec ses oreilles / Benjamin Péret / 22 mai 1934*
Binding by Hugnet with coloured decalomania endpapers
GMA.A.42.0385

Immortelle maladie was published before the Surrealist movement was launched officially in October 1924 with the publication of Breton's First Manifesto. There are two copies in the Keiller collection, one of which Péret presented to Hugnet in May 1934. Hugnet bound it and provided particularly beautiful black and violet decalcomania endpapers. It was purchased by Mrs Keiller from John Armbruster, Paris, in April 1978. The other copy formerly belonged to Marcel Mariën.

360

BENJAMIN PÉRET, LOUIS ARAGON & MAN RAY

1929

Paris, [no publisher cited], 1929

Edition of 215; this copy no.44 of 48 on Hollande van Gelder zonen paper; 26pp.; illustrated, with 4 photographs by Man Ray; pb. with cover of smaller size than text; 31 × 23.8 (pages), 28.5 × 22.4 (cover)
GMA.A.42.0262

1929 is one of the most notorious pieces of Surrealist erotica, and was conceived as a parody of the traditional genre of the suite of poems or paintings on the theme of the four

seasons. Péret was responsible for the *Premier semestre* (January-June) and Aragon for the *Deuxième semestre* (July-December). Man Ray took the four pornographic photographs (titled Spring, Summer, Autumn, Winter). The woman involved in these was Kiki de Montparnasse (Alice Prin), a famous artist's model and bohemian character who became Man Ray's lover in 1922, and was the subject of many of his photographs until they split up at the end of the decade.

Mrs Keiller purchased this copy from John Armbruster, Paris, in October 1975. It came from the library of Georges Hugnet.

361

BENJAMIN PÉRET

De derrière les fagots

Paris, Editions Surréalistes, 1934

With an etching by Pablo Picasso
Edition of 599; this copy no.25 of 16 copies numbered 25–49 and marked *hors commerce*
Format: 136pp.; illustrated with hand-coloured drypoint *La Mort de Marat* by Picasso; pb. inside hb. with slipcase; 20.5 × 15.5 overall (pp. of various sizes); inscribed on half-title: *A Georges Hugnet / qui monté par les jésuits en / hortensia les passe sous le massicot / Benjamin Péret*
Enclosed at front are: a. envelope with ms. poem *Et ainsi de suite*, inscribed by the author to Georges Hugnet; b. publisher's leaflet; c. publisher's subscription form; d. publisher's card with introduction by Paul Eluard; e. ms. note about the book and the etching; drypoint by Picasso: *Mort de Marat 1934*, drypoint and burin with coloured ink on paper, 13.5 × 10.6 (paper 20.3 × 15.1); not signed or inscribed. [The etching (GMA4075) was removed from the book and framed by Mrs Keiller]
Binding: green board with black half-leather and leather-edged green board slipcase
GMA.A.42.0258 WITH GMA4075

Colour plate 60

As a publisher's leaflet slipped into this copy of Péret's *De derrière les fagots* makes clear, it was originally intended that the poems be published by René Laporte's Editions des Cahiers Libres with an etching by Salvador Dalí. It was, presumably, when that small publishing house foundered that the project was transferred to José Corti's Editions Surréalistes and that Picasso was asked to provide the frontispiece instead.

The book bears a general dedication to Paul Eluard, who did not provide a preface but signed the short text in praise of Péret's unfailing intransigence which was used for the subscription form. This concludes: 'It is a source of pride to me that I know only men who love as much as I do this intentionally subversive poetry which has the colour of the future'. (One of these forms is preserved in this copy of the book.)

The subject of Picasso's drypoint and burin frontispiece – which in the Keiller copy has brightly coloured patches of maroon, green, red, yellow, purplish-black and blue distributed over the surface (possibly printed in monotype) – is *La Mort de Marat* (The Death of Marat). The composition is distantly related to David's famous neoclassical painting on the same subject in the Musées Royaux des Beaux-Arts, Brussels – a suitable source given both the author's and Picasso's own political allegiances. Picasso executed the first state on 21 July 1934, and the book itself was published less than a month later (*achevé d'imprimer*, 16 August 1934). For full details of the complex history of the print, see B. Geiser and B. Baer, *Picasso. Peintre-Graveur, Vol. II, Catalogue raisonné de l'oeuvre gravé et des monotypes, 1932–1934*, Berne, 1992, no.430. (See also S. Goeppert, H. Goeppert-Frank and P. Cramer, *Pablo Picasso. The Illustrated Books: Catalogue Raisonné*, Geneva, 1983, no.23.)

The theme of Charlotte Corday's murderous attack on Marat had fascinated Picasso since at least December 1931, when he painted the small but exceedingly violent and dramatic canvas entitled *La Femme au stylet* (Woman with a Stiletto) now in the Musée Picasso, Paris (MP 136). On 7 July 1934, just three weeks before he executed the present drypoint, Picasso made a detailed drawing on the same theme, except that there the murder victim is the naked figure of his current mistress Marie-Thérèse Walter. It would seem that his jealous and detested wife Olga had become associated in his mind with the fanatical Charlotte Corday. (This drawing is also in the Musée Picasso [MP 1135].)

Péret dedicated this copy of *De derrière les fagots* to Georges Hugnet. In addition to Picasso's drypoint and the leaflets mentioned above, it includes a brief poem in Péret's hand entitled *Et ainsi de suite* written on the front of an envelope from the Taverne du Palais, 5 Place St-Michel, Paris. Hugnet commissioned the cover and slipcase from the master binder Mercher, whom he used on many occasions in the latter part of his life. Mrs Keiller purchased it from John Armbruster, Paris, in October 1975, and framed up the Picasso so that she could hang it in her house.

362

BENJAMIN PÉRET

Je ne mange pas de ce pain-là

Paris, Editions Surréalistes, 1936

With an etching by Max Ernst
Edition of 250, of which nos.2–6 on Japon impérial paper, and 17–41 on burgundy-coloured Le Roy Louis paper have an etching by Max Ernst; this copy no.27
Format: 102pp.; illustrated, etching by Ernst stitched in after half-title; pb.; 21 × 16 overall (pp. of various sizes); etching: 11.6 × 8.1 (page size 14.8 × 10); inscribed in ink on half-title: *A Maurice Heine / L'épée sur la gorge / Avec toute mon affection / Benjamin Péret*
GMA.A.42.0139

This was published in January 1936 six months before *Je sublime* (cat.363), on which Péret and Ernst also collaborated. For the de-luxe copies of *Je ne mange pas de ce pain-là* Ernst created a frontispiece in drypoint which depicts a strange marine creature, a little like a sea horse, but with a chicken's leg and claw and staring eyes. It has been suggested that the imagery was inspired by 'Nungesser und Coli sind verrecht', one of the poems in the collection (A. Hyde Greet, 'Max Ernst and the Artist's Book: From *Fiat Modes* to *Maximiliana*', in *Max Ernst. Beyond Surrealism. A Retrospective of the Artist's Books and Prints*, New York and Oxford, 1986, pp.102–103, and no.36). Péret presented this copy to Maurice Heine, an expert on the Marquis de Sade who was involved in the Surrealist movement in the 1930s.

363

BENJAMIN PÉRET

Je sublime

Paris, Editions Surréalistes, 1936

With 4 frottages by Max Ernst
Edition of 241, one on Japon nacré paper with 4 original frottages by Max Ernst and the original manuscript, 15 examples numbered 2–16 on Japon impérial paper with 4 frottages, 25 hors commerce examples on Le Roy Louis paper with the frottages numbered 17–41 and 200 examples on Vergé paper numbered 42–241; this copy no.6
Format: 52pp.; illustrated, frottages by Ernst; pb.; 18.9 × 21.8 overall size (pp. various sizes); frontispiece, 14.8 × 9.5, and frottage nos.2–4, 14.2 × 9.8
GMA.A.42.0265

Ernst illustrated *Je sublime* with four exquisite multi-coloured frottages, three of which depict erotic imaginings inside a human skull and the fourth the imagined naked figures at liberty and existing in their own right. To reproduce his frottages as multiples for Péret's book, Ernst had line blocks fabricated after his own original drawings. By placing the sheets of paper on top of the line blocks, and rubbing over the areas of the blocks' raised metal ridges with several coloured crayons, he was able to reproduce the designs by hand without the aid of a printing press, and simultaneously achieve subtle variations of colour. (See R. Rainwater, 'Max Ernst, Printmaker', in *Max Ernst. Beyond Surrealism. A Retrospective of the Artist's Books and Prints*, New York and Oxford, 1986, p.28, and no.34.)

Je sublime was published at the end of June 1936 shortly before the outbreak of the Spanish Civil War. By early August Péret had arrived in Spain to join the Anarchist troops in defence of the Spanish Republic.

364 / Etching by Tanguy

364

BENJAMIN PÉRET

Feu central

Paris, Collection le Quadrangle, K. Editeur, 1947

With etching and cover design by Yves Tanguy
Edition of 1030; this copy no. XII of 30 examples numbered I–XXX with an etching by Yves Tanguy, reproductions of 4 gouaches by Tanguy, and cut-out cover design for first 230 copies after a drawing by Tanguy
Format: 108pp.; illustrated; pb. with cover, in slipcase; 42.5 × 19; etching: 17.6 × 13.7 (paper size 23.8 × 18.8), inscribed in ink below plate left: *XII*
GMA.A.42.0263

This was purchased through Tony Reichardt, London, at an unknown date. A collection of Péret's poems both old and new, *Feu central* was published very shortly after his return to France in the autumn of 1947 following six years in Mexico.

365 / Title-page by Ernst

365

BENJAMIN PÉRET

La Brebis galante

Paris, Les Editions Premières, 1949

With etchings and illustrations by Max Ernst
Edition of 316; this copy no.281, with 3 etchings by
Max Ernst
Format: 124pp.; illustrated with etchings and
reproductions of 22 drawings of which 18 are
coloured with pochoir; pb. with lithographic cover
designed by Ernst, in book-box; 24 × 19.5; etchings:
title-page etching with aquatint, 19.9 × 15 (page size
24 × 19) inscribed in plate: LA BREBIS / GALANTE /
BENJAMIN PERET / MAX ERNST; blue etching:
12.8 × 10 (page size 24 × 19); black and red etching
with aquatint: 12.8 × 10 (page size 24 × 19);
inscribed in pencil on flyleaf: *Joe Tilson*
GMA.A.42.0464

Péret's Surrealist fairy tale – the title may be
translated as *The Flirtatious Ewe* – was written in
the autumn of 1924 but was published here for
the first time. Ernst, who had only recently
returned to Paris from the United States, where
he had taken refuge after the Occupation,
provided suitably whimsical and humorous
illustrations which took a variety of forms and
involved various techniques. (For a thorough
analysis of the relationship between Ernst's
illustrations and Péret's text, see A. Hyde
Greet, 'Max Ernst and the Artist's Book: From
Fiat Modes to Maximiliana', in *Max Ernst. Beyond
Surrealism. A Retrospective of the Artist's Books and
Prints*, New York and Oxford, 1986, pp.108–118,
and no.4g.). The Keiller copy is from the
collection of Joe Tilson.

366

FRANCIS PICABIA

Poèmes et dessins de la fille née sans mère

Lausanne, Imprimeries Réunies, 1918

Format: 78pp.; illustrated with reproductions of
drawings by Picabia; pb.; 24 × 15.8
GMA.A.42.0425

Mrs Keiller purchased this book from H. A.
Landry, London, in January 1977. The book
was dedicated by Picabia 'to all neurologists in
general and particularly to doctors: Collins
(New York), Dupre (Paris), Brunnschweiller
(Lausanne)'. Picabia, who had been in a state
of severe nervous tension for some time, was
admitted for treatment into the clinic of the
last named of these specialists in February
1918. Most of the fifty-one poems and eighteen
drawings collected in the book were composed
in Switzerland while he was recuperating and
the whole was completed, according to the
dedication, on 5 April 1918. The diagrammatic,
heavily annotated drawings are closely related
to Picabia's sexualised machines of 1915–17,
but betray the rapidity with which they were
executed in their much looser, sketchier style;
the straight lines, circles, etc. were done free-
hand and often quite shakily, with slight
blotting, redrawing and so on. The dedication,
indeed, appears to invite the reader to interpret
them and the poems as confessional and
therapeutic. Not one of the drawings or poems
– all of which have individual titles – refers to
the *fille née sans mère*. That had served as the title
for at least three earlier works (see cat.152);
here it would seem that 'the girl born without a
mother' is Picabia's acknowledged alter-ego.

367

FRANCIS PICABIA

Râteliers platoniques
Poème en deux chapitres

Lausanne, 1918

With 2 drawings by Picabia
Format: 20pp.; pb. bound in hb. special red leather
and marbled paper binding; 21.5 × 22.4; bound
inside front cover are 2 original watercolour and
gouache drawings by Picabia (1p., 2 sides);
26.4 × 20.2; inscribed in ink on endpaper facing
drawing: *Très amicalement à Eluard / Francis Picabia /
Paris 1er Décembre 1922* and on title-page: *Très
sympathiquement à Georges Hugnet / 31 octobre 1947 /
Francis Picabia*
GMA.A.42.0416

The text of this prose-poem, which was written
in Lausanne where Picabia had been receiving
treatment for neurological problems (see
cat.366), is dated 15 December 1918. He
dedicated the book to the memory of his great
friend Guillaume Apollinaire who had died just
over a month earlier. Its title may be translated
as 'Platonic False Teeth'.

This copy contains original watercolour
drawings by Picabia on ruled exercise book
paper. On the front of the sheet, in the style
typical of his figure drawings of the early
1920s, he has depicted a nude woman on her
knees apparently begging mercy from an
enraged man dressed in pink-striped pyjamas.
On the back is an automatist scribble-style
drawing in red, black and green signed and
dated July 1923. Mrs Keiller purchased it
through Tony Reichardt at an unknown date.

368

FRANCIS PICABIA

Jésus-Christ rastaquouère

Paris, Au Sans Pareil, Collection Dada, 1920

With an introduction by Gabrielle Buffet Picabia, and
illustrations by Georges Ribemont-Dessaignes
Edition of 1060; this copy no.17 of 50 on Lafuma
paper
Format: 67pp.; illustrated; hb., bound in green and
red leather; 25 × 19.3; inscribed on title-page: *à
Georges Hugnet sympathiquement / Francis Picabia / Paris
31, octobre 1947* and on p.9 below introduction: *en
vieille amitié - / Gabrielle Buffet Picabia*
GMA.A.42.0196

Picabia dedicated this typical piece of Dadaist
iconoclasm to 'all young ladies'. The blasphe-
mous title (roughly translatable as 'Jesus Christ
Flashy Foreign Adventurer') and certain
passages in the text got him into trouble with
his publishers. Breton intervened on his behalf
and in the end the book was published without
cuts. However, Breton refused to write the
preface he had promised, thus precipitating a
violent quarrel with Picabia who got his wife,
Gabrielle Buffet, to write one in Breton's place.
Georges Ribemont-Dessaignes was one of
Picabia's closest allies within the Parisian Dada
group, sharing his iconoclastic and nihilistic
approach and, like him, enjoying a stormy
relationship with the far more idealistic
Breton. His illustrations are modelled on
Picabia's own freehand machine drawings,
resembling, for example, those in *Poèmes et
dessins de la fille née sans mère* (cat.366).

Mrs Keiller purchased this copy from John
Armbruster, Paris, in April 1978.

367 / Drawing by Picabia

369

FRANCIS PICABIA

Exposition Francis Picabia
Organisée par Emil Fabre

Cannes, Cercle Nautique, 1927.

Exhibition catalogue, January – February 1927 with introductory texts by Emil Fabre and Emeran Clemansin du Maine
Edition of 200; this copy no.51
Format: 40pp.; illustrated; loose-leaf in paper cover; 26.8 × 19.5; inscribed on colophon: *Francis Picabia*; enclosed at front is original ink and watercolour drawing by Picabia signed bottom right: *Francis Picabia*; 26.7 × 19.3
GMA.A.42.0426

Having inherited a small fortune from an uncle, Picabia moved to Mougins on the Côte d'Azur in 1925 where he lived in luxury in his new house, the Château de Mai. His exhibition at the Cercle Nautique in Cannes in 1927 was dominated by recent watercolours of Spanish figures in the slick, idealising style he had practised sporadically since the beginning of his career. (Such a figure constitutes the lowest layer of his Transparency, *Sotileza* [cat.153].) The vernissage was one of the events of that winter season and attracted numerous celebrities and socialites, the general critical consensus being that Picabia had finally turned his back on Dada and his bohemian past. In fact, however, one can interpret the adoption of a frankly popular, kitsch style as an iconoclastic act worthy of Dada at its height. The irreverent humour of the original watercolour depicting a naked female fencer which is slipped into this copy of the catalogue would seem to confirm this view. Picabia's catalogue statement entitled 'Lumière', which is dated 11 December 1926, and another article he published in *Comoedia* in March 1927 ('Picabia contre Dada ou le retour à la raison'), caused further controversy and drew the wrath of the editors of *L'Humanité* because of his denunciation of Socialism, Communism and democracy in art (e. g. in 'Lumière' Picabia wrote: 'Poor revolutionaries, made in series, carrying their labels like a flag; their niches are too narrow for my soul of a wolf').

370

FRANCIS PICABIA

La Loi d'accommodation chez les borgnes. 'Sursum Corda'
(Film en 3 Parties)

Paris, Editions Th. Briant, 1928

Edition of 350, including 35 examples on Hollande van Gelder paper numbered 16–50; this copy no.35
Format: 36pp.; illustrated; pb. with coloured illustrated cover by Picabia; 27.8 × 22.3
GMA.A.42.0431

This film scenario with lithographic illustrations was written at the same time as Picabia was working on his new series of Transparencies (see cat.153). It was published by Théophile Briant in May 1928; six months later Picabia exhibited his *Transparencies* in Briant's gallery in Paris. The film itself is a dadaist exposé of the absurdity and injustice of convention, the title itself ending on a characteristically blasphemous note (*Sursum corda* – Lift up your hearts – is a quotation from the Mass). Picabia's preface is written in the same irreverent spirit. There he exhorts the reader / spectator to 'roll' the film himself; he can even watch it from his bed: 'the seats are all the same price, and you can smoke without annoying your neighbour'. Each, he continues, must see the film on 'the screen of his imagination', which is 'infinitely superior' to the 'wretched' screens of ordinary cinemas. Although *La Loi d'accommodation ...* is an anti-scenario, Picabia was fascinated by film-making throughout his life, like Dalí, believing it had the potential to be the ultimate subversive medium. In 1924, for example, he wrote the scenario for and appeared in René Clair's proto-Surrealist film *Entr'acte*.

This copy of *La Loi d'accommodation* was formerly in the library of Georges Hugnet.

371

GISÈLE PRASSINOS

La Sauterelle arthritique

Paris, G. L. M., 1935

With a preface by Paul Eluard and frontispiece by Man Ray
Edition of 125 plus several *hors commerce* copies; this copy *hors commerce*
Format: 30pp.; frontispiece, photograph of Prassinos by Man Ray; pb.; 22.2 × 16; enclosed is an original copy of frontispiece photograph by Man Ray
GMA.A.42.0339

370 / Cover by Picabia

La Sauterelle arthritique (The Arthritic Grasshopper) was the first book of Prassinos's writings to be published after she was 'discovered' by the Surrealists in 1934. (Printing was completed in March 1935.) Man Ray's frontispiece photograph is a posed reconstruction of the famous session in which the fourteen-year-old schoolgirl read out her poems before Breton, Eluard and other leading poets in the group. (See also cat.64.) In his short preface Eluard wrote: 'For over a year [Gisèle Prassinos] has devoted any free time she has from school to writing and has produced a quantity of texts, all of them different, all of them marvellous. Automatic writing constantly opens new doors onto the unconscious, and the more it provokes a confrontation between the unconscious and the conscious mind or the world at large, the more treasures will accrue.'

372

HERBERT READ

Art Now

London, Faber & Faber, 1933

Format: 144pp.; illustrated; hb.; 20.7 × 14.5; inscribed in pencil at front: *Eduardo Paolozzi / Slade School*
GMA.A.42.0956

Subtitled 'An introduction to the Theory of Modern Painting and Sculpture', this book quickly established itself as the Bible of the British Modern movement, containing as it did chapters on Picasso, Surrealism, Klee and Abstraction, and being informed by Jungian psychology. By 1933 Read (1893–1968) was emerging as the successor to Roger Fry and Clive Bell as the mouthpiece of the modern art movement in Britain. That year he resigned from his post as Watson Gordon Professor of the History of Art at Edinburgh University, and moved to Hampstead where he stayed in Henry Moore's studio behind Parkhill Road before finding a studio of his own in the same block. Barbara Hepworth and Ben Nicholson were other close neighbours. This, his first book on contemporary art (following on from *The Meaning of Art* and several volumes on poetry and literature), was based on lectures Read had delivered at University College, Bangor, the Courtauld Institute, London, and Armstrong College, Newcastle-upon-Tyne (the Charlton Lecture). The book, which was one of the first to be printed entirely in sans-serif type, went through numerous reprints. The selection of more than 100 illustrations, including works by Arp, Bacon, Picasso and Miró, was partly chosen by Douglas Cooper,

co-director of the Mayor Gallery. This copy of *Art Now* belonged to Eduardo Paolozzi when he was a student at the Slade from 1945–47 (see cats.75–76); it contains extensive underlining by him.

373

HERBERT READ (ed.)

Surrealism

London, Faber & Faber, 1936

Edited and with an introduction by Herbert Read and contributions by André Breton, Hugh Sykes-Davies, Paul Eluard and Georges Hugnet, with dust-jacket designed by Roland Penrose
Second edition
Format: 250pp.; illustrated with 96 plates; hb. with dust-jacket; inscribed on half-title in red ink: *exemplaire de Germaine / tendresses Paul /* and in Hugnet's hand: *amour* GEORGES; in green ink in Breton's hand: *avec l'affection d'André Breton*
Enclosed is ts. letter with ink ms. additions, 1 sheet, dated 15.11.36 from Herbert Read to Georges Hugnet
GMA.A.42.0142

This was published in September 1936 in the aftermath of the successful *International Surrealist Exhibition* held in London in June-July. It contains: a long introduction by Herbert Read; Breton's 'Limits not frontiers of Surrealism' (a translation of the lecture he had given in London on 16 June); Hugh Sykes-Davies's 'Surrealism at this Time and Place'; Eluard's 'Poetic evidence' (George Reavey's translation of his lecture in London on 24 June); and Hugnet's '1870–1936', a survey of Surrealist poetry and its origins from the Symbolist period onwards. The dust-jacket was designed by Roland Penrose.

This copy of *Surrealism* belonged to Hugnet's first wife, Germaine, and is inscribed to her by Hugnet himself, Breton and Eluard. Mrs Keiller purchased it from John Armbruster, Paris, but the date is not recorded. Slipped inside is an interesting letter in rather halting French from Read to Hugnet, dated 15 November 1936. In the letter Read expresses the hope that the Surrealists in Paris will approve of the book, apologises for the delay in sending copies of the *International Surrealist Bulletin* (cat.410) to Paris, and thanks Hugnet for his offer to send Read some of his books. It concludes with references to divisions over political allegiance within the Surrealist group. Read agrees that 'the Communist orthodoxy' of David Gascoyne and Roger Roughton is 'rather disturbing', and adds that he personally is deeply absorbed in the current events in Spain because: 'I still have an underlying sympathy with the anarcho-syndicalist theories of Bakunin, Kropotkin, etc, and, really, those people are the most steadfast, the best'.

374

GEORGE REAVEY & STANLEY WILLIAM HAYTER

Faust's Metamorphoses

Poems

Paris, The New Revue Editions, 1932

With 6 etchings by Hayter
Edition of 137, nos.1–100 printed on Hollande van Gelder paper; this copy no.40
Format: 62pp.; illustrated, 6 etchings; pb.; 25.6 × 19.7; etchings: 14.8 × 10.8 (page size 24.8 × 18.7); signed by the author and artist on colophon
GMA.A.42.0428

Although it was published in May 1932 just a few weeks after *Ombres portées* (cat.290), *Faust's Metamorphoses* was in fact Hayter's first *livre d'artiste*; the six engravings he provided date from 1931. Like Hayter, George Reavey became involved in the Surrealist movement in the 1930s, and was one of several poets to contribute to *Thorns of Thunder*, a collection of Eluard's poems translated into English and published in the spring of 1936 in the run-up to *The International Surrealist Exhibition* in London. He also contributed to several issues of *London Bulletin* (cat.424).

375

ARTHUR RIMBAUD

Les Poètes de sept ans

Paris, G. L. M., 1939

With illustrations by Valentine Hugo
Edition of 620; this copy no.43 on Normandy vellum
Format: 36pp.; illustrated with phototype reproductions of 7 drypoints by Valentine Hugo; pb.; 33.1 × 25.4
GMA.A.42.0301

After Lautréamont (cat.320), Rimbaud was the Symbolist poet the Surrealists most admired. In the first Surrealist Manifesto published in October 1924 Breton described him as 'Surrealist in the way he lived, and elsewhere'. Valentine Hugo's own style and imagery were profoundly influenced by Symbolist art, and she was therefore an appropriate choice as illustrator. This copy of the book formerly belonged to Hugnet.

Mrs Keiller purchased it through Tony Reichardt, London, at an unknown date.

376

LUCAS SAMARAS

Book

New York, Pace Gallery, 1968

Edition of 100; this copy no.7
Format: 20pp. of block-card, cut-out, with collages, fold-outs; 25.3 × 25.3 × 5.5
GMA.A.42.1028

Book measures ten inches square and has ten thick cardboard pages. It has substantial die-cut sections, while each page has different flaps, pull-out sections and images; some of the pop-up flaps reveal texts printed in minuscule type, and some of these are violent and pornographic in nature, recalling those of the Marquis de Sade. Samaras's *Book* develops from Duchamp's *Green Box* (cat.249) and *Boîte-en-valise* (cat.28), though its character is very much of the 1960s, reflecting Samaras's connections with the Pop Art movement, and also with the New York literary world of writers such as Alan Kaprow (born in Greece in 1936 Samaras moved to the United States aged twelve). The idea of making the book may have originated in the Pace Gallery's invitation to him to make a suite of prints. Samaras instead decided to make a book project using his own stories which date back to the early 1960s. When first published it was priced at $1200. It is one of numerous box / book projects made by Samaras, all of them having an intensely autobiographical aspect. (For full details see Kim Levin's article on *Book* published in *Art News*, February 1969.)

377

ARTURO SCHWARZ & MARCEL DUCHAMP

The Large Glass & Related Works
(with nine original etchings by Marcel Duchamp and 144 facsimile reproductions of his notes and preliminary studies for the Large Glass)

Milan, Schwarz Gallery, 1967

Edition of 150; this copy no.61 signed by the artist and author on colophon. Format: 295pp.; illustrated; loose-leaf in binder in perspex box; 43.3 × 26.8 × 7.6; collation: title-page and introduction (pp.1–2); Part One: Prolegomena to the Large Glass (pp.3–52); 9 inset original etchings by Marcel Duchamp (pp.53–90), all etchings 41.5 × 25 (page size), all inscribed in image bottom right M. D. :*The Large Glass*, 35 × 23.5; *The Bride*, 26.4 × 11.5, *Top Inscription* or *Milky Way with The Nine Shots*, 15.6 × 34.2 (double-page image); *The Nine Malic Moulds and The Capillary Tubes*, 13 × 17.5; *The Sieves or Parasols*, 17.6 × 13.2; *The Oculist Witnesses*, 14 × 9; *The Water-Mill*, 24.5 × 13.9; *The Chocolate Grinder and The Scissors*, 25.5 × 32.3 (double-page image); *The Large Glass, with the missing elements added*, 35 × 23.6 (in black and red); Part Two: Duchamp's Notes and Preliminary Studies (pp.91–219); Part Three: Psychogenesis and Iconographic Development (pp.220–293)
GMA.A.42.1015

The Galleria Schwarz in Milan did more than any other gallery to promote Duchamp's work in the latter part of his life. In 1964, for example, the gallery produced thirteen of

Duchamp's readymades, including the notorious *Fountain* (urinal), in editions of eight signed and numbered replicas. Arturo Schwarz himself is the foremost expert on Duchamp's work and in 1969 published the first edition of his major monograph and catalogue raisonné, *The Complete Works of Marcel Duchamp* (New York, Abrams). The present item was the last collaborative venture between Schwarz and Duchamp to be completed before the latter's death in October 1968. Duchamp made the nine original etchings included in it which show details and views of the *Large Glass* in 1965.

378

JEAN SCUTENAIRE

Les Haches de la vie

Repères 20

Paris, G. L. M., February 1937

With a frontispiece from a drawing by René Magritte
Edition of 70; this copy no.10
Format: 20pp.; illustrated frontispiece; loose-leaf in red cover; 25.3 × 19.5; inscribed on colophon: *Guy Lévis-Mano*
GMA.A.42.0136.09

379

PHILIPPE SOUPAULT

Westwego

Poème 1917 – 1922

Paris, Editions de la Librairie Six, 1922

Edition of 318; this copy unnumbered
Format: 24pp.; illustrated; pb.; 23.7 × 16.5; inscribed in ink inside front cover: *à Jacques Rigaut / sans le sourire de circonstance / et de convention. / En lui laissant ce poème / comme une bague de miel / un cerceau de soleil / une heure de sommeil / et puis après tout / sans cordialité / Philippe Soupault / 12 avril 1922*
GMA.A.42.0363

This was published at the end of March 1922 and thus coincides exactly with the first issue of the new series of *Littérature* (cat.422), which was edited jointly by Soupault and Breton. This was also the moment when the Parisian Dada group finally split apart, and Breton and his poet-friends set about elaborating and promoting the doctrine of what would shortly be the Surrealist movement. Soupault remained a central figure in Surrealism until 1928–29, but in Breton's *Second Manifesto* he was one of many original members to be harshly denounced for, in Breton's view, failing to uphold the movement's essential principles.

Soupault dedicated this copy of *Westwego* to Jacques Rigaut, like him a Dadaist-turned-Surrealist poet. Mrs Keiller bought it from John Armbruster, Paris, but the date is not recorded.

380

DANIEL SPOERRI

Krims-Krams Magie

Dokumente Documents Documenti zur Krims-Krams Magie

Berlin, Merlin Verlag, 1971

Format: portfolio of 8 envelopes each containing miscellaneous papers; 27.5 × 20.5
1. Postcard of Bellmer's *La Poupée*; Emmet Williams *Vorwort zür Übersetzung des Symi-Zyklus*, 4pp.
2. Daniel Spoerri *25 Zimtzauberzeuge. . .56pp.*, illustrated
3. Addendum... .1 sheet folded
4. Pierre Alechinsky *Toko Shinoda* 16pp., illustrated
5. Daniel Spoerri *Max und Morimal Art mit Fußnoten von Peter Heim*, 45pp
6. *Krims Krams Objekte* 1 cut-out sheet
7. Daniel Spoerri *Nachwort*, 4pp
8. *Exkursion über die Gerste*, 4pp
also *Brevet de garantie / tableau-piège* signed, in print, by Spoerri, dated *7 avril 1971* and inscribed: *to Gabriel Kealer [sic] / Daniel Spoerri / this occasion found / by Edouardo [sic]*
GMA.A.42.0182

This compendium volume was produced on the occasion of an exhibition by Daniel Spoerri, entitled *Krims-Krams-Magie*, held at the Galerie Ernst, Hamburg in 1971. Spoerri used the opportunity to publish (and republish) a number of texts about new and old work by himself and friends such as Emmet Williams (the American Fluxus artist) and Pierre Alechinsky (former Belgian member of the COBRA group). The *Brevet de garantie* enclosed in envelope number 8 was used by Spoerri to guarantee the authenticity of 155 objects dropped by him in an 'action' in the Hamburger Kunsthalle on 6 April 1971. The guarantee cards were only included in the deluxe edition of the publication.

381

Surrealist Diversity 1915–1945

London, Arcade Gallery, 1945

Exhibition catalogue 4–30 October 1945
Format: 8pp.; illustrated; pb; 24.1 × 15.2
GMA.A.42.0986

This is the catalogue of a mixed exhibition of Surrealist art at the Arcade Gallery in London – the first to be held after the declaration of peace. The list of works on display is prefaced by a series of quotations from recent Surrealist texts selected and edited by E. L. T. Mesens, and by a brief extract from Freud's *Totem and Taboo*.

382

YVES TANGUY

Yves Tanguy Retrospective

New York, Pierre Matisse Gallery, 1946

Exhibition catalogue, November 1946
Format: 4pp. (1 sheet folded); information poster; illustrated; 54 × 41 (sheet size)
GMA.A.42.0294.2

383

ANDRÉ THIRION

Le Grand Ordinaire 1934 [1943]

Paris, 1943

With 2 etchings and pen and ink drawings by Oscar Domínguez
Edition of 128; this copy unnumbered *hors commerce* copy
Format: 130pp. with 2 loose-leaf etchings at front and 2 loose-leaf errata pp. at back; illustrated with 2 etchings and 8 pen and ink drawings; pb.; 19.8 × 14.8; drawings: 19 × 14 (page size); etchings: 12.6 × 7.6 (paper 19.3 × 14.1) and 18 × 13 (paper 19.3 × 14.1); inscribed full page on half- title by Thirion and beginning: *Si j'étais roi de France, ou maréchal Idem, ou / plus simplement administrateur des domaines, / j'offrirais à mon ami Georges Hugnet: / la tour Saint-Jacques (mais rendue / horizontale de manière que les étages y fussent de / plain-pied) afin qu'il y installât sa bibliothèque et / y reçût ses amis [...]* signed and dated *25 février 1944*
Enclosed is envelope containing some of Thirion's war-time official documents, including 1 sheet ms. inscribed : *Paris se repeuple* with pen & ink drawings in margin
GMA.A.42.1023

Le Grand ordinaire was published anonymously and clandestinely during the Occupation. The *achevé d'imprimer* – 14 July 1934 – is a deliberate falsehood, and according to Thirion in his autobiography the book was written in 1941–42 and published in the spring of 1943 (A. Thirion, *Révolutionnaires sans Révolution*, Paris, 1972, pp.235, 484). He describes reading

383 / Etching No.2 by Domínguez

the principal chapters out aloud to Georges Hugnet in 1942 (ibid., p.478), and it was to Hugnet that he dedicated this *hors commerce* copy in a long and elaborate note dated 25 February 1944. The illustrations in *Le Grand ordinaire* also appear anonymously but were the work of Oscar Domínguez, and may be compared with his illustrations to Hugnet's *Le Feu au cul*, also published in 1943 (cat.304). The two original etchings slipped into *Le Grand ordinaire* are also by Domínguez.

Thirion became involved in the Surrealist movement in the late 1920s, but his increasing commitment to political action and the French Communist Party led to a parting of the ways with Breton. (In *Révolutionnaires sans Révolution* he describes in detail the tortuous relationship between the movement and the Party, and the divisions caused by the Party's repressive attitude to art and artists.) During the Occupation Thirion was involved in the Resistance and a close friendship with Hugnet developed. Tucked into the book is an envelope containing some of Thirion's official wartime documents, variously dated 1943–45, including a warrant for his arrest for having insulted a police officer, and a page listing the projected contents of *Paris se repeuple*. A keen historian, Hugnet carefully preserved these documents belonging to his old friend. At the end of his life he was, however, outraged by what he regarded as the gross inflation in Thirion's account of his own rôle in the Surrealist movement, and denounced *Révolutionnaires sans Révolution* as an 'imposture' in a long and angry review published in *Pleins et déliés. Témoignages et souvenirs 1926–1972* (Paris, 1972, pp.392–415).

384
WALASSE TING & SAM FRANCIS
1c Life
Berne, E. Kornfeld, 1964

Edition of 2000 with special edition of 100 on hand-made paper signed by the artists; this copy no.1988
Format: 168pp.; illustrated; loose-leaf in hb. binder with dust-jacket; 41.5 × 30.4; includes lithographs by Alan Davie, Sam Francis, James Rosenquist, Pierre Alechinsky, Asger Jorn, Jean-Paul Riopelle, Karel Appel, Tom Wesselmann, Bram van Velde, Joan Mitchell, Alan Kaprow, Andy Warhol, Robert Indiana, Robert Rauschenberg, Roy Lichtenstein, Claes Oldenburg, Jim Dine, Enrico Baj and others
GMA.A.42.0585

The texts are by the Chinese-born poet and artist Walasse Ting (b.1929), while the sixty-eight lithographs are by twenty-eight different European and American artists, most of whom are now associated with Pop Art, the later flowering of Abstract Expressionism or the

Cobra movement. The book was edited by Sam Francis (who also contributed six prints) and was published by the Berne art dealer Eberhard Kornfeld, who has shown Francis's work since 1957. The first major *livre d'artiste* to feature work by a range of Pop Artists from America and Europe, it was printed in France.

385
LOUIS TRENTE
Le Petit
Paris, 1934

Edition of 50 with nos.6–10 printed on Hollande paper; this copy unnumbered but printed on Hollande paper
Format: 48pp.; pb.; 16.4 × 12.1
GMA.A.42.0079

Louis Trente was one of the pseudonyms of Georges Bataille. Bataille was a rival of Breton's in the Parisian avant-garde but shared many of the fundamental beliefs and preoccupations of the official Surrealist group. Thus *Documents*, which he edited between 1929 and 1930, became the house-magazine of the 'dissident' Surrealists in the aftermath of the splits within the movement in the late 1920s. *Le Petit* is highly characteristic of Bataille's work in its fearless combination of eroticism, violence and blasphemy. It was published privately in June 1934. Mrs Keiller purchased this copy from John Armbruster, Paris, at an unknown date.

386
TRISTAN TZARA & HANS ARP
vingt-cinq poèmes
Zurich, J. Heuberger, Collection Dada, 1918

Format: 52pp.; illustrated with 10 woodcuts by Hans Arp; pb.; 20.5 × 14.7; inscribed in ink on p.3: *très cordial / hommage / tristan tzara / zurich – seehof / schifflande 23- Suisse*
GMA.A.42.0998

Tzara, a Rumanian poet, critic and theorist, was one of the most important animators of the whole Dada movement. A founder-member of the group in Zurich (where the Dada movement was baptised in 1916), he moved to Paris in 1920 and masterminded a series of sensational 'happenings' modelled on those organized in Switzerland during the war. Ideological differences and personal rivalry soon led to bitter disputes with Breton, for Tzara was adamantly opposed to Breton's idealist tendencies and to his desire to impose order and system in the place of Dada anarchy and nihilism. Later, however, he was reconciled with Breton and became an influential, if intermittent, force within the Surrealist movement.

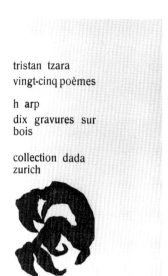

386 / Title-page woodcut by Arp

The Dada poems gathered in this book date from 1915–18 and are perfectly complemented by Arp's bold, abstract woodcuts. With its modest proportions and rough, consciously 'primitive' appearance, the book is a classic example of Dada typography and design. Arp's illustrations reflect the influence of Kandinsky's woodcuts in *Klänge* (Munich, 1913), but are very characteristic of the personal biomorphic style developed in the series of wooden reliefs he initiated in Zurich during the war. Like the woodcuts for *vingt-cinq poèmes*, these reliefs carry suggestions of spontaneous organic growth and constantly shifting identity. This copy formerly belonged to Georges Hugnet.

387
TRISTAN TZARA & HANS ARP
De nos oiseaux
Paris, Editions K R A, n.d. [c.1923]

Edition number not given
Format: 110pp., illustrated with reproductions of 10 drawings by Hans Arp; pb; 18.4 × 12.9; inscribed on flyleaf: *à Georges Hugnet / avec / l'amitié / de / Tristan TZARA / Juillet 1929*
GMA.A.42.0069

Arp and Tzara were close friends and collaborated successfully on several occasions, notably on *vingt-cinq poèmes* in 1918 (cat.386). The poems by Tzara collected in *De nos oiseaux* are variously dated 1912–22 and are accompanied by reproductions of ten bold and highly simplified drawings by Arp. This copy was given to Hugnet in 1929 by Tzara, whose *L'Arbre des voyageurs* (cat.388) was published by Hugnet's Editions de la Montagne during the same year.

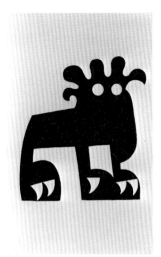

387 / Woodcut by Arp

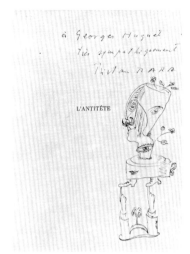

389 / Drawing by Tzara

388

TRISTAN TZARA & JOAN MIRÓ

L'Arbre des voyageurs

Orné de quatre lithographies de Joan Miró

Paris, Editions de la Montagne, 1930

With lithographs by Joan Miró
Edition of 502 of which 65 examples numbered 36–100 were printed on Vélin d'arches paper and contain 4 lithographs by Miró, signed by the author and artist; this copy no.40
Format: 102pp.; illustrated, 4 lithographs; pb.; 25.4 × 17.2, lithographs 25 × 16 (page size), final plate inscribed in image Miró / 3.29; signed by the author and the artist on colophon
GMA.A.42.0239

This book was published by Georges Hugnet's Editions de la Montagne and unites two radical figures whom he admired greatly and who were good friends of his. Hugnet had become keenly interested in the history of Dada in the 1920s, and Tzara was an invaluable source of first-hand information as he gathered documents for the essays on the movement he published in *Cahiers d'Art* in 1932–36 (see cat.308). Hugnet's friendship with Miró, whose own work was often inspired by poetry, dates from the same period.

L'Arbre des voyageurs was one of Miró's earliest *livres d'artistes*, for although the book was not published until the end of December 1930 the project was initiated in the spring of 1929. (There is a letter from Hugnet to Miró about the project postmarked 15 April 1929, and the fourth of Miró's lithographs is dated '3.29'.) For further details, see: P. Cramer, *Joan Miró. The Illustrated Books: Catalogue Raisonné*, Geneva, 1989, no.1.

389

TRISTAN TZARA

L'Antitête

Paris, Editions des Cahiers Libres, 1933

With a frontispiece etching by Pablo Picasso
Edition of 1218, of which 18, numbered 1–15, and 3 *hors commerce* copies were printed on Japon nacré paper, signed by the author and illustrator, with a frontispiece etching by Picasso; this copy no.14
Format: 92pp.; illustrated frontispiece; 20 × 15.5; etching: 14 × 11.3 (page size 19 × 14); half-title has original ink drawing, 13 × 4.5 overall, inscribed: à *Georges Hugnet / très sympathiquement / Tristan* TZARA; enclosed inside front cover is publisher's notice for the book
GMA.A.42.0432

The three groups of texts gathered here – *Monsieur AA l'Antiphilosophe*, *Minuit pour géants* and *Le Désespéranto* – were written between 1916 and 1932, and trace the evolution of Tzara's writing from the beginning of the Dada period to his integration into the Surrealist movement in 1929. Picasso agreed to provide the frontispiece, and himself pulled eighteen impressions of a recent etching for the de-luxe copies of L'Antitête. Letters indicate that these impressions were pulled in late January-February 1933 just after printing of the regular edition was completed on 20 January. The subject of Picasso's etching, which was executed on 7 December 1932, is three female bathers posed in the manner of the dancers in *The Three Dancers*, 1925 (Tate Gallery, London) – the picture which Breton had hailed as a masterpiece of Surrealist painting and illustrated in *La Révolution Surréaliste*. no.4, July 1925. (For the etching, see B. Geiser and B. Baer, *Picasso. Peintre-Graveur, Vol. II, Catalogue raisonné de l'oeuvre gravé et des monotypes, 1932–1934*, Berne, 1992, no.280; for the book, see S. Goeppert, H. Goeppert-Frank and P. Cramer, *Pablo Picasso. The Illustrated Books: Catalogue Raisonné*, Geneva, 1983, no.21.)

390

TRISTAN TZARA

La Main passe

Paris, G. L. M., 1935

Edition of 300; this copy *hors commerce* on Normandy vellum paper, signed by the author
Format: 32pp.; pb.; 19.3 × 14.2; enclosed inside front cover are two red publisher's notices for *La Main passe* and for *Repères*
GMA.A.42.0065

This was purchased from John Armbruster, Paris, at an unrecorded date.

391

TRISTAN TZARA

La Deuxième Aventure céleste de M. Antipyrine

Paris, Editions de la Réverbère, 1938

Edition of 125; this copy no.43
Format: 16pp.; stencilled title-page; pb. with stencilled cover of thick grey rag paper, stitched with grey linen thread; 25 × 17.5
GMA.A.42.0243

Tzara arrived in Paris in the middle of January 1920 and moved into Picabia's apartment. From there he masterminded a series of riotous Dada 'happenings' complete with plays, sketches, recitations of Dada manifestos, etc., similar to those in which he had been involved in Zurich during the war. His play *La Première Aventure céleste de M. Antipyrine*, was performed at the *Manifestation Dada de la Maison de l'Oeuvre* on 27 March 1920. (It had already been published in July 1916 in Zurich [Collection Dada] with woodcuts by Marcel Janco.) *La Deuxième Aventure céleste de M. Antipyrine* (Second Celestial Adventure of Mr Analgesic), which was intended as a sequel, was first performed two months later on 26 May 1920 at the *Festival Dada*. The venue on this occasion was the plushly bourgeois Salle Gaveau, a famous concert hall in Paris. The whole event drew many hecklers and ended in tumult – exactly as Tzara had hoped.

La Deuxième Aventure céleste... was first published in *Littérature* (cat.421), no.13, in June 1920. This copy of the 1938 edition formerly belonged to Georges Hugnet, an admirer and friend of Tzara's and one of the first serious historians of the Dada movement. The details are stencilled in bold black letters on the cover (which is made of thick grey rag paper) and on the title-page – a good example of the abiding interest in typography of all committed former Dadaists.

392

TRISTAN TZARA

Le Cœur à gaz

Paris, G. L. M., 1946

With a frontispiece etching by Max Ernst
Edition of 380; this copy no.2 of 28 with a coloured
drypoint with aquatint by Max Ernst
Format: 41pp.; illustrated frontispiece; pb.;
25.5 × 19.5; etching: 16.6 × 13.6 (page size
24.9 × 18.8), inscribed bottom left: *2 / 28* and signed
in pencil bottom right: *Max Ernst*
GMA.A.42.0244

Colour plate 54

Tzara's Dada play, *Le Cœur à gaz*, was first
performed at the Galerie Montaigne in Paris on
10 June 1921. The parts were taken by fellow
Dadaists Philippe Soupault, Georges
Ribemont-Dessaignes, Théodore Fraenkel,
Louis Aragon and Benjamin Péret; Tzara
himself took the part of Sourcil (Eyebrow).
When performed for a second time with a
different set of actors on 6 July 1923 during the
Soirée du Cœur à Barbe which Tzara organised at
the Théâtre Michel, it was violently interrupted
by members of the breakaway Surrealist group,
including Breton and Eluard, who took
exception to a verbal attack on Picasso. By 1923
the Parisian Dada group had split irrevocably
into warring factions and Tzara's *Soirée* was an
excuse to make hostilities public; fighting
broke out in the theatre and a good deal of
damage was done. It took a long time for the
rift to be healed, but eventually Tzara was
reconciled to Breton and played a significant, if
sporadic, rôle in the Surrealist movement from
1929 onwards.

 This edition of *Le Cœur à gaz* may be seen as
an act of historical recuperation, and came out
at the very moment when Breton was attempt-
ing to re-establish Surrealism as the leading
force within the avant-garde after the war. It is
embellished with a boldly coloured aquatint
and drypoint by Max Ernst, which was printed
in an edition of twenty-eight by S. W. Hayter in
New York. In its iconography of birds with
eggs it harks back to the *Interior of Sight* series
of paintings Ernst had made in the late 1920s,
but the introduction of a heart-shaped frame is
an obvious reference to the title of Tzara's play.
This print is one of the few Ernst made in the
1940s and is no.23 in W. Spies and H. R.
Leppien, *Max Ernst: Oeuvre-Katalog I: Das
graphische Werk*, Menil Foundation, 1975.

393

TRISTAN TZARA & ANDRÉ MASSON

Terre sur terre

*Paris and Geneva, Editions des Trois Collines,
1946*

Edition of 3160; this copy no.3071 of 100 *hors
commerce* copies numbered 3001–3100 on cream-
coloured laid paper
Format: 72pp.; illustrated with reproductions of
drawings by André Masson; pb.; 22.3 × 16
GMA.A.42.0342

Tzara and Masson had never collaborated on a
book before. To accompany Tzara's twenty-
two poems, Masson provided ten semi-
automatic ink drawings, using the variable
thick-thin line he had developed while in
America during the war. The de-luxe copies of
the book have an additional original litho-
graph. (For full details, see L. Saphire and P.
Cramer, *André Masson. The Illustrated Books:
Catalogue Raisonné*, Geneva, 1994, no.21.)

394

TRISTAN TZARA

La Première main

Paris, Pab, 1952

Edition of 33, nos.1–25 on Auvergne paper;
this copy no.10
Format: 12 sheets, 24pp.; loose-leaf in paper cover;
5.6 × 7.5
GMA.A.42.0033

This miniature book contains a handful of
poems, three of which are dedicated to Tzara's
painter-friends Ernst, Miró and Tanguy. It is
the work of the same small publishing house
responsible for printing Duchamp's letter to
Tzara (cat.252). This copy formerly belonged
to Georges Hugnet. Mrs Keiller purchased it
from John Armbruster, Paris, at an unknown
date.

395

PIERRE UNIK

Le Théâtre des nuits blanches

Paris, Editions Surréalistes, 1931

Edition of 110; this copy no.96
Format: 35pp.; pb.; 19.3 × 14; inscribed on half- title:
*à Claude Cahun / et Suzanne Malherbe / c'était plutôt un
petit bateau-lavoir / et ma foi les nuits sont toujours blanches
/ les jours essaient de ne pas trop leur rassembler / 15 janvier
1933 / avec mon amitié / Pierre Unik*
GMA.A.42.0067

Pierre Unik became an active member of the
Surrealist group in 1926. In May 1927, with
Breton, Aragon, Péret and Eluard, he was a co-
signatory to the tract *Au grand jour*, which laid
out their reasons for joining the Communist
Party at the beginning of that year. His break

with Breton came in 1932 in the wake of the
'Aragon Affair' (cat.197) when, like Aragon, he
chose the Party in preference to the Surrealist
movement.

 Mrs Keiller purchased this from H. A.
Landry, London, in August 1975.

396

ROBERT D. VALETTE

Deux fatrasies, ornées par Dalí

Cannes, Ateliers d'Art 'Ryp', 1963

With etchings by Salvador Dalí
Edition of 99, nos.16–85 printed on Vélin d'arches
paper, with 4 etchings by Dalí; this copy no.18
Format: 64pp.; illustrated, 4 etchings by Dalí; loose-
leaf in pb. cover, with repeat of plate 1 on cover, in
dust-jacket; 25.8 × 17.3; etchings: image, 8.7 × 10
(plate 1), 22.5 × 14.7 (plates 2–4) (page size
25 × 16.4); signed in pencil on colophon *Dalí / 1963
& Robert D Valette*
GMA.A.42.0241

Dalí's etchings for *Deux fatrasies* (Two
Hotchpotches) are nos.87–90 in R. Michler
and L. W. Löpsinger, *Dalí. Catalogue Raisonné of
Etchings and Mixed-Media Prints, 1924–1980*,
Munich, 1994.

397

VARIOUS AUTHORS & ARTISTS

Violette Nozières

Brussels, Editions Nicolas Flamel, 1933

Contributors: André Breton, René Char, Paul Eluard,
Maurice Henry, E. L. T. Mesens, César Moro,
Benjamin Péret, Guy Rosey, Salvador Dalí, Yves
Tanguy, Max Ernst, Victor Brauner, René Magritte,
Marcel Jean, Hans Arp, Alberto Giacometti
Edition of 2000
Format: 46pp.; illustrated; pb.; 19.4 × 14.3; enclosed
is 4pp. publisher's leaflet
GMA.A.42.1002

397 / Magritte

The heroine of this booklet was an eighteen-year-old schoolgirl who was arrested in Paris on 28 August 1933 accused of poisoning her father and attempting to murder her mother. The dramatic story aroused intense public interest, particularly since Violette Nozière (the correct spelling) alleged incest immediately after her arrest. Her trial finally came to court in October 1934, and she was convicted and condemned to death. Within a couple of months her sentence had been commuted to life imprisonment with forced labour. In 1945 she was pardoned by De Gaulle, and in 1963 her conviction was overturned.

The idea for a cheaply produced and widely distributed anthology of texts and drawings in honour of Violette Nozière originated with the Surrealists in Paris, but they offered the job of publishing it to E. L. T. Mesens, who had recently set up his Editions Nicolas Flamel in Brussels. Contributions from their Belgian colleagues were also actively sollicited. (For further details, see D. Sylvester and S. Whitfield, *René Magritte. Catalogue Raisonné*, Vol. II, *Oil Paintings and Objects, 1931–1948*, Menil Foundation, 1993, pp.23–24.) The booklet came out, with a cover design by Man Ray, on 1 December 1933. The Keiller copy formerly belonged to the Belgian Surrealist, Achille Chavée, who has stamped his name on the inside cover. It was purchased through Tony Reichardt at an unknown date.

Like insanity, violent crime fascinated the Surrealists, and they were especially excited by the prospect of women who committed murder. In a montage published in the very first issue of *La Révolution Surréaliste*, December 1924, photoportraits of the members of the group – all of them male – surround the much larger photograph of Germaine Berton, an anarchist who had achieved notoriety by murdering the leader of an extreme right-wing group; the impression thus created is of a female divinity adored by a host of male disciples. A schoolgirl-parricide like Nozière, who was vilified in the bourgeois press, could not fail to attract their ardent support.

398
VARIOUS AUTHORS
La Main à Plume
Paris, Editions de la Main à Plume, 1941
With etching by Gérard Vuillamy printed in 4 colours
Edition of 50 on coloured paper; this copy no.1
Format: 16pp.; illustrated, etching in 4 colours; loose-leaf in paper cover; 20 × 14; etching: 10 × 13.8 (page size 13.7 × 17.8); texts and illustrations inscribed in pencil with names of authors
GMA.A.42.0424

This rare pamphlet published by the Main à Plume group during the Occupation formerly belonged to Georges Hugnet. It is the first of fifty copies on coloured paper and contains an original etching by Vuillamy, dated 1941, which is printed in four different colour-ways. Hugnet has noted in pencil the names of the authors of the texts and illustrations which are printed anonymously in the pamphlet itself. They include Noël Arnaud, J-F. Chabrun, Achille Chavée, Christian Dotremont, J-V. Manuel, Marcel Mariën, Marc Patin and Tita – all prominent Surrealists in Paris during the war.

399
VARIOUS AUTHORS
Transfusion du Verbe
Paris, Editions de la Main à Plume, December 1941
Edited by Noël Arnaud, with texts by Nöel Arnaud, J-F. Chabrun, Paul Eluard, Marc Patin and others and illustrations by Oscar Domínguez, Aline Gagnaire, Pablo Picasso, Raoul Ubac, Tita and Gérard Vuillamy
Edition of 400; this copy unnumbered
Format: 32pp.; illustrated; pb.; 25.6 × 19.8
GMA.A.42.0203

This anthology of poems, texts and illustrations by members of the Main à Plume group was edited by Noël Arnaud and published in December 1941. (See also, *inter alia*, cat.398). Although Eluard had quarrelled definitively with Breton in 1938 and was therefore no longer a member of the official Surrealist group, his poems were included in some of the Main à Plume collective *plaquettes*, no doubt because he was such an important symbol of resistance against Fascism. *Transfusion du verbe* includes his 'Les raisons de rêver (à Alberto Giacometti)', and reproduces Picasso's famous illustrated poem 'Pour Paul Eluard', which is dated 24 May 1936.

This copy formerly belonged to Marcel Mariën. Mrs Keiller purchased it from John Armbruster, Paris, in April 1978.

400
VARIOUS AUTHORS AND ARTISTS
Salvo for Russia
London, 1942
Folio of poems, etchings and engravings by various authors and artists, edited by Nancy Cunard & John Banting
Edition of 100; this copy no.46
Format: 4pp. text and 9 prints, loose-leaf in portfolio; 23 × 17; prints of various sizes (paper size 23 × 16.5), each print signed by the artist
GMA.A.42.0186

The purpose of *Salvo for Russia* was to raise money for the Comforts Fund in aid of women and children in Soviet Russia following the German invasion in 1941. A limited edition portfolio of prints and poems edited by Nancy Cunard and John Banting in 1942, it contains poems by Cunard herself, Cecily Mackworth, James Law Forsyth and J. F. Hendry, and signed etchings and engravings by Banting, John Buckland Wright, Ithell Colquhoun, John Piper, Roland Penrose, C. Salisbury, Wolf Reiser, Julian Trevelyan and Mary Wykeham. It dates from a time when the Surrealist group in England was fragmented and dispersed as a consequence of the war, with, for example, E. L. T. Mesens and Jacques Brunius working for the BBC and Trevelyan, Penrose and Buckland Wright involved in camouflage.

401
BORIS VIAN
Le Goûter des généraux
Dossiers acénonètes du Collège de Pataphysique 18–19
Paris, Le Minotaure, n.d. [1962]
Format: 128pp.; illustrated; pb.; 24 × 15.8
GMA.A.42.0245

Born in 1920, Boris Vian was a well-known character in Paris's Latin Quarter in the post-war years. Patterning the terse and racy style of his novels on that of popular American crime fiction, Vian was as famous for his nightclub singing and jazz playing as for his writing. He died prematurely in 1959.

The self-styled Collège de Pataphysique, which numbered several ertswhile Dadaists and Surrealists amongst its 'students', derived its title and its principal ideas and methods from Alfred Jarry's *Pataphysique* – an eccentric

400 / Etching by Penrose (with Buckland Wright)

system of thought which posited a logic of the absurd. (See, above all, Jarry's *Gestes et opinions du docteur Faustroll, pataphysicien*, published in 1911.) Also included in this *dossier* is an illustrated essay devoted to Picabia by Noël Arnaud.

402
SIMON WATSON-TAYLOR (ed.)
Free Unions – Unions Libres
London, July 1946

With cover design by Conroy Maddox
Format: 48pp.; illustrated; pb.; 28.4 × 22
GMA.A.42.0126

This is an anthology of texts, articles and drawings mainly by members of the English Surrealist group. It was, as the editorial note informs us, assembled during the war and thus under significantly different circumstances from those in 1946 at the time of publication. Conroy Maddox, who had been a committed Surrealist since the mid-1930s, but had refused to participate in the 1936 *International Surrealist Exhibition* in London on the grounds that much of the work displayed was not Surrealist at all, became a prominent force in the group during the war and designed the cover for *Free Unions*. Simon Watson-Taylor joined in the group in the latter part of the war and was appointed secretary when it was reorganised and relaunched as The Surrealist Group in England in August 1945.

Mrs Keiller purchased this copy from H. A. Landry, London, in January 1975.

Periodicals

For fuller information on the Dada and Surrealist periodicals in the Keiller Bequest, see Dawn Ades, *Dada and Surrealism Reviewed*, London, Arts Council of Great Britain, 1978.

403
Arson
An Ardent Review. Part One of a Surrealist Manifestation
London, Toni del Renzio, 1942

Toni del Renzio, editor
Sole issue, March 1942
Format: 32pp.; illustrated; pb.; 28 × 22
GMA.A.42.0429

Although designated 'Part One of a Surrealist Manifestation', *Arson* had no sequel because of lack of funds to publish one. Toni del Renzio, the editor, had joined the English Surrealist group late in 1940 and intended Arson to be in some sense a replacement for *London Bulletin* (cat.424), which had ceased publication in June 1940. As a militant Trotskyist, del Renzio was, however, determined that *Arson* should be political through and through, and as a passionate supporter of Breton he was equally determined that the review's politics should be those of Breton, not of Aragon or Eluard. *Arson*, which was intended to be a rallying-cry in the dark days of the war to 'Surrealists all over the world', comprised mainly contributions by new English converts, including Robert Melville, Edith Rimmington, Emmy Bridgwater and del Renzio himself, and extracts of texts by leading French Surrealists including, of course, Breton. E. L. T. Mesens, who had hitherto masterminded Surrealist events in England, was outraged by del Renzio's growing prominence and his pretensions to be Breton's spokesman, and by the end of 1942 the two men had clashed and a schism developed within the English group which was not healed until after the end of the war. During 1943–44 their hostility towards one another was paraded in public by means of a series of pamphlets and open letters, including *Idolatry and Confusion*, issued by Mesens and Jacques Brunius in March 1944, and del Renzio's riposte entitled *Incendiary Innocence* (cat.241) which came out the following month.

404
Aventure
Paris, 1921

René Crevel, editor
No.2, December 1921, of 3 issues, November 1921–January 1922; incomplete run
Format: 32pp.; illustrated; pb.; 23 × 14.5
GMA.A.42.1033

Aventure was a short-lived literary review edited by René Crevel. Like Crevel himself, the other young poets associated with the magazine – Jacques Baron, Max Morise, Georges Limbour and Roger Vitrac – fraternised with Breton and the other Dadaists in Paris and later became founder-members of the Surrealist movement. This, the second issue of *Aventure*, is especially notable for its reproductions of several early woodcuts by Jean Dubuffet. Dubuffet renewed his association with Breton after the Second World War when the latter lent his active support to the foundation of Dubuffet's *Compagnie de l'Art Brut*.

405
Axis
A Quarterly Review of Contemporary 'Abstract' Painting and Sculpture
London, 1935–1937

Myfanwy Evans, editor
Nos.1–8, January 1935–Winter 1937; complete run
Format: pp. various; illustrated; pb.; 27.3 × 21.8
GMA.A.42.0443

Axis came into being as a direct consequence of the meeting in September 1934 between Myfanwy Evans and the French abstract painter Jean Hélion – a meeting engineered by Ben Nicholson. Hélion encouraged Evans to found a review in England which would actively promote abstract and constructivist art and be in effect the English equivalent to *Abstraction-Création* in France. Hélion and Nicholson were united in their opposition to Surrealism, which they considered wholly inimical to abstraction, and were anxious that the new magazine should keep as clear as possible of Surrealist influence. And initially *Axis*, which began publication in January 1935, was openly committed to abstract art, and featured many of the same artists who were represented in *Abstraction-Création*, among them Arp, Hélion, Hepworth and Nicholson. However, by the time of its demise late in 1937 Evans and John Piper, another leading contributor, had come to regard pure abstraction as a blind-alley and advocated a return to the object and in particular to landscape painting. Moreover, the clamorous arrival of Surrealism in England did not pass unnoticed: the sixth issue of *Axis*,

published in the summer of 1936, was subtitled 'Abstraction? Surrealism?'.

Mrs Keiller purchased her run of the review from H. A. Landry, London, in September 1974.

406
Bifur
Paris, Éditions du Carrefour, 1929–1931

Georges Ribemont-Dessaignes, editor
Nos.1–6 and 8, of 8 issues, May 1929–June 1931; incomplete run
All issues in editions of 2240–3200
Format: pp. various; illustrated; pb.; 23.8 × 18.8
GMA.A.42.0172

Georges Ribemont-Dessaignes, the editor of *Bifur*, was a leading figure in Parisian Dada and, despite recurrent ideological differences with Breton, was an occasional participant in Surrealist activities in the mid-and late 1920s. However, he quarrelled with Breton at a famous 'inquest' the latter summoned in March 1929, and when *Bifur* began publication two months later it not only published texts by some of Ribemont-Dessaignes's old Dada comrades, such as Tzara, Soupault and Picabia, but also texts by dissident Surrealists, such as Leiris, Limbour, Desnos and Baron, who had gathered round Georges Bataille and were contributing to his newly founded review, *Documents*. Ribemont-Dessaignes was duly denounced by Breton in the *Second Surrealist Manifesto*, where he was accused of publishing 'odious little detective stories [...] in the lowest movie magazines'. Not one to take insults lying down, he responded with a sharp attack on Breton in the collective pamphlet *Un Cadavre*, published in January 1930.

407
Blast
The Review of the Great English Vortex

London, John Lane, The Bodley Head, 1914; 1915

Percy Wyndham Lewis, editor
Nos.1–2, June 1914–July 1915; complete run
Edition of 1700
Format: No.1, 164pp.; illustrated; pb., cover design by Lewis; 29.8 × 24.4; No.2, War Number, 108pp.; illustrated; pb.; 30.3 × 24
GMA.A.42.0284–0285

Lewis came to prominence in 1914 when he founded the Rebel Art Centre and published the first issue of his arts review *Blast*. These projects were launchpads for what would be known as Vorticism, which was a British synthesis of Cubism and Futurism. Lewis, who was famously quarrelsome and egotistical, had had a row with Roger Fry in the autumn of 1913, and the Centre and review were, as their titles implied, designed to challenge the more genteel aesthetics of Fry and the Bloomsbury Group.

The title *Blast* (subtitled 'The Review of the Great English Vortex') was suggested by C. R. W. Nevinson, a painter associated with the Vorticists. The first issue was a substantial affair, containing more than 160 large-format pages, with articles by Ezra Pound, Gaudier-Brzeska, Edward Wadsworth and various others including of course Lewis himself, and a Manifesto with eleven signatories. The Manifesto was not strictly speaking a Vorticist Manifesto, but a Vortex Manifesto; the term Vorticism is not employed within the first review. The content was abrasive, aggressive and anarchic, and was matched by the bold layout and imaginative typography, which derived from Furturist publications. The opening lines of Lewis's Manifesto indicated the tenor of both issues: 'BLAST FIRST (from politeness) ENGLAND / CURSE ITS CLIMATE FOR ITS SINS AND INFECTIONS / [...] / CURSE WITH EXPLETIVE OF WHIRLWIND / THE BRITISH AESTHETE / CREAM OF THE SNOBBISH EARTH'.1700 copies of *Blast I* were printed, paid for in large part by Lewis's mother. Although the intention had been to publish issues quarterly (at 2/6d a copy), only two issues ever appeared, the first in July 1914 (the advertised publication date of 20 June is wrong: it appeared on 2 July) and the second, billed as a 'war number', in July 1915. The review lost money but it is now recognised as a landmark publication, notable in particular for its militant views and dynamic typography, and also for its satirical humour. It was printed by Leveridge & Co., Harlesden.

408
The Blind Man
New York, May 1917

Marcel Duchamp, editor, with editorial participation from Man Ray
No.2, May 1917, second of 2 issues, April–May 1917; incomplete run
Format: 16pp.; illustrated; pb.; 27.8 × 20.8
GMA.A.42.0469

Duchamp arrived in New York in June 1915 and, already notorious because of the scandal provoked by his *Nude Descending a Staircase* when it was exhibited at the Armory show in 1913, immediately became the centre of a proto-Dada group gathered around the poet and patron of the arts, Walter Arensberg. Intending to rouse America from its artistic torpor and entrenched conservatism, the group planned a new review entitled *The Blind Man*. The first issue, subtitled *Independents' Number*, was published on 10 April 1917 to coincide with the opening of the exhibition of the Society of Independent Artists, a supposedly liberal, jury-free organisation of which Duchamp was a director. The more famous second issue, published in May, was largely taken up with the *cause célèbre* occasioned by the rejection of Duchamp's *Fountain*, an up-ended urinal which he had signed with the pseudonym R. Mutt, and which the Independents' hanging committee had at first tried to hide by placing it behind a curtain, and finally refused to exhibit at all. (Duchamp instantly resigned from the board of directors.)

The cover of P. B. T. *The Blind Man*, No.2 – the letters refer to Pierre (Henri-Pierre Roché), Beatrice (Beatrice Wood), and Totor (Duchamp) – illustrates the second version of Duchamp's *Chocolate Grinder*, 1914, and inside substantial space is given over to 'The Richard Mutt Case'. Alongside a photograph of the offending readymade taken by Stieglitz, there is an editorial by Beatrice Wood, written under Duchamp's direction, followed by a defence of Duchamp's *blague* by Louise Norton, humorously entitled 'Buddha of the Bathroom'. The editorial, a classic piece of Duchampian irony concealing a serious argument, concludes:
'What were the grounds for refusing Mr Mutt's fountain:
1. Some contended it was immoral, vulgar.
2. Others, it was plagiarism, a plain piece of plumbing. Now, Mr Mutt's fountain is not immoral, that is absurd, no more than a bath tub is immoral. It is a fixture that you see in plumbers' show windows.

Whether Mr Mutt with his own hands made the fountain or not has no importance. He CHOSE it. He took an ordinary article of life, placed it so that its useful significance disappeared under the new title and point of view – created a new thought for that object.

As for plumbing, that is absurd. The only works of art America has given are her plumbing and her bridges. '

409
The Booster / Delta
A monthly in French and English

Paris, 1937–1939

Alfred Perlès, editor. The periodical changed its name from *The Booster* to *Delta* from issue No.2, second year, April 1938
The Booster, Nos.7–8, 10–11 of 11 issues; incomplete run
Format: pp. various; pb.; sizes various
Delta, Nos.1, 3 and 4, of 4 issues; incomplete run
Format: pp. various; pb.; sizes various
GMA.A.42.0156

The Booster was originally the magazine of a country golf-club near Paris. The club had been founded by Elmer Prather, a wealthy American businessman, for English-speaking ex-patriots. Prather employed the Austrian-born journalist Alfred Perlès to edit the magazine and tout for new club members. Perlès proved unsuitable and was sacked, but he was allowed to keep the title of the magazine and publish it as a literary review. This he did with the collaboration of his close friend Henry Miller, whom he had known for some years (Perlès is the character Carl in Miller's *Tropic of Cancer*, published in 1934). In satirical style, Miller was named as Fashion Editor, Lawrence Durrell, who had moved to Paris in 1937, was Sports Editor (writing under the *nom-de-plume* of Charles Norden), and Durrell's wife, Nancy Myers, was in charge of the Department of Metaphysics and Metempsychosis. The first issue was published in September 1937, with Miller's home at the impasse Villa Seurat, Paris, acting as the editorial address. Anaïs Nin, David Gascoyne (see cat.281), Kay Boyle, Dylan Thomas and Antonia White were other contributors. The content became increasingly esoteric and controversial, leading to Prather's withdrawal of support and advertising (the early issues feature copious and incongruous advertising for golfing equipment and consumer items). The title of the magazine changed in April 1938 to *Delta*. Perlès and Durrell left Paris in December 1938 and the final issue dates from Easter 1939.

410
Bulletin International du Surréalisme
International Surrealist Bulletin

Prague, Brussels, London, 1935–1936

Nos.1, 3–4, of 4 issues, April 1935–September 1936; incomplete run
Bulletin International du Surréalisme No.1, Prague, April 1935
Format: 12pp.; illustrated; pb.; 29.8 × 21
Bulletin International du Surréalisme No.3, Brussels, August 1935
Format: 8pp.; illustrated; pb.; 29 × 20.6
International Surrealist Bulletin No.4, London, A. Zwemmer, September 1936
Format: 20pp.; illustrated; pb.; 27.4 × 21.6
GMA.A.42.0437.1–3

In total four of these bilingual *Bulletins* were published, each acting both as the follow-up (or in one case the prelude) to a major Surreal-ist exhibition and as an effective means of publicising the movement to as wide as possible an audience. With the format of a pamphlet, the *Bulletins* typically included a manifesto signed by members of the national group concerned, quotations from reviews of

the exhibition, and extracts from the lectures, texts, etc. delivered by visiting Surrealists from Paris (usually Breton and Eluard). The first, with texts in Czech and French, was published by the Czech Surrealists in April 1935 in the wake of their exhibition earlier in the year and of Breton's and Eluard's very successful lecture tour to Prague (see cat.437). The second commemorated *The International Surrealist Exhibition* held in May 1935 in the Ateneo de Santa Cruz, Tenerife (see cat.204). This time the texts were in Spanish and French. The third, published in August 1935 in Brussels, was devoted to Belgian Surrealism and was printed in anticipation of the Surrealist exhibition being organised by Mesens at La Louvière (13–27 October). The cover repro-duces Magritte's *La Gâcheuse* (cat.61). The final *Bulletin* celebrated *The International Surrealist Exhibition* held in London in June-July 1936, and came out that September. In this case the cover carried an extraordinary photograph of Sheila Legge posing among the pigeons in Trafalgar Square, wearing a long white dress, black, elbow-length rubber gloves, and a mask made of roses which completely covers her face. (She is not, however, carrying either the dummy leg or the pork chop which she carried during the vernissage of the exhibition.)

Mrs Keiller acquired three of the Bulletins from H. A. Landry in November 1977; the missing one is the second.

411
Cahiers G. L. M.

Paris, G. L. M., 1936–1939

Nos.1–9, May 1936–March 1939; complete run
All issues editions of 35; copies unnumbered
Format: pp. various; illustrated; pb.; 19.6 × 14.2
GMA.A.42.0052–0060

BULLETIN INTERNATIONAL
DU
SURRÉALISME

N° 3 Publié à Bruxelles
par le Groupe surréaliste en Belgique
20 AOUT 1935 PRIX : 1,50 Fr.

LA GACHEUSE
SOMMAIRE
1) LE COUTEAU DANS LA PLAIE.
2) André BRETON : Discours au Congrès des Ecrivains pour la défense de la Culture
Illustrations de René MAGRITTE et Max SERVAIS

410 / Cover by Magritte

The letters G. L. M. are the initials of Guy Lévis-Mano, director of Editions G. L. M., the small publishing house much patronised by the Surrealists in the 1930s. The *Cahiers*, which Lévis-Mano originally planned to bring out six times a year, were in fact published at very irregular intervals over a three-year period, and took the form of limited edition, handsomely designed pamphlets featuring most of the poets and artists active in the Surrealist group at the time. Mrs Keiller obtained her set from John Armbruster in April 1978.

Typically *Cahiers G. L. M.* contained extracts from the books Lévis-Mano was on the point of publishing. Thus the first, which appeared in May 1936, reflects the current ascendancy of Hans Bellmer, and includes four of his drawings printed on his signature pink paper, Robert Valançay's translation of his text 'Naissance de la poupée' – an extract from *La Poupée* (cat.187) – and 'La Naissance', a text by the schoolgirl-Surrealist, Gisèle Prassinos, which is dedicated to Bellmer and inspired by his Doll. Similarly, the third *Cahier*, published in November 1936, reproduces eight photo-graphs from Man Ray's *La Photographie n'est pas l'art*, which was published in full as a portfolio with an introduction by Breton the following May (cat.331). For the seventh *Cahier* Lévis-Mano secured the full cooperation of Breton. Published in March 1938, this was one of several Surrealist anthologies of texts and images Breton assembled during his life, and was dedicated to one of his all time favourite subjects, the dream. The eighth and ninth *Cahiers* (October 1938 and March 1939) were taken over with that other favourite Surrealist genre, the *enquête* (survey), the subject on this occasion being 'La poésie indispensable' (indispensable poetry).

412
Cannibale
Revue Mensuelle

Paris, Au Sans Pareil, 1920

Francis Picabia, editor, with Tristan Tzara (No.1) and Marcel Duchamp (No.2)
Nos.1& 2, April–May 1920; complete run
Format: 16pp.; illustrated; pb.; 24 × 15.7
GMA.A.42.0433

Picabia temporarily interrupted publication of *391* (cat.438) in order to bring out the two issues of *Cannibale* in April and May 1920. His advertised aim was to produce a 'Monthly review [...] with the collaboration of all the Dadaists in the world', but by July 1920, when the deferred thirteenth issue of *391* finally appeared, he had come to see this as an 'impossible' and 'stupid' ambition. *Cannibale*

featured contributions by all the members of Parisian Dada, but also contained texts by Jean Cocteau (whom Breton loathed). As always, Picabia's own offerings were ferociously irreverent and included, in the first issue, his *Tableau Dada* – a board onto which he had nailed a stuffed monkey surrounded by the graffiti-like inscription 'Portrait de Rembrandt, Portrait de Cézanne, Portrait de Renoir – Natures Mortes'. This issue concluded with a 'Note' congratulating Maurice Ravel on refusing the *légion d'honneur*. The second issue featured *inter alia* a photograph of Picabia and Tzara in the former's latest expensive sportscar, a Mercer 85 HP. This bears the defiant, signed caption: 'Gentlemen and Revolutionaries, your ideas are quite as narrow as those of a *petit-bourgeois* from Besançon'.

413
Le Centaure
Chronique Artistique Mensuelle

Brussels, Galerie 'Le Centaure', 1927–30

Georges Marlier, editor
15 numbers, in 4 volumes, October 1926–July 1930; incomplete run
Vol.1: No.8, May 1927; Vol.2: No.3, December 1927, No.4, January 1928, No.10, July 1928; Vol.3: No.1, October 1928, No.3, December 1928, No.4, January 1929, No.5 February 1929, No.6 March 1929, No.8 May 1929, No.10 July 1919; Vol.4: No.1, October 1928, No.8, May 1930, Nos.9–10, June-July 1930
Format: pp. various; pb.; 24.2 × 16
GMA.A.42.0188

Le Centaure began publication in October 1926 under the editorship of Georges Marlier. A monthly, non-partisan review devoted to the modern movement in the arts, it was the house-magazine of the Galerie Le Centaure, one of the foremost galleries devoted to contemporary Belgian, French and School of Paris art in Brussels. The co-directors of the review and of the gallery were Walter Schwarzenberg and Blanche Charlet. Schwarzenberg had founded the Galerie Le Centaure in October 1921. Wanting to expand and capitalise on the currently buoyant market, he joined forces with Blanche Charlet of the Galerie Charlet and relaunched the business in much larger premises in October 1926 at the same time as the first issue of the new review appeared. The gallery not only exhibited works of art but hosted poetry readings, lecture series, concerts and so forth, thus keeping in step with the eclectic mix of items in the review itself.

From the time it was relaunched in 1926 the Galerie Le Centaure operated in conjunction with P-G. van Hecke, the leading artistic impresario of the time in Belgium. Van Hecke, who edited the reviews *Sélection* and later *Variétés* (cat.442), dealt in and collected contemporary art and had various artists under contract, including Magritte to whom the Galerie Le Centaure gave a major exhibition in April-May 1927. Although his first love was Belgian Expressionism, van Hecke began to take a serious interest in Surrealism in about 1925–26. *Le Centaure*, although by no means a Surrealist review and, indeed, relatively conservative in its presentation, reflected the growing influence of the movement in its articles and illustrations.

414 / From June 1934

414
Documents
Brussels, 1933–1936

Jean Stéphane, director, E. L. T. Mesens, editor
Documents 33, Nos.1–8, April–December 1933;
Documents 34, Nos.9–10, January–February 1934;
Documents 34, nouvelle série, Jean Stéphane & E. L. T. Mesens editors, No.1, June 1934, Intervention Surréaliste, No.2 November 1934; *Documents* 35, Nos.1–6, March–November/December 1935; *Documents* 36, 1936 February-March; complete run
Format: pp. various; illustrated; pb., bound in 3 hb. volumes; 27.3 × 19.0
GMA.A.42.0144–0146

Documents (not to be confused with the 'dissident' Surrealist magazine published in Paris in 1929–30) began publication in Brussels in April 1933. The director was Jean Stéphane. At that time the review's prime motivation was a survey of developments in the cinema with a view to establishing the actual or potential connections between film and contemporary art, literature, philosophy and society. By 1934 the ties with Surrealism had become much tighter, and in June of that year a special number of the review entitled *Documents*

34: *Intervention Surréaliste* came out with Mesens as editor. This gathered together a series of important texts and illustrations by members of both the French and Belgian Surrealist groups, including Breton's essay 'Equation de l'objet trouvé' which focused on the vital rôle a seemingly chance *trouvaille* could play in the creation of a work of art. (Breton's essay was later incorporated in *L'Amour fou*, cat.207.) The following number of *Documents* 34, published in November, was almost as rich in contributions by the Surrealists. But in 1935 the rapidly deteriorating political situation led to another shift in direction: the review was taken over by the Association Révolutionaire Culturelle (A. R. C.), a mixed group of left-wing intellectuals united in their anxiety about the rise of Fascism. The Belgian Surrealists were involved in this organisation, but they were not in charge. (For further information, see M. Mariën, *L'Activité Surréaliste en Belgique 1924–1950*, Brussels, 1979, pp.232–260, 301–304.)

Mrs Keiller's set of *Documents* formerly belonged to Marcel Mariën, who joined the Belgian Surrealist group in 1937. She purchased it from John Armbruster in April 1978.

415
The Enemy
A Review of Art and Literature

London, The Arthur Press, 1927–1929

Percy Wyndham Lewis, editor
Nos.1–3, January [February] 1927–March 1929; complete run
Editions of 1500 Nos.1–2; No.3 edition of 5000
Format: pp. various; illustrated; pb. with illustrated cover; 28 × 18.5; No.1 inscribed on title-page top left: *Wyndham Lewis*
GMA.A.42.0281–0283

Like Lewis's other periodicals (see cats.407 and 441), *The Enemy* was primarily a vehicle for publishing the editor's own work. In the editorial, Lewis announced that 'there is no movement gathered here (thank heaven!), merely a person; a solitary outlaw and not a gang.' This outlook, and indeed the title of the periodical itself, are indicative of the author's self-generated outsider, status and perhaps also of his persecution mania. The first issue, published in February 1927 (January is incorrectly signalled on the cover) had a few short, introductory articles, including a note on poetry by T. S. Eliot and an article on de Chirico by Wilfred Gibson, but the main body of the publication was given over to Lewis's own essay 'The Revolutionary Simpleton', which formed an attack on writers such as Joyce and Gertrude Stein (and was shortly afterwards published in book form as the first half of *Time and Western*

Man). The second issue of September 1927 was mainly devoted to the essay 'Paleface' (published two years later as a book of the same title, with an added section at the beginning); and the third issue, published in the first quarter of 1929, carried the full text of *The Diabolical Principle*.

416
Enemy Pamphlets No.1
London, The Arthur Press, 1930

Percy Wyndham Lewis & Roy Campbell and others, editors
Format: 63pp.; illustrated cover; pb.; 28 × 21
GMA.A.42.0288

This sole issue was published as a rebuff to the *New Statesman*, and its editor's decision not to publish a favourable review of Lewis's own novel *The Apes of God* (cat.322). (The novel appeared in June 1930 and this pamphlet was published in October.) In his customary style, Lewis reprinted letters vaunting the novel (from H. G. Wells, W. B. Yeats and others), republished excerpts from favourable reviews, and gave a lengthy exigesis on satire and fiction.

417
491
Paris, 1949

Michel Tapié, editor
Picabia issue, 4 March 1949; sole issue
Format: news-sheet, 4pp.; illustrated; 65 × 50
GMA.A.42.1024

491 was designed to imitate the format and typography of *391* (cat.438), and to act simultaneously as the catalogue of the Picabia retrospective at the Galerie René Drouin in Paris in March 1949. (The show was called *50 ans de plaisir*.) There were contributions by, among others, Breton, Cocteau, and Picabia's former wives Gabrielle Buffet Picabia and Olga Picabia. In his text, 'Jumelles pour yeux bandés' (Binoculars for blindfold eyes), Breton wrote nostalgically of his old collaborator and sometime adversary: 'For many years, every new work [by Picabia] was a lavish challenge to the already experienced, to the predicted, to the permitted, a marvel of irreverence, an invariably successful quest to launch a rocket into the unknown'.

The editor of *491* was Michel Tapié, a critic and artist. Before the war he had edited *Les Réverbères* (cat.431). After the war he became involved with Dubuffet and Breton in the promotion of *Art brut* and also of *Art informel*.

Mrs Keiller purchased her copy of *491* from H. A. Landry, London, in June 1976.

418
Le Grand Jeu
Paris, 1928–1930

Roger Gilbert-Lecomte, René Daumal, Josef Sima and Roger Vailland, editors
Nos.1–3, Summer 1928, Spring 1929 and Summer 1930; complete run
Format: pp. various; illustrated; pb.; 24 × 19.2
GMA.A.42.0155.01–03

Le Grand Jeu was the review of a para-Surrealist group who had taken their name from the title of a book of poems by Benjamin Péret published in 1928. The group comprised the poets René Daumal and Roger Gilbert-Lecomte, the critic André Rolland de Renéville, the novelist and journalist Roger Vailland, the cartoonist Maurice Henry, and the Czech painter Josef Sima. Although many of their attitudes and methods were directly influenced by Surrealism, they were determined to retain their autonomy of action and resisted Breton's efforts either to draw them into the official Surrealist movement or to impose on them 'collective discipline', whether in the artistic or political sphere.

Breton suspected them of political compromise, and in March 1929, at a 'reunion' he had called at the Bar du Château on the pretext of determining what to do about the treatment of Trotsky (who had been forced into exile in Kazakhstan early in 1928), the Grand Jeu group was called to account. The special focus of Breton's wrath was an article by Vailland published in the conservative newspaper *Paris-Midi*, which glorified an arch right-wing police commissioner called Jean Chiappe. A fierce and protracted row exploded between the Grand Jeu members and those Surrealists who, like Aragon, gave Breton their full support. Other Surrealists, including Desnos, Leiris and Ribemont-Dessaignes, were, however, disgusted by these tangible signs of Breton's unbendingly autocratic nature, and moved over to the camp of his long-term rival, Georges Bataille. The Bar du Château incident was in effect the prelude to the purge of dissidents within the Surrealist group which followed shortly afterwards, and which is commemorated in Breton's *Second Surrealist Manifesto*. Despite their humiliating experience, the Grand Jeu group survived until 1932. Breton's relationship with some of the members, including Sima, later became cordial.

Mrs Keiller's set of *Le Grand Jeu* formerly belonged to Marcel Mariën and was purchased from John Armbruster, Paris, in April 1978.

419
L'Invention collective
Brussels, Clichés Apers, 1940

Raoul Ubac, editor
Nos.1–2, February and April 1940; complete run
Format: 16pp. & 22pp.; illustrated; pb.; 23.3 × 17.6
GMA.A.42.0452

The first issue of *L'Invention collective* was published in February 1940. The intention was to publish a new number every two months, and the second duly appeared in April. However, the German invasion of Belgium in May 1940 made continuation impossible; the second issue was the last. Mrs Keiller purchased her copies from H. A. Landry, London, in April 1981.

The initiative for the new review came from Magritte and the Surrealist photographer Raoul Ubac, the latter acting as editor. According to the prospectus, the purpose of *L'Invention collective* was: 'to guard intact the state of mind which Surrealism has created', and 'to break the silence which the war has imposed on many of our foreign friends'. Under the influence of Ubac and Magritte, painting and photography were given great prominence, and the second issue carried a revised version of Magritte's autobiographical essay, 'La Ligne de vie'. While most contributions came from within the ranks of the Belgian Surrealist group, Breton was represented with a new text in the second issue.

420
Koncretion
Interskandinavisk tidsskrift for kunsten af i dag
Copenhagen, Oslo, Stockholm, 1935–1936

Vilhelm Bjerke-Petersen, editor
Nos.1–6, September 1935–March 1936; complete run
Format: pp. various; illustrated; pb.; 23 × 14.5
GMA.A.42.0185.1–6

Koncretion was a pan-Scandanavian avant-garde review which, while not dedicated exclusively to promoting Surrealism, reflects the very widespread interest in the movement by 1935–36 when it was being published. Thus the third issue, subtitled 'English art today' (November 1935), included a translation of David Gascoyne's 'First English Manifesto of Surrealism', and nos.5–6 (March 1936), subtitled 'Surrealism in Paris', reprinted in translation and in the original many texts by leading figures in the group. Furthermore, many of the works by native Scandanavian artists which are illustrated in the pages of the review show a detailed knowledge of the latest trends in Surrealist art.

Mrs Keiller purchased her run of *Koncretion* from John Armbruster in April 1978.

421 / Cover by Picabia, May 1923

421
Littérature
Revue Mensuelle

Paris, Place du Panthéon, 1919–1921

Louis Aragon, André Breton and Philippe Soupault, editors
Nos.1–20, March 1919–August 1921; complete run
Format: 24pp. average; illustrated; pb.; 22.6 × 14.2
GMA.A.42.0173 AND 0183

422
Littérature
Nouvelle Série

Paris, 1922–1923

André Breton and Philippe Soupault, editors
Nos.5–10, October 1922–May 1923, 6 issues of 13,
March 1922–June 1924; incomplete run
Format: 2pp. average; illustrated; pb.; 23 × 17.9
GMA.A.42.0449

Littérature, edited jointly by Aragon, Breton and Soupault, began life in the spring of 1919 as an avant-garde review with a strong allegiance to the Symbolist and post-Symbolist tradition in French literature. The first issues, which appeared monthly, had contributions from such relatively established writers as André Gide, Paul Valéry, Blaise Cendrars, Guillaume Apollinaire and Max Jacob, and featured reprints of more or less inaccessible works by such late nineteenth-century poets as Rimbaud, Mallarmé and, above all, Lautréamont. As time went on, however, the review began to mirror the awakening to Dada of the three young editors. By May 1920, when the delayed thirteenth issue was at last published, *Littérature* had been transformed into a thoroughgoing Dada review: that issue was given over to twenty-three high-voltage Dada manifestos which had been 'performed' at the Salon des Indépendants and the Université Populaire du Faubourg Saint-Antoine in February.

As it turned out, however, the commitment to Dada was relatively short-lived as the antagonism between Breton and Tzara – the very voice of Dada – became more acute and destructive, the one favouring a more idealistic, positive and didactic approach, the other pure iconoclasm and nihilism. The famous 'Barrès affair' – a mock-trial of the once revolutionary, born-again conservative writer, Maurice Barrès, which was organised by Breton in the face of Tzara's resistance, and fully reported in the issue of August 1921 (no.20) – was in effect the beginning of the end of Dada in Paris. That same issue of the review was also the last of the first series of *Littérature*.

Littérature was relaunched after a long hiatus in March 1922. This time only Breton and Soupault were the editors. The 'new series' was to all intents and purposes the first Surrealist magazine. The second number (April 1922) contained Breton's 'Lâchez tout', his definitive and bitter farewell to Dada, and over the next two years it carried many texts on the kinds of topics which are central to the first Surrealist manifesto of October 1924. Thus in 'Entrée des médiums', published in November 1922 (new series, no.6), Breton was already defining Surrealism in terms of a 'certain psychic automatism which corresponds quite closely to the dream state'. Accounts of dreams, transcriptions of monologues uttered in a state of 'hypnotic trance', texts written 'automatically', puns and other linguistic games – these and the like dominate the new series of *Littérature*, which, however, continued to pay tribute to heroes from the past, like Rimbaud and Lautréamont, who were claimed as Surrealists *avant la lettre*. The visual arts played a more prominent role than in the first series – a further anticipation of fully-fledged Surrealism. Picabia provided arresting cover designs exuding sexual innuendo, and works by Picasso, de Chirico, Duchamp, Ernst and Man Ray were illustrated.

Mrs Keiller acquired her complete set of the first series of *Littérature* from H. A. Landry, London, through purchases made in September 1974 and March 1975. Her broken set of the new series was bought from John Armbruster, Paris, in October 1975; she was never able to complete it.

423
The Little Review

Chicago, New York, Margaret Anderson, 1922–1924

Margaret Anderson and Jane Heap, editors
Two issues, *Picabia Number*, Spring 1922 and Autumn-Winter 1923–24, of 12 volumes, March 1914–March 1929; incomplete run
Format: 62pp.; illustrated; pb.; 24.5 × 19.2
GMA.A.42.0413 & GMA.A.42.0414

Probably the most widely known and respected avant-garde literary and artistic periodical to be produced in America at the time, *The Little Review* ran from 1914 to 1929. During the years 1920–24 leading members of Parisian Dada and Surrealism contributed to it on occasion, among them Aragon, Breton, Eluard and Tzara. Mrs Keiller acquired two issues of the magazine, both of which were published when Ezra Pound was acting as assistant editor. The earliest, dated Spring 1922, has particular relevance to her collection because it is dedicated to the work of Picabia.

424
London Bulletin

London, The London Gallery, 1938–1940

E. L. T. Mesens, editor, with variously Humphrey Jennings, Roland Penrose, George Reavey, Gordon Onslow-Ford
Vols.1–20, in 15 issues; complete run
Format: pp. various; illustrated; pb.; 25 × 19
GMA.A.42.0434.01–0434.20

Published as the house magazine of the London Gallery, *London Bulletin* was the official forum of the English Surrealist group. (See also cat.410.) Its commitment to Surrealism was not, however, exclusive, for the often bitter sectarianism which marked the avant-garde in Paris – Surrealism in particular – was largely absent in England, where the main priority was felt to be the defeat of the entrenched enemy forces of conservatism and parochialism. Among other things, *London Bulletin* published the catalogues of exhibitions held at the London Gallery as well as of exhibitions at Peggy Guggenheim's Guggenheim Jeune Gallery and at the Mayor Gallery. While the London Gallery itself, under the directorship of the Belgian Surrealist writer and artist E. L. T. Mesens, focused predominantly on Surrealism, Guggenheim Jeune and the Mayor Gallery were more broadly based, and occasionally featured the work of abstract and constructivist artists who were, if anything, deeply hostile to Surrealism with its literary content and contempt for formal values.

From the third issue in June 1938 until the magazine ceased publication two years later, Mesens was editor of *London Bulletin*, although he was sometimes assisted by prominent English Surrealists, most frequently Roland Penrose. With Mesens at the helm, Belgian Surrealism – and especially the work of his old friend Magritte – was given extensive coverage. Among the leading French poets, Eluard rather than Breton was most often represented, no doubt because he was a close friend of both Mesens and Penrose. After the demise of

London Bulletin, and despite the fact that Eluard had quarrelled with Breton and left the official Surrealist movement, Mesens continued to promote his poetry in England; in 1942, for example, London Gallery Editions published translations of Eluard's *Poésie et vérité* (cat.263).

Mrs Keiller purchased her set of *London Bulletin* from H. A. Landry, London, in September 1974.

425
Marie
Journal bimensuelle pour la belle jeunesse

Brussels, Puvrez, 1926

E. L. T. Mesens, editor
Nos.1–3 in 2 issues, June–July 1926; complete run
Format: news-sheet format, pp. various; illustrated;
32.5 × 25
GMA.A.42.0475.

The prospectus for *Marie* announced that it would appear twice a month, but like so many other Dada-Surrealist reviews it folded rapidly, a victim both of precarious finances and the insatiable desire for change and innovation. Only two issues were published in June and July 1926, both edited by the ever-energetic E. L. T. Mesens, who eventually emerged as one of the leading impresarios of Surrealism. A belated swan-song, *Adieu à Marie*, edited by Paul Nougé, appeared in February or March 1927. The first issue of *Marie* was almost entirely given over to contributions by Belgian poets, but the second double issue drew heavily on Mesens's contacts with ex-Dadaists in Paris, notably Picabia, Ribemont-Dessaignes and Tzara. Magritte's emergence as a leading figure in the recently formed Surrealist group in Brussels is reflected in a de Chirico-inspired drawing.

426
Minotaure
Revue Artistique et Littéraire

Paris, Editions Skira, 1933–1939

Albert Skira editor, Efstrathios Tériade artistic editor
Nos.1–13 in 11 issues; complete run
Vol.1 1933, cover by Picasso; Vol.2 *Mission Dakar-Djibouti 1931–1933*, 1933, cover by Gaston-Louis Roux; Vols.3–4 1933, cover by André Derain and frontispiece by Man Ray; Vol.5 May 1934, cover by F. Borès; Vol.6 Winter 1935, cover by Marcel Duchamp; Vol.8 June 1936, cover by Salvador Dalí; Vol.7 June 1935, cover by Joan Miró; Vol.9 October 1936, cover by Henri Matisse; Vol.10 1937, cover by René Magritte; Vol.11 1938, cover by Max Ernst; Vols.12–13 1939, cover by André Masson
Format: pp. various; illustrated; pb.; 31.5 × 24.4
GMA.A.42.0002–0005; 0422; 0447; 0470; 1029–1032

Far from being envisaged as the new Surrealist review to replace the recently defunct *Le Surréalisme au Service de la Révolution* (cat.434), *Minotaure* was originally planned as the forum for the 'dissident' Surrealists who had gathered round Breton's implacable rival, Georges Bataille. Thus the second issue, dated 16 June 1933, was devoted to the Dakar-Djibouti ethonographical expedition to Africa, on which ex-Surrealist Michel Leiris served as secretary. Notwithstanding, the first issue (which appeared in May 1933, despite the printed date of February), had many contributions by members of the official Surrealist group, including Breton's enthusiastic essay on Picasso's recent work ('Picasso dans son élément') illustrated with Brassaï's magnificent photographs of his sculpture studios at Boisgeloup, and Dalí's 'paranoiac-critical' interpretation of Millet's *The Angelus*. Gradually and inexorably *Minotaure* was taken over by Breton and his friends so that it did become to all intents and purposes a Surrealist review, even though non-Surrealists like Matisse and Derain continued to be featured in it. The last three issues (Winter 1937–May 1939), although still produced under the direction of Albert Skira, were edited by a committee comprising Breton, Duchamp, Eluard, Maurice Heine and Pierre Mabille for numbers 10 and 11, and Breton, Heine and Mabille only for the final double number.

Lavishly produced and beautifully illustrated from the first, *Minotaure* reflected the abiding passion for top-quality printing and reproduction of its two original directors, Skira and Tériade. (In 1937 the latter left to found the even more luxurious but also more mainstream review *Verve*.) Each issue had a specially designed cover by a leading artist depicting the Minotaur in some guise or another, the first being a reproduction of Picasso's extraordinary collage assembled from corrugated cardboard, silver paper, a lacy doily, a strip of wallpaper and some real leaves. In general, the breathtaking range of subjects covered in the magazine is testimony to Surrealism's sheer richness of culture in the 1930s.

Mrs Keiller obtained her complete run of *Minotaure* from H. A. Landry, the London book dealer, in September 1974.

427
Plastique
Paris, Imprimerie des 2 Artisans, 1937–1939

Sophie Täuber-Arp & César Domela, editors
Nos.1–5, Spring 1937–1939; complete run
Format: pp. various; illustrated; pb.; 24.1 × 15.5
GMA.A.42.0183

The editors of *Plastique* described it on the back cover of the first issue as: 'a magazine devoted to the study and appreciation of Abstract Art', and themselves as 'painters and sculptors identified with the modern movement in Europe and America'. In line with this international programme, they promised to publish articles in English, French and German. The first three numbers of the review, which were edited jointly by Sophie Täuber-Arp and César Domela, were indeed dedicated to abstraction, the first being conceived as a homage to the pioneer abstract painter Kasimir Malevich, who had died in 1935. But the last two issues, which were published in 1939 and edited by Täuber-Arp alone, were given over to a collaborative 'novel' entitled *L'Homme qui a perdu son squelette* (The man who has lost his skeleton) by Arp, Leonora Carrington, Duchamp, Eluard, Ernst, Hugnet, Pastoureau and Prassinos, all of whom had been prominent in the Surrealist movement. In these issues, *Plastique* was accordingly described in notably less specific terms as 'dedicated to avant-garde works of plastic art and literature'. Like many other avant-garde reviews, it was forced out of existence by the war.

428
Proverbe
Feuille Mensuelle

Paris, 1920

Paul Eluard, editor
Nos.1–5, February–May 1920, 5 issues of 6, February–July 1920; incomplete run
Format: 5 sheets, folded into 4pp. (nos.1–3 & 5), & 1p. (no.4); 22.5 × 14
GMA.A.42.0463.01–05

Proverbe was a Dadaist review consisting of a single folded sheet, and was edited by Paul Eluard. The first five numbers were published between February and May 1920, during a hiatus in the publication of *Littérature* (cat.421). A sixth and final issue came out in July 1920 under the title *L'Invention no.1 et Proverbe no.6*. *Proverbe* published poems, texts and the occasional drawing by the leading Dadaists in Paris, including – in addition to Eluard himself – Aragon, Breton, Picabia and Tzara. Mrs Keiller bought the first five issues from John Armbruster, Paris, at an unknown date.

429
Les Quatre Vents

Paris, Aux Editions de Quatre Vents, 1945–1947

Henri Parisot, editor
Nos.1, 3–4, 6–8, 6 issues of 9, June 1945–June 1947;
incomplete run
Format: 104pp.; pb.; 19 × 14
GMA.A.42.0071–0076

Henri Parisot, the editor and publisher of *Les Quatre Vents*, had been involved in the Surrealist movement since the 1930s. Each issue was a compilation of literary texts, the first appearing on 12 June 1945, just weeks after the unconditional surrender of Germany and almost a year before Breton's return to France from America. Some of the texts were by historic Romantic and Symbolist writers, like Achim von Arnim, Alfred Jarry and Lewis Carroll, who had long been favourites with Breton and his followers. Others were by leading members, past and present, of the Surrealist movement. Thus the fourth issue (1 February 1946) was subtitled 'L'Evidence surréaliste' and the eighth (27 March 1947) 'Le Langage surréaliste'. The urge to anthologise and to trace – and retrace – its artistic and ideological roots had been a feature of Surrealism since its inception, and was, indeed, one of the characteristics which distinguished it most sharply from Dada.

Mrs Keiller's collection of these *cahiers de littérature*, as Parisot designated them, is incomplete.

430
Repères

Paris, G. L. M., 1936–1937

Guy Lévis-Mano, editor
Nos.13–25 issues; incomplete run; issues loose in
binder and slipcase
GMA.A.42.0136

Repères – the title may be translated as 'Landmarks' – was edited by Guy Lévis-Mano, who published many Surrealist texts in the 1930s. Each number took the form of a pamphlet consisting of a shortish text and a frontispiece, and appeared in an edition of seventy numbered copies. In many respects *Repères* is similar to Lévis-Mano's other contemporary publishing venture, *Cahiers G. L. M.* (cat.411), and many of the same writers and artists are represented.

Because, unlike *Cahiers G. L. M.*, *Repères* invariably featured one writer and one artist only, the individual issues have been listed in the Books section of this catalogue under various authors (cats.184, 189, 190, 224, 284, 294, 311, 314, 315, 321, 334, 342, 357, 378.)

431
Les Réverbères

Paris, Imprimerie des 2 Artisans, 1938–1939

Michel Tapié, Jean Marembert and Pierre Minne, editors
Nos.1–6 in 5 issues, April 1938–July 1939; complete run
No.1, April 1938. Format: 8pp.; illustrated, inserted lithograph, *Narcisse* by Tapié; loose-leaf; 32.7 × 25; lithograph 32.6 × 24.7, inscribed bottom right: M. *Tapié 66/130*
No.2, June 1938. Format: 8pp.; illustrated, inserted lithograph with crayon additions by Roger Sby; pb.; 32.2 × 24.5; lithograph 25 × 32.2, inscribed bottom left: N 67 SBY
No.3, November 1938. Format: 8pp.; illustrated, inserted lithograph by Minne [?]; pb.; 32.3 × 24.5; lithograph 32.2 × 25
No.4, March 1939. Format: 8pp.; illustrated, inserted lithograph by Aline Gagnaire; pb.; 32.3 × 24.5; lithograph 32.5 × 24.8, inscribed in plate bottom right: *Aline Gagnaire.38*
Nos.5–6, July 1939. Format: 1 sheet, 8pp., uncut; 64.4 × 50.4 (paper size) (page size 32.2 × 25.2)
GMA.A.42.0300

Les Réverbères defined itself as 'a post-Surrealist magazine' and issued a challenge to Breton in the form of an 'open letter' printed on the front page of the first number (April 1938). Thereafter it appeared at irregular intervals until it ceased publication in July 1939. Apart from the editor, Michel Tapié, contributors included Jean-François Chabrun, Robert Ruis and Aline Gagnaire – all leading lights in Noël Arnaud's Main à Plume group during the Occupation (see cat.183). Except for the final issue, which took the form of a pink folded poster printed back and front, every number contained an inserted, signed original print. Mrs Keiller purchased her complete run of the magazine from H. A. Landry, London, in January 1975.

432
La Révolution Surréaliste

Paris, Gallimard, 1924–1929

André Breton, Pierre Naville and Benjamin Péret, editors
Nos.1–12, December 1924–December 1929; complete run
Format: pp. various; illustrated; pb. in hb. folder in slipcase; 29.2 × 20
GMA.A.42.044

La Révolution Surréaliste was the main forum of the Surrealist movement during the heroic five-year period between the publication of Breton's first Surrealist Manifesto in October 1924 and of his Second Manifesto, which appeared in the twelfth and final issue in December 1929. The content of the magazine is extremely varied and accurately reflects the main preoccupations of the Surrealists at this time. Thus there are accounts of dreams, 'automatic' texts, poems and drawings, virulently worded tracts on a variety of moral, intellectual and political issues, essays on madness, hysteria and mediumism, attacks on the enemy-institutions of Church, State and Family, ruminations on love and desire, and so on. The polemical tone is impassioned, and the ideal of revolution in its widest sense uppermost. The movement's often violent, internal ideological battles are aired in public, never more painfully than in the *Second Surrealist Manifesto* which effected a devastating purge of former allies with whom the always uncompromising Breton had quarrelled definitively. The changed, and much reduced, membership of the group is mirrored in the famous montages of photo-portraits published in the first and last issues.

The first three numbers of the magazine were edited by Pierre Naville and Benjamin Péret (December 1924–April 1925), the remainder by Breton himself. From the outset far more space was devoted to the visual arts than had been the case with *Littérature* (cat.421) – a consequence both of Breton's deep-seated love of art and absolute determination to break down the traditional barriers between *peinture* and *poésie*, and of the constant presence in his entourage of artists such as Ernst, Masson, Tanguy, Miró, Man Ray, Arp and, eventually, Magritte and Dalí. Thus it was in the pages of *La Révolution Surréaliste* that Breton's seminal essay 'Le Surréalisme et la peinture' first appeared in serialised form (nos.4, 6, 7, 9–10; July 1925–October 1927). (His text was published with additions as a fully illustrated book in 1928.) In format the magazine parodied the respected scientific journal *La Nature* and consciously eschewed the fancy and flamboyant typography of Dada periodicals. On the other hand, the page layouts, while appearing to the superficial glance eminently sober and rational, were in fact deeply subversive in their abrupt juxtapositions of unrelated texts and images. Photography played a key role throughout the lifetime of the review, its supposed objectivity proving to be the perfect, if paradoxical, vehicle for communicating *le merveilleux* – the ultimate goal of the Surrealist movement during these years.

Mrs Keiller purchased her complete set of *La Révolution Surréaliste* from H. A. Landry in April 1975.

433

SIC

Sons, Idées, Couleurs, Formes

Paris, Gallery Editions, 1916–1919

Pierre Albert-Birot, editor
Nos.1–54, January 1916–December 1919; complete
run
Format: pp. various; illustrated; all issues pb. in
green mock-snakeskin binder and slipcase; issues
vary in size, slipcase size 29.5 × 23.8
GMA.A.42.0128

The initials of SIC stand for *Sons, Idées, Couleurs*.
Founded in January 1916, SIC survived for an
unsually long time for an avant-garde review at
this very volatile period, finally ceasing
publication in December 1919. In all fifty-four
numbers appeared. The success of the
magazine – it easily outlasted its main rival,
Pierre Reverdy's *Nord-Sud* (1917–18) – had
much to do with its editor, Pierre Albert-Birot,
who managed to operate within his limited
budget by keeping to a modest format,
published at regular intervals, and saw to it
that distribution was efficiently organised. His
approach towards contributors was generally
open-minded and tolerant, provided, that is,
that they represented a broadly radical
tendency. Thus although initially SIC was a
forum for those who, like Paul Dermée,
Guillaume Apollinaire and Pierre Reverdy,
were supporters of Cubism, and although
Albert-Birot's own poetry had affinities with
Futurism, it was gradually infiltrated by Dada
and became a regular forum for the young
poets who, like Aragon, Soupault and Drieu La
Rochelle, emerged as leading figures in
Parisian Dada in 1920.

Mrs Keiller bought her complete set of SIC
from Sims, Reed and Fogg, the London
antiquarian bookshop, in June 1982.

434

Le Surréalisme au Service de la Révolution

Paris, 1930–1933

André Breton, editor
Nos.1–6, July 1930–May 1933; complete run
Format: pp. various; illustrated; pb.; 27.8 × 19.3
GMA.A.42.0448

The sequel to *La Révolution Surréaliste* (cat.432)
and, as the change in title implies, a more
strictly politicised review altogether, *Le
Surréalisme au Service de la Révolution* mirrors the
often strained relationship between the
Surrealists and the Communist Party (Hegel is
one of its chief heroes). Throughout its
relatively short lifespan, and in the wake of the
bitter purges of 1929 reenacted in the final

issue of *La Révolution Surréaliste*, the Surrealist
movement went through very troubled times –
the climax coming in 1932 with the 'Aragon
affair', which resulted in a further spate of
defections (see cat.182). Even so, Breton
himself maintained that: 'of all the Surrealist
publications, *Le Surréalisme au Service de la
Révolution* [. . .] is by far the richest, in the
sense that we understand it, the best balanced,
the best constructed, and also the most alive
(with a dangerous and exalted life). It is there
that Surrealism is shown at full flame: for a
while some saw only that flame, and were not
afraid of being consumed in it' (André Breton,
Entretiens 1913–1952 avec André Parinaud, Paris,
1952, pp.153–154). Its uncompromising,
'purist' character was, indeed, a close
reflection of Breton's own, while the promi-
nence given to the Marquis de Sade and to
Freud is an indication of those areas, aside
from the strictly political, in which the
'dangerous and exalted life' was played out.

Produced in the grim financial climate
ushered in by the Wall Street Crash, *Le
Surréalisme au Service de la Révolution* has far fewer
illustrations than *La Révolution Surréaliste* and
these, for the most part, are gathered at the
back of each issue. The cover is also extremely
plain. The magazine therefore looks much
more austere and rigorous than its predeces-
sor, and lacks the latter's visual irony – and
many frankly comic touches – another sign of
Breton's total commitment to 'purity' in the
early 1930s. Not surprisingly, its readership
was considerably smaller than that of the more
seductive *La Révolution Surréaliste*.

This said, the great importance Breton
attached to recent artist-recruits, especially
Dalí and Giacometti, is revealed in the major
place they occupy in the pages of the review. It
was thanks primarily to Dalí and Giacometti

that the Surrealist object was invented as a new
genre in 1930–31. This development was
strongly highlighted in the magazine for Breton
was in no doubt that the *objet surréaliste* repre-
sented the most promising creative initiative.
He saw it, indeed, as the equal of automatism,
on which he had staked so much in the mid-
1920s but which he now feared was potentially
subject to cynical exploitation for purely
aesthetic purposes.

Mrs Keiller purchased her complete set of *Le
Surréalisme au Service de la Révolution* from Tony
Reichardt, London, at an unknown date.

435

Le Surréalisme en 1929

Brussels, Editions 'Variétés', 1929

Special hors-séries number of *Variétés*
Format: 74pp.; illustrated; pb. re-bound in marbled
green and gold paper cover with leather title; 24.8 × 18
GMA.A.42.1000

This was a special, extra issue of the Belgian
periodical *Variétés* (cat.422) to which most of the
Surrealist poets and painters in both Paris and
Brussels contributed. The invited editors were
Breton, Aragon and Eluard, who travelled to
Brussels in April 1929 in order to prepare it for
the printer. Richly illustrated throughout, it has
a visually provocative layout similar to that
adopted in *La Révolution Surréaliste* (cat.432). One
of the most memorable items is the 'Surrealist
Map of the World'. This dramatically reframes
geography in terms of the current ideological
and artistic preoccupations of the movement,
and is resolutely anti-colonialist in its presenta-
tion. Thus Alaska, Labrador, Mexico and the
South Sea Islands are shown to dominate the
world, while Europe has shrunk to a pathetic
growth to the west of an enormous Russia.

Le Surréalisme en 1929 came out at a time of

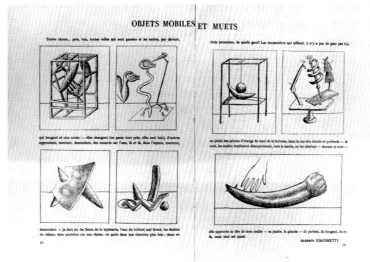

434 / No.3 1932. Illustrations by Giacometti

steeply mounting tension within the Parisian Surrealist group. Among its other notable items is Breton's and Aragon's 'dossier' recording the tumultuous events of the reunion at the Bar du Château on 11 March 1929, in which the Grand Jeu group were called to account for supposed anti-revolutionary activities, and which led to a series of defections of first generation Surrealists such as Robert Desnos and Michel Leiris. (See also cat.418.)

436
Le Surréalisme, Même

Paris, Librairie Jean-Jacques Pauvert, 1956–1959

André Breton, editor
5 issues, October 1956–Spring 1959; complete run
Format: pp. various; illustrated; pb.; 19 × 19
GMA.A.42.0153.01–05

Together with its predecessors *Néon* (1948–49) and *Médium* (1953–55), *Le Surréalisme, même* gives the most complete representation of the preoccupations of the Surrealists who had regrouped around André Breton after his return to France in May 1946. The existence of a review, albeit sporadic, was intended to provide clear proof of the survival of the movement – proof, even, that it was positively flourishing – in the face of the scepticism of many critics who claimed, in the aftermath of the war, that Surrealism was dead and buried. Whereas *Néon* and *Medium* were edited by other, younger members of his circle, Breton himself edited *Le Surréalisme, même*. Although much space was given over to the work of newly recruited poets and painters, such as Robert Benayoun, Jean-Louis Bédouin, Vincent Bounoure, Joyce Mansour, Pierre Molinier and Jean Schuster, the few members of the old guard who had remained on good terms and in close contact with Breton were also in evidence and provided continuity with the 'heroic' past. Chief among these was Marcel Duchamp, for whom Breton's admiration had never wavered. Duchamp provided the highly provocative cover for the first issue (October 1956) – a photograph of *Feuille de vigne femelle* (cat.29) lit in such a way that it appears convex rather than concave. Even the title of the review was a homage to Duchamp, for it employs the same pun on, *même*/ *m'aime*, (even/ loves me) as he had in *La Mariée mise à nu par ses célibataires, même* (see cat.249).

437
Surrealismus

Prague, 1936

Vítêzslav Nezval, editor
Format: 56pp.; illustrated; pb.; 29.3 × 21
GMA.A.42.0261

Nezval was the leader of the Prague Surrealist group. On a trip to Paris in 1933 he met Breton, whose work he already knew and admired, and the following year the Prague group was formally constituted. A manifesto was published and Breton and Nezval entered into a regular correspondence, much of it concerned with the content of the review Nezval planned to publish under the title *Surrealismus*. In 1935 Breton and Eluard travelled to Prague to give a series of lectures and to see the first exhibition of Czech Surrealism, which featured the work of the painters Toyen (see cat.214) and Styrsky and the sculptor Makovsky. The tour was a great success, and finally, after many delays, *Surrealismus* was printed in February 1936. The one and only issue of the review as it turned out, it contains both original Czech material and translations from key French Surrealist texts. Mrs Keiller bought her copy from John Armbruster, Paris, in April 1978.

438
391

Barcelona, New York, Zurich, Paris, 1917–1924

Francis Picabia, editor
Nos.1–2, 8–9, 11–19, 13 issues of 19, January 1917–October 1924; incomplete run. No.15 has supplement entitled 'Le Pilhaou-Thibaou'
Format: news-sheet; pp. various; illustrated; sizes various
GMA.A.42.0474

The longest-lived of the true Dada periodicals, *391* was very much the vehicle of its editor and principal contributor, Francis Picabia, the different places of publication (Barcelona, New York, Zurich and Paris) corresponding to his changes of abode. In all there were nineteen numbers, including 'Le Pilhaou-Thibaou' which was described as an 'illustrated supplement to *391*' and was published in Paris as no.15 on 10 July 1921. After an initial fairly regular start – the first seven issues were published between January and August 1917 – *391* appeared sporadically, with occasionally quite lengthy hiatuses when Picabia was immersed in other projects. Thus between the publication of 'Le Pilhaou-Thibaou' and the next issue, no.16, which came out in May 1924, there was a gap of almost three years. During that time Picabia had been involved in, among

other things, *Littérature* (cat.421), and when he decided to re-launch the review for a final flourish (nos.16–19) part of his purpose was to derail Surrealism, then in the process of emerging as a very serious-minded, polemical movement. The final issue of *391* published in October 1924 pretended, indeed, to launch a rival avant-garde movement entitled 'Instantanéisme' – the Instantaneist is described as 'an exceptional being, cynical and indecent' – but Picabia had no intention of running any such movement and was motivated primarily by a desire to ridicule André Breton. In general, Picabia's shifting allegiances with other Dadaists worldwide are accurately mirrored both in the varying list of contributors to *391* and in his often biting texts and gossip columns – whether his undeviating friendship with Duchamp, or his bumpy relationships with Tzara and Breton.

Always satirical and iconoclastic, *391* was influenced in its eye-catchingly unpredictable typography and lay-out by *291* (cat.440), and several of the issues were of a similar broadsheet-style format. As he had for the earlier review, Picabia created a series of laconic machine images which, if anything, are more frankly nihilistic. Some of them take the form of barely retouched photographs; thus the cover of No.5 (New York; June 1917) is entitled 'Ane' (Ass) and simply reproduces a propeller, and the cover for no.6 (New York; July 1917) is entitled 'Américaine' (American girl) and reproduces an electric light-bulb inscribed 'Flirt-divorce, Flirt divorce'. Other notorious images include the large inkblot/splash of blood blasphemously labelled 'La Sainte-Vierge' (The Holy Virgin), and his version of Duchamp's *L. H. O. O. Q.* – Leonardo's *Mona Lisa* equipped with waxed moustaches (both in no.12; Paris; March 1920). The latter image was reproduced above a brutally intransigent 'Dada Manifesto', which ends: 'Dada wants nothing, nothing, nothing. It does things only so that the public will say: "We understand nothing, nothing, nothing". "The Dadaists are nothing nothing, nothing, and they will amount to nothing, nothing, nothing". Francis Picabia who knows nothing, nothing, nothing. '

439
Transition

Paris, The Hague, New York, Transition, 1927–1938

Eugène Jolas and Elliot Paul, editors
Vols.1–27, April 1927–April-May 1938; complete run
Vols.1–12 (vol.12 includes index to vols.1–12)
Format: pp. various; illustrated; pb.; 19.3 × 14
Vols.13–20 subtitled: *An International Quarterly for Creative Experiment*

Vol.13, Summer 1928, *American Number*, cover design by Picasso
Vol.14, Fall 1928, cover design by Stuart Davis
Vol.15, February 1929, *James Joyce in New Work*, cover design by Man Ray
Vols.16–17, June 1929, *Spring-Summer Number*, cover design by Gretchen Powell
Vol.18, November 1929, *From Instinct to New Composition/Word Lore Totality/ Magic Synthesis*, cover design by Kurt Schwitters
Vols.19–20, June 1930, *Spring-Summer Number*, cover design by Eli Lotar
Format: pp. various; illustrated; pb.; 23 × 16.8
Vols.21–22, November 1930, *An International Workshop for Orphic Creation*, The Hague, The Servire Press, March 1932 & February 1933, Eugène Jolas editor
Format: 326pp. and 180pp.; illustrated, cover designs by Hans Arp and Sophie Täuber-Arp; pb.; 23 × 15.3
Vol.23, July 1935, *An Intercontinental Workshop for Vertigralist Transmutation*
Format: 206pp.; illustrated, cover design by Paul Klee; pb.; 23 × 14.7
Vol.24, June 1936, *Quarterly Review*
Format: 148pp.; illustrated, cover design by Fernand Léger; pb.; 21 × 15.1
Vol.25, Fall 1936 *Quarterly Review*; New York, Transition; Eugène Jolas, editor and James Johnson Sweeney, associate editor
Format: 216pp.; illustrated, cover design by Joan Miró; pb.; 21.5 × 15.3
Vol.26, 1937, *Quarterly Review*
Format: 220pp.; illustrated, cover design by Marcel Duchamp *3 ou 4 gouttes de hauteur n'ont rien à faire avec la sauvagerie*; pb.; 21 × 15.4
Vol.27, April–May 1938, *Quarterly Review. Tenth Anniversary*
Format: 382pp.; illustrated, cover design by Wassily Kandinsky; pb.; 20.5 × 15.1
GMA.A.42.0157

Transition was probably the most influential English language avant-garde literary and artistic periodical to be published during the inter-war years. Initially appearing at monthly intervals (nos.1–12; April 1927–March 1928), it switched to being a quarterly (nos.13–20; Summer 1928–Spring/Summer 1930), then to making an occasional appearance (nos.21–23; March 1932–July 1935), before finally reverting to being a quarterly again (nos.24–27; June 1936–April/May 1938). Throughout this time the chief editor, Eugène Jolas, whether he was working from Paris or New York, resisted becoming narrowly sectarian: thus the covers of the issues published after *Transition* ceased to be a monthly were designed by a wide range of internationally recognized artists, including Picasso, Stuart Davis, Man Ray, Arp, Klee, Léger, Miró, Duchamp and Kandinsky. Nevertheless, Surrealism was well represented from the first, and *Transition*, which was distributed in London, proved to be an important source of information about the movement for artists living in England.

440
291
New York, 1915–1916

Arthur Stieglitz, editor
Nos.1–11, March 1915–February 1916 in 8 issues; complete run
Format: news-sheet; pp. various; illustrated; 44 × 29.8 (No.1), 48 × 31.9 (Nos.2–11)
GMA.A.42.0473.01–08

Named after Arthur Stieglitz's 291 Gallery in New York, 291 was always intended to be experimental, to have a strictly limited lifespan, and to be dedicated to the most avant-garde tendencies in contemporary art. During the year that it lasted – from March 1915 to February 1916 – Stieglitz's long-running magazine *Camera Work* (founded in 1903) was duly suspended. Although often iconoclastic and satirical in character, 291 was a luxurious and costly production and makes a dramatic visual impact with its bold confrontations of text and image and its always highly inventive and unconventional typography and page layouts. To be even more eye-catching, the format was unusually large and two editions were printed, one ordinary and one de-luxe (the latter in an edition of 100 on high quality paper). According to Stieglitz, 291 was a commercial disaster and – as a Dada gesture – he eventually sold off most of the numerous unsold copies to a ragpicker for the derisory sum of five dollars, eighty cents. Not surprisingly, complete runs of the magazine are very rare.

Among the principal contributors to 291 were the poet and caricaturist Marius de Zayas, who had close links with Apollinaire, Max Jacob and Picasso in Paris; Stieglitz's disciple Agnes Ernst Meyer; the writer Paul Haviland; and, above all, Francis Picabia. Picabia arrived in New York in June 1915 and immediately became caught up in the production of the review, publishing in its pages some of his very first machine drawings adapted from advertisements and illustrations in technical and scientific journals and automobile magazines.

440 / Picabia and de Zayas from November 1915

441
The Tyro
A Review of the Arts of Painting, Sculpture and Design

London, The Egoist Press, 1921–1922

Percy Wyndham Lewis, editor
Nos.1–2, April 1921–March 1922; complete run
Format: No.1, 66pp.; illustrated; pb.; 37.5 × 24.7.
No.2, 98pp.; illustrated; pb.; 24.8 × 18.5
GMA.A.42.0667.01–02

Like *Blast* (cat.407), Lewis's second periodical, *The Tyro: A Review of the Arts of Painting, Sculpture and Design*, lasted just two issues, the first published in April 1921 and the second the following March. As with *Blast*, the intention had been to publish quarterly. The first issue, a large-format magazine, carried articles by T. S. Eliot and Herbert Read, and a stinging attack on Roger Fry by Lewis himself. The second issue, smaller in format but boasting more pages than the first, again carried articles by Eliot, Read and others, and had more illustrations, including works by Dismorr, Lewis, Dobson, Cedric Morris and Wadsworth, and what is probably the first reproduction of a sculpture by Lipchitz to appear in a British publication. Tyro means a 'novice' or 'beginner', but Lewis expanded upon this definition, calling him 'a new type of human animal, like harlequin or Punchinello ... The Tyro is raw and underdeveloped; his vitality is immense, but purposeless, and hence sometimes malignant. His keynote, however, is vacuity, he is an animated but artificial puppet, a "novice" to real life ...' (letter to John Quinn, 18 March 1921, quoted in W. Michel, *Wyndham Lewis: Paintings and Drawings*, London, 1971, p.100). Lewis painted a series of Tyro paintings from 1920–21, exhibiting them at the Leicester Galleries in London in April 1921. Lewis's position vis-à-vis the tyros was somewhat ambiguous: although they were satirical portraits, all bearing the same grotesque, toothy grin, he also painted a self-portrait as a tyro.

442
Variétés
Revue Mensuelle Illustrée de l'Esprit Contemporain

Brussels, Editions Variétés, 1928–1930

P-G. van Hecke, editor
24 issues, May 1928–May 1930; complete run
Format: pp. various; illustrated; pb.; 25.3 × 18
GMA.A.42.0110–0112; 0442 & 0468

Paul-Gustave van Hecke, the editor of *Variétés*, was a leading dealer in contemporary Belgian art during the 1920s. His wife Norine was a successful couturière, and together they assembled an important private art collection. (Among the

442 / Cover January 1929

paintings they owned was Delvaux's *La Rue du tramway*, cat.23.) In 1926 van Hecke, who had various Belgian artists under contract, including Magritte, joined forces with the Galerie Le Centaure in Brussels (see cat.413), sharing his stock with it. Then in October 1927 the van Heckes opened their own gallery, called Galerie 'L'Epoque' entrusting its management to their protégé E. L. T. Mesens. (It folded in 1929, a victim of financial crisis.) The policy of the Galerie 'L'Epoque' was more progressive and less eclectic than that of Le Centaure, and its primary commitment was to Expressionism and Surrealism.

This twin bias is mirrored in *Variétés*, which began publication in May 1928 and ceased in April 1930. Described on the cover as an 'Illustrated monthly review of contemporary thought', *Variétés* was modelled on the avant-garde Berlin review *Der Querschnitt*. Although Mesens aided van Hecke in this enterprise as well as in the gallery, the design, typography, and choice of photographs and articles was, apparently, very much van Hecke's own. His sympathy for Surrealism is most obvious in the publication in June 1929 of a special, extra number of the review entitled *Le Surréalisme en 1929* (cat.435). Mrs Keiller purchased her complete run of *Variétés* from John Armbruster, Paris, at an unrecorded date.

442 / From July 1929, photograph by Ufa

443
View
New York, View Inc., 1940–1947

Charles Henri Ford, editor
37 issues of 40, September 1940–Spring 1947; incomplete run: Series II, Nos.1–4, 1942–43; Series III, Nos.1–4, 1943–44; Series IV, Nos.1–4, 1944–1945; Series V, Nos.1–6, 1945–46; Series VI, Nos.1–3, 3[4], 1946; Series VII, Nos.1–3, 1946–1947; Bound at back: Series I Nos.1, 2, 6, 7–8, 9–10, 11–12, 1940–42
Format: pp. various; illustrated; pb. bound in hb.; 30.2 × 23
GMA.A.42.0006

View, founded in September 1940, was an avant-garde literary periodical which was not committed to any particular contemporary movement. Nevertheless, the editor Charles Henri Ford was very sympathetic to Surrealism, and when Breton and other members of the movement arrived in New York in 1941–42 they found a natural home within its covers. One of the main contributors, Nicolas Calas, formed a close friendship with Breton and edited a special Surrealist number in October-November 1941; in 1942 successive issues were devoted to Ernst (April) and Tanguy (May). But perhaps the best-known issue of *View* is the one devoted to Duchamp (March 1945), which included among other things a translation of extracts from Breton's pioneering interpretation of *The Bride Stripped Bare by her Bachelors, Even* entitled 'Lighthouse of the Bride'. (This essay had been published in the original French in *Minotaure*, no.6, Winter 1935.) For the occasion Duchamp designed an arresting cover depicting a starry night sky invaded by a floating, inverted bottle which, in a typically ironic gesture, bears a label detailing his military service record. (The image has been interpreted as an oblique reference to the Bachelor apparatus and the Bride in the *The Bride Stripped Bare. . .*)

444
XXe Siècle [i. e. Vingtième Siècle]
Paris, Chroniques du Jour, 1938–1939

Gualtieri di San Lazzaro, editor
Six numbers in 4 issues, March 1938–May 1939; complete run
Nos.1–3, French editions, Nos.4–6 English editions
Format; pp. various; illustrated; pb.; 31.8 × 24.5
GMA.A.42.0302

XXe siècle was a luxurious, non-sectarian review. One of its most notable features was the inclusion of original prints by leading contemporary artists. San Lazzaro's attitude was eclectic, and most contemporary tendencies were well represented, including abstraction and Surrealism. Mrs Keiller purchased her set of *XXe siècle* piecemeal from H. A. Landry, London, in 1975.

445
VVV
Poetry, Plastic arts, Anthropology, Sociology, Psychology
New York, 1942–1944

David Hare, editor, with André Breton, Marcel Duchamp and Max Ernst
Nos.1–4, June 1942–February 1944; complete run
Format: pp. various; illustrated; pb.; 28.2 × 21.4
GMA.A.42.0421

Although *View* (cat.443) had welcomed their participation, the Surrealist exiles were determined to found their own review and thus ensure the continuation of the movement in the face of the threat posed by the war. *VVV* was that review, and the rich content of its three issues is testimony to the sense of optimism, and even of renewal, that Breton and his colleagues seem to have felt in the energetic environment of New York. *First Papers of Surrealism*, the exhibition they organised in New York in October-November 1942 (cat.278), was another significant rallying-point.

The editor of *VVV* was David Hare, a young American photographer and sculptor, but Breton, Ernst and Duchamp acted as his advisors. Some of the funding was put up by Peggy Guggenheim and Bernard Reis (see cat.253). Although necessarily less luxurious, *VVV* was modelled on *Minotaure* (cat.426) and like it carried articles on a great variety of subjects alongside Surrealist texts and tracts. The magazine's sub-heading, 'Poetry, plastic arts, anthropology, sociology, psychology', gives a good inkling of the characteristic mixture. (Claude Lévi-Strauss was a very active member of Breton's circle and contributed several important anthropological essays.) Like *Minotaure*, *VVV* was richly illustrated, and each issue had a specially commissioned cover. Ernst provided the first (June 1942) – a fantastic-looking combination of diagrams illustrating the movement of birds, insects, fish, etc. Roberto Matta, who had joined the movement in the late 1930s, provided the last (February 1944). But the most memorable of the three is Duchamp's cover for the double number published in March 1943. The front cover used an anonymous etching of an allegorical figure of death clothed in the American flag. The back cover is an elaborate construction consisting of a cut-out of a woman's torso drawn by Duchamp, with real chicken wire inserted in the opening; through the opening one can glimpse part of Frederick Kiesler's spoof-questionnaire/competition entitled 'Twin-Touch-Test', which is illustrated with a photograph of a woman ecstatically fondling a sheet of chicken wire.

Mrs Keiller purchased her set of *VVV* from H. A. Landry, London, in May 1975.

Catalogue Index

Numbers refer to catalogue numbers. Numbers in **bold** denote principal artist, author, editor, illustrator or subject.